Mara~Serengeti
A PHOTOGRAPHER'S PARADISE

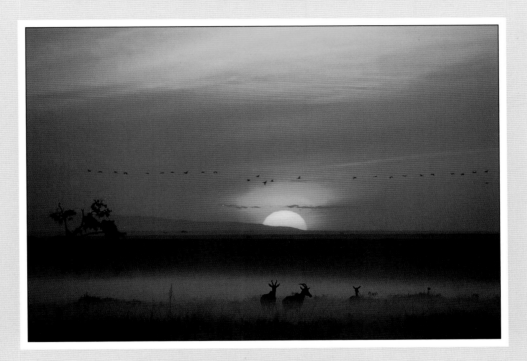

The dawn of a new millennium

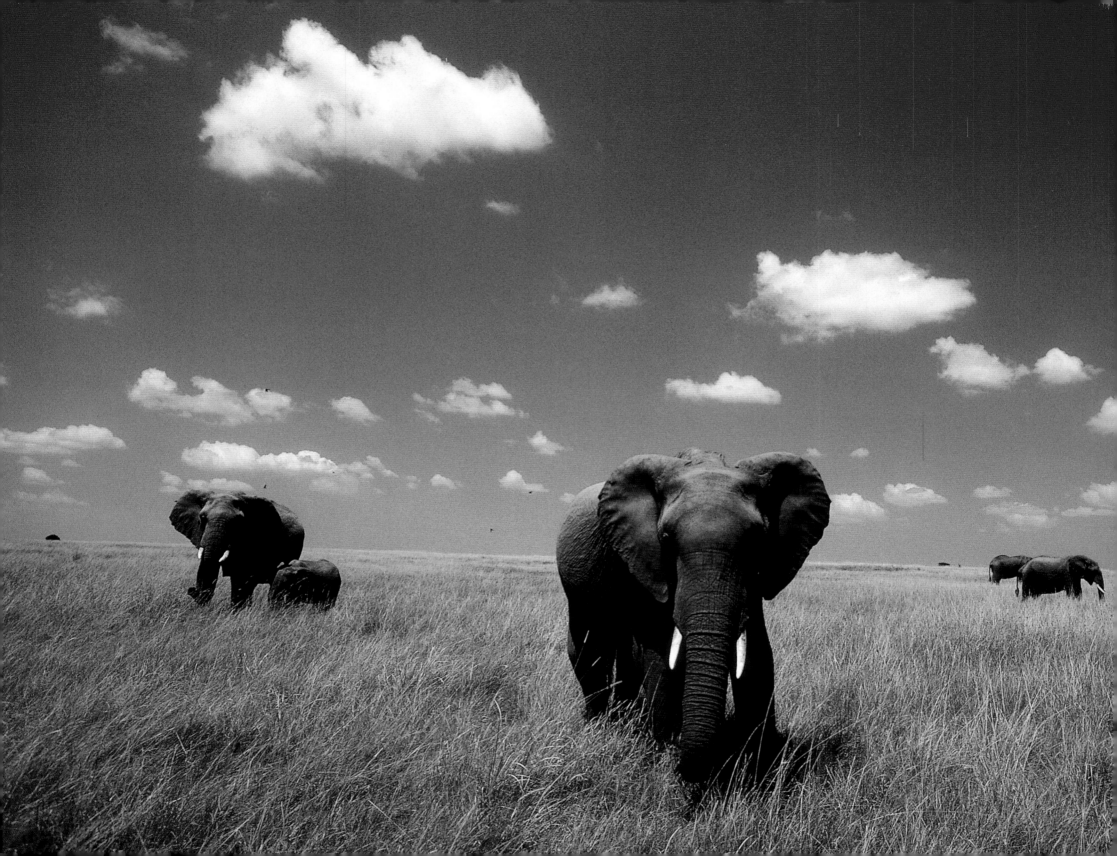

Mara~Serengeti

A PHOTOGRAPHER'S PARADISE

Jonathan & Angela Scott

Design
Grant Bradford

Editor
Caroline Taggart

FOUNTAIN PRESS

Published by
FOUNTAIN PRESS
Newpro UK Ltd
Old Sawmills Road
Faringdon
Oxfordshire SN7 7DS

Mara-Serengeti
© Fountain Press 2000

Photographs & Text
© JONATHAN & ANGELA SCOTT

Design & Layout
GRANT BRADFORD
Design Consultants
Tunbridge Wells, Kent

Editor
CAROLINE TAGGART

Origination
New Century Colour
Hong Kong

Printing & Binding
Supreme Publishing Services

Photographs courtesy of
PLANET EARTH PICTURES
planetearth@visualgroup.com

Jonathan & Angie Scott
would like to acknowledge the support of

TOYOTA

Canon

ISBN 0 86343 398 7

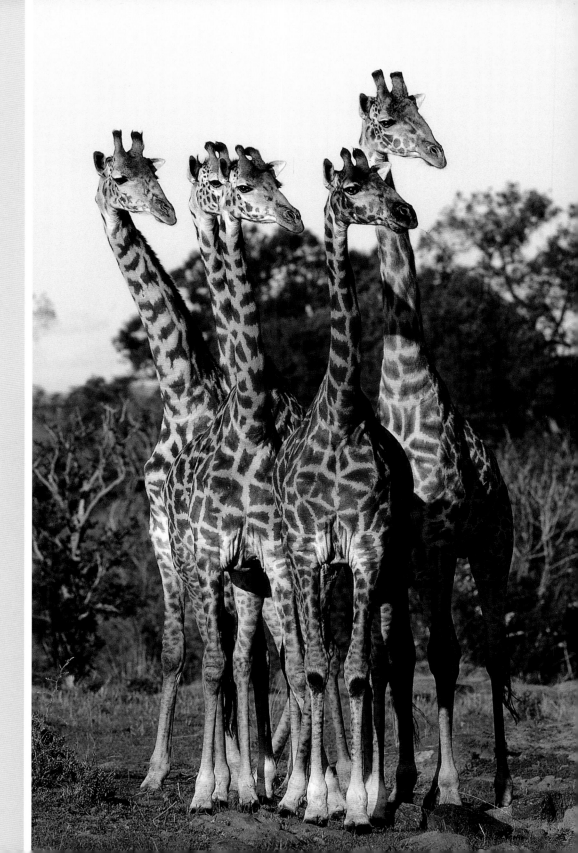

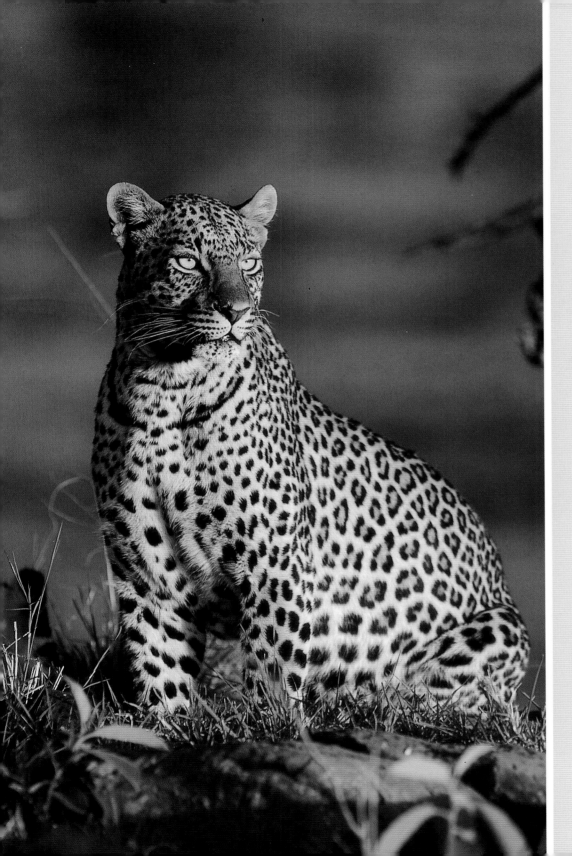

Foreword

*E*veryone, at some point in their lives, dreams of taking a safari to Africa. Lions and elephants are universal symbols of wild places and nowhere embodies that thought better than the Mara-Serengeti, a vast tract of land lying astride the Kenya-Tanzania border – a far-off place steeped in mystery.

In the language of the Masai, Serengeti means land of endless space – the place where the land runs on forever. Here there are rocks more than three billion years old, a fitting backdrop for the endless procession of plains game that treks across the ancient landscape: hundreds of thousands of wildebeest, zebras and gazelles; a Pleistocene vision, a fragment of times past.

Man has always been an integral part of the Mara-Serengeti. Two million years ago our early ancestors emerged from the forests and moved into the savannas of Africa, eking out an existence as hunter-gatherers among the great predators that today enthrall us with their power and strength. In more recent times Masai herdsmen staked their claim to the grasslands, moving with their livestock according to the season, following the rains, just like the migratory herds.

This book celebrates the diversity of life to be found in the Mara-Serengeti: the great predators, the wonders of the migration, the people. It is a book of personal memories and favourite photographs of animals that we have followed throughout their lives – the ultimate safari.

Jonathan & Angie Scott

Nairobi, Kenya

Mara~Serengeti

CONTENTS

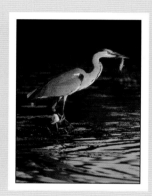

Introduction 8

How I first came to live in Africa. My first impressions of the Mara-Serengeti, my passion for the big cats and my joy in finding a kindred spirit in my wife Angie.

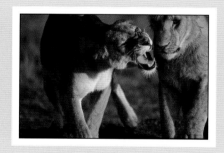

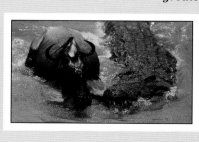

Lords of the Savanna 34

Lions are the undisputed kings among Africa's predators. For many years we have followed the lions of the northern Mara, focusing on a pride known as the Marsh lions. Drawing on personal experience and the latest findings of biologists we explore the life of lions.

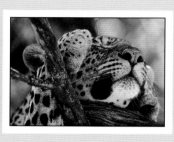

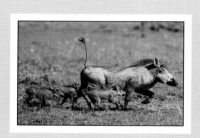

Shadows in the Grass 70

It was the chance of seeing a wild leopard that fired my ambition to live and work in Africa. Eventually I was lucky enough to get to know a succession of leopard females and their cubs: Chui, the Mara Buffalo female, Half-Tail and her surviving offspring Beauty, Mang'aa and Zawadi.

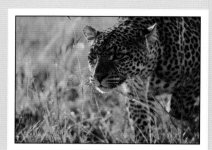

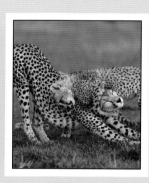

Land of Endless Space 108

The Mara-Serengeti ecosystem is defined by the movements of its vast herds of migratory wildebeest and zebra. We follow the wildebeest's journey from birth to death, exploring the background to the greatest wildlife spectacle on earth.

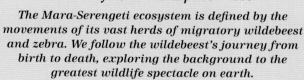

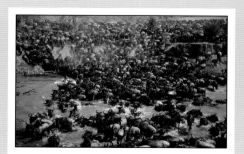

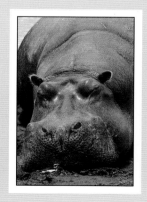

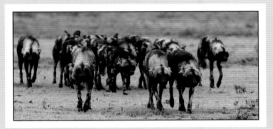

Humans have persecuted Africa's wild dogs to the point of extinction. To see a pack of these brindled hunters racing across the plains of East Africa is now a rare sight. We chart their demise in the Mara-Serengeti and consider their bleak future.

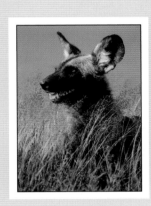

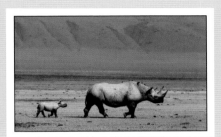

We are brought up to date on the animals we have come to know as individuals. We discuss the lives of the wild animals in the context of a changing landscape and the pressure of ever more people crowding the boundaries of the Mara-Serengeti.

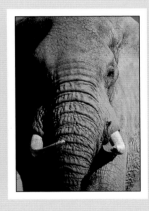

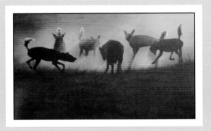

Photography is all about light, about learning to see with the eye of your camera and using different lenses to create different images.

Masai herdsmen have been a unique part of the Mara-Serengeti landscape for hundreds of years. But as the Masai become more sedentary the wildlife that shares their land is coming under increasing pressure.

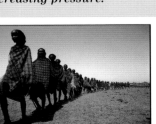

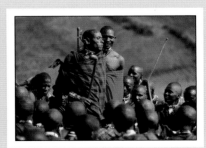

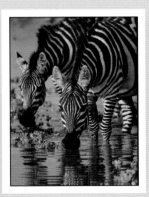

A Photographer's Paradise

It is absolutely essential that man should manage to preserve something
other than what helps to make soles for shoes or sewing machines, that he
should leave a margin, a sanctuary, where some of life's beauty can take
refuge and where he himself can feel safe from his own cleverness and folly.
Only then will it be possible to begin talking of a civilization.

Romain Gary *Les Racines du Ciel*

When I first visited the Masai Mara National Reserve in Kenya 25 years ago it was for the briefest of glimpses, a single game drive on my way to Nairobi via the Serengeti National Park in Tanzania. I was on an overland trip in a Bedford truck from London to Johannesburg. As for all of my travelling companions, this was a journey that would change my life; for some an escape from a mundane existence, an open-ended adventure, or simply the chance to visit Africa from north to south. For me it was the realisation of a dream. I had always been enthralled by Africa's wild animals and was searching for a way to transform my lifelong love of natural history into a career. In those days nothing could compare with the thought of exploring the bush in a four-wheel-drive vehicle, living among lions and elephants and camping under a flat-topped acacia tree miles from nowhere, the eerie whooping of hyenas sending tingles down my spine. It all seemed unbelievably exciting to a youngster raised on a farm in Berkshire, England.

With the truck's canvas roof rolled back I lived those four months on the road with my head in the clouds, sucking in the enormity of the continent, sleeping out in the open beneath clear star-studded Sahara skies, feeling the stifling heat of the Congo's tropical rainforests where the sweat runs from your body as fast as you try to replace it and mosquitoes swarm around your head all night. Malaria and amoebic dysentery visited before too long, unwelcome travelling companions for a week or so before we reached East Africa. We hit the Serengeti during the rainy season, ploughing our way through black cotton soil the texture of chewing gum. But none of it mattered. This was the Africa I had come in search of: grassy plains dotted with flat-topped acacia trees – just as they had been in the books and TV documentaries that had dominated my childhood, except now they had form and size, a breadth limited only by the sky and the plains themselves.

Nothing can adequately prepare you for a place like Serengeti – the space, the colours, the sense of timelessness. This is a land harbouring some of the most ancient rocks on earth, over three billion years old. Here you see a Pleistocene vision, life as it must have looked before man stepped upright into the savanna. It was February, the season when the great migration journeys to the southern plains, a time of rebirth for the herds. This is the greatest wildlife spectacle on earth, more than a million wildebeest and zebras reclaiming the vastness of the Serengeti's short-grass plains. I still remember the vivid mix of colours, the intensity of the light and clarity of the air, the sounds and smells of the great herds. We were stunned by the numbers of wild creatures spread like a banquet before us, startled by how 'tame' the animals seemed, how trusting.

Things haven't always been so peaceful in the Garden of Eden. In the 1920s and '30s the Serengeti was the domain of trophy hunters. Wealthy clients were only too happy to pay top dollar for the chance of killing Africa's big game. This was the birthplace of 'safari': a tented camp and sundowners around the campfire, shooting with guns rather than with cameras. In those days lions and leopards were considered vermin and could be shot on sight. Game wardens and hunters were convinced that the predators took too heavy a toll on valuable plains game and needed to be controlled in order to prevent them decimating prey populations.

The magnitude of the slaughter seems almost unbelievable today. In his book *My Serengeti Days*, Myles Turner, the legendary warden of the Serengeti from 1956 to 1972, recounts how in two months in 1925 one hunting party bagged over 50 lions; some took many more. Included in this figure were lionesses and cubs – perfectly legal quarry at the time. Hunting ethics were often non-existent: lions were pursued by cars and shot when they turned at bay. A wounded leopard was flushed from cover by backing a Model A Ford into the patch of bush where it had taken refuge and running the exhaust fumes into the undergrowth. There was little respite until 1937, when all hunting in the area was stopped and the Serengeti became a permanent game reserve.

Events of those early days were far from our thoughts as we ticked off the animals we had seen. Though most appeared willing to parade in front of us, one creature clung to its reputation for stealth and concealment. We had seen plenty of lions and a pair of handsome male cheetahs striding across the plains. By now the word 'leopard' was on everyone's lips.

The opportunity to visit the Serengeti had been one of my main reasons for joining the overland trip (at that time I knew nothing of the Mara, which really only came to prominence after Tanzania closed its border with Kenya in 1977). Situated at the heart of the Serengeti, the Seronera Valley offered the best chance of seeing a leopard anywhere in Africa, just as it had offered the best chance of shooting one to the early hunters. Rarely a day would pass without someone finding a leopard prowling along one of the tributaries of the Seronera River, which reaches out like gnarled green fingers into the plains. Tall, yellow-barked acacias and leafy sausage trees provided the perfect daytime resting place for leopards, and the tangled thickets lining the tortuous course of the river offered plenty of cover for a stalking cat. The surrounding grasslands were alive with Thomson's gazelles, impalas and reedbucks – just the right-sized prey for a leopard.

That afternoon we collected a ranger from park headquarters at Seronera, where we were camped. Word was that a leopard had been seen early that morning. The old male was well known to the rangers and drivers at Seronera. He was just one of a number of leopards that they kept tabs on. But a park regulation forbidding off-road driving within 16 kilometres of Seronera Lodge meant that getting a good look at a leopard even when you knew where it was resting might not be possible. The ranger told us how the Senior Warden David Babu sometimes acted like a leopard himself, lying in wait for drivers who broke the rules. Woe betide anyone who did, he cautioned. I've never forgotten the effect that Babu had on rangers and drivers alike, and often wished that there were more wardens like him.

That first leopard lying in the grass at the base of an acacia tree was something to behold. I remember the golden yellow eyes, the necklace of spots, the broad head and dog-like muzzle so typical of males. He barely looked up as we wrestled excitedly with cameras and lenses to record his presence. On reflection he probably wasn't much of a picture, shrouded in all that long grass. But he was a leopard; that was all that mattered. Around the campfire that night we talked about the leopard as if he was the only creature we had seen – an old friend. The thought of him consumed us like some deity. Lions, cheetahs, elephants, giraffes and zebras – all fascinating and beautiful in their own way – suddenly

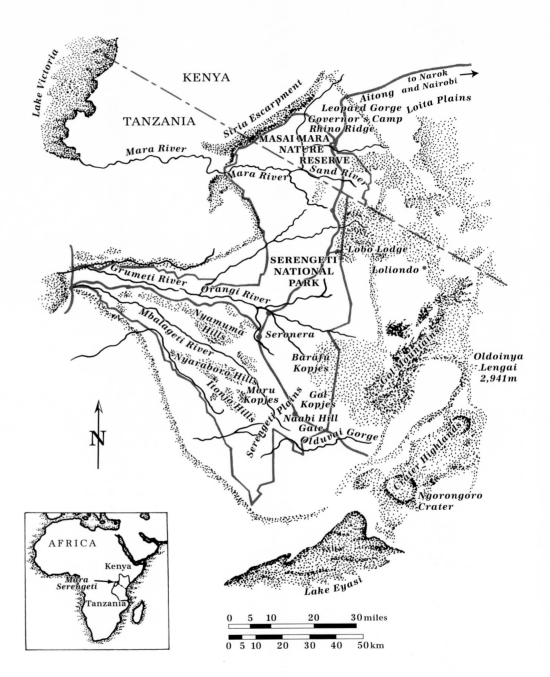

seemed ordinary by comparison. Yet we knew nothing about that beguiling spotted cat. I wondered how old he was, how many cubs he had sired, how long he had held his territory. I wanted a sense of the individual. It wasn't enough just to look, to record the different species of animals we had seen and then move on. Others in the group were anxious to hit Nairobi's bright lights. But for me, time was passing too fast. It was all too quick.

By the time we crossed the border into the Masai Mara, my mind was made up; I had to find a way to stay in Africa. That was still my dream, and the leopard was an essential part of it. On arrival in South Africa I immediately cashed in my onward boat ticket from Cape Town to Sydney in Australia. Three months later I headed for Botswana, where I worked with wildlife in various capacities for the next 15 months. By then I had earned enough money to buy a vehicle with a friend and travel overland once again, back to the Mara–Serengeti.

It was just as I remembered – a kingdom of predators, a photographer's paradise. The challenge now would be finding a way of financing my passion. As one of my lecturers at university had cautioned, 'Natural history is a pastime, not a profession. We'd all love to do "something" with wildlife and earn a living doing it, but unless you have a private income you'd better think again.'

I had already discovered that it was possible to work with wild animals in Africa: scientific research, tour guide, wildlife art and photography all offered the chance to spend time in the bush – and a precarious living. My ambition was to try and eke out an existence as a wildlife artist, producing pen-and-ink drawings as limited-edition prints, and I had recently had my first set of prints published. I remember my excitement on seeing my work published, clutching the prints in one hand as I ran down Kenyatta Avenue from the post office to show them to friends. In fact, it was with the help of a friend from university who now lived in Nairobi that I was able to stay at Mara River Camp, a small tented camp perched on a lazy bend of the river just to the north of the Masai Mara Reserve. The Mara was the perfect place to collect material for my drawings. Nowhere else can you see such a variety and abundance of animals in a single game drive – lions, leopards, cheetahs, elephants, rhinos, buffaloes, a rich array of antelope as well as a colourful sample of the Reserve's 500 species of birds. There was to be no remuneration, just free board and lodging and the chance to learn my way around the Mara by taking visitors on game drives. With a degree in zoology and an unquenchable appetite for books on natural history I was able to help visitors make the most of what they were seeing and gain experience as a wildlife illustrator. My life in the bush had begun.

Tucked away in the corner of my study in Nairobi are a dozen or more scruffy notebooks which tell the story of my years in the Mara–Serengeti, a mishmash of observations, sketches and maps pinpointing exactly where things had happened. In time this allowed me to recognise individuals among the various animals I saw regularly: the lions, cheetahs, wild dogs, elephants and rhinos that occupied most of my days. I read everything I could about animal behaviour, devouring the scientific papers written by field biologists working throughout Africa. I treated the whole experience as if I was preparing a PhD, recording exactly where I found the animals, who they were with, what they were doing, the time of day, the weather, plotting their home ranges. Patterns emerged, revealing associations between certain individuals; suddenly it wasn't just a lion or a wild dog, but that particular lion with whom I now felt a familiarity. This was exciting beyond my dreams; I was being a 'zoologist' on my own terms, in the field rather than the laboratory, studying whatever I wanted to.

Two years later, with a loan from the bank, I was able to purchase a Toyota Landcruiser of my own. This meant freedom; the freedom to spend as much time as I wanted alone in the bush, free from the necessity of driving other people around as a way of watching the animals and earning my keep. By now photography had become much more than a way to collect material for my artwork, and every shilling that I saved was invested in cameras and lenses. But I had quickly found out that it was impossible to do justice to one's role as a guide and take photographs at the same time. Photography is such a single-minded business that it shuts you off from other people; your focus is within, it is personal. Being a good guide means giving 100 per cent of your attention to other people's needs, at times rushing from place to place in an attempt to see as many different animals as possible. Understandably not everyone wanted to spend the amount of time that I did in getting a particular photograph or finding a certain animal. I well remember the utter frustration I felt when, after days of searching, visitors wanted to move on within minutes of finding the leopard that they had so wanted to see; or discovering lions hunting a buffalo, only to be forced to leave in the middle of the battle because clients were hungry and wanted to head back to camp in time for breakfast. Photography is too all-consuming for that.

For years nothing was more important to me than being up at the crack of dawn to search for a leopard or to drive to the Aitong plains, where wild dogs used to den. While my friends celebrated birthdays or Christmas back in camp or took a few days off to relax down at the coast, all I could think of was what I might miss if I joined them. The sight of

leopard cubs scrambling about in a thicket or a pack of wild dogs racing across the plains in pursuit of a gazelle was reward enough.

A day never passes without my thinking how fortunate I am living a life like this and to have met a kindred spirit in my wife Angie, who was born and raised in Africa and shares my love of art and photography. Hardly surprising, then, that we chose the top of the Siria Escarpment for our wedding, reciting our vows with a clear view across the Mara plains south as far as the Serengeti. Angie always says she is happiest when it is time to pack the car, lock up our beautiful home overlooking the Ngong Hills on the outskirts of Nairobi and head for the Mara. Placing two wildlife photographers under the same roof might seem a recipe for disaster, and a short marriage. The inside of a safari vehicle can become a cauldron of emotions when it is home for weeks at a time, 14 hours a day – and nights, too, if you are camping in the back of the car. Sometimes you wait all day for something to happen – the leopard to emerge or the lions to hunt – and end up with nothing but the joy of being there. Harmony in these circumstances is impossible if you're worrying that the other person is bored or hungry or tired or wants to go back to camp. To survive together you need an empathy that allows you to be as one, rejoicing in shared experiences.

Depending on the state of the road, it can take anything from five to seven hours to drive to the Mara. Up at dawn, one last check to see that everything is packed securely: food, water, cameras, a basket-full of film, spares for the vehicle and countless bits and pieces that have proved indispensable over the years, from a tiny tube of superglue to wooden planks for placing under the jack when we get stuck in mud. But above all there is a sense of optimism and adventure, the feeling of well-being that wild places such as the Mara instil.

Less than an hour down the road, that first glimpse of the Great Rift Valley is always a revelation, a prehistoric gash that runs for 5000 kilometres from the Red Sea as far as Mozambique at the other end of the continent. Plenty of time to enjoy the view as we negotiate the winding path to the bottom of the rift, wedged among the inevitable convoy of trucks. The country unfolds before our eyes as if there is no end, ancient volcanic cones marooned among plains speckled with whistling thorn. For every man in long trousers and jacket there is a red-robed Masai herdsman wandering across the landscape with his bony cattle. We have already seen giraffes, gazelles, Coke's hartebeest, zebras and ostriches. We pull off the road and disappear among the thornbushes to picnic under a favourite acacia tree. Laying claim to the spot in our minds, we wedge an old hartebeest skull in the fork of the tree before heading for Narok on the far side of the escarpment – a ramshackle town that marks the last port of call for supplies.

The long dusty road leading to the northern Mara beckons. If we don't delay we will have time for an evening game drive on our way in to camp. We hurry past vast tracts of open country hidden beneath a sea of wheat. The road is torn and rutted from heavy vehicles. In places wild animals still manage to cling on here; zebras and wildebeest, gazelles and impalas dot the horizon along with the livestock. Beyond the wheat fields, the trees and bush close in again as the road disappears between wooded hills. Suddenly the land opens out again and we are there, the blue of the Siria Escarpment to the west welcoming us home. I hear myself exclaim as I look out across the Mara plains. Even after all these years, it still leaves me breathless. We tumble out of the car to celebrate our arrival with tea, cold drinks, macadamia nuts and crisps.

Being confined within a vehicle for days on end gives a very blinkered view of the Mara and its inhabitants, tunnel vision instead of the big picture. You long to stretch your legs, to soak up the sense of place. But

within the reserve it is prohibited to leave your vehicle, except when accompanied by a ranger or at special sites where visitors can view hippos. Really to appreciate the scale and grandeur of the Mara you must take to the sky, fly in a balloon or hike to the top of the Siria Escarpment which forms the western boundary of the Reserve. This is something we often do, a family ritual of sorts.

From 300 metres above Mara River Camp you can see virtually the full extent of the area that we think of as our second home. The most obvious landmark is the band of riverine forest marking the course of the Mara River, which rises to the north of the reserve in a shallow swamp among the dwindling forests of the Mau Escarpment. The river neatly bisects the Reserve into an area known as the Mara Triangle to the west and the land where we spend most of our time to the east. Eventually the river reaches Lake Victoria via the Serengeti in Tanzania. During the dry season thousands of wildebeest and zebras congregate along the banks of the river to drink or to brave the muddy waters and cross in search of fresh pastures. Often I have spotted a massive build-up of animals eager to cross and hurriedly retraced my steps down the rocky hillside in time to witness the spectacle.

To the east of the river a wide green stain marks the extent of Musiara Marsh where on a good morning you can see more than 50 species of birds: herons and egrets, storks and kingfishers, eagles and vultures. The Marsh spreads south for a kilometre or more, fed by a spring that seeps from the base of a low escarpment just within the northern boundary of the Reserve. In the rainy season the tall reed beds provide a haven for buffaloes, elephants and waterbucks.

When I was based at Mara River Camp, I would drive south each morning until I reached the rocky rise overlooking the Marsh. Today there is a windmill marking the place where the spring bubbles from the base of the ridge, a green tin eyesore intended to pump water to the entrance gate to the Reserve a kilometre or so to the east. Sometimes I would find a cheetah perched atop one of the termite mounds among the acacia thickets above the Marsh, and if I were very lucky I might even snatch a glimpse of a spotted tail dangling enticingly from the canopy of one of the trees dotted along the ridge or in the dense stand of trees above the spring.

Beyond the Marsh and to the south of Governor's Camp the land rises gently to touch the blue of the sky, forming a belt of higher ground known as Rhino Ridge. I once counted nine black rhinos on a single game drive between the ridge and the Marsh. But that was before the poachers set to work. By the time they had finished in 1982 there were only 11 black rhinos scattered among the Mara's croton thickets compared to perhaps 150 in the 1960s. In recent years, with the help of funding from Friends of Conservation, the population has recovered to 25 and the Mara is a key refuge for black rhino. But changes in the vegetation in and around the Reserve over the last 30 years, due to the impact of fire, elephants, cattle encroachment and tourism, have led to a decline in the woodlands and croton thickets, making it unlikely that the rhino population will be able to expand to previous levels. With the exception of a single female called Naishuru, who is sometimes seen in the Musiara area, all the rhinos are located in the eastern sector of the Reserve, a morning's drive away from Mara River Camp.

I still vividly remember the excitement of seeing my first wild lions not far from the spring. Two magnificent males stood resplendent in the long grass, golden manes blowing in the wind, staring out across the Marsh, the dry-season heart of their territory. Joseph Rotich, my guide and mentor, told me that these were two of the Marsh lions – the name given to the pride of lions that hunted the area between the Mara River and the Bila Shaka Lugga, a seasonal watercourse two or three kilometres to the east, where a thin line of trees and bushes stands out from the surrounding plains. Luggas are a recurring feature of the Mara, dividing up the rolling plains and acacia thickets, and providing a convenient grid for finding one's way around.

Bila Shaka means 'without fail' in Swahili and as far as the drivers from the tented camps in the area are concerned the croton thickets bordering the Bila Shaka Lugga are as good a place as any to begin their daily search for lions. Here the big cats can find shade from the midday sun; countless generations of cubs have been born here, tucked deep in the croton thickets, under a fallen log or in a tangle of vegetation.

A lion's roar away to the west, the Mara River forms a natural boundary separating the Marsh lions from their relatives and rivals, the Kichwa Tembo pride. It is rare for the Marsh lionesses to risk crossing the river and entering alien territory. But over the years males from both prides have encroached on neighbouring territory, seeking to enlarge their realm of influence and to mate with any lionesses receptive to their advances. Sometimes at the beginning of the dry season, when the sound of zebras and wildebeest drifts across the river, the Kichwa Tembo pride cannot resist the lure of an easy meal. Bunched together for protection against the crocodiles, the lions wade across the shallows, swimming when necessary to trespass in Marsh lion territory.

Though there are no fences to impede the movement of the wild animals – just the occasional concrete beacon marking the Reserve boundary – from the top of the escarpment a distinct transition in the vegetation is clear to the eye. To the south of the boundary the country

is open rolling plains, to the north the land is stippled with acacia bushes, which is perhaps why the Masai named this land Mara, which means spotted in their language. Hidden within this belt of acacia woodlands are Fig Tree Ridge and Leopard Gorge, rocky havens for leopards since time immemorial. To the north east there is wooded park-like country and open plains where you often find cheetahs. Here among the Masai herdsmen the cheetah has always prospered. There are fewer lions and hyenas in this area and those there are keep a wary eye out for the red-robed tribesmen, generally lying up in cover during the daytime to avoid trouble. This suits the cheetahs, who do most of their hunting by day.

Not only is the northern Mara perfect big cat country, but for visitors these particular lions, leopards and cheetahs have the added attraction of being habituated to vehicles. They have been photographed and written about for many years by people such as myself and Angie, and filmed by television crews from all over the world; they have a history to them and are known on an individual basis – many are seen so regularly that they have been given names by the drivers and guides.

It was for this reason that the BBC decided to film the first series of *Big Cat Diary* in the northern Mara in 1996. This was to be a big cat soap opera, focusing on the daily lives of a pride of lions (the Marsh lions), a cheetah family and a leopard and cub (Half-Tail and Shadow, whose Swahili name is Zawadi, meaning gift). There were six half-hour programmes, presented by Simon King and me. A second series was commissioned in 1998, with a third due to begin filming in September 2000. *Big Cat Diary* tries to capture the essence of how it feels to be on safari for an extended period of time, distilling the excitement of watching the big cats at work and play, the drama of the wildebeest migration as the animals pour into the Mara from the Serengeti during the dry season, the sense of being there, up close, among the wild animals – which is exactly what I have always tried to do in my books with words, photographs and drawings.

When the last roll of tape is shot and our bags are packed, the big cats carry on with their lives just as they have for thousands of years in the Masai's spotted land. And each time we say how lucky we've been to get such spectacular footage. But the truth is that luck has very little to do with it. The Mara is simply the finest place in Africa to watch and photograph big cats – and countless other animals besides. It is truly a photographer's paradise.

The short rains. Normally, these start in mid-October and continue through to the end of December. The long rains start at the end of March and continue until June. But in recent years the seasons have been far less predictable; cycles of drought and deluge are a feature of many of Africa's wildlife areas.

Giraffe and calf dwarfed by the precipitous slopes of Oldoinyo Lengai, the Masai's 'Mountain of God', a dormant volcano lying to the east of the Serengeti. Over millions of years, ash carried on easterly winds from eruptions of volcanoes such as this was responsible for the creation of the treeless Serengeti plains.

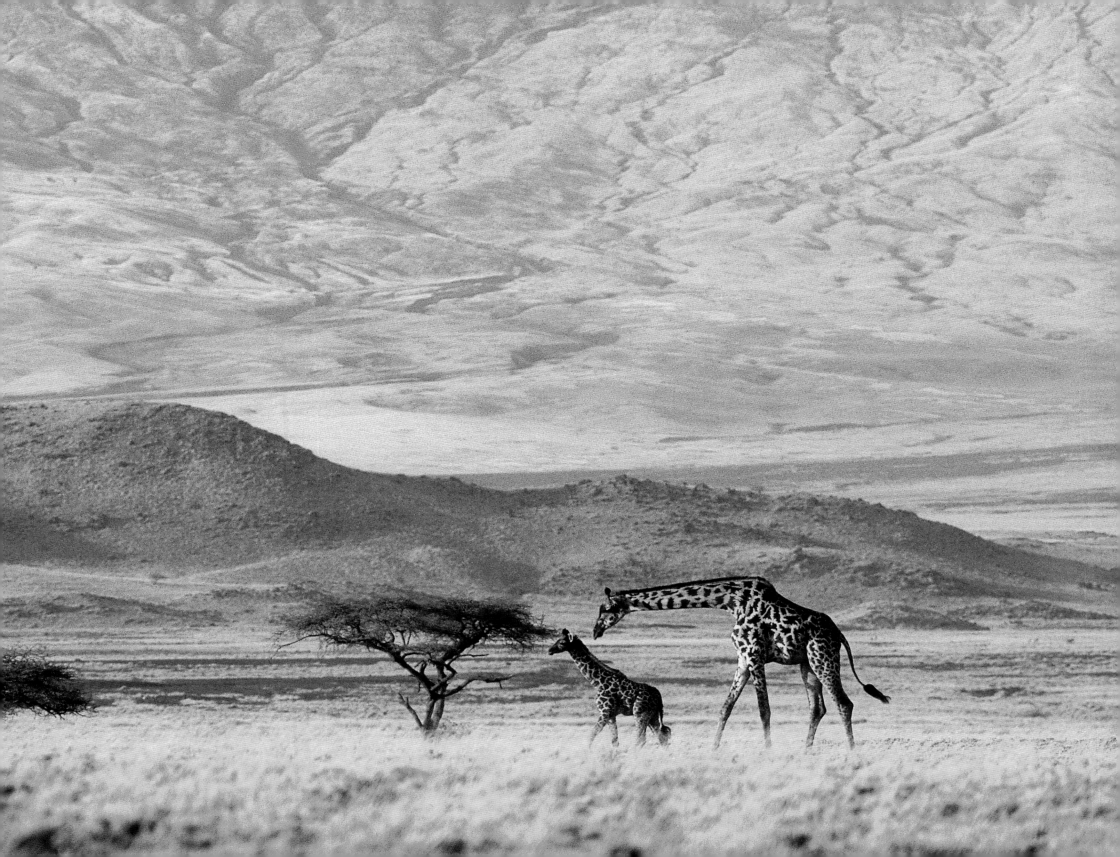

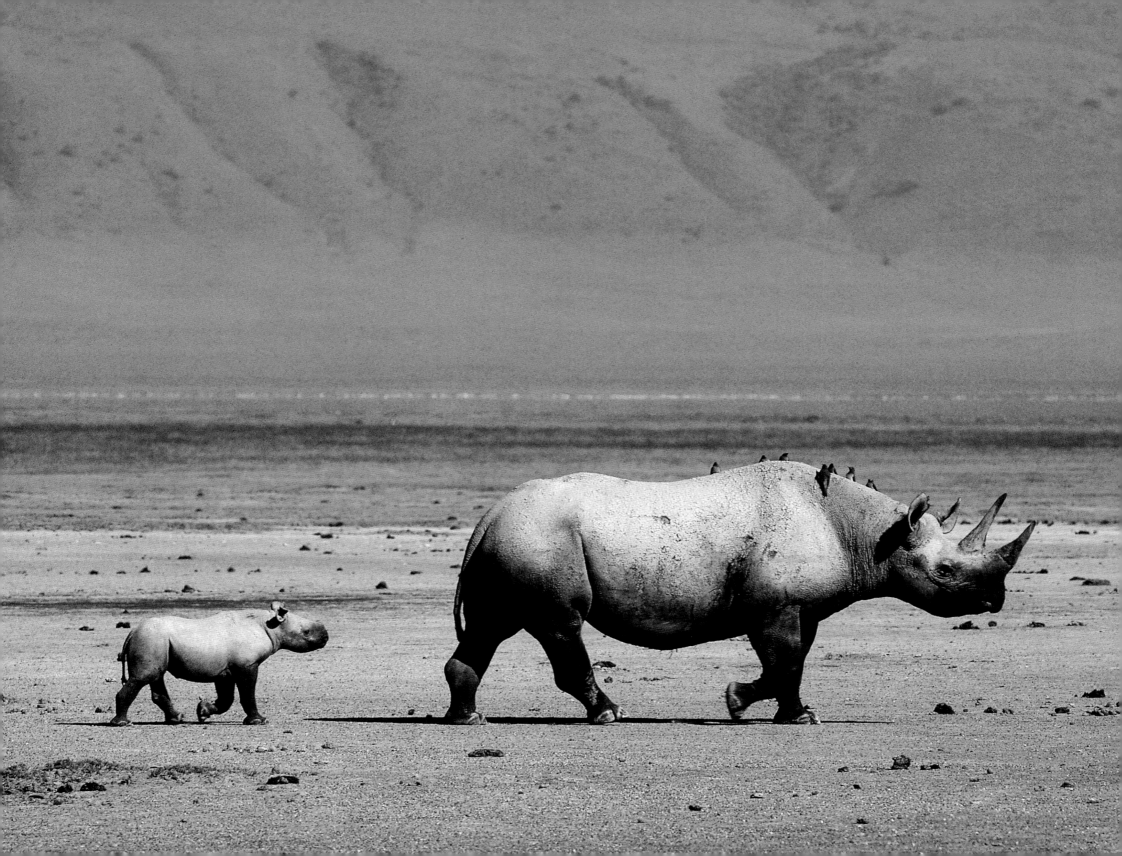

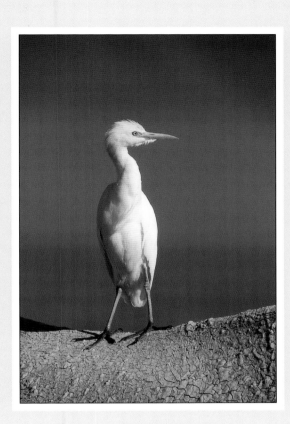

*Cattle egrets often associate with
grass-eating animals, picking up
insects and frogs disturbed by the
animals' movements.*

*Left, Ngorongoro Crater, Tanzania.
Though black rhinos have rather
poor eyesight, they have excellent
hearing and a fine sense of smell.
They have been known to kill
predators with their horn while
defending their young.*

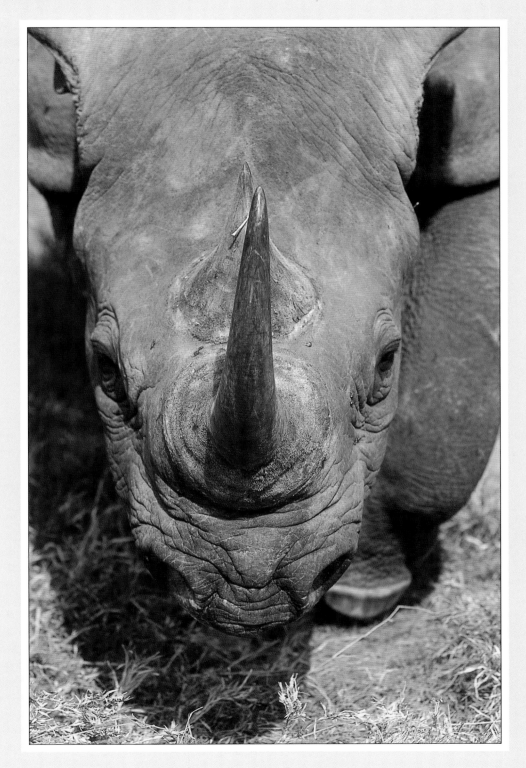

17

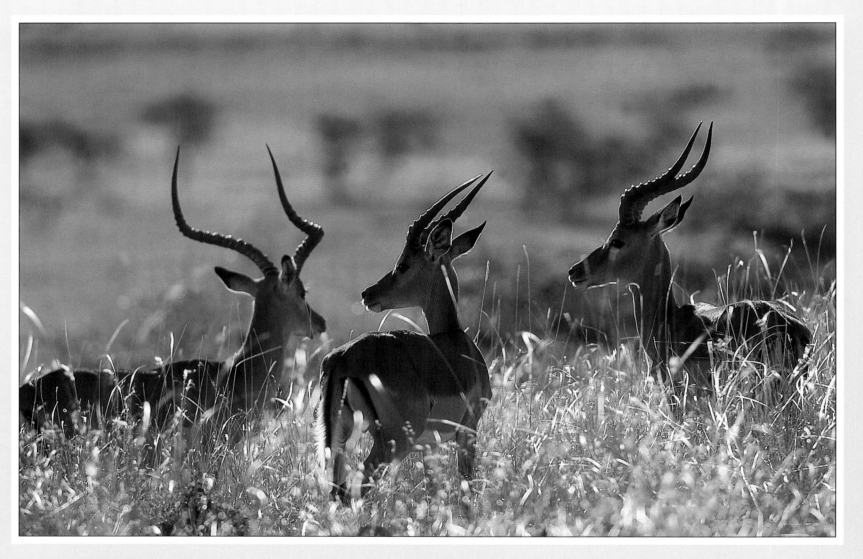

Impalas are commonly found along
the transitional zone between
woodland and grassland.
They browse and graze, preferring
short green grass during the rains
and leaves and seed pods in the
acacia thickets in the dry season.
They are one of the leopard's
favourite prey in the Mara-Serengeti.

The Paradise female before she lost
part of her tail, after which she
became known as Half-Tail. Leopards
prefer areas of cover, with plenty of
trees and bushes where they can
rest and remain concealed.

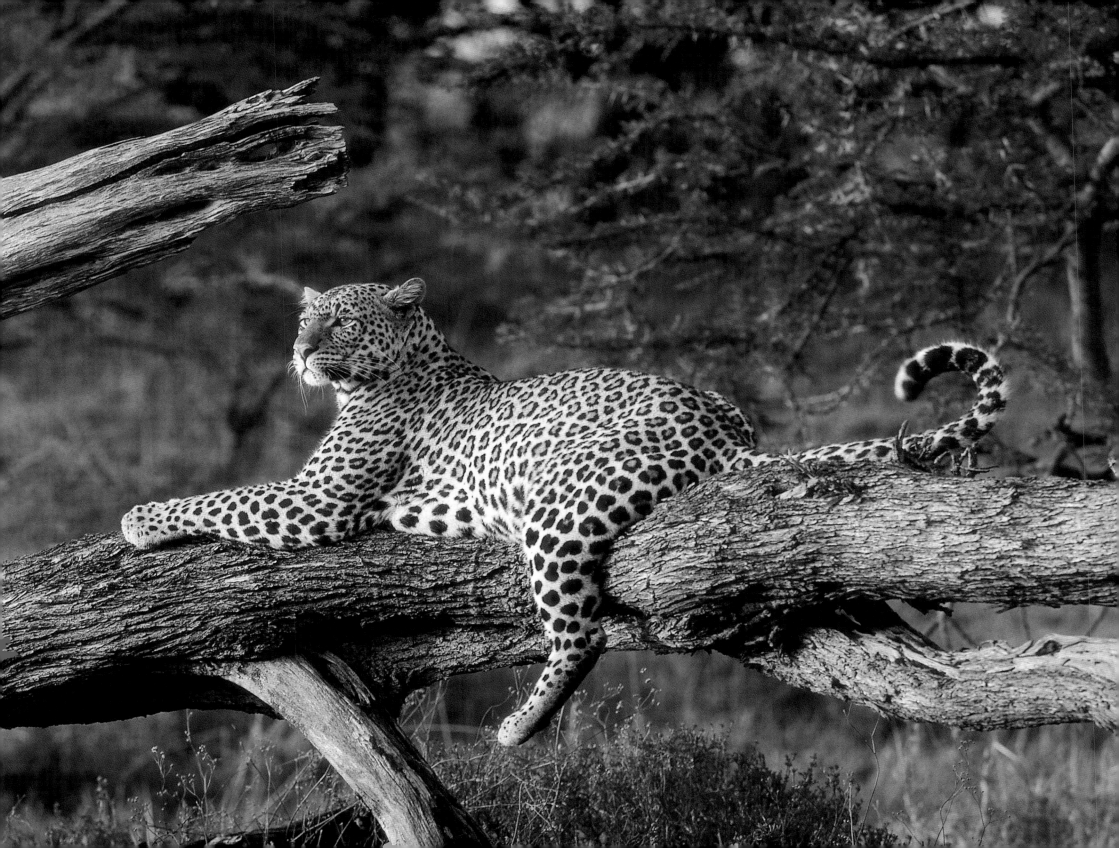

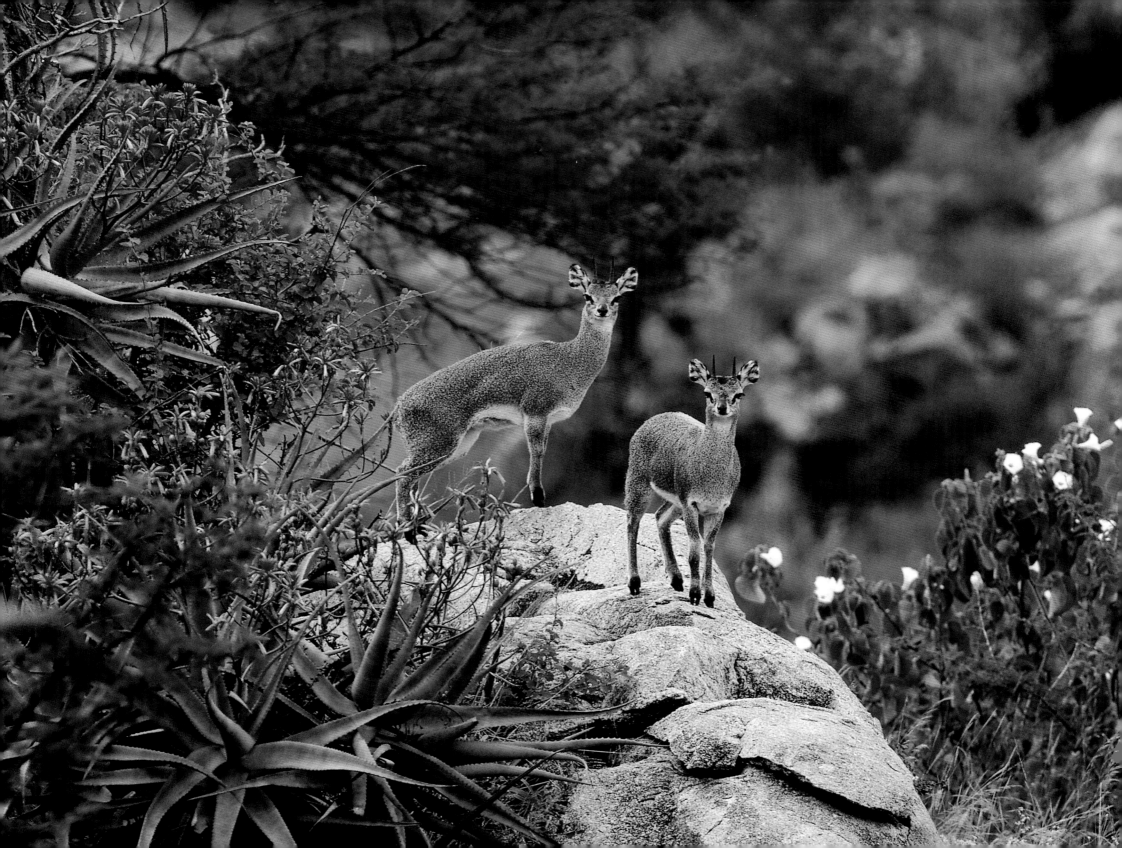

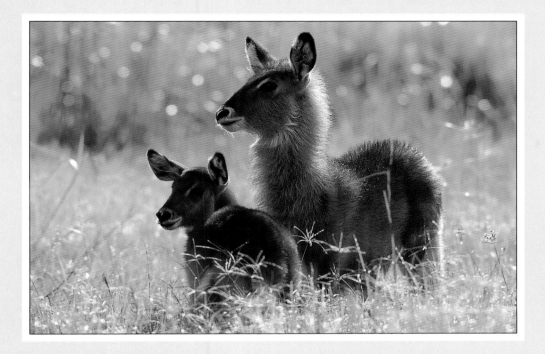

Waterbuck give birth to their calves in cover, periodically returning to allow their young to suckle, after which the calf hides itself away again among long grass or at the base of bushes. This helps to avoid predators, who target vulnerable young animals.

Klipspringers, left, near Lobo Lodge in northern Serengeti. Klipspringers pair for life and defend a territory of 8-16 hectares, which they mark with dung, urine and secretions pasted on to twigs from a gland situated in front of each eye. They also advertise their presence to other territory holders by standing conspicuously on prominent rocky outcrops. Both males and females have horns.

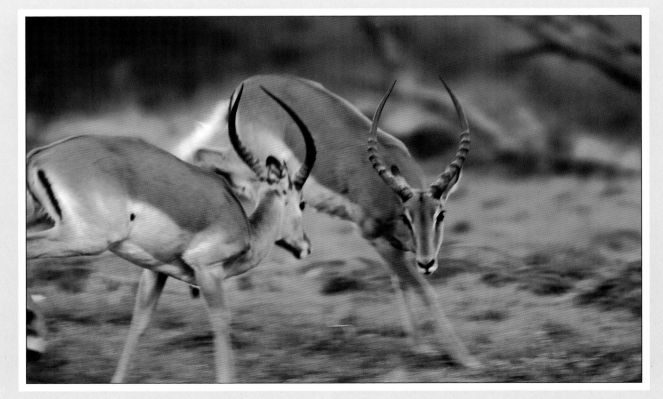

Young impala males jousting. At the age of seven or eight months male calves are forced to leave their natal group and join a bachelor herd comprising both young males and older males who have lost their territory, with individuals ranked in a dominance hierarchy. When a territorial male is ousted he rejoins the ranks of the bachelors, where he can regain condition and prepare himself to challenge for control of another harem.

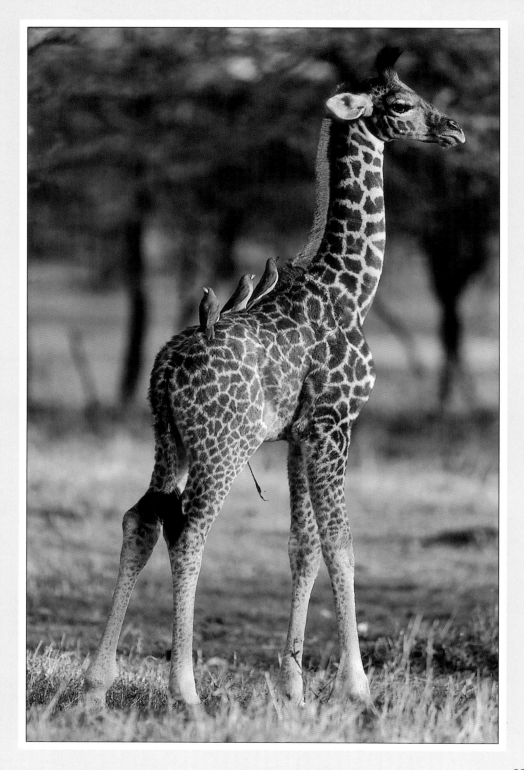

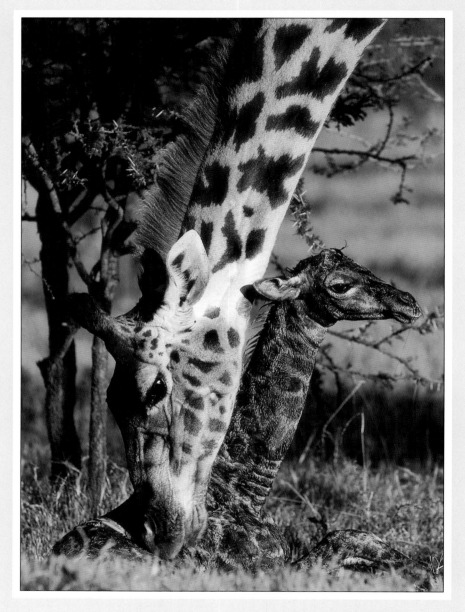

Giraffes give birth to a single young after a gestation period of 14-15 months. The newborn calf stands nearly 1.8 metres high and weighs 55 kilograms. Giraffe mothers creche their young on high, bush-covered ground for safety while feeding. Calves are vulnerable to predation by lions and hyenas, though their mother will try to defend them with hefty kicks from her plate-sized feet.

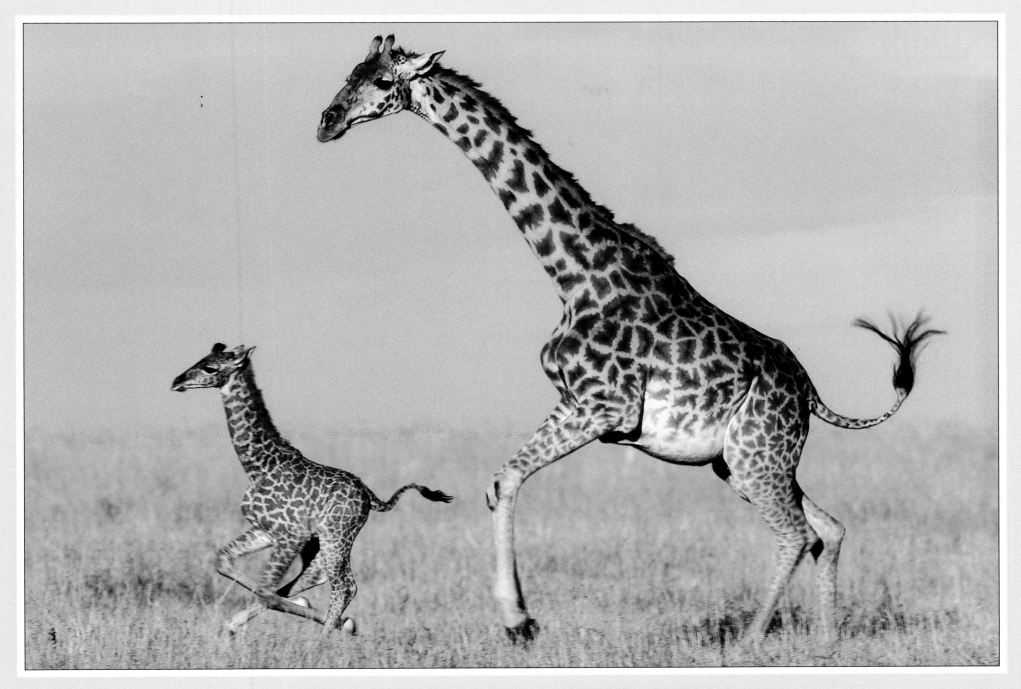

Giraffes can run at 50-60 kilometres an hour. Their height (males 5.5 metres or more, females 5 metres) and excellent vision help them to avoid predators. The decline of woodland in parts of Mara-Serengeti due to the impact of fires and elephants has caused a drop in the giraffe population.

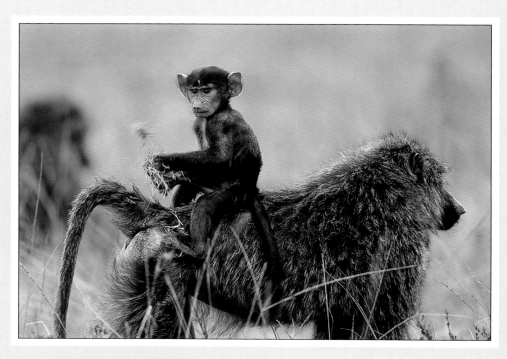

Young baboons start riding jockey-style on their mother's back when they are six weeks old. Prior to this they cling to their mother's chest fur as she moves about. Baboons eat grass and vegetable matter, insects, birds' eggs and nestlings, and the large males sometimes kill and eat hares and young gazelles and impalas.

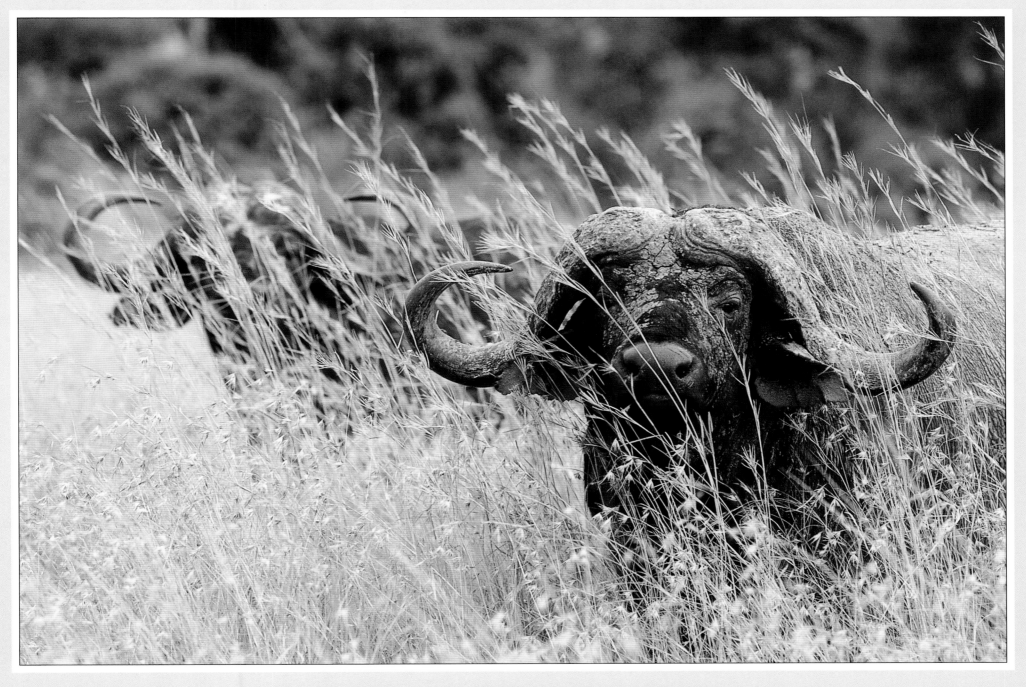

*During the long rains the Mara's red oat grass grows as tall as a buffalo,
and many of the vehicle tracks become impassable as the black cotton
soils are waterlogged. Buffaloes are uncompromising adversaries,
as many a professional hunter has learned to his cost.*

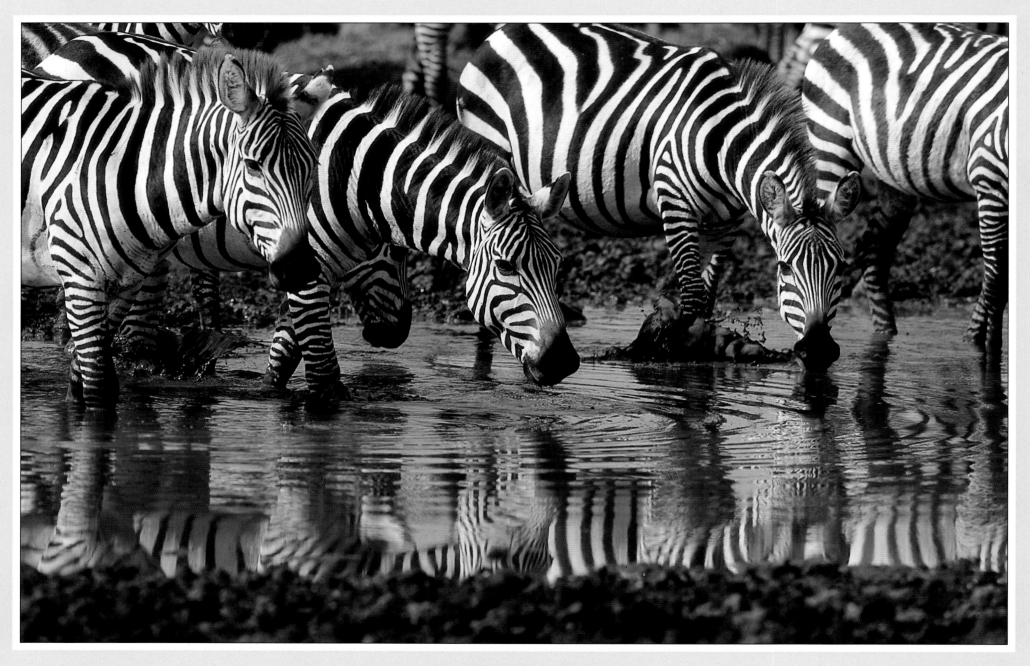

*Zebras must drink daily during the dry season when
there is little moisture in the grass. Predators often
lie in wait at waterholes and rivers to ambush
the herds, making them skittish.*

Oxpeckers or tick birds have flattened, scissor-
like bills for removing ticks and scraps of
flesh from open wounds on large mammals.
Sharp claws and stiff tail-feathers help them
to cling to their host as it moves about.
The birds also act as sentinels, warning their
hosts of danger with noisy alarm calls.
They line their nests with animal hair.

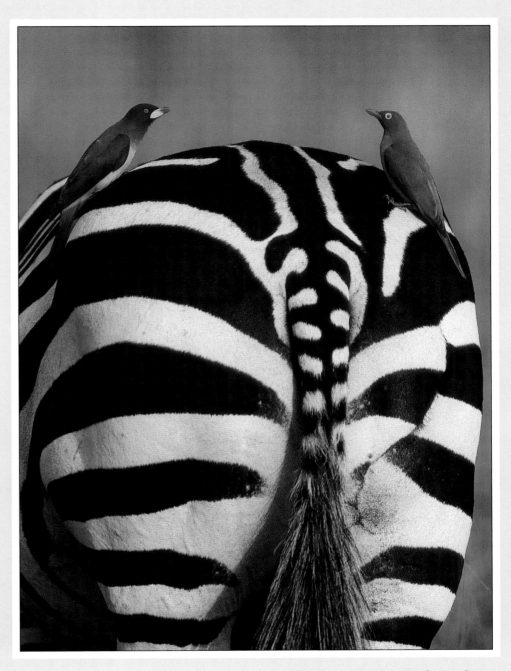

There are two species of oxpeckers,
yellow-billed and red-billed. Note the
scar on the zebra's rump, the result
of a lucky escape from a lioness.

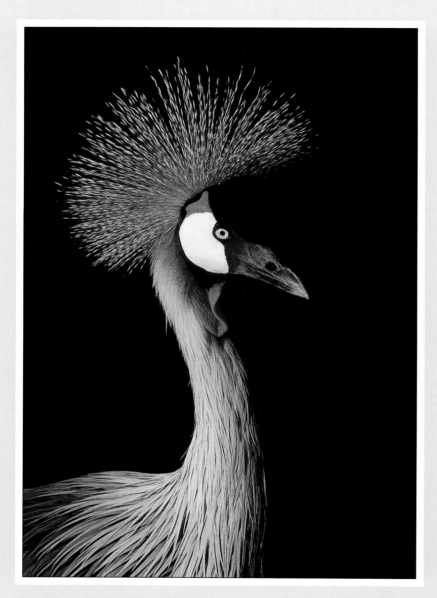

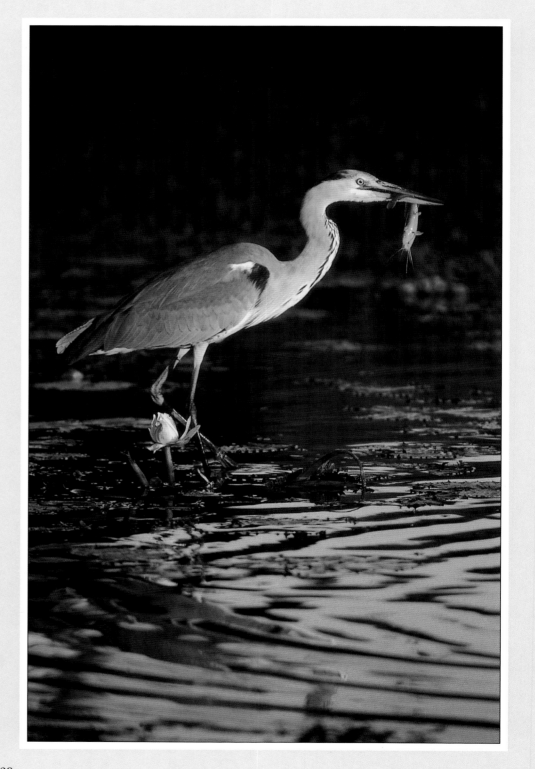

Grey crowned crane. Cranes perform a nuptial dance during the breeding season, leaping into the air with wings flung wide and bobbing their heads. Males and females are identical and utter a resonant trumpet or nasal honking call.

Grey heron with young catfish. There are a number of species of heron in the Mara-Serengeti, mostly found near water. The rather similar black-headed heron is often seen hunting for food in the open grasslands, and can be distinguished from this species by its black neck and crown.

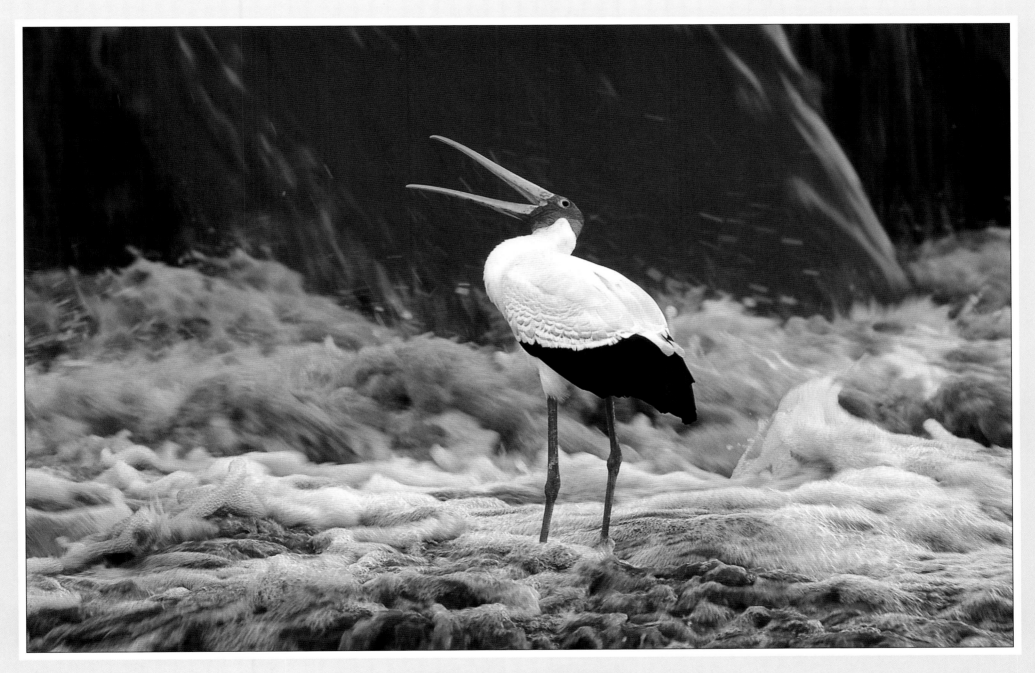

Yellow-billed storks are gregarious birds.
They often use their feet to stir up the bottom as
they search for fish. This one had paused while
fishing to watch an eagle flying overhead.

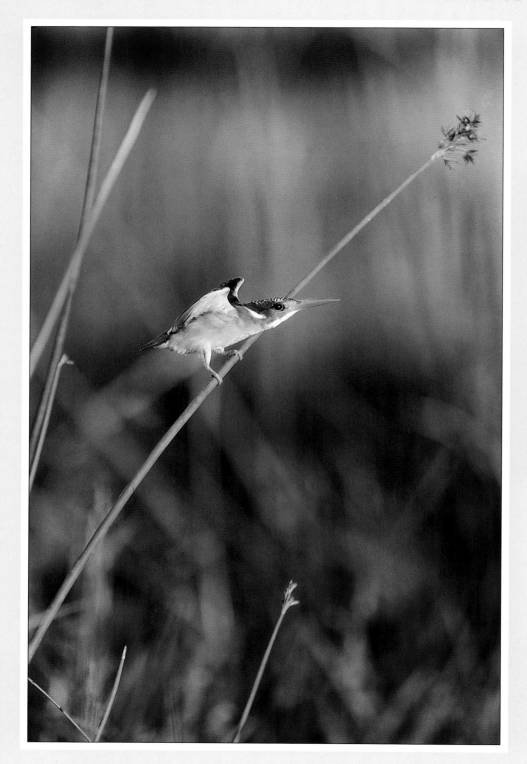

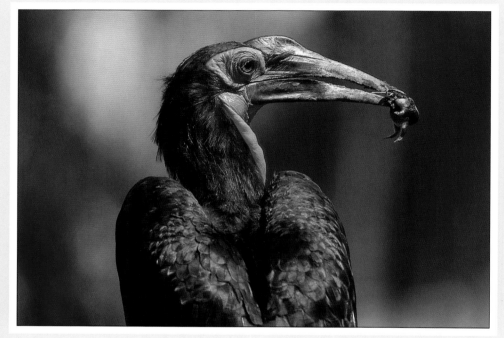

The ground hornbill is the largest of
the African hornbills and spends
much of the daytime searching for
food on the ground. It is entirely
carnivorous, taking prey up to
the size of hares, tortoises
and terrapins.

*Malachite kingfisher. Kingfishers
usually nest in holes excavated in
banks or termite mounds and line
the nest chamber with fish bones.
An exception to this is the striped
kingfisher, which usually nests in
a hole in tree and eats insects.*

*Pied kingfishers hover over open
water to capture fish. The female
(shown) has a single black breast
band, males have a double band.*

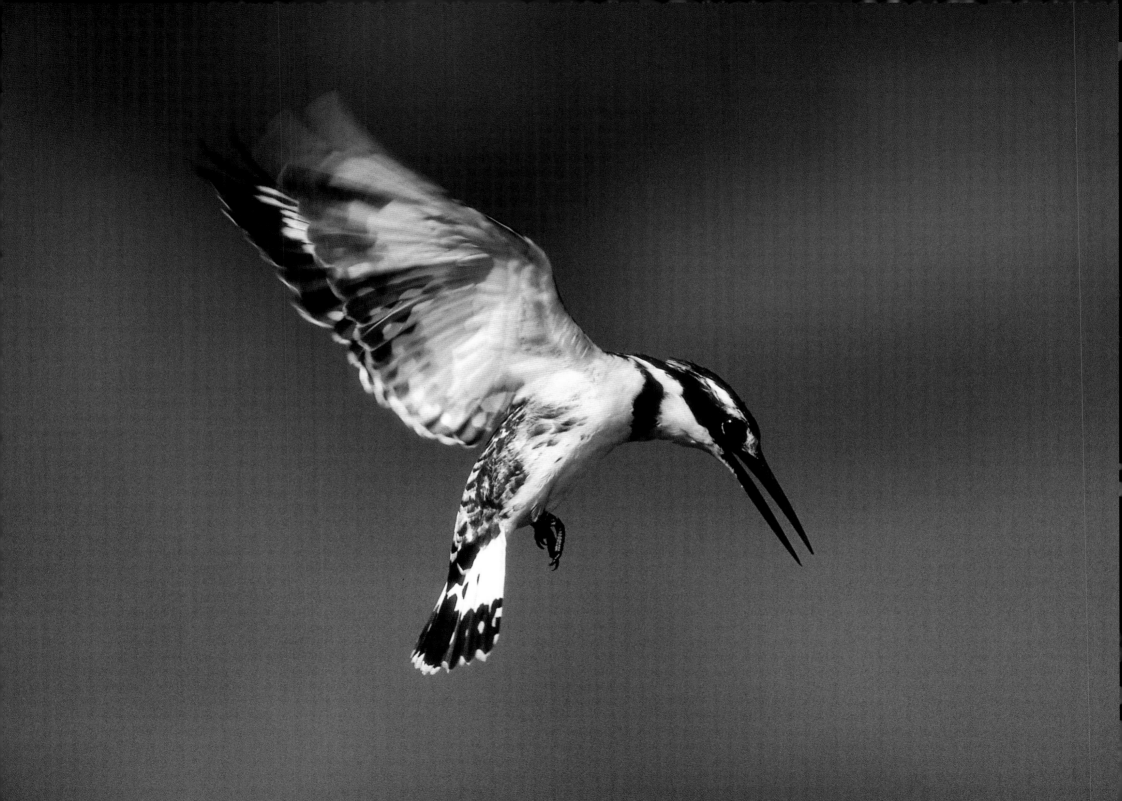

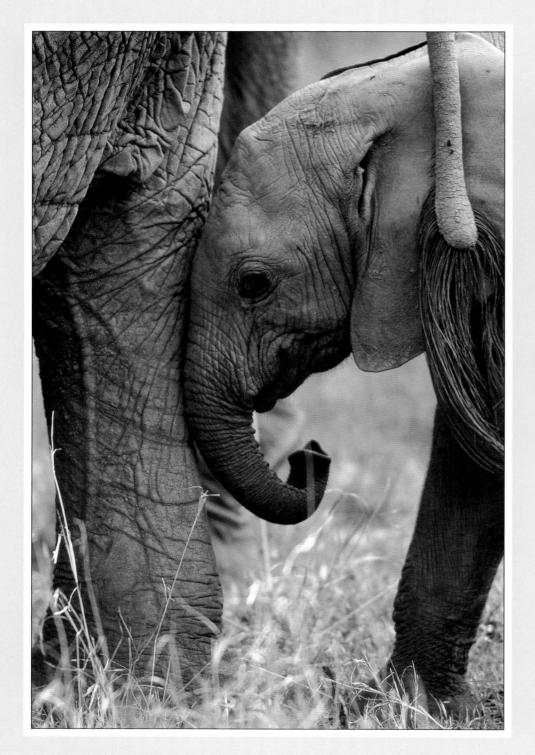

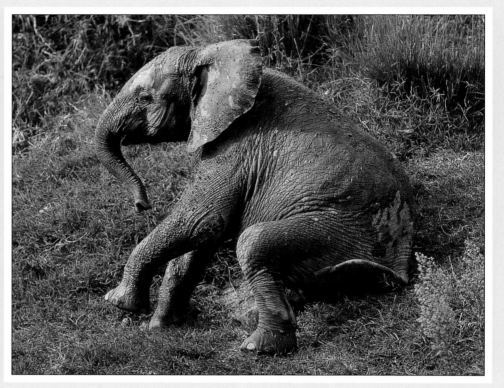

Calves are very playful, spending time rolling around on the ground, scratching themselves, learning to use their trunks and frolicking with other young calves.

Elephant calves spend most of their first year within a few metres of their mother and continue to suckle until the next calf is born, about four years later. If for some reason a calf is separated from the herd it becomes vulnerable to attack by lions or hyenas.

Young bulls playing in a muddy pool covered with Nile cabbage. Bulls leave their natal herd when they are 12-15 years old and form loose associations with up to 15 other bachelors. They begin breeding when they are about 25.

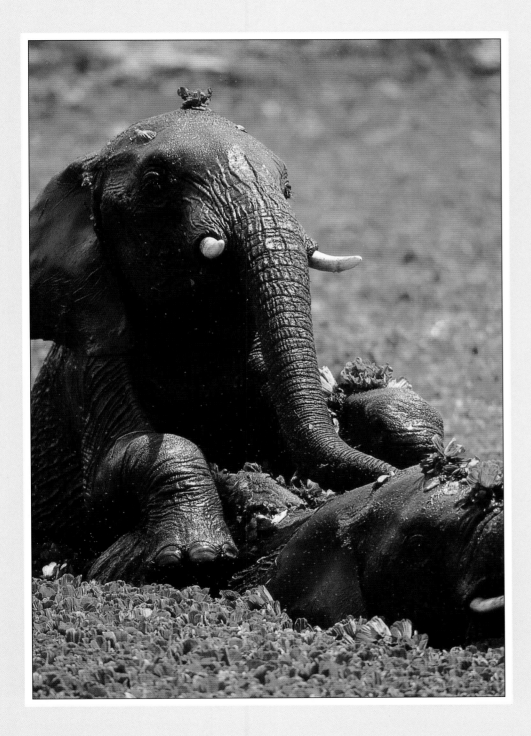

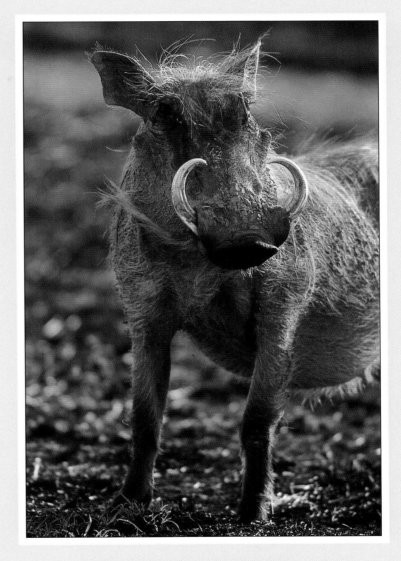

Wart hogs spend the night in burrows to keep warm and avoid predators. They graze on short green grass, and root around for bulbs and tubers. During the heat of the day they often lie up in mud wallows. They are a favourite prey of lions, and piglets are often taken by hyenas, leopards and cheetahs.

Lords of the Savanna

Lions are not animals alone: they are symbols and totems and legends;
they have impressed themselves so deeply on the human mind, if not its blood,
it is as though the psyche were emblazoned with their crest.

Evelyn Ames *A Glimpse of Eden*

*N*o safari to Africa would be complete without the sight of wild lions. The lion is a symbol of Africa, savanna golden in colour, the warrior king of beasts, embodying strength, power and courage. In ancient times lions were found in the Middle East and India as well as throughout Africa, in every type of habitat except for the densest forests and most barren deserts. Only a determined mob of hyenas is capable of matching the singular strength of a lion, though wisely they usually give the big males a wide berth.

Apart from their size (only the tiger is bigger), the thing that sets lions apart from the rest of the world's 39 species of cats is that they are intensely social. All the others lead a basically solitary life, with males and females avoiding one another except for the few brief days spent together when mating. Lions are very different. They obviously enjoy physical contact and do almost everything as a group, from rearing their young communally and hunting together to defending a jointly held territory. Such groups are known as prides, each composed of a nucleus of adult females, their cubs and a coalition of males who are not related to the females. Trying to make sense of who is who among the different Mara prides is all part of the fascination of watching lions.

As I write a dozen lionesses and their cubs lie sprawled in the shade of our vehicle. They are so close that Angie and I can hear them breathing – short sharp pants of breath, slowing now that they have found shade. As they loll in a great pile, patches of tawny hide pressed together, massive muscular limbs reaching out to make contact, you could be forgiven for thinking that you could step out of the car and join them. Every so often one of the lions sneezes or clouts its head on the underside of the car. It all might seem a little unreal if it hadn't happened so many times before.

I lean carefully out of the window with a wide-angle lens to take a photograph. The Marsh lions ignore me. They are so familiar to us that we can identify each one of them as surely as we would recognise close friends. Each is different, both physically and in temperament: some are placid by nature, others touchy and somewhat aggressive, quick to react; some are better hunters than others – either due to innate ability or because of differences in age and experience – though none of the females would go hungry separated from the pride. When there is fighting to be done – such as when females from another pride encroach on their territory and must be chased away – some of the lionesses are braver than others, quicker to challenge and confront strangers. In fact lions are far more complex and individual than I ever imagined when I started to focus on the Marsh pride more than 20 years ago.

The key to learning about lion society is to be able to recognise individuals. Some are easy to distinguish, due to the size and colour of their mane, a tattered ear or missing eye, the loss of part of a tail. Such physical differences certainly help, and I have often thought that I could never forget the face of a particular lion. But the only way to be sure that you are looking at the same animal is to use a reference file of photographs showing both sides of an individual's face. Every lion has four or five rows of whisker spots, known scientifically as vibrissae, on each side of its muzzle, as well as a few extra spots above them called the reference row. These are easy to see in the smallest cubs and are constant throughout a lion's life. Using this technique enabled me to identify one of the Marsh males who disappeared from the Musiara area in 1978. Old Man, as he was called, was a particularly successful male who eventually sired offspring with four different prides. Unbeknown to me, when he was ejected from the Marsh pride, he had crossed the river and joined up with the lionesses of Kichwa Tembo. By the time I caught up with him three years later he had lost his left eye and had a much bigger and darker mane. But by checking his whisker spot pattern I was able to confirm my hunch that this was indeed my old friend from across the river.

Watching the Marsh pride slumped together in the heat of the afternoon, it would be easy to describe them as lazy creatures, indolent in human terms, sleeping and resting for up to 20 hours a day. But they are simply biding their time, waiting for when it is cooler or, better still, dark. Then they will rise from the grass, stretching and yawning,

rubbing against one another, head to head, reinforcing the distinctive scent that helps identify them as a pride. That ritual over, the males set off to patrol the territory, the females to hunt, providers of food for them all.

The strength of lion society is forged from the bonds of relatedness. At the core of each pride is a group of adult females (five or six is the norm, though prides numbering up to 40 individuals may have 12 or more) – sisters, cousins, aunts, mothers and grandmothers who live in a permanent territory that provides a year-round supply of prey such as wart hogs, buffaloes, topi and zebras. Even giraffes are not immune to predation during the lean times. It is these resident species – not the great herds of migratory wildebeest which roam the Mara from July to October – that ultimately control the number of lions that can survive in a given area. In this respect the Marsh lions are currently a fairly typical pride in this part of the Mara, with five adult lionesses, 13 cubs and two big pride males known as Scruffy and Brown Mane. In general the larger prides are concentrated in the south and east of the Reserve, areas with good populations of resident prey and where the migration tarries longest. When the Mara lions were counted in 1992, there were 484 lions and cubs living in 22 prides, plus 74 nomads – one of the highest densities in Africa.

Being part of a pride offers a number of benefits: added protection against predators, an increased chance of gaining a meal and communal care in rearing offspring. The pride's territory is 'owned' by the females and passed down from mothers to daughters for generations, helping to create an intimate knowledge of the hunting range and den sites. Territories vary in size, reflecting differences in habitat, the availability of food and the density of lions, and may expand or contract depending on the season and the relative strengths of the adjacent territory holders. Some Mara prides occupy areas of as little as 12 square kilometres, others require more than 100, though most of the northern prides generally survive comfortably in territories of 50–60 square kilometres.

Some territories are very distinct and vary little from one year to the next, sometimes for many generations. They may be fixed more precisely than others by the lie of the land: bounded and defined by watercourses, marshes and rocky outcrops. But nothing is forever in nature. Frequency of use is what really defines ownership; abandon any one part of a territory for too long and others will claim it.

Both males and females defend their territory fiercely and are particularly intolerant of members of their own sex. Lionesses will attack any strange female who wanders into view and will gang up

against males too, while pride males do everything possible to prevent other nomadic males from gaining access to their females. Bigger prides have greater success in these encounters, and woe betide any individual who gets caught on his or her own in such battles, risking death or serious injury.

Like all pride males, Scruffy and Brown Mane regularly patrol their territory, spray-marking the bushes along the Bila Shaka Lugga with urine tainted with the pungent secretions from their anal glands. On approaching a suitable bush they draw themselves up to their full height, sniff the leaves for signs of previous scent-marking, sinuously rub their faces and manes against the foliage and then turn, arching their tails high in the air and squirting a stream of urine backwards and upwards, dousing the bush with their scent. The odour can last for days, weeks even, and identifies the callers by sex, age, size and time – a highly economic means of conveying information in a large area. Where there are no bushes, territory holders of both sexes scrape with their hind feet at the same time as urinating, leaving a visible and odiferous mark. They also have scent glands between their toes, so that they leave a scent trail as they move about their territory. Scent-marking serves a multitude of functions – acting as a threat to intruders, a display of identity and an indication of sexual receptivity. It also helps to reassure individual pride members by creating a sense of familiarity in time and space and reduces the chance of conflict between prides.

Roaring serves a similar function and can be heard right across a pride's territory, particularly if the air is moist, which is when sound carries furthest. Both lions and lionesses roar to announce their presence to friend and foe alike, telling other lions who they are, where they are and who is with them. Most roaring occurs at night when it is cool and less taxing. On a still night a lion's roar can carry for up to eight kilometres.

All young males are forced out of their natal pride as sub-adults, when they are two to four years old. By this time their mothers are already fully occupied with rearing the next generation of cubs, and become increasingly aggressive towards their older sons. Brothers, half-brothers and cousins of a similar age leave as a group and must then wander widely, hunting for themselves or scavenging from the kills of other predators, often tagging along with the migration in their efforts to stay alive. But life can be hard for these young nomads, who make up perhaps 15 per cent of the lion population. They are helped to a degree when hunting by not yet having a full mane, which may also help to lessen conflict with mature males. If they are lucky young males may split from their natal pride with their sisters, making it easier for them to acquire a meal. This is often the case when new males take over a pride and all of the sub-adults are evicted.

In the old days people assumed that these coalitions of nomadic males were always made up of relatives. But when they appear as different as Scruffy and Brown Mane you begin to wonder. Scruffy looks younger and has a sparser mane than Brown Mane, who is bigger and has a luxuriant ginger mane. When scientists examined the DNA of males in coalitions they found that at least 42 per cent of coalitions included non-relatives, with two-thirds of all male pairs and nearly half of the trios containing non-relatives. Strength lies in numbers, with most Mara prides having two or three adult males. A single male has little chance of hunting or winning fights in places like the Mara–Serengeti. His only chance of success is to form an alliance with one or more unrelated males, which is probably what happened with our Marsh males. Solitary males most often form pairs, sometimes trios, but never, it seems, quartets. Among the larger coalitions competition to breed is so intense that many males never sire cubs, but at least if the members of their alliance are brothers or cousins they help to promote the genetic interests of close relatives. Only in pairs do males achieve equal mating success – justification for non-relatives to stay together and fight off rivals, as each receives a direct genetic benefit from co-operating.

If in fact Scruffy and Brown Mane are not related, you would never know it from watching them enthusiastically greeting one another and fiercely defending their joint interests. In lion society there are no dominance hierarchies; equality is the norm among both males and females. Only if there is a pronounced difference in size or age does one see some level of dominance between members of male coalitions.

Coalitions of young nomads are a constant threat to the pride males, wandering through their territories or biding their time on the sidelines, waiting, watching. By the time they are four or five years old they are big-bodied and powerful, ready to challenge the established order and sire cubs of their own. The incumbent pride males do whatever they can to thwart these invasions – patrolling, marking and fighting when necessary to defend their right to breed with the females.

There is no more magnificent sight in Africa than a full-grown pride male standing tall in the long grass, nose pushed into the breeze, sniffing the air. At 180 kilograms or more and with a 1.2 metre chest, he is 50 per cent heavier than a lioness, stands 1.2 metres at the shoulder and measures 3 metres from nose to tail-tip. When he has to, he can charge with explosive speed and has the strength to clasp a full-grown buffalo in his teeth and drag it from an exposed position to the shade of a thornbush.

But awesome as he looks, he is vulnerable on his own. One evening along Rhino Ridge I watched a huge pride male, with a luxuriant black and ginger mane, fighting for his life against two young nomads. One on one it would have been no contest. But the big male's younger rivals weren't in the least bit intimidated by their opponent's power. The stakes were high, the prize a territory of their own. The big male drew himself up to his full height, standing broadside on with neck arched, roaring mightily, calling to the other members of his pride to come to his aid. But they were too far away to help him now. As one of the youngsters challenged him head to head, the other moved in behind him, raking his backside with his claws and attempting to bite into the older male's spine. He let out a bellow of pain, whipping round to defend himself as the nomads closed in again. The adversaries rose up on hind legs, flailing at each other with outstretched paws, ivory-coloured claws slicing through flesh, tufts of mane flying, blood oozing from their wounds. Suddenly the older male looked cumbersome – slow and clumsy by comparison with his sleek, muscular rivals. No quarter was given, but the battle had already been lost. As they broke apart the old male turned and ran. The nomads chased after him, then stopped. Now it was their turn to roar.

Being forced out of a pride does not always mean the end of the road for the males. If they are lucky they may manage to find another pride to take over, so long as they have companions to assist them. This turned out to be the case with the Serena pride males whom Angie and I

photographed in 1996 while working on the book to accompany *Big Cat Diary*. Both males had magnificent manes and were in their prime – perhaps six or seven years old. One had dark chest hair and a distinctive large wound above his left nostril, which had healed to leave an unsightly gouge.

Four years later I was watching a group of three lionesses with eight young cubs just to the south of Rhino Ridge. They were being kept under close surveillance by two males, both of whom looked as if they had seen better days. These were real old warriors, still ready to fight to protect their females and cubs, but increasingly vulnerable to the marauding bands of nomadic males. One of the males had a permanently thick lip and when he yawned I could see that his upper canines were worn down and yellow with age. His nose had the look of an old carpet, rutted with a mishmash of scars, and there was a noticeable stiffness to his gait when he walked. As he stood staring into the distance with fierce yellow eyes, defying the years, I had a feeling that I had seen this male before.

And so I had. When I got back to Nairobi I showed Angie the pictures of the old male. We flicked through a copy of *The Big Cat Diary*, and there he was. I read the caption: 'Dark Mane, one of the Serena pride males, recognisable by the split in his left nostril and his magnificent dark mane.' The gouge in his nose had healed so perfectly that it was no longer visible, his dark mane was sparser now and the nicks on his ears of four years ago had been replaced by different ones. The only marks that had not changed were the whisker spots. It was Dark Mane all right, still breeding, still with his original male companion, though with a different pride of females.

The tenure of the more successful coalitions of males lasts from two to six years, though males rarely live more than 12 years and are past their prime at nine. Weakened by years of brawling, old lions such as Dark Mane face a bleak future if their partner is killed and they end up on their own, unless by luck they can forge a new alliance with other nomads. Exiled from their pride, old males are forced to try and hunt for themselves and must constantly war with the hyenas for scraps from other predators' kills. They often end up with serious injuries: gored by buffaloes, kicked by giraffes, a broken jaw or damaged spine making them even more vulnerable to violence from other males. Starved for food, they may be tempted to loiter in the vicinity of the Masai's bomas and try for an easier meal by preying on livestock. The end is inevitable.

This process of periodic change among the male population helps to prevent inbreeding between fathers and daughters. By the time a lioness is three to four years old and capable of breeding, a new

generation of adult males will almost certainly have forced her father and uncles out. But these transitions often wreak havoc in the life of a pride. Nomadic lions kill any young cubs sired by the previous pride males, and lionesses with older cubs do everything possible to avoid contact with these new males, becoming fugitives in their own territory until their cubs are old enough to fend for themselves. Sometimes it is months, even years, before all the lionesses are reunited.

Under normal circumstances a lioness does not breed again until her cubs are at least a year and a half old. But if she loses her cubs she quickly comes into oestrus and continues to do so until she conceives. By killing cubs new males wipe the genetic slate clean, giving themselves an early opportunity to mate and allowing their own offspring a greater chance of survival with no older cubs to compete for resources.

Just as humans seem to find males with big dark manes the most impressive, so apparently do lionesses studied in the Serengeti. A big mane is generally an indication of good health, and a dark mane seems to help intimidate intruders from a distance. It is usually the female who initiates copulation, sinuously winding herself around her partner, raising her tail and wafting her scent under the male's sensitive nose. But often she has only to sneeze or raise her head to prompt him to get up and approach, though she may rebuff him with a harsh grunt or growl. Whenever she tries to move away, he immediately pursues her for fear of losing her to a rival. Food seems to be of no interest during mating and attempting to hunt is out of the question with the male making himself so conspicuous.

All cats require the act of copulation to trigger the release of eggs from the female's ovaries. The male's penis has tiny backward-directed spines which may roughen the vaginal wall and play a part in inducing ovulation. Every 10–15 minutes, day and night for the next four days or so, the pair mate: a brief noisy coupling which often ends with the female turning round and swatting the male with outstretched claws. But despite all the copulation only about one in five bouts of mating results in pregnancy, equivalent to 1500 matings per litter born and double that number per offspring reared to adulthood. One theory is that mating helps to bond males and females within the pride, which is very important when new males take over. It also permits more than one male to mate with the same lioness and it often happens that a male's companion eventually gets his chance to mate with the same female. We have seen this with Scruffy and Brown Mane on many occasions. If a single copulation is of little genetic consequence, males should be less inclined to fight, increasing the life expectancy of male coalitions and reducing the risk of takeovers and infanticide.

When I first started watching the Marsh lions in 1977, a new chapter was just unfolding in the life of the pride. Five young lionesses had recently formed an alliance with three big pride males and produced a dozen cubs. I did not know enough about lions then to realise that these lionesses had recently split away from the Bila Shaka pride in which they had been born. Only later did I find out that this is not an uncommon event – not all females are recruited into their natal pride. When a new generation of lionesses reaches adulthood and is ready to have cubs there are times when there simply isn't enough food and

living space to sustain the whole pride. Under these circumstances the group may split, with the younger lionesses taking over part of the pride area and at times expanding into an adjacent territory. This is what happened to the Bila Shaka pride. The five young lionesses gradually disassociated themselves from their older relatives and claimed the Marsh – the Bila Shaka pride's traditional dry-season hunting ground. With three big males to help protect the territory it was time for the Marsh lionesses to breed and they soon produced cubs.

This pattern has repeated itself over the years. At times a single pride has controlled the full extent of the Bila Shaka area and the Marsh, only to find themselves forced to cede ground as younger lionesses from the pride mature and mark out a territory of their own, leaving each group to consolidate its hold on just one part of the pride's domain. Sometimes a single alliance of males controls both prides, but there are always new males looking to stake their claim to groups of females and there have been times when the Bila Shaka and Marsh prides have become firmly established with their own pride males.

With each new generation of cubs, the demand for food becomes critical. Neither the Marsh nor the Bila Shaka Lugga alone can provide sufficient prey year round for a large pride. During the dry season the Marsh may be teeming with animals while the lugga is empty. Likewise during the rainy season the Marsh sometimes becomes so waterlogged that many of the herbivores move to higher ground, forcing the lions to seek food elsewhere. Inevitably this leads to conflict as they encroach on the other pride's territory.

Ten years ago the Marsh lions lost part of their pride territory. They had moved north during the wet season, as they had done every year since I had started watching them, vacating the waterlogged, low-lying country around the Marsh and occupying the acacia country bordering Mara River airstrip. Here there was a plentiful supply of zebras, topi, buffaloes, wart hogs and impalas. In the past the pride had been powerful enough to retake the Marsh at the onset of each dry season. But this time they faced formidable opposition from their relatives in the Bila Shaka pride, who coveted the rich hunting ground for themselves to feed their numerous cubs.

The Marsh pride was vulnerable – only one of its pride males was still in the area and he was too old to see off the challenge of the three young nomads whose belligerent voices I had grown used to hearing in recent weeks. Once it became obvious that they could not recapture the Marsh, the pride headed north again, and in time prospered.

In the summer of 1996, Angie and I were able to spend time reacquainting ourselves with the Marsh pride. Only one of the original

lionesses remained, a grizzled veteran who, though nearly 13 years old, was still in good health. Thickset, with a massive head and battered ears, she was the oldest of eight lionesses who made up the core of what became known as the Big Pride. They were watched over by four powerful pride males who had sired 16 cubs, all under one year of age at the time we filmed them. We later discovered that one of the lionesses had secreted four tiny cubs in a patch of forest, making 20 in all.

The reason for the Big Pride's success was that they lived in an area supporting good densities of prey all year round, with the arrival of the migration each dry season a welcome bonus, helping to ensure that any young cubs had plenty of food. The Big Pride lived just outside the northern boundary of the Reserve, so they were forced to share their territory with the Masai herdsmen, who daily wandered with their cattle across the plains and through the thorn thickets. But by seeking the cover of dense forests or rocky hillocks during the hours of daylight, the lions were able to live side by side with the Masai with little conflict.

Currently the Bila Shaka pride controls both the Bila Shaka Lugga and the Marsh, and for the purposes of *Big Cat Diary* is called the Marsh pride. A second pride, composed of younger lionesses exiled from the Bila Shaka pride as sub-adults when Scruffy and Brown Mane took over at the end of 1996, do their best to avoid contact with their older relatives, loitering along the southern reaches of the lugga or around the Marsh, constantly moving. This group, known as the Marsh Sisters, consisted originally of three females, all of whom have given birth over the last few years. They have recently been joined by two other females (almost certainly relatives) and have a number of cubs of various ages. Scruffy and Brown Mane monitor the movements of these females and have been responsible for killing and siring some of their cubs, but without a well-defined territory and the constant protection of pride males, the Marsh Sisters and their allies will continue to struggle to raise cubs to maturity.

Lionesses in a pride often give birth at the same time, sometimes as a result of having lost their young when new males took over the pride. Born deep in a thicket, among dense reeds or in a rocky outcrop, a lion cub is tiny at birth, weighing about 1.5 kilograms, with eyes tightly closed. Such vulnerable young must be carefully protected by their mother and it is not uncommon for a lioness to give birth in the place where she herself was born. There are certain croton thickets along the Bila Shaka Lugga that generations of lionesses have used as a birthplace. Apart from the constant danger posed by nomadic male lions, hyenas and leopards are always on the look-out for an easy meal and are just two of the predators that will kill and eat lion cubs. The cubs' only

defence is to try and remain undetected during the many hours that they are left on their own while their mother is off hunting. During the first few weeks of the cubs' life, a mother may move them a number of times to avoid unwanted attention, carrying them in her mouth by the scruff of the neck. Initially she keeps them apart from other pride members, which helps to forge a strong bond between mother and cubs. Only when they are six to eight weeks old and ready to eat meat are they introduced to the rest of the pride.

Ultimately it is in the interests of the lionesses in a pride to conceive within a few weeks of each other and rear the cubs communally in a creche, where they can be suckled and protected as a group. Competition over food is reduced when cubs are of a similar size, as older cubs will bully small ones at a kill, particularly when food is in short supply. Having lots of cubs of a similar age also helps to ensure that both males and females have companions of the same sex when the time comes to leave the pride and fend for themselves.

It is noticeable that pride males are much more in evidence when cubs are small. Scruffy and Brown Mane were nearly always around when the litters they had sired were first introduced to the pride, helping to protect the cubs and often allowing them access to a kill while keeping the lionesses at bay. This made genetic sense, as the cubs were Scruffy and Brown Mane's offspring, while the lionesses were unrelated to either male.

In September and October 1998 we were fortunate to be able to film four of the five Bila Shaka or Marsh lionesses with 11 young cubs. The bond between the mothers was very evident; they became even more gregarious than usual, hunting together, feeding together and returning together to their cubs. Daily activities focused on the creche, which acted as a convenient meeting place for pride members. Most mornings the whole pride would retreat during the heat of the day to the croton thickets along the Bila Shaka Lugga where their cubs were hidden. Each litter was born in a separate thicket, but it wasn't long before all of them were creched together.

By contrast, lionesses without cubs tend to be less sociable and may stay some distance from a creche, hunting on their own or with other non-breeding females. They tend not to act as babysitters when mothers in the pride are off hunting: the cubs simply remain behind, lying up in cover and generally keeping a low profile when the adults are away.

Even when cubs are of a similar age and size it is possible to identify who belongs to whom. Each of the Marsh lionesses licked and groomed her own cubs more frequently, picking over their fur for ticks, mites and

other parasites. When she uttered the characteristic soft *iauu* sound to gather her cubs to her or to encourage them to follow her, it was her own offspring who were most likely to respond. Even though a lactating female will allow other cubs to suckle, particularly if she has a small litter, she is more likely to rebuff them with a warning snarl and teeth exposed than she would her own. By the time the cubs were three months old they were well established on a diet of meat and though they still tried to suckle up to the age of six months, it was more for the social comfort of being close to their mother than for food.

The migration has a big influence on the survival of young cubs. Lionesses tend to produce more milk when they are well fed, and from July to October, when wildebeest and zebras flood into the Mara, the lionesses are in peak condition, food is plentiful and cubs can afford to indulge in protracted periods of play. But once the migratory herds have retreated 200 kilometres to the south to spend the rainy season on the Serengeti plains, life can only get harder. Starvation is a constant threat – it accounts for a quarter of cub deaths in the Serengeti. For the rest of the year the Marsh lions must hunt resident prey, particularly wart hogs and topi, taking zebras when they are available and at times buffaloes and giraffes, though it is generally prides with more than six lionesses that tackle prey this size.

During the long rains of 1999 Angie and I returned to the Mara to see how the 11 Marsh cubs had fared. We found eight surviving youngsters huddled together in the long grass at the edge of the Marsh, not far from Governor's Camp. They looked thin and listless and there was no sign of the playful antics that we had so enjoyed watching a few months earlier. Every so often one would sit up and look around for signs of its mother. We were told that the pride had killed a waterbuck a few days earlier and that prior to that the rangers had shot two topi for them to tide them over.

Even at two years of age a lion is barely half-grown, and though it has acquired a semblance of adult hunting skills it is still inexperienced and clumsy. Not until it is four years old is it fully grown and ready to breed. Depending on individual circumstances, anything from 40–80 per cent of cubs fail to reach adulthood. But those lionesses who do can expect to live a long time; at the age of ten they are still at the peak of their breeding years, and do not stop being fertile until they are 15, almost at the end of their lives.

Early one morning, to the north of Fig Tree Ridge, I came upon a pair of mating lions from the Big Pride. The lioness led the way, striding through the long red oat grass, young and sleek, in the first flush of oestrus. The male followed close behind her, casting a baleful look towards my car, wary of a potential rival in any shape or form and warning me to keep my distance. He was in his prime, magnificent blond mane tussled by the wind, an old wound below his eye now raw and bleeding, token of a brief spat with one of the other pride males. Blond Mane tracked the lioness's every move. This was essential. The male who doesn't guard an oestrus female jealously will soon lose her to a more attentive rival.

Something must have warned Blond Mane of danger. He turned and began his charge long before the three Masai crested the brow of the hill. Fast and bold, giant paws beating against the hard ground, he startled me with his speed. Surprised and in the open, without spears to defend themselves, the men could only stand their ground – no trees to scramble up, not even the spindliest of bushes to bolster faint hearts. Blond Mane pulled to a halt, grunting fiercely, his black-tipped tail lashing furiously from side to side. He glowered at his adversaries, pupils narrowed to dark pin-pricks in wild yellow eyes. The Masai stood impassively, staring down the lion, who turned quickly and hurried after the lioness, anxious not to lose her. He slunk rather than ran, acknowledging the deeper fear that he held for human beings, which a moment earlier had been buried beneath the need to defend his female against any challenge. The Masai chuckled, amused at the lion's bravado, admiring his spunk – they understood him. It was bluff and they knew it. They continued on their way. This wasn't the first lion that they had faced and a lioness with small cubs would have been a very different proposition.

Filming the first series of *Big Cat Diary* provided us with a unique opportunity to watch predators day and night, something I had never done before. We were all astonished at just how much of an advantage night-time bestowed on creatures such as lions and leopards. Using infra-red lights and cameras we were able to illuminate their world without disturbing them (they are unable to see light of infra-red wavelength and so were not affected by it). The headlights of our vehicles were covered with infra-red filters and an infra-red camera mounted on the roof relayed a black and white image on to a small monitor positioned above the steering wheel, so that we could see where we were going. It was the strangest feeling – driving over rough terrain with the world outside reduced to a 15 x 10 centimetre picture and trying to gauge the real size of obstacles took a lot of getting used to, with some dramatic jolts and bumps. More like being in a space ship than a Landcruiser.

With an extra layer of cells in their retina (called the tapetum) to help capture more light, lions can see extremely well on even the darkest of

nights and their night vision is much better than that of most other animals. In fact the darker the better as far as they are concerned; moonlit nights favour the prey, and the lions are far less successful or simply don't bother to hunt. It might be pitch black looking out of my window, but there were the lions ambling along on the screen, picking their way without faltering through the rockiest terrain, and locating their prey long before it saw them. It was eerie to watch a lioness, seemingly exposed in the open, trotting in a semi-crouch directly towards a herd of wildebeest. Face to face, yet blithely unaware of the predator's approach, the herd just stood and stared. Until what? Did they hear her muffled footsteps first, or catch her scent, or pick up her movement out of the darkness? Despite the disadvantage of inferior night vision, the prey's speed off the mark often enabled it to escape.

For the lions, there are many other benefits to hunting at night, not least of which is avoiding contact with the Masai, who each night retreat inside thornbush bomas with their precious livestock. It is far cooler and therefore less exhausting for the lions than hunting during the day. And at night they can hunt species which by day they would usually ignore. We saw the Big Pride take Grant's gazelles and impalas by sneaking up close to them while they were lying down resting. Confused in the darkness, the antelope were no match for four or five lionesses converging on them simultaneously. Even so the lionesses never seemed in any great hurry to hunt, as if they knew that sooner or later prey would wander in their direction. After an initial burst of activity in the cool of the evening, they often settled down again and slept for most of the night.

As filming drew to a close, Angie and I watched as the Big Pride feasted on a zebra kill. There were more than 20 lions, including the big blond male with the distinctive scar below his right eye whom I had seen charge the Masai. We waited with the pride until it was dark, listening as the cubs squabbled over the scraps. The deep grunts and snarls seemed far too grown-up to be coming from such tiny lions, some of which were less than six months old. But from the earliest age a lion learns to fight for its share of a kill, at times lashing out with razor-sharp claws to defend its position among older relatives. Hyenas whooped in the distance, forcing the lionesses to edge closer to their offspring. It was almost time to move on.

The first roar shattered the cold chill of the night, a deep throaty groan. Angie leaned forward and squeezed my arm with excitement. A lioness standing only a metre from our car added her voice. Soon all the adult lions were roaring, the sound pulsing across the plains. Blond Mane lay on his side, adding a series of deeper, louder roars than those of the females. The message seemed clear enough: 'It is us, we are here, where are the rest of you? This is our territory, we are many.' The other three pride males must have heard their companions, known where to look for them – and so would members of the adjacent prides. The hyenas stopped to listen; they would soon be here to feed on whatever was left.

During the many years that Angie and I have spent observing lions, so much has happened from the perspective of the individuals that we have learned to recognise – or so it seems. We have watched tiny cubs grow into sleek adults, shared the joy of seeing them with their own cubs, followed them in the twilight of their years, seen them die. But the truth is, despite the many hours of detailed observations, humans still know little about wild creatures. Deductions made from even the most scientific of studies represent good guesses, acknowledging how incomplete is our sense of worlds outside our own. Generalisations mask the uniqueness of the individual, clouding our perceptions; we cease to let them be themselves, imprisoning them in our own superficial descriptions. Biologists working with the 35-year-old Serengeti Lion Project have given us a new lion, one separated from folklore. But they have not found the whole truth; the animal's inner lives remain a mystery – and that to us is the true fascination.

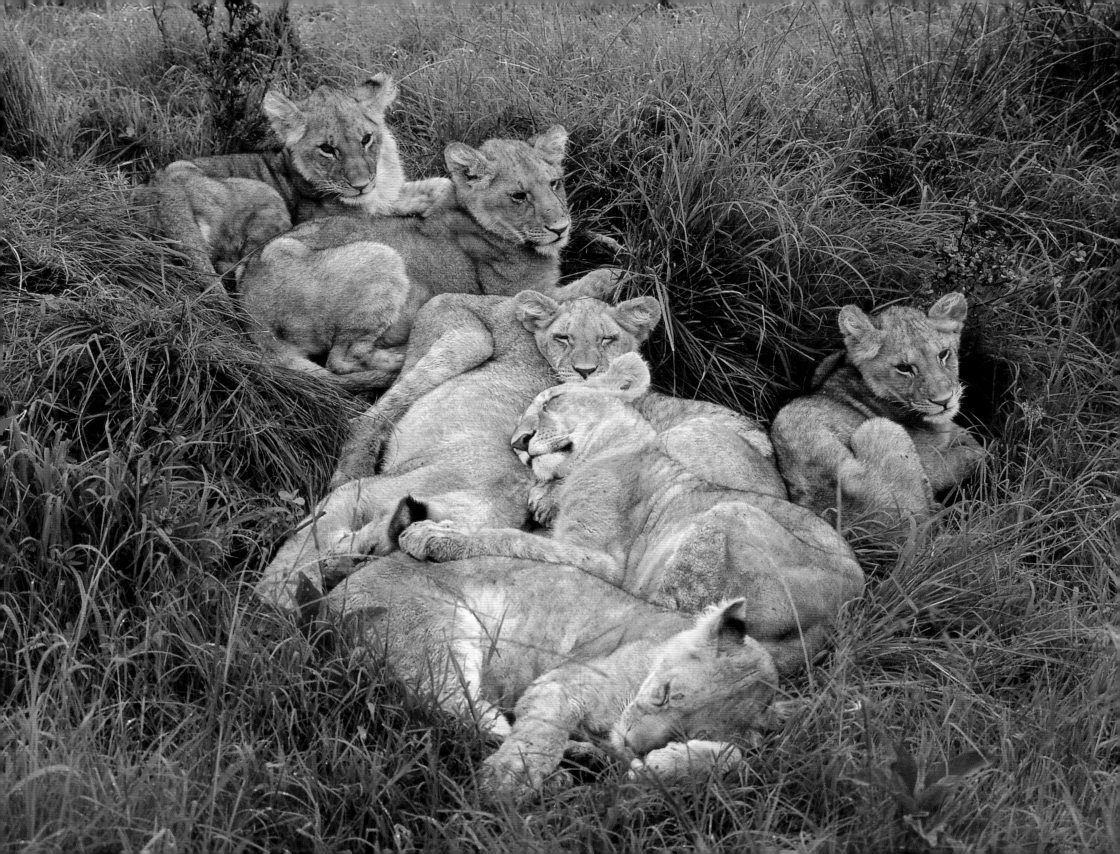

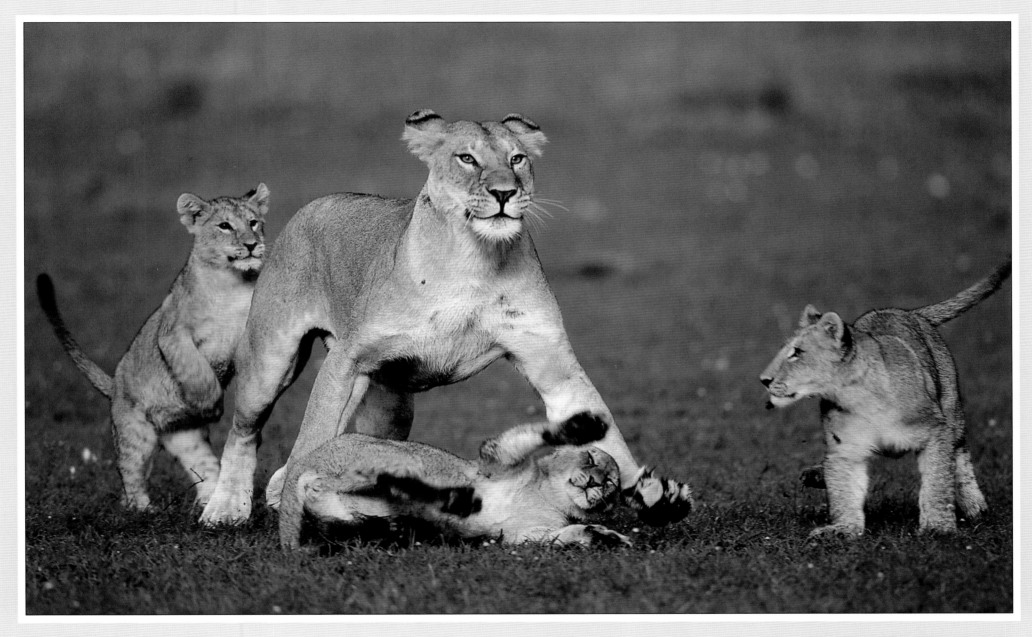

The Marsh lions' cubs waiting for their mothers to return from a hunt during the long rains. By this time of year the migration has departed and catching sufficient prey for the whole pride can be difficult.

Play provides young cats with the chance to practise their hunting skills. Adult lionesses often initiate and join in these play sessions. When food is scarce, however, cubs conserve their energy and play less.

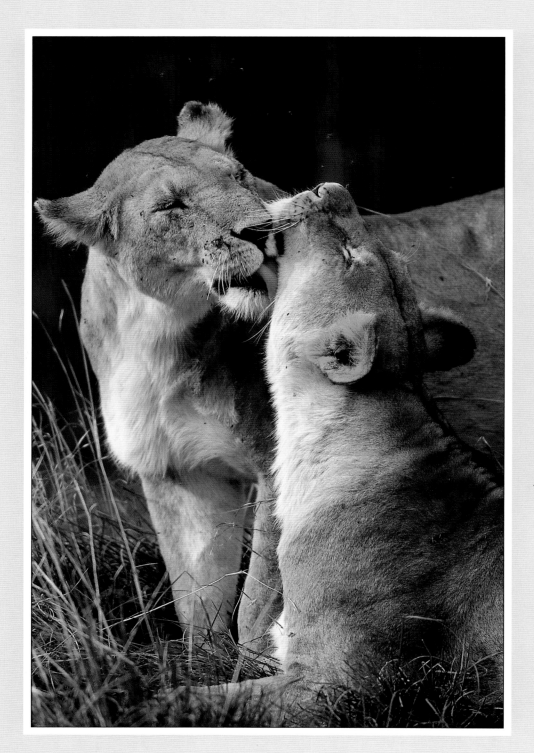

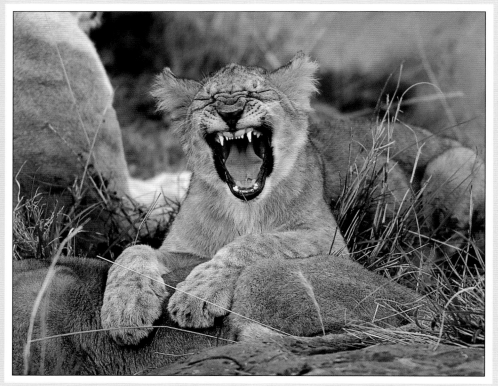

Cubs start to eat meat when they are about six weeks old. Their adult teeth erupt when they are about fifteen months old.

All the lionesses in a pride are related. Mutual grooming means that another lion can reach places an individual cannot attend to herself. Rubbing up against one another and grooming help to reinforce the bonds between pride members and to maintain the group's identity by creating a communal scent.

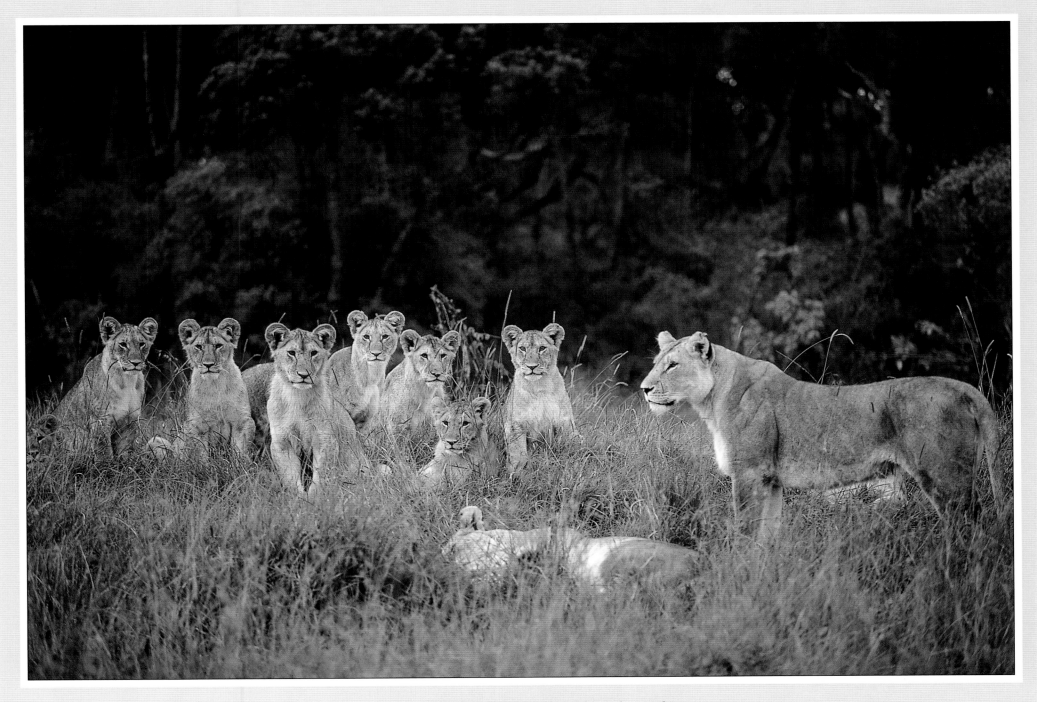

*Lionesses often give birth to cubs within a few weeks
of each other and they are raised communally.*

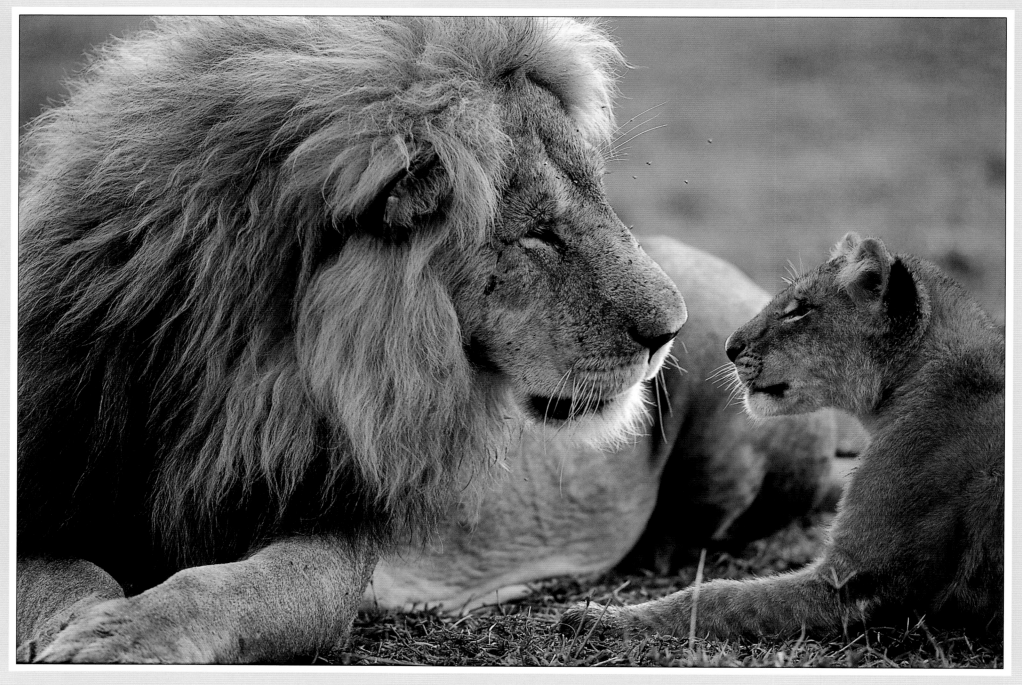

*Pride males spend more time close to the pride when their
cubs are small. This helps to reduce the risk of infanticide
by nomadic males seeking to take over a pride. Even so,
infanticide accounts for up to 25 per cent of cub mortality.*

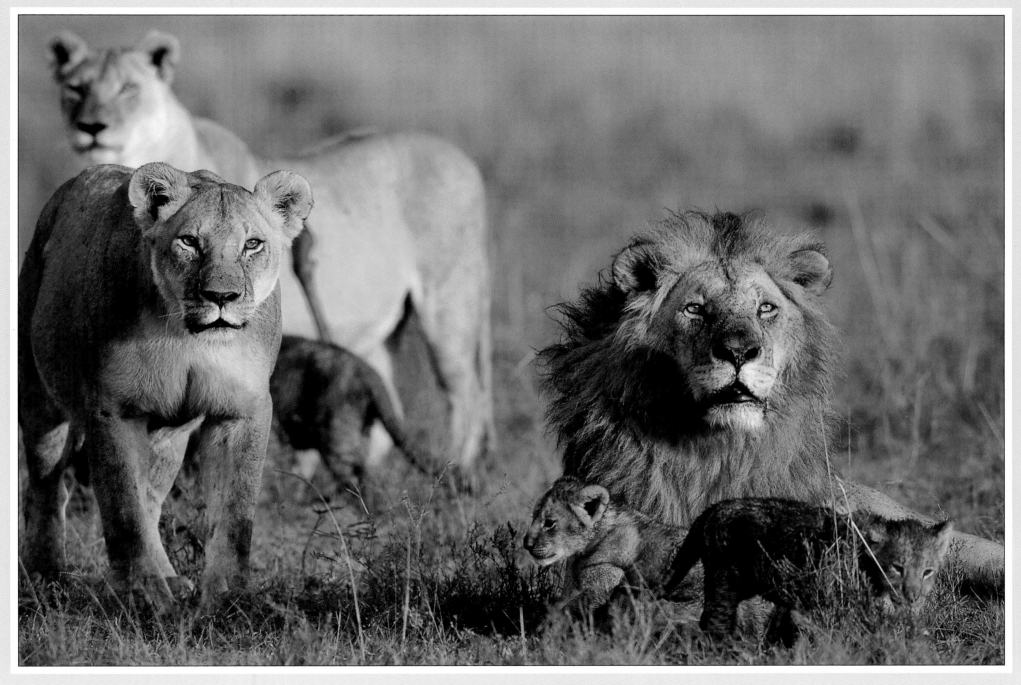

It is a tough life for pride males. Many coalitions manage to stay with a pride of lionesses for only two or three years, just enough time to sire a generation of cubs and see them through to independence.

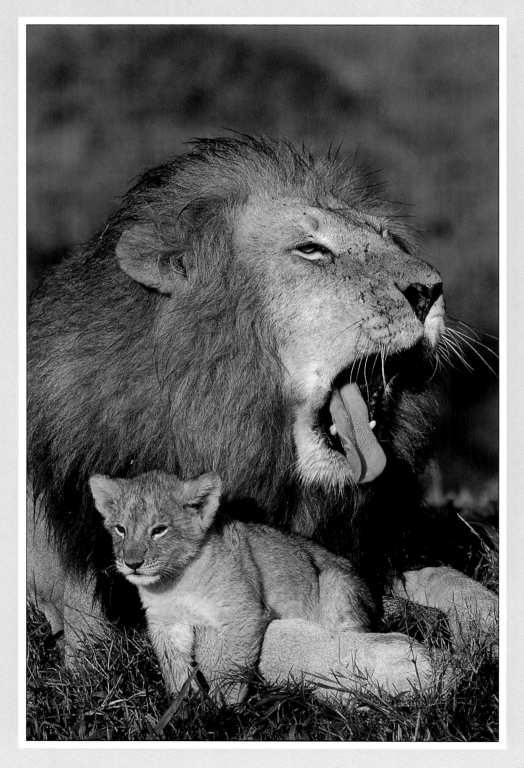

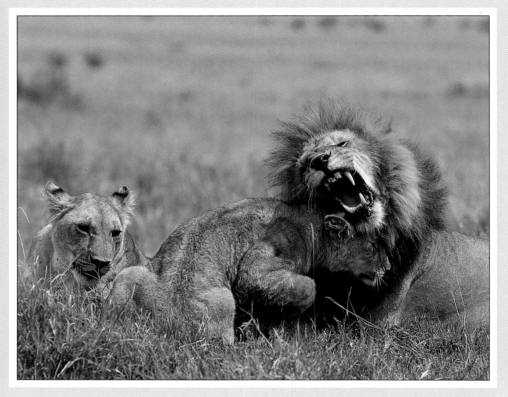

Brown Mane of the Marsh pride, left. Young cubs are fascinated by the big pride males and often try to greet or play with them, rubbing under their chins, nibbling their manes and biting their tails. Some pride males are very tolerant of all this attention; others can be short tempered, particularly as the cubs get older, rebuffing them with a snarl or a swat of their massive forepaw.

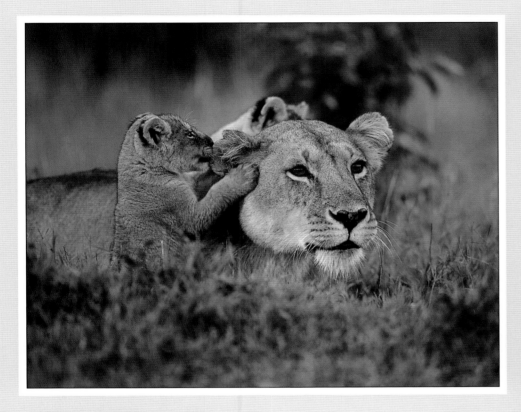

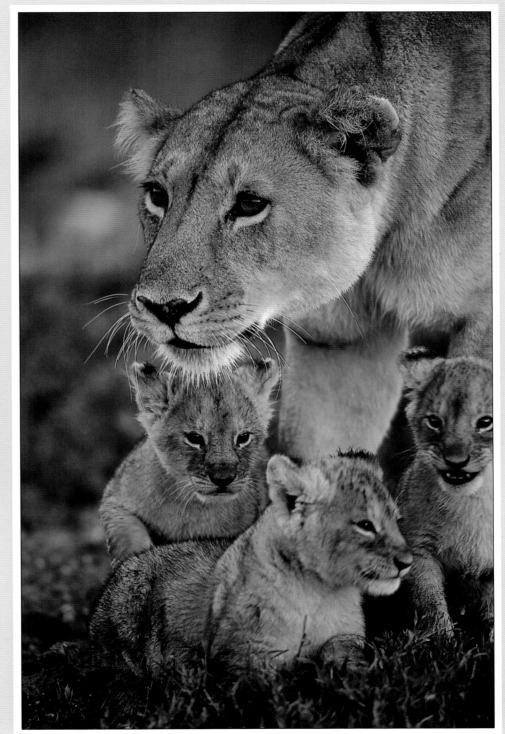

Khali of the Marsh pride with eight-week-old cubs, keeping a close eye on trespassing males from another pride. A lioness keeps her cubs hidden for the first few weeks to protect them from predators and to allow them time to imprint on her. Lionesses will act together to defend their young against attack by nomadic male lions, risking serious injury and even death in the process.

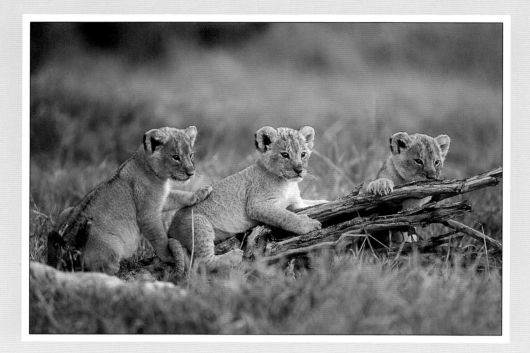

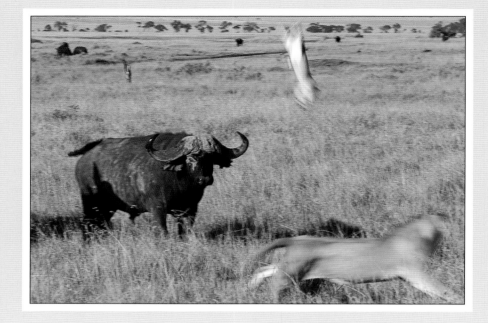

*Khali's eight-week-old cubs
(the one in the middle was
killed by the buffalo). Many
lion cubs do not survive to
maturity. Starvation, nomadic
male lions and predators all
contribute to mortality.*

*Buffaloes are an important
prey species for the larger lion
prides. But buffaloes are well
equipped to defend themselves.
Here one of Khali's young cubs
is tossed and killed, despite
its mother's attempts to
distract the buffalo.*

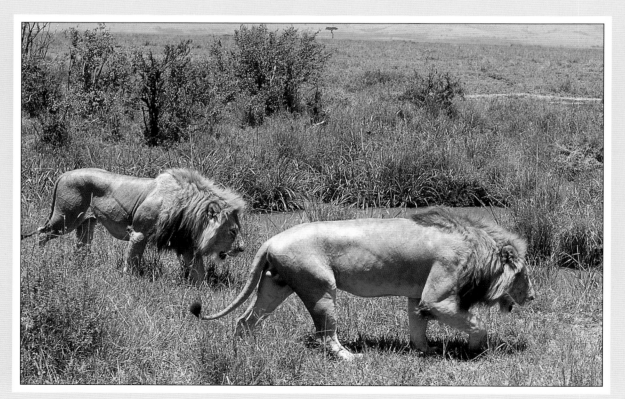

*Living and hunting in groups
means that lions are capable
of killing prey far larger than
themselves. In this instance
the Marsh lions had ambushed
a giraffe with a newborn calf.
Each time the mother tried
to lead her calf away the lions
would leap on its back and pull
it to the ground, injuring it and
sapping its strength. For five
hours the mother managed
to fend the lions off, lashing
out with feet powerful
enough to crush a lion's skull.
But eventually the lions
prevailed.*

*The Topi Plain's pride males
searching for Khali's cubs
along the Bila Shaka lugga
after chasing Brown Mane
from his territory.
Fortunately Khali had spotted
the males and moved the cubs
from their hiding place.*

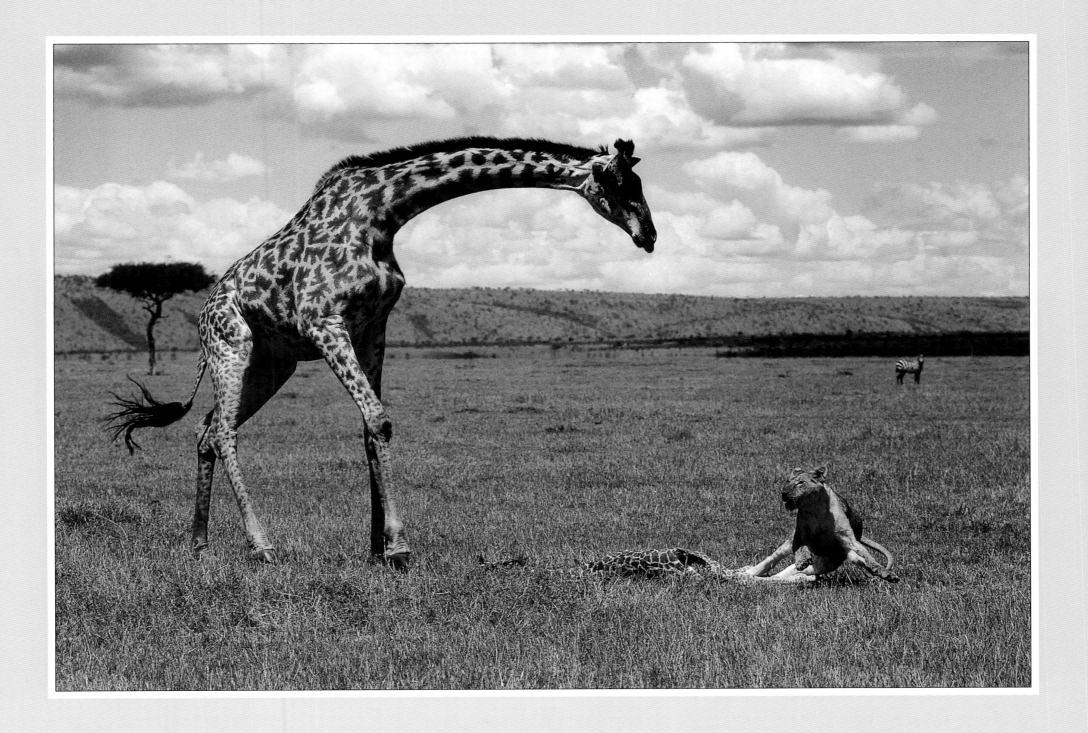

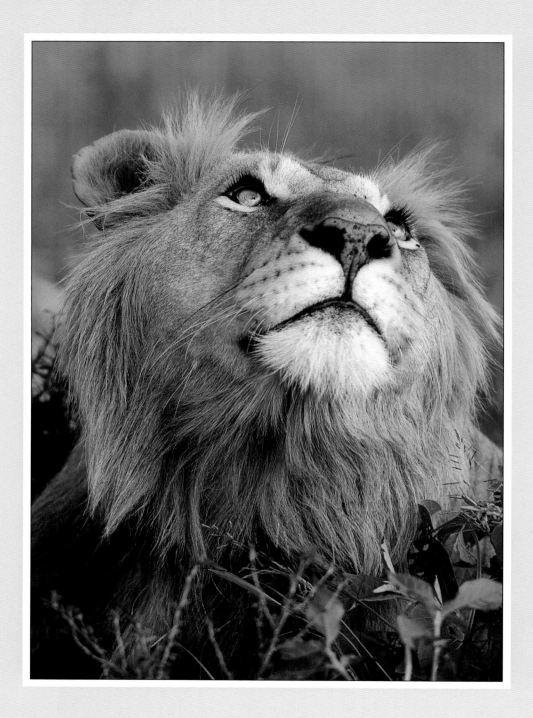

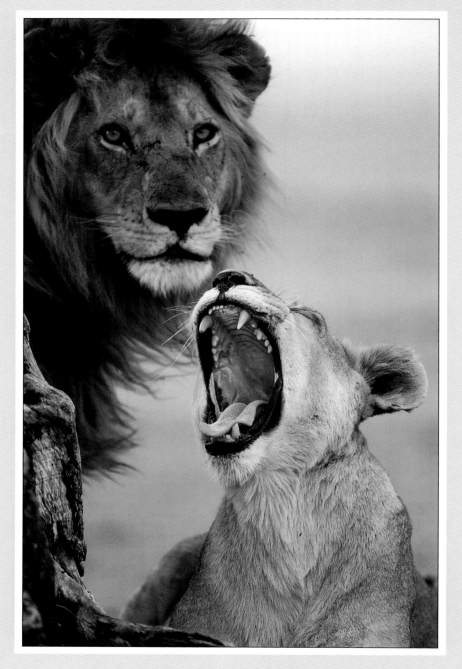

*Scruffy, one of the Marsh pride males, watching
baboons trapped in the tree above him.
Whenever a male stays close to a lioness and
guards her it is a sign that she is in oestrus.*

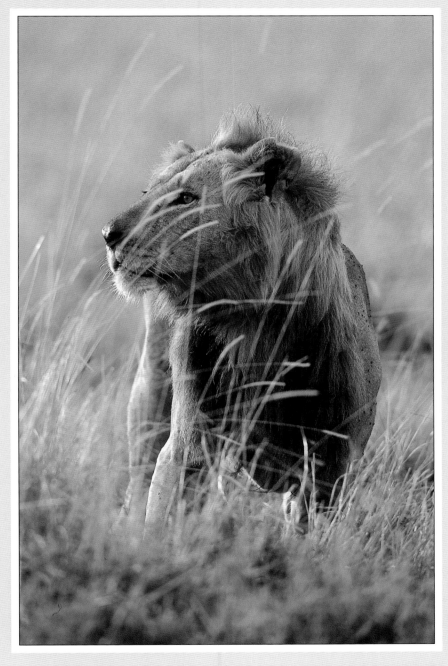

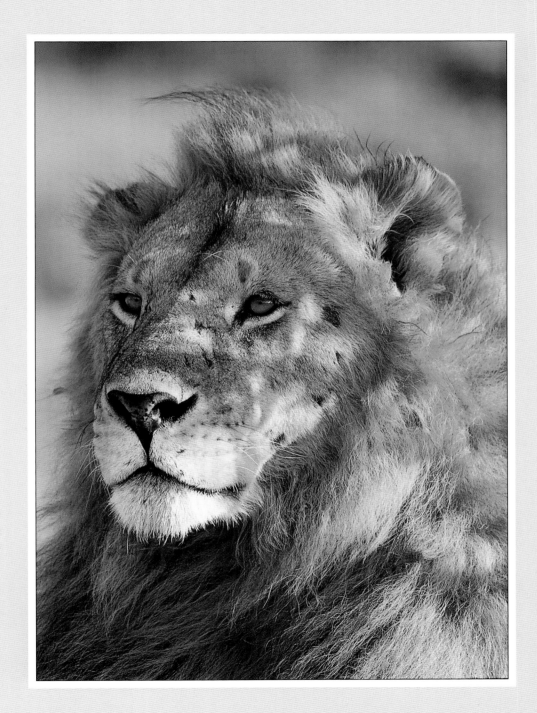

Some males, such as Scruffy, above, never grow particularly luxuriant manes. Studies in the Serengeti show that lionesses prefer males with large dark manes, implying that it is a sign of good health and genetic fitness. A lion's mane is fully developed by the time he is five to six years old, though it may thicken and darken with age.

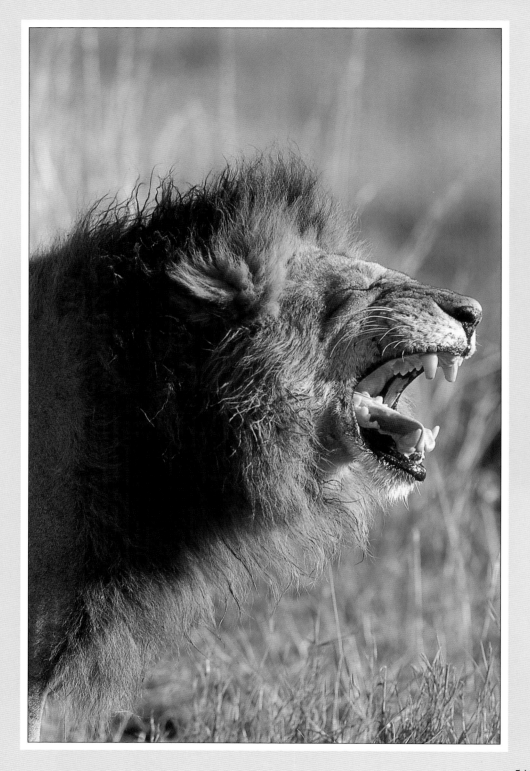

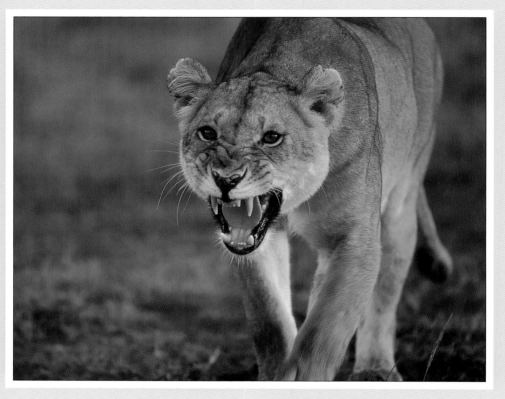

Khali of the Marsh pride, above, defending her young cubs from male intruders. All cats have very expressive faces, with black gums helping to highlight their dagger-like canines. Sounds – growling, snarling and hissing; the position of their ears – upright or flat; open-mouthed gestures and the size of their pupils help signal varying levels of aggression or submission to friend and foe alike.

Brown Mane of the Marsh pride, left, showing a flehmen face. By grimacing in this way males can analyse chemical signals from a female, to determine whether she is in oestrus.

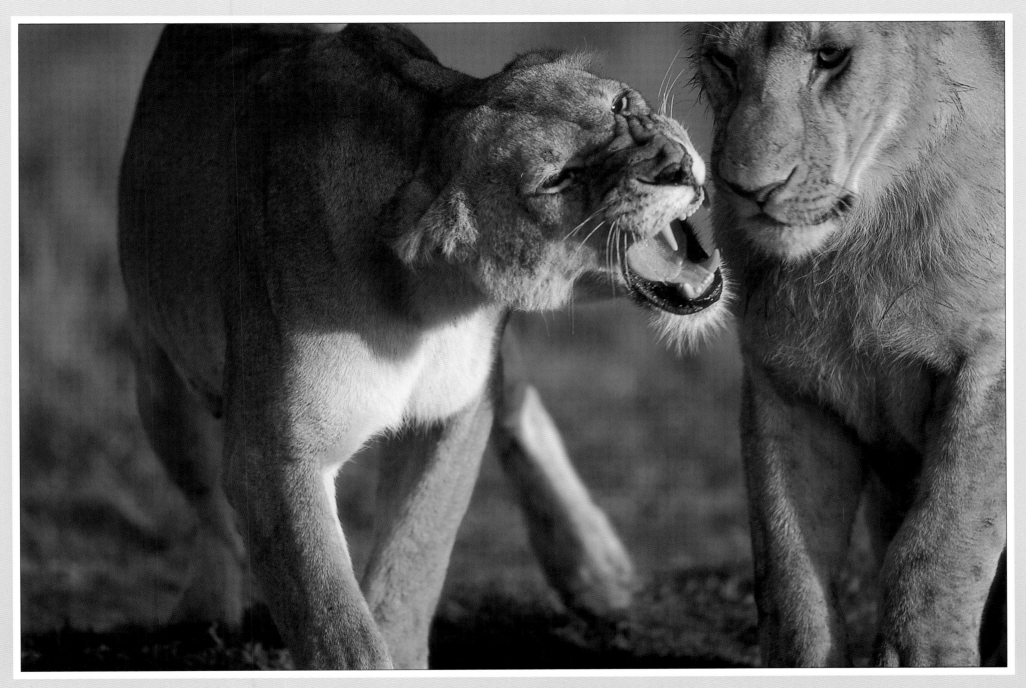

Khali warning a young male in the pride to keep away from her small cubs. Lionesses are noticeably less tolerant of sub-adult males than they are of young lionesses in their pride.

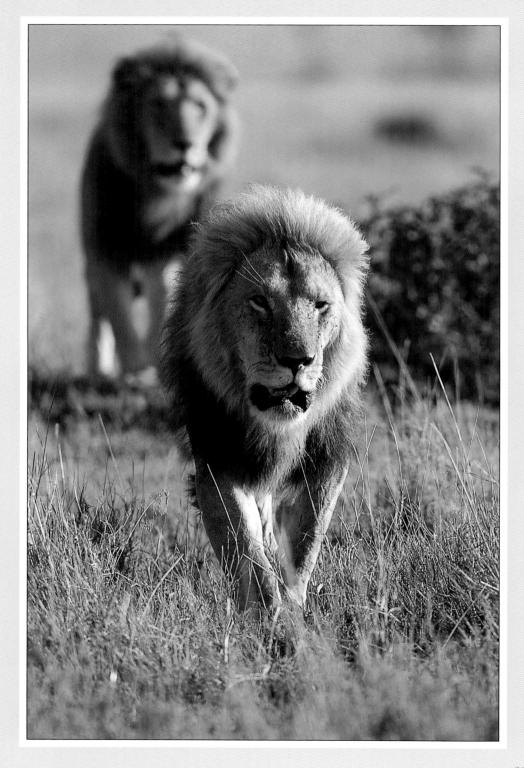

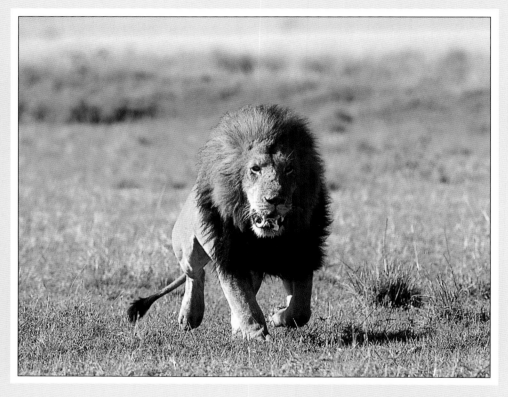

*Brown Mane fleeing for his life,
pursued by males from
the Topi plains.*

*Topi plains pride males intruding
on the Marsh Lions' territory.
All young males are forced from the
pride at two to three years of age,
by which time they are ready
to challenge resident pride males
and sire cubs of their own.*

56

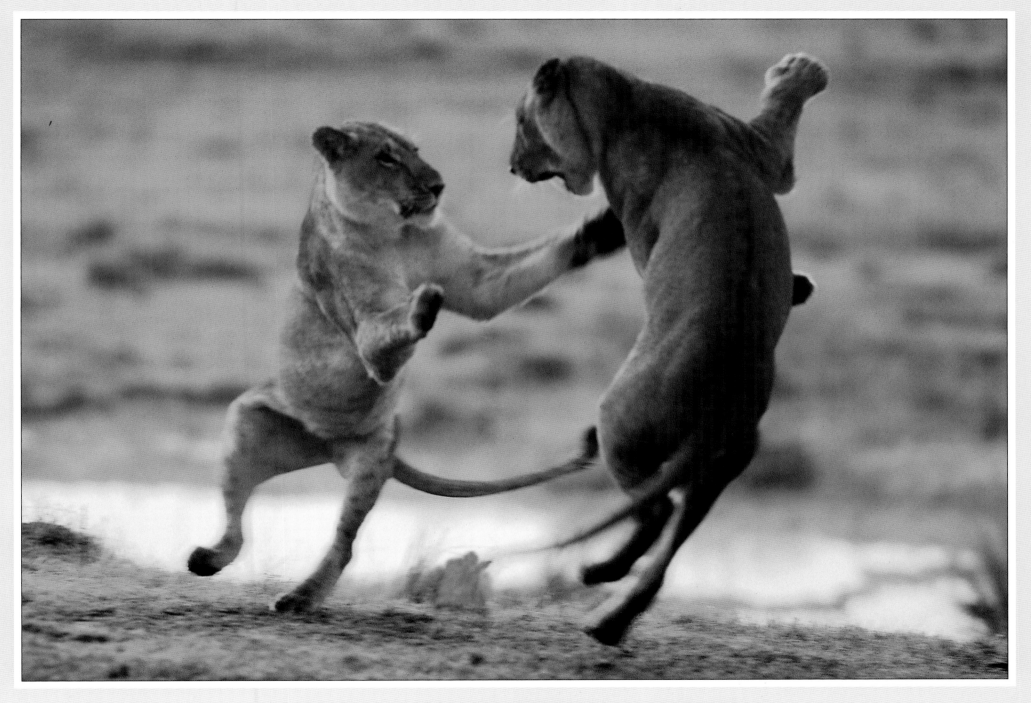

A two-year-old lioness and her brother play-fighting above the spring feeding Musiara Marsh. All young males leave their natal pride at about three years of age and as a group eventually try to take over another pride, thus helping to prevent inbreeding.

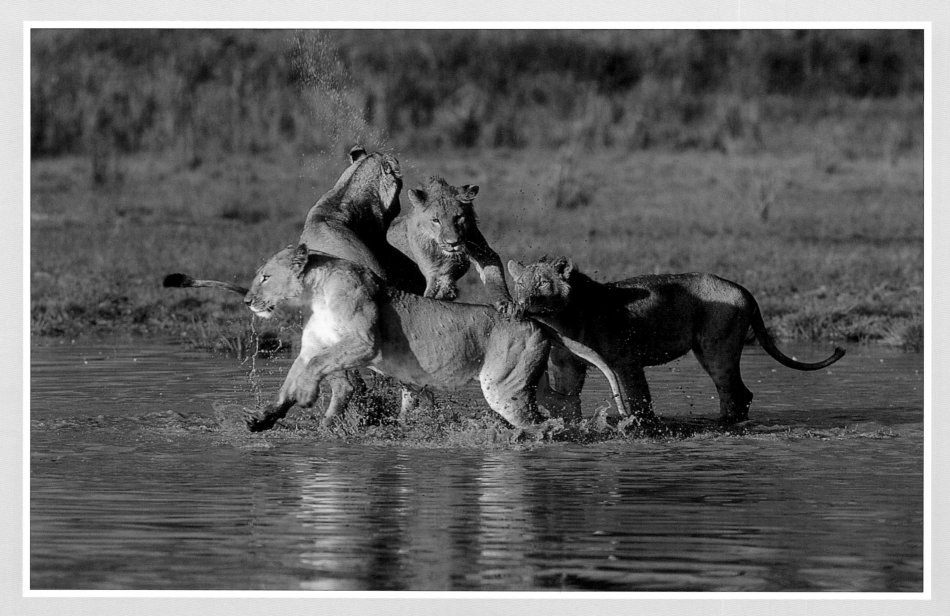

A lioness playing with three young relatives. Though lions only occasionally lie up in water to keep cool in the manner of tigers, they love to play in shallow water.

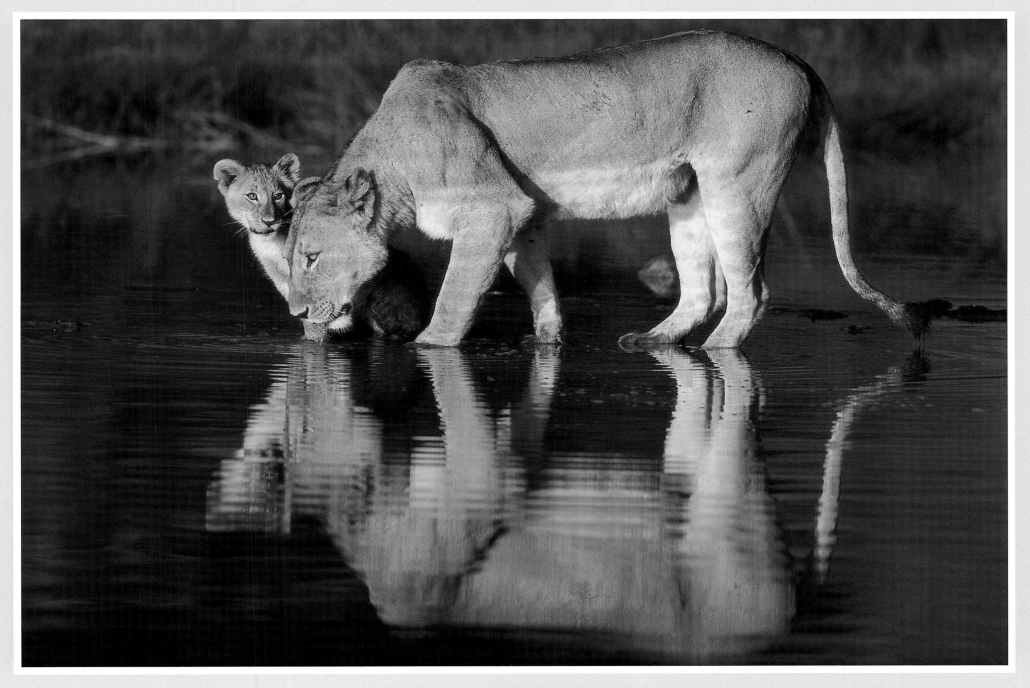

Lioness with four-month-old-cub. Lions try to avoid overstressing themselves when it is hot. After a large meal they often drink before seeking a shady spot to rest up during the daytime.

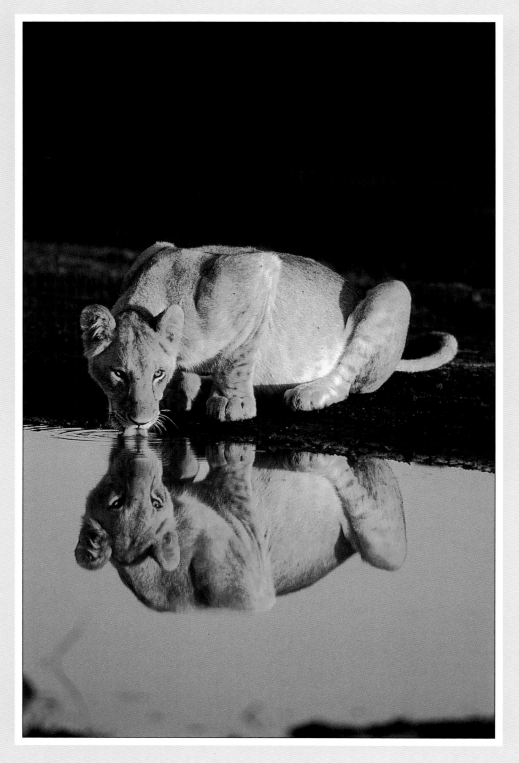

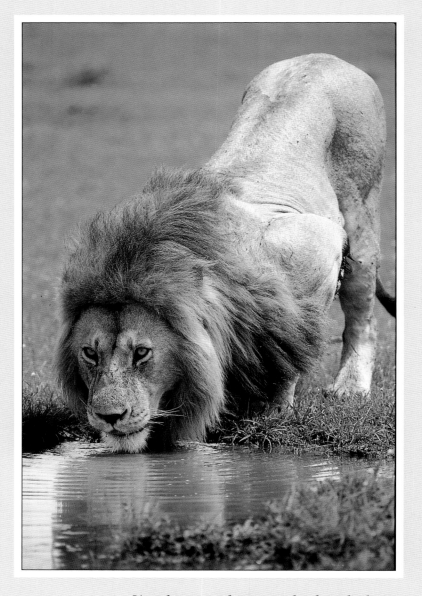

Lions have very few sweat glands and rely on panting to lower their body temperature when it is hot. If water isn't readily available to replenish moisture lost by panting they must survive on the blood and body fluids of their prey. In dry areas they may become more nocturnal as a way of conserving water.

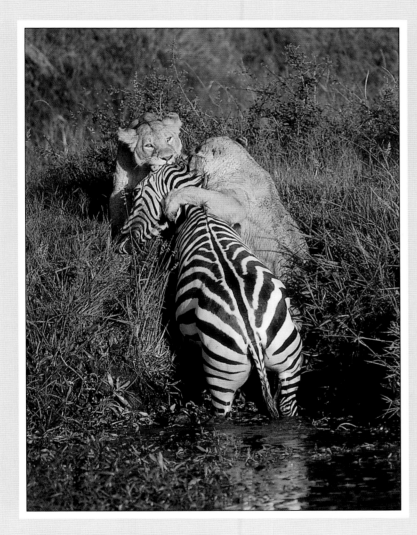

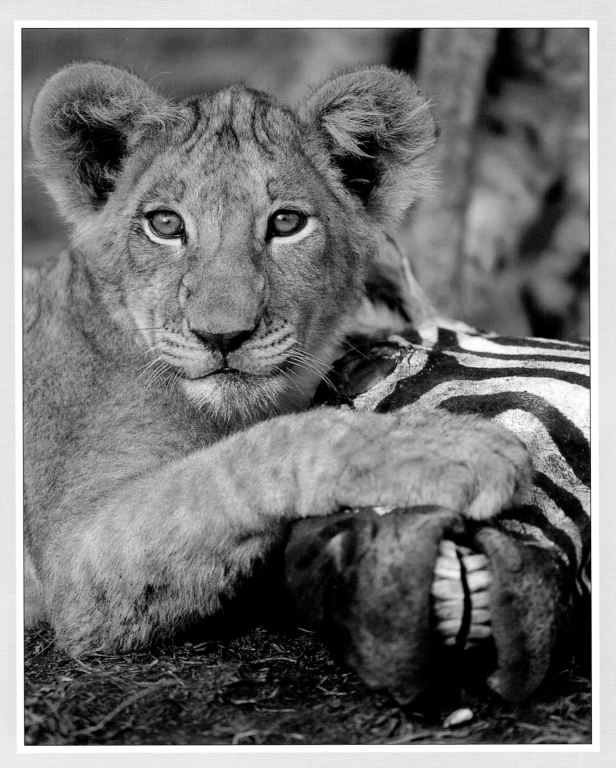

Zebras are an important prey for lions in the Mara-Serengeti, though in this instance the young lionesses were robbed of their prey by a clan of hyenas. A full-grown zebra can weigh up to 300 kilograms, food enough for the whole pride. However, zebras have a powerful kick and sometimes escape the clutches of a lioness.

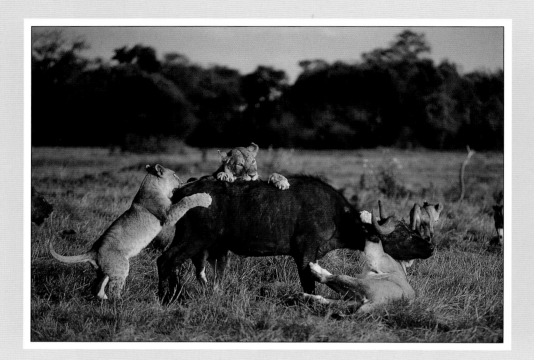

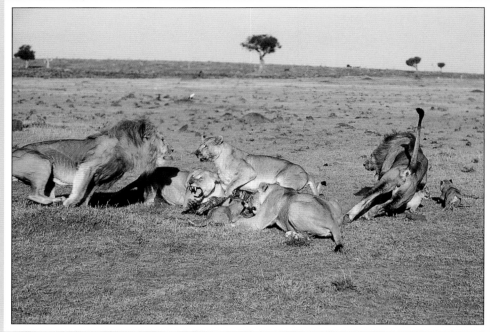

A lioness hunting alone can usually kill often enough to feed herself. But hunting with other members of the pride enables her to tackle a greater variety of prey and have a better chance of defending it against hyenas and lions from another pride. Lions are successful in only 10-20 per cent of hunting attempts, and when prey is scarce or a pride makes a small kill such as a wart hog, competition can be fierce. Buffaloes are an important prey for the larger prides – particularly when the migratory wildebeest are absent – though lions will attack just about anything they can get close to. They have even been known to kill and eat crocodiles – and to be killed by them.

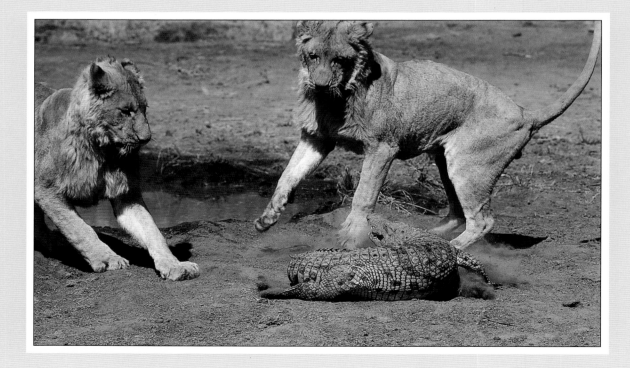

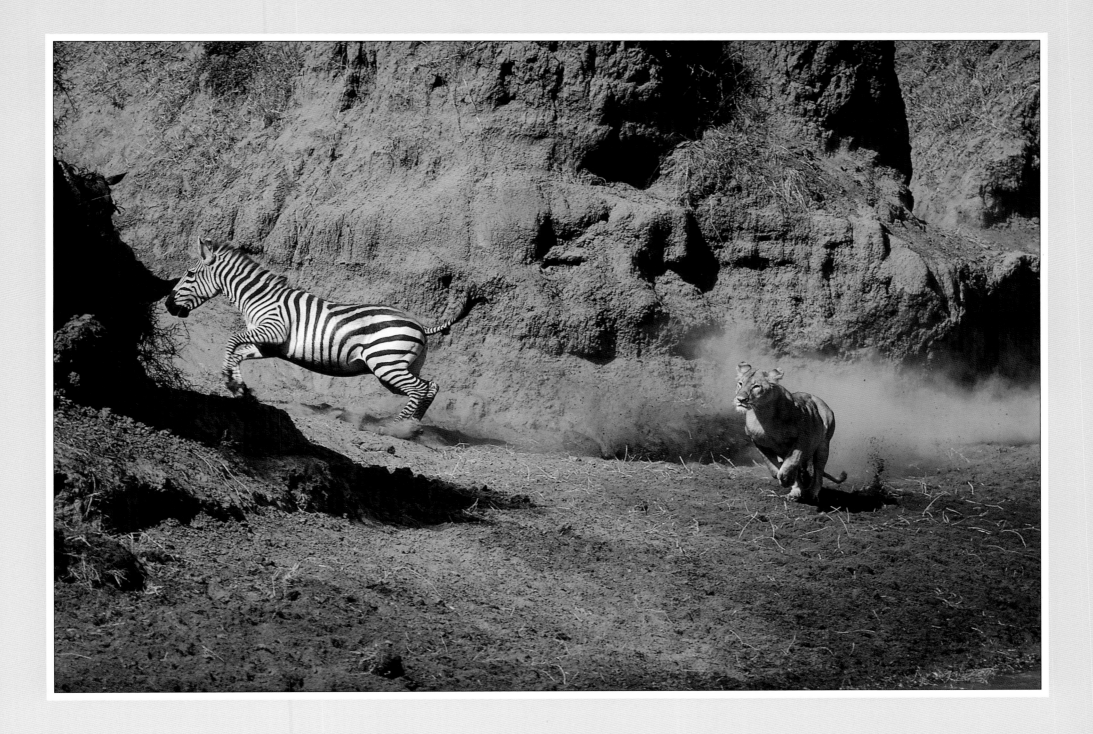

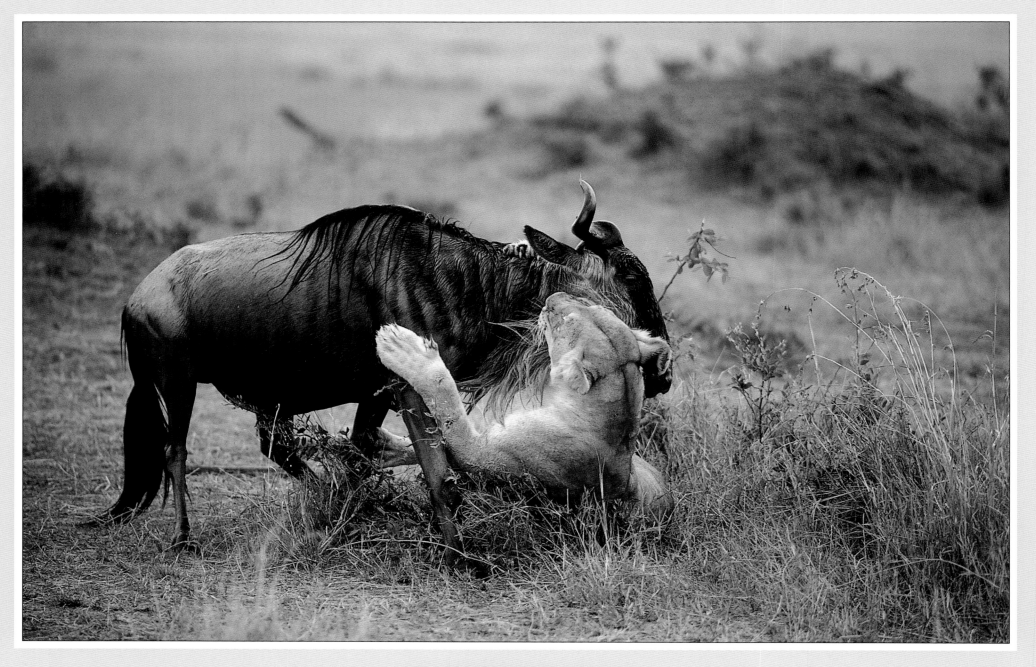

*All of Africa's big cats kill their prey by
strangling or suffocating it, thereby avoiding
their victims' horns and hooves. Smaller cats
tend to kill their prey by biting into the
neck or base of the skull.*

64

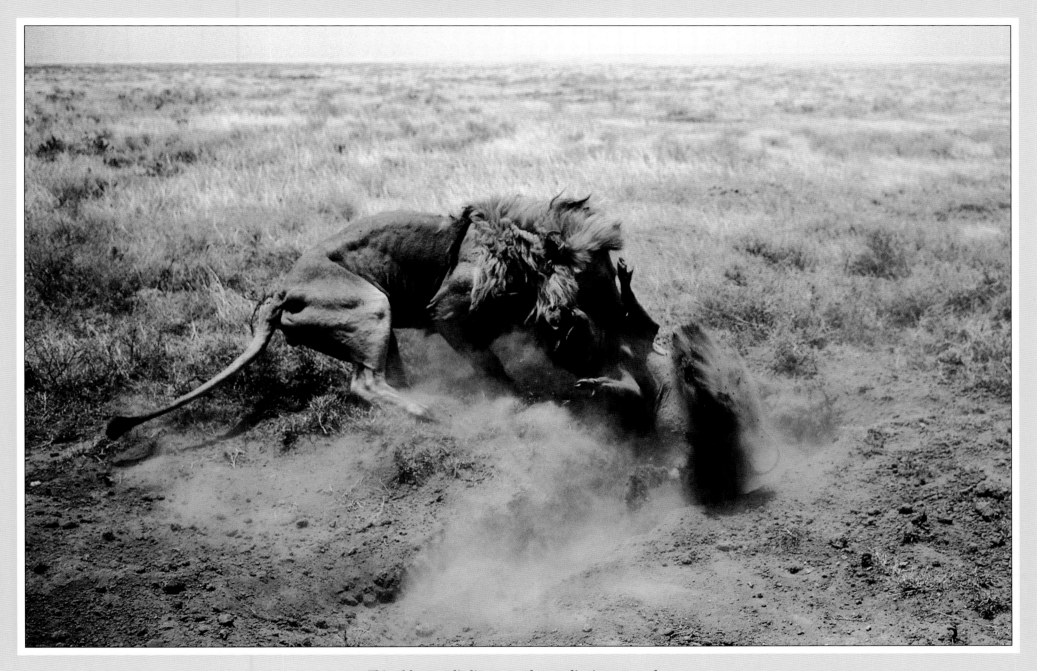

*This old nomadic lion spent hours digging a trench
into the rock-hard Serengeti plain so that he could
drag this wart hog from its burrow. Most of the
lions in the Serengeti stake out territories in the
woodlands where prey is available year round.*

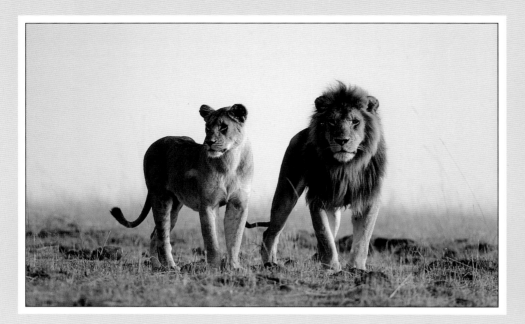

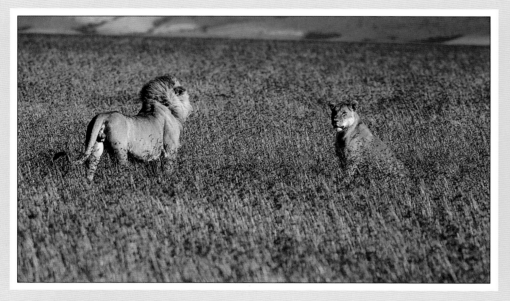

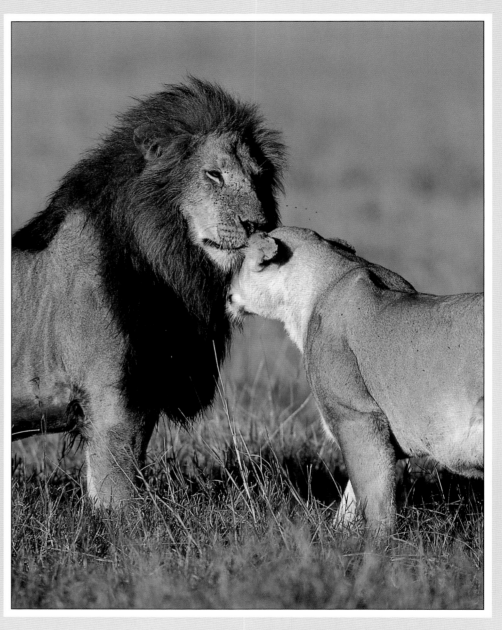

Male lions are far bigger than lionesses – 180 kilograms or more compared to a lioness's 120 kilograms – highlighting the division of labour within the pride. Males use their superior strength to defend the territory against other males, whilst females provide the food.

A lioness tries to keep a nomadic male at bay to give her cubs time to escape. Nomads always try to kill cubs sired by the pride males. This brings the mothers into oestrus again and gives the nomads a better chance of mating.

The tension between adult males and females in a pride is never far beneath the surface. When a lioness is accompanied by young cubs she forces the males to keep their distance until she is sure that her cubs will come to no harm.

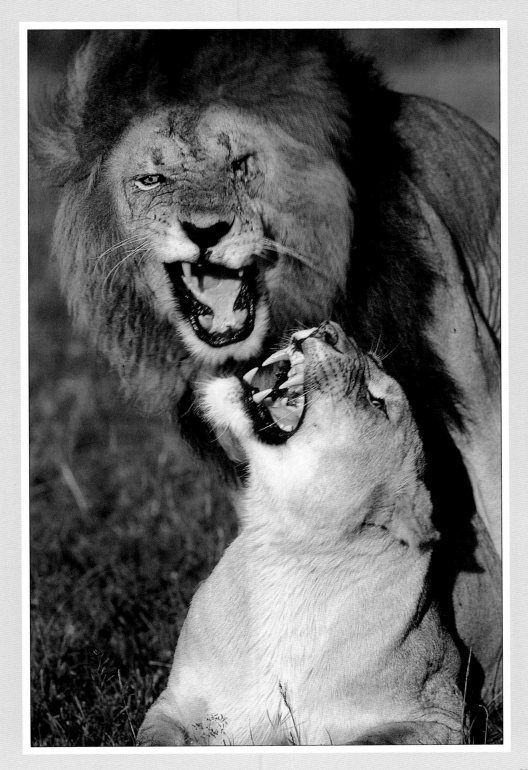

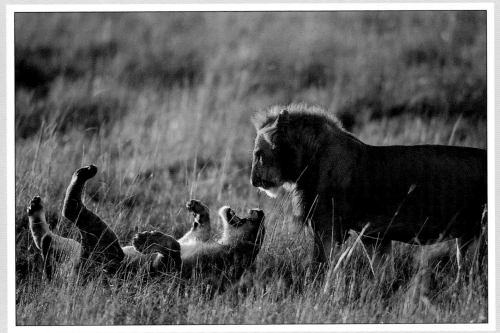

Lions mate two to three times an hour throughout the two-to-six-day period that a lioness is in oestrus. Cats are induced ovulators, with copulation helping to stimulate ovulation. Lionesses often roll on their backs after mating, perhaps to aid fertilisation.

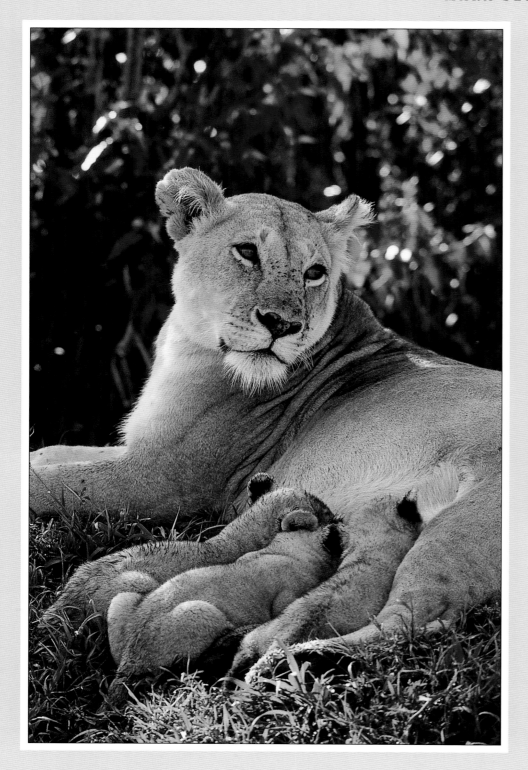

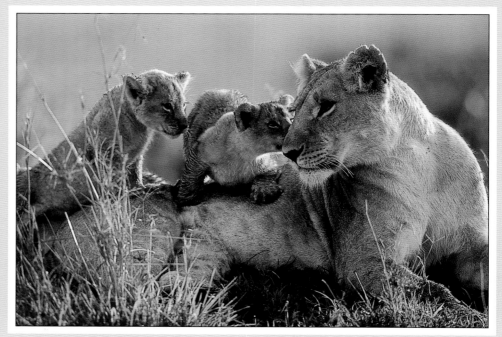

After a three-and- a-half-month gestation period, a lioness gives birth, sometimes choosing the place where she herself was born as the birthplace of her cubs. Most litters number two to four cubs, though six have been recorded. Lionesses in a pride often have cubs at the same time and rear them communally. A lioness will even allow a relative's cubs to suckle her if she has sufficient milk.

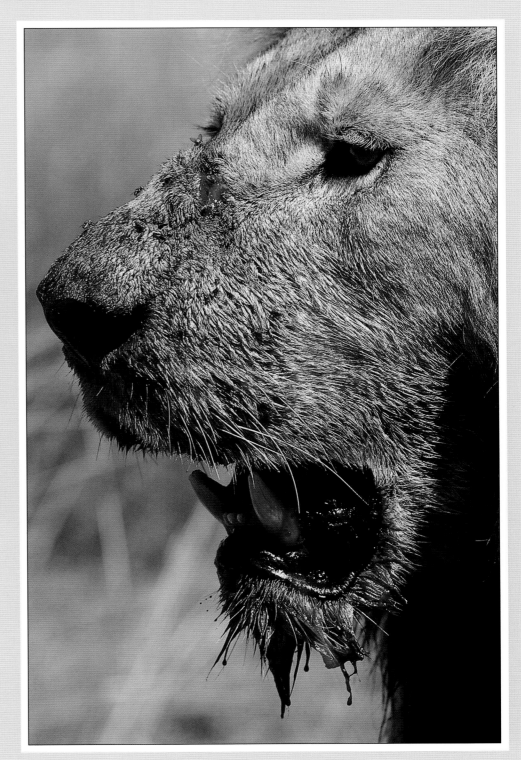

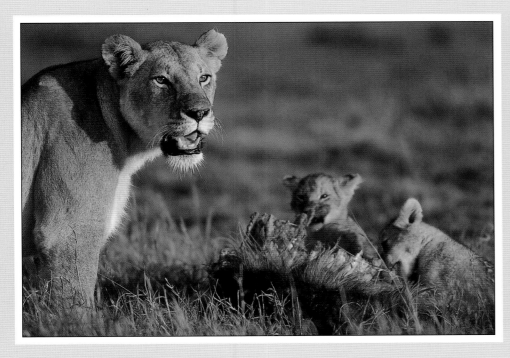

A lioness keeps a watchful eye out for hyenas, allowing her cubs to feed. Males often allow their offspring to feed with them on a kill, while keeping away the lionesses, who are not related to them.

Shadows in the Grass

For the animals shall not be measured by man. In a world older and more complete than ours, they move finished and complete, gifted with extensions of the senses we have lost or never attained, living by voices we shall never hear. They are not brethren, they are not underlings; they are other nations caught with ourselves in the net of life and time, fellow prisoners of the splendour and travail of the earth.

Henry Beston *The Outermost House*

*M*uch as I love to watch lions, the leopard was the animal I most wanted to see when I first came to Africa. Even as a young child I was aware that this was a creature apart: a master of concealment, the ultimate predator. My fascination with all things wild and living found perfect expression in the form of this elegant spotted cat. In those days the creature that held me in its thrall padded up and down within a barred enclosure in London's Regents Park Zoo. But a leopard needs the backcloth of the thorny branches of an African acacia tree or to be caught mid-stride padding along a game trail in the moonlight.

There is something about the way a leopard moves, a combination of such grace and power, a raw mixture of muscular street fighter and lithe gymnast. Leopards can hunt at any time of the day or night, survive in the deepest forest or at the edge of the driest desert – wherever there is food to sustain them. Almost anything will do – from insects and reptiles to large antelopes twice their size. They are brave, too, and at times short tempered; push a leopard too far and it will end up in the car with you, scratching and biting each and every one of its human adversaries before anyone has time to protect themselves.

The leopard is the most cat-like of wild cats, utterly self-sufficient, as silent in its movements as the faintest whisper. When a leopard wants to remain hidden it is almost impossible to find. Why so shy, you may ask? But it is in a leopard's interest to be cautious, to remain concealed. There is danger to hide from: man perhaps, lions most certainly – bigger and stronger predators that are quick to defend their domain. When leopards do emerge their appearance causes a special kind of panic among their prey – soon the alarm snorts and whistles are echoing through the thickets even if the leopard isn't interested in hunting. Hurrying now, the spotted one slips away to a quieter place, melting into the shadows. What a contrast to lions which often wander around as if they own the place, their size and social nature giving them a confidence that none of Africa's other predators can match.

Close is never close enough for a hunting leopard. Angie and I have seen them edge to within a few metres of their prey, then wait – and wait – until the moment is right, blending so perfectly with their dappled surroundings that when the time comes to strike there is barely a chase. Which is just the way a leopard wants it to be. You hold your breath, aching with the excitement: the explosive charge, lightning-like pounce, and it is all over. But there are always hyenas to contend with, bigger and heavier than any female leopard. With their keen sense of smell and acute hearing very little happens that the hyenas don't know about. Often it is a race against time for the leopard. It must hide its kill in a dense patch of croton bush or better still drag it up into a tree where no hyena can follow. I have seen a hyena bite deep into the foot of a leopard that was trying to hang on to its kill, watched the two of them brawling in the bottom of a lugga. But when there is no food to fight over, the two predators tend to ignore each other, and it is not uncommon to see a hyena approaching from downwind and walking right up to a leopard lying on the ground, sniffing its face to see if there is a kill in the vicinity. The leopard will hiss, baring its teeth, but will otherwise ignore its larger rival, which may even decide to lie down close by. But a big male leopard weighs as much as some hyenas and will sometimes stand and fight – until more hyenas arrive.

During my first year living in the Masai Mara I saw a leopard on only two occasions. They were no more than fleeting impressions, yet the memory of them is as clear as a moonlit night. One evening as I returned to camp a beautiful young female crossed the rocky path barely 15 metres from the front of my vehicle. Emboldened by the darkness she paused for a moment and stared at me before slipping away among the croton bushes. It was visible proof that there were leopards out there, even if I wasn't having much luck in finding them.

On another occasion I came upon a big male leopard crouched in the top of a lone tree on the rocky flanks of Rhino Ridge. I had been

attracted to the spot by another vehicle parked near the base of the tree. I watched through binoculars. The leopard was already showing signs that he didn't like all the attention. Within minutes a cluster of vehicles had encircled the tree and the old male had no choice but to abandon the half-eaten gazelle carcass he had stashed among the branches. With a growl of displeasure he bolted down the tree and galloped away to the nearest thicket. We were shocked at the speed with which he departed and for a moment there was chaos in the back of the vehicles as people ducked back through the roof hatches, heads bumping, cameras flying.

The visitors were overjoyed at having seen a leopard up close. At the time, so was I. But some years later a shy male leopard was killed in just such circumstances – the pressure of too many vehicles sent him fleeing into the arms of a group of lions which had been resting near by. They knew the leopard was in the tree, watched as he descended, heard his grunts and snarls of fear and alarm at being surrounded by half-a-dozen vehicles packed with excited and noisy visitors. The lions flattened themselves against the ground as the leopard raced blindly towards them. He never had a chance – 60 kilograms against four male lions weighing 180 kilograms apiece. The leopard was quickly subdued and bitten through the throat and spine. The visitors were stunned by what had happened, realising the part they had played in the tragedy.

Lions have always killed leopards, as do tigers where the ranges of the two cats overlap. Predators have little mercy for anything smaller than themselves when competing for food and space; lions show particular antipathy to the other big cats and will kill leopards and cheetahs of any age. This is nature's way of balancing numbers, and leopards do everything possible to avoid conflict with lions. But keeping safe from humans has not been so easy.

During the 1960s and '70s leopards were slaughtered in their tens of thousands in response to the unquenchable thirst for fur coats. It was estimated that 60–70,000 leopards were killed annually in Africa during this period, with demand for fur coats being particularly strong from France, Italy, Spain, Scandinavia and Japan. But by the mid 1970s public opinion had begun to change. It was no longer fashionable to wear spotted cat-skin coats and the International Fur Trade Federation called for a voluntary halt to trade in the more endangered species. In 1975 the snow leopard, clouded leopard, tiger, jaguar, leopard and cheetah were listed on Appendix 1 of CITES (the Convention on International Trade in Endangered Species of Wild Fauna and Flora) – a treaty that has since been adopted by more than 140 countries – prohibiting international commercial trade in these species. But there is no doubt that a significant trade in spotted cat skins – particularly those of Latin

America's smaller cats – continues. It could be the deciding factor that pushes them to extinction.

Despite its status as a protected area the Mara was no more immune to poaching than anywhere else. Leopards that had become accustomed to tour vehicles were the first to disappear and, by the time I arrived in the Mara in 1977, visitors had little chance of seeing a leopard. Poaching involving both trophy hunters and the game department was prevalent and flagrant abuse of the rules governing hunting licences and quotas was the norm, with large sums of money paid to corrupt officials. The issue was even raised in Parliament.

All of the big cats, as well as elephants and rhinos, suffered losses during this period, not least the Mara's black-maned lions. In 1976 the East African Wildlife Society arranged for a short survey to be carried out in an 8-kilometre radius around Governor's Camp which found a dearth of big, mature male lions. On one occasion a black-maned lion was shot within a kilometre or so of camp, its head hacked off and slung in the back of the hunting vehicle with impunity. A photograph of a safari operator's staff breaking up one of eight very strong wooden leopard traps found in the space of about 400 metres just off the road between Ngong and Suswa in the Rift Valley was published in the society's magazine in the same year. But it wasn't just guns and box traps. Agricultural poisons used for tick control, mainly toxaphene, were a cheap and readily available way for herdsmen and poachers to poison predators.

The Kenyan government had already tried to put a stop to the destruction of the country's wildlife by prohibiting private trade in ivory in 1973, then in 1975 making elephant hunting illegal. Two years later a ban on the hunting of all wildlife was announced. The Ministry for Tourism and Wildlife said that one of the main reasons for outlawing all hunting was the difficulty of differentiating between a

poacher and a bona fide hunter – both carrying guns. From now on, they said, 'Only thieves will carry guns.'

The ban on trophy hunting was quickly followed by a ban on the trade in all wildlife products, but it would still be years before the Mara regained its reputation as one of the best places in Africa to see leopards. The leopards of the Seronera Valley in Serengeti suffered the same fate, and I often wondered if the old male that I had seen in 1975 managed to escape the poachers. I still clung to my dream of one day finding a leopard that I could study. In the meantime there was always plenty to do keeping track of the Marsh lions. As for the cheetahs – well, they were certainly easier to find than leopards in those days, even though there were fewer of them. But the cheetahs had one advantage over lions and leopards, both of whom might be lured to a bait and then shot or poisoned. Cheetahs rarely if ever scavenge and so tended to be harder for poachers to kill.

While I had to rely on chance to find a leopard, there was one person who, given a day or so of his undivided time, might well enable you to see one, however brief the view might be. His name was Joseph Rotich and he was the head driver at Mara River Camp, where I was based. I would sometimes tag along with him on game drives in the hope of absorbing some of his wisdom. Joseph's technique had been refined by years in the field; in the early days he had worked for a professional hunter visiting areas where leopards could ill afford to show themselves. It was knowing what to look for, *how* to look – not how sharp your vision was – that made the difference. Joseph saw the leopard as part of something bigger, intuitively understanding the interplay between predator and prey, how the balance shifted from one season to the next.

Joseph would have you out of bed an hour before first light, allowing you to snatch a quick cup of steaming coffee around the dying embers of the campfire before hurrying you on. With a twinkle in his eyes he might press a dry rusk into the palm of your hand. 'Breakfast!' he would chuckle as he caught you looking round for something more substantial to eat. Impatient now as the white-browed robin chats greeted the new dawn, he would head into the acacia country, stopping every so often to scan the countryside with binoculars, switching off the engine to listen. 'It's not just seeing,' Joseph would chide me when I would ask him what exactly he was looking for. 'You must listen too.' The sound of vervet monkeys or baboons calling in alarm or, better still, the high-pitched yelp of a black-backed jackal might well lead you to your leopard.

Joseph read the signs as deftly as a blind man reading braille, taking in everything, looking for something untoward, a ripple of disturbance in the patterns he saw before him. As we drove past promising clumps of bushes and ancient fig trees I would stare into them, convinced that one of these days I was going to find myself a leopard. Joseph would just laugh at my naivety: 'Even if there had been a leopard there it would be long gone by now – look into the distance.'

It wasn't long before Joseph introduced me to a place called Leopard Gorge. Just hearing the name brought me hope and a rush of excitement. To this day I have never found anywhere quite like the gorge. Home to hyenas and hyraxes, agama lizards and eagle owls, it has an atmosphere all its own. Many of the ancient fig trees and euphorbias that were there when I first knew it have now fallen, victims of the annual fires set by the Masai and the work of honey hunters hacking into the fig trees to encourage bees to swarm there. But if a certain sparseness now permeates the place, the rocky outcrops are as dramatic as ever, washed a delicate shade of grey and yellow by the lichen. Joseph told me that this was as good a place as any to begin the search for a leopard. Barely a day would pass without my inching my vehicle carefully along the narrow path running the length of the gorge. I would crane my neck to scan the caves and crevices that pock-mark its high walls, hoping for a glimpse of a leopard peering back at me from the lichen-covered rocks or camouflaged among the broad leaves of one of the fig trees, yet found nothing but disappointment to reward me for the effort – except, of course, the thrill of returning the next day. There was always tomorrow.

The female whose home range included Leopard Gorge and a place to the west called Fig Tree Ridge – another of Joseph's favourite leopard haunts – was notoriously shy. I had often listened to Joseph talking about this wily old female. She was as big as some male leopards, weighing at least 55 kilograms, and dark – the colour of polished oak. Joseph recognised her by the V-shaped notch in her right ear and a single dark spot just above her pink nose. In fact every leopard has a distinct pattern of spots and rosettes, a spotted fingerprint that identifies each individual and remains constant throughout the animal's life. But with leopards being so shy it was impossible to build up a photographic record to identify individuals positively as I had done with the lions.

Towards the end of 1978, as I sat in my vehicle photographing the Marsh lions, I noticed another car flashing its headlights, a sure sign that the driver was either stuck or had seen something special. It turned out to be Joseph and I held my breath as he told me that the old female had been sighted with two young cubs in the Leopard Gorge area. He smiled hugely, enjoying my obvious delight at his good news.

Whenever I could during the next few weeks I headed for Leopard Gorge, scanning each tree and rocky outcrop for signs of mother or cubs. Then one evening I found them. A slight movement in the top of an elaeodendron tree caught my eye. It was the female. A large, darkly spotted shape shot down the tree and bounded away. She never even paused to look back as she reached the edge of the gorge. I remember my heart pounding wildly with excitement as I inched carefully towards the tree where she had been hiding. Sprawled at its base was the partially eaten carcass of a six-month-old wildebeest calf. Crouched over it were two small leopard cubs, their faces smeared red with the blood of their prey. They stared at me, wild blue eyes watching my every move. I foolishly reached for my camera – and they were gone.

I kept track of the leopard family as best I could during the next year, relying on reports from drivers and friends to add to the handful of occasions that I saw them for myself. Sometimes it was weeks, even months between sightings. One cub, a male, was shy, but his sister was very different. I called her Chui, which is Swahili for leopard. She was the first of a new generation of leopards who gradually allowed vehicles into her life.

Like all female leopards, Chui occupied a home range that she knew intimately: somewhere providing her with food and water, shelter from lions and hyenas, and a place where she could find a mate and raise cubs. Chui's home range was 20–25 square kilometres in extent, with Fig Tree Ridge and Leopard Gorge at its core. Impalas abound here, and are the commonest large prey taken by leopards in the Mara, along with Thomson's gazelles and smaller fare such as hares and hyraxes. Despite the fact that lions from the Gorge pride also frequent these areas and sometimes give birth to their cubs among the rocky outcrops, this has always been prime leopard habitat.

Chui's home range was not exclusive; parts of it overlapped the home ranges of two other females that I was aware of, one of whom was her mother. It is not uncommon for young females to share part of their mother's home range after independence. But as adults, females generally avoid contact with one another, depositing scent messages on prominent 'scent posts' – fallen trees, bushes, rocky outcrops – to leave a pungent, long-lasting odour signifying who they are, when they visited, their sexual state, and indicating to any other leopard in the vicinity when the area is occupied. In this way the leopards in an area get to 'know' each other – they recognise each other's scent, their sex, their call. There is economy to this system. With a home range of anything from 15–50 square kilometres in wooded habitat, it is impossible for a single leopard to be everywhere at once, but these signals warn potential intruders that the territory is not vacant. Leopards also use their characteristic rasping call, a guttural explosion of sound often heard at night when a leopard first starts to move about, helping to mark its position to friend and foe alike.

Most females I have watched look remarkably unscarred, so even though they actively defend part of their home range as a territory at times, serious fights are rare. It is far better for leopards to avoid injury by spacing themselves without fighting. In fact people have reported seeing a number of leopards gathered at a bait put out by lodges, taking it in turns to feed and not being overly aggressive towards each other nor trying to drive the other leopards away. One might guess that the participants in these man-made circumstances might be a mother leopard with cubs, a recently independent offspring from the previous litter, a female relative with an overlapping home range and the territorial male from the area. A density of one leopard per ten square kilometres is the norm in moderately suitable habitat, with one per five square kilometres in favourable ones and even one to every one square kilometre in exceptionally suitable areas such as the Aberdare forest in Kenya where there are fewer lions and hyenas, and plenty of prey.

Chui had her first litter of cubs in Leopard Gorge in 1980 when she was three years old. Once again it was Joseph who told me where to find her. She had chosen a cave in a massive rocky outcrop at the east end of the gorge, within a leap and a bound of a huge fig tree. Joseph and I slunk around the vicinity, trying not to precipitate the arrival of a torrent of vehicles from the other camps which would have ensured Chui's early departure with her cubs.

In the end it was lions, not vehicles, that forced Chui to abandon her hideout. The Gorge pride had been hunting in the area for the last few days and it was inevitable that sooner rather than later they would visit the gorge. Their menacing presence would not have gone unnoticed by

When I returned to the Mara in September 1983 I found that the two females were Chui and her mother, whom I named the Mara Buffalo female. The Mara Buffalo female had located her eight-month-old male and female cubs around a rocky bluff, 5.5 kilometres north-east of Leopard Gorge. Chui, meanwhile, had given birth to two male cubs along Fig Tree Ridge, five months after her mother.

The Mara was in the grip of a drought that had robbed the leopards of much of the dense cover on which they normally rely to conceal themselves from lions and hyenas. Consequently both Chui and her mother remained with their cubs at their rocky lairs for much longer than any of us could have hoped. Hardly a day passed during the next three months without my spending time with Chui and her family, patiently waiting for the moment when the cubs would emerge from one of the caves. Even at three months of age it was possible to tell them apart by the colour of their spotted coats. One was Dark, the other Light.

Though I had missed the first three months since Chui gave birth, little had been seen of the cubs during the early weeks. Even with a leopard as tolerant as Chui, it is rare to see cubs during the first month unless one is fortunate enough to glimpse a female transferring her young from one hiding place to another, carrying them in her mouth. Leopards regularly move their cubs to try and protect them from predators: the keen nose of a hyena can pick up the scent of a leopard from far away. By the time cubs are two to three months old they are mobile enough to follow their mother over short distances and can scramble up into bushes when danger threatens. Fortunately for both Chui and her mother, lions did not seem to be much in evidence. The caves the leopards had chosen as hide-aways had massive entrances, but within the dark interior were narrower passageways and crevices – just big enough for cubs to squeeze into if threatened. During the first few weeks when the cubs were most vulnerable, Chui and her mother spent much of their time lying hidden inside the caves with their cubs or resting on the rocks or in a tree within view of the surrounding plains.

Chui. On this occasion she managed to escape with her cubs and I saw them once more when they were six months old, perched in the top of a small euclea tree along the northern reaches of Leopard Lugga. The cubs peered inquisitively at me with their dark brown eyes, and then continued playing, wrestling and biting one another in typical leopard cub fashion. At the time I thought them safely on their way to adulthood – particularly seeing how adept they were at climbing trees. It was not to be. A few weeks later one of the cubs was trapped and killed by a lioness from the Gorge pride at almost the same spot where I had last seen them. But by all accounts the other survived to independence.

The handful of hours that I had now spent in the company of leopards had reinforced my feelings that these were the ultimate prize. I was beginning to think that it might one day be possible to watch and photograph a female – perhaps when she had cubs and was more restricted in her movements. With cubs to nurture a mother leopard is much easier to find; she keeps them in a secure hide-away to which she must return from time to time, and when she has cubs she hunts more often during the daytime and is far more active than when she has only herself to feed.

As fate would have it that day finally arrived while I was flat on my back in England recovering from an operation on a herniated disc. Friends wrote to tell me that two female leopards had given birth within six months and seven kilometres of each other. Suddenly the northern Mara was enjoying its best leopard viewing for more than ten years, eclipsing even that once offered by the Serengeti.

Watching the mother leopards and their cubs was made all the better by the years of waiting. At last I had managed to put a face to the shy one – the Mara Buffalo female, Chui's mother. She was a different kind of leopard, the one that shuns the open places and leads a secret life, so different from how Chui had become. Finally, during the second week of January 1984, Chui and her seven-month-old cubs vanished. One part of me had wished that it would go on forever, but in many ways I felt a sense of relief. The pressure of so many vehicles had often cast a cloud over the situation and there were many occasions when it was only too apparent that Chui would rather have been left in peace.

Nearly two years after Chui disappeared, friends told me that they had seen a shy female in Leopard Gorge with three young cubs playing among the rocks and bushes halfway along the north face of the gorge. This was the same spot that Joseph felt sure Chui and her brother had been born. I waited there the following day and in the afternoon the female appeared, calling to her cubs with the soft puffing sound called prusten or chuffling that leopards sometimes use to locate their cubs, though they more commonly use a short, sharp, rather harsh *aauu*. I had heard Chui chuffle on many occasions when summoning Light and Dark from their hiding place. Even though mine was the only vehicle present and I made sure to keep my distance, the female was nervous, peering cautiously from behind bushes. At one point she hissed and snarled in the direction of my vehicle, even though I was 75 metres away, separated by the wide mouth of the gorge. By the following morning she had gone.

Little did I suspect at the time that this was Chui. Not until a year later did I chance upon the single photograph I had taken of her that day with my 800 mm lens. I checked the spot markings on her face – it was definitely Chui. I still find it hard to accept that I had failed to recognise her. Chui had slipped back into a more secretive way of being, moving further north where tour vehicles rarely visited. I was filled with a great sadness that this beautiful, tolerant creature had felt the need to hide from vehicles, just as her mother, the Mara Buffalo female, had been forced to do years earlier to avoid the poachers.

Meanwhile I had also wandered further afield; during the next three years I spent months at a time in the Serengeti, writing books on the wildebeest migration (*The Great Migration*) and on wild dogs (*Painted Wolves*). But I never lost contact with the Mara, as both stories focused on the Mara as well as the Serengeti. Each time I returned I would ask about the leopards, but for a while it seemed as if they had melted back into the shadows.

Then in 1990 a young female leopard known as the Paradise female appeared in Chui's old home range. When I first saw her I thought that she was probably about two years old and newly independent. But even at that age she was quite remarkable, so tolerant of vehicles that she must have learnt to ignore them from an early age. Yet nobody seemed sure who she was or where she had come from. The only female I knew who was habituated to vehicles was Chui's younger sister, born to the Mara Buffalo female in 1983 at Mara Buffalo Rocks. But she had established herself further north and was no longer seen around Chui's old haunts, though she had certainly raised cubs in the intervening years – could it be one of them? Other than that there were no habituated females in the Fig Tree Ridge area, and no reports of cubs having been seen regularly. So who was this intriguing creature?

One theory was that the Paradise female had been born in a thicket bordering Paradise Plain, not far from the sites regularly used by the wildebeest to cross the Mara River, 18 kilometres to the south of Leopard Gorge. At independence she had wandered north along the Bila Shaka Lugga, carefully avoiding the lions and eventually finding living space in Chui's old home range. By now I had learnt that there is often far greater flexibility in an animal's behaviour than science gives them credit for; each is an individual, much more so than any generalisation implies. What to us might seem unusual is often nothing more than an animal exploring what is possible, nature's answer to changing circumstances.

Regardless of where she came from, the Paradise female quickly established a reputation for herself as the most habituated leopard any of us had ever known. At times she walked right up to vehicles, spray-marked them with her own familiar scent, crawled under them when she felt like it, even used them as cover to launch an ambush. But it wasn't just her trusting character that set her apart. In 1992 the Paradise female was badly bitten on the tail, partially severing it. Perhaps she had survived an attack by a lion or been injured in a fight over territory with another leopard. Nobody knows for sure how the injury occurred, though the most likely cause was baboons, who are quick to try and intimidate a leopard caught in the open. I once saw a group of male baboons chasing the Paradise female along the top of Leopard Gorge, reaching out to grab at her hind quarters and try to bite her, forcing her

to flip on to her back and defend herself before slithering out of harm's way and disappearing into one of the caves. I was away at the time of the incident, but people sent me photographs of the Paradise female showing her tail hanging limp and awkward, still attached by skin and flesh along one side. Shortly afterwards the lower two-thirds of her tail broke off, though it did little to impair her wonderful tree-climbing skills. Ever since then she has been known as Half-Tail.

Half-Tail gave birth to her first litter of cubs in May 1990, but they were never seen. Perhaps they were stillborn, or she had chosen her den unwisely: it is not uncommon for domestic cats and dogs to fail to raise their first litter due to inexperience, and predators are quick to penalise any error in judgement. Eighteen months later, when Half-Tail was almost six years old, she gave birth to three cubs along Fig Tree Ridge. One of the cubs was said to have been killed by lions, possibly the second one too, but the third cub, a female named Beauty, survived.

Angie and I watched Half-Tail and Beauty for a number of weeks in early 1993. Half-Tail had shifted the focus of her activity from the ridge to the tree-lined Ngorbop Lugga (the next lugga east of Bila Shaka), which has a dense understorey of croton and acacia bushes. Close to the lugga are three rocky hills with a patchwork of bushes. It was ideal country for Half-Tail, with plenty of impalas and Thomson's gazelles and numerous hiding places for Beauty. Even so, there were the inevitable close encounters with troops of baboons, uncomfortable hours treed by lions and wars over food with the ever-present hyenas.

Beauty was a lovely little cub, raised among the inevitable throng of vehicles, and she would sometimes creep under the cars or chew on the tyres. Otherwise she was just like any other leopard cub, at home in the treetops, slinky smooth in her movements, stalking up on agama lizards and small birds from an early age. Without brothers or sisters to play with during the long hours that she was left alone, Beauty amused herself with a variety of games: leaping against tall willowy plants and catapulting to the ground, biting sticks, chewing balls of elephant dung or rolling pebbles around in the floor of the lugga.

Whenever Half-Tail returned from her long absences Beauty would leap all over her mother, who willingly participated in games of hide and seek or tag with her boisterous youngster. It was like watching two cubs tumbling and sparring, biting and grappling; all in fun, of course, but nevertheless an important form of activity for the young leopard, strengthening muscles, refining hunting skills, practising the stranglehold that she would need to kill gazelles and impalas. As the months passed the rough and tumble, stalk and pounce, grab and bite, between mother and cub became more vigorous, and then waned

sharply when Beauty was eight or nine months old. By this time she had killed insects and lizards, then hyraxes, and now her first hare, surprised while crouched motionless in its form beneath the tangle of grass and branches of one of the many acacia bushes pushed over by elephants. Beauty's attention was now focused firmly on the outside world and by the time she was a year old Half-Tail was no longer the primary influence in her daughter's life, though still an important provider of food. Long before a lion or cheetah is old enough to survive on its own the leopard is master of its own destiny.

The age at which leopard cubs become independent varies according to individual circumstance. Some cubs are killing large prey when barely a year old, others still associate with their mothers on occasion when they are nearly two. Normally – said with caution – a leopard produces a litter of cubs every 18 to 24 months if her previous cubs survive. So it came as a surprise when Half-Tail gave birth to a new litter of cubs when Beauty was only 13 months old. Unknown to us, she must have mated and become pregnant when Beauty was ten months old. I wondered if being an 'only cub' hastened maturity and self-sufficiency, allowing or perhaps inducing the mother to breed again more quickly? Whatever

the reason, Half-Tail managed to balance the needs of both generations of her young perfectly. Far from being ostracised by her mother, Beauty was sometimes allowed to play with her younger brother and sister, who were delighted to have an additional playmate. Half-Tail's presence was sufficient to ensure that things did not get too rough and when they did she hissed and growled to warn Beauty to back off. On more than one occasion both generations of young fed from kills made by Half-Tail, though not at the same time; where food is concerned leopards are intolerant of one another from an early age, preferring to wait their turn rather than risk hostility and possible injury through fighting. Eventually, of course, these meetings between the two generations of siblings became less frequent, though even when the cubs were 11 months old, Beauty (who was now two years old) made a kill, hung it in a tree and let her younger brother and sister feed from it.

Half-Tail's two younger cubs were inseparable for the first few months. The drivers called the male Mang'aa, meaning 'someone who doesn't care', while his sister was named Taratibu – 'gentle' or 'careful'. They were born along Fig Tree Ridge, close to Beauty's birthplace. It was wonderful to see Half-Tail nurturing her cubs in the same caves that Chui had used for Light and Dark, and lying up in the same giant fig tree that Chui used to rest in along the top of the ridge.

Our children, David and Alia, loved to spend their school holidays on safari in the Mara and it would always be the highlight of their trip to see Half-Tail with her latest litter of cubs. Mang'aa was bold and confident, taking life as it came. One of the drivers told me that Mang'aa was so relaxed in the presence of vehicles that when he saw Masai, lions or baboons he would often choose to seek refuge by keeping close to the cars, almost as if he was saying, 'Try and get me now, if you dare.' Even at three months male cubs are bigger than females and Mang'aa dominated his sister in disputes over food and was rougher in his play, often causing Taratibu to bare her teeth and flatten her ears in protest. As they got older the play fights became shorter in duration, the desire to spend time on their own ever more apparent and they would often choose to rest in different trees or under different bushes.

Then early one morning a year after the cubs were born, the drivers found Taratibu lying dead on the ground. The lioness that had killed her lay close by, with two male lions watching from the wings. Mang'aa looked down on the scene from the top of a nearby tree where he had been feeding on a Thomson's gazelle carcass. Forty metres away Half-Tail could only watch from another tree. As is so often the case in such incidents, Taratibu had not been eaten by the lions – they had killed her as a competitor, not for food. With hyenas it would have been different – they would have consumed the carcass, flesh, bones and fur.

Beauty meanwhile had staked her claim to an area to the east of Fig Tree Ridge including the top of the Bila Shaka Lugga as far as the Mara Buffalo signpost, ranging both north and south of the main Narok road. Sadly, she is now far shyer, a victim of vehicles pressing ever closer, refusing to give her the space that she seemed to crave once she was independent. Her reaction was to hiss and snarl, even charging the cars to try and force them to back off. Some people thought this was funny, snarling back at the 'wild animal', laughing at Beauty's dramatic displays of anger. For whatever reason she just doesn't have the easy-going temperament of her mother, to whom vehicles are a part of everyday life. As a result Beauty is rarely seen, ducking away into cover or hurrying off along the rocky profile of Leopard Gorge at the first sign of a vehicle.

Finding Beauty is almost as difficult as trying to catch a glimpse of a male leopard. I have only seen a handful of males in all the years I have been game-driving in the northern Mara – shadowy figures melting into the grass. If you are lucky there may be the briefest of glimpses of the massive spotted head staring back at you, hunched over powerful shoulders. Then he is gone.

But even the shyest male at times reveals himself when courting a female, particularly if she is used to being approached by vehicles. During the filming of the first series of *Big Cat Diary* in 1996 Angie and I had the opportunity to witness leopards mating near Leopard Gorge. The female turned out to be Beauty, who was now four years old and whom I hadn't seen for two years. When we first discovered the mating couple they were secluded in a patch of thick croton bush on top of a rocky hill bordering the northern end of the Bila Shaka Lugga. The male was huge – he looked almost twice the size of Beauty – with a dark coat and floppy tip to his spotted tail. Beauty was in the height of oestrus, and so hyped up that she could hardly keep still for more than a minute or so at a time. She slunk towards the male, whipping round and shoving her hindquarters provocatively in his face before sitting on his head for good measure, pushing up under his chin and nudging him into a sitting position. Then she darted forward and crouched, ears laid back, growling. No sooner had the male mounted her than he reached sharply forward and gaped across her neck, exposing his long dagger-like canines. As Beauty rumbled – a low, deep growl – he let out a high-pitched gurgling noise, a most unexpected and extraordinary throaty explosion of stuttering, quite unlike the sound made by a mating lion.

A pattern quickly became apparent. Every 50 minutes or so, Beauty would initiate another bout of mating, the act itself lasting no more than ten seconds, with intervals of only a few minutes before another coupling, repeated four or five times in all – then silence as both cats lay

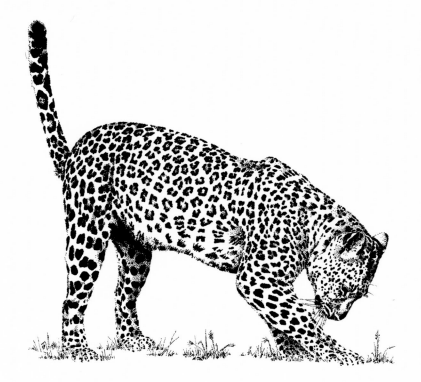

hear. In all probability the male whose territory covers the oestrus female's home range will be the successful suitor, though any adult male wandering through the area will no doubt try to mate with her.

In early 1996 Half-Tail gave birth to her fourth litter of cubs, though only one of them survived, a female called Zawadi, which means 'gift' in Swahili. Both Half-Tail and Zawadi became stars of the first series of *Big Cat Diary*, filmed later that year. As a cub, Zawadi was very like her older sister Beauty: boisterous, independent and completely relaxed around vehicles. She spent much of her first year with Half-Tail in the Fig Tree Ridge and Leopard Gorge area, rarely visiting the Ngorbop Lugga where Beauty and Half-Tail had spent so much time, probably because the area was overgrown with tall grass and consequently there were few impalas and gazelles to hunt.

The following year Half-Tail was lucky to escape with her life. She had been seen with a big male leopard, and it was thought that they were courting. At some point one of the leopards killed a goat belonging to a Masai herdsmen and Half-Tail was shot in the face with an arrow, which penetrated her nostril and lodged in her palate with the arrowhead protruding into her mouth. Fortunately she was spotted by drivers from Governor's Camp, looking very poorly. The drivers kept track of her until veterinarians from Kenya Wildlife Service could fly down to the Mara and operate. The arrowhead was removed cleanly by pulling it through into her mouth and the wound left to drain. She was injected with long-lasting antibiotics and was able to feed from kills made by Zawadi until she was strong enough to hunt for herself. With an animal such as Half-Tail, letting nature take its course was never a consideration. Her injury was caused by man, so it seemed only fitting that she should be saved by man's intervention.

When Zawadi was a year and a half old, Half-Tail once more gave birth in Leopard Gorge. Angie and I drove down to the Mara with an American film crew to present a story on Half-Tail and her two new cubs. A few days later we were delighted when our support vehicle spotted a leopard at the mouth of the gorge: surely it must be Half-Tail. But this leopard not only had a tail, it was much bigger than Half-Tail. In fact it was a young male of about three years old; not as impressive as the big territorial male whom I had seen the previous year mating with Beauty and who was almost certainly the father of Half-Tail's latest litter, but nevertheless this was a fine-looking leopard.

flat in the long grass, hidden from view. One evening a week or so later we found the pair mating again. Beauty must have failed to conceive and come back into oestrus. They had been seen together in Leopard Gorge and by the time we arrived had moved to a hillside covered with long grass. The area was a minefield of concealed rocks, but we were able to inch forward through the grass; at one point Beauty came towards us, the last of the light golden on her spotted coat.

Angie and I stayed with the courting couple until it was dark, hoping that we might hear them call. It was one of those evenings when the sun sets against inky black clouds, casting deep shadows across the long golden grass. Every so often one of the leopards would sit up, or they would mate, moving closer and closer to where we had parked. We felt like voyeurs, deriving intense pleasure from such a rare moment, watching these two solitary creatures drawn together briefly, virtual strangers rubbing up against one another in the most intimate fashion.

Normally a female produces her first litter of cubs when she is three or four years old, and continues to breed throughout her life. If she loses her litter before they are old enough to become independent she quickly comes into oestrus, advertising the fact by wandering widely and spraying her scent against fallen trees, rocky outcrops and bushes – places where other leopards might pass by. She also calls more frequently – the rasping 'wood-sawing' sound that Angie and I so love to

Whoever the young male was, he now looked nervous, slinking around the massive boulders where Half-Tail had left her litter. Angie and I felt uneasy. The male was undoubtedly searching for the cubs. Every so often he paused to sniff the rocks, perhaps trying to trace Half-Tail's

footsteps. No wonder females move their young so frequently. We could only hope that Half-Tail's years of experience would keep them safe.

The male continued silently in his search. Angie gripped my arm as he suddenly dropped down behind one of the boulders and disappeared into a clump of long grass shielding the mouth of a cave. Moments later he reappeared with a tiny cub in his mouth. There was blood on the neck of the lifeless body. The male dropped the cub behind the rock face before entering the cave for a second time. Once again he emerged, his grizzly prize hanging upside down.

Leopards have catholic tastes, eating anything they can catch, and we presumed that the young male must have eaten Half-Tail's cubs by the time he emerged again along the top of the gorge (leopard females returning to cubs killed by lions often carry their dead cubs around on finding the abandoned carcasses, before finally eating them). Later in the morning Half-Tail returned to the gorge after resting in a tree 400 metres to the west. She could obviously smell the male long before she reached the cave. She looked nervous, at one point leaping aside as she crept around the rocks. Then she walked over to the giant fig tree halfway along the top of the gorge. What we didn't know was that the young male leopard was hiding close by. A confrontation must have taken place, because the next thing we saw was Half-Tail bounding into the top of the fig tree. The male pursued her and a brief but violent fight took place. As I hurried to manoeuvre the vehicle into a better position we saw a leopard crash backwards out of the top of the tree in a shower of twigs and leaves – a fall of more than seven metres. We assumed it was Half-Tail. But no; it was Half-Tail who climbed down the broad trunk of the fig tree, hissing out a warning to her adversary to move on. We gave a silent cheer for the gutsy female as the young male skulked off, followed at a distance by Half-Tail, limping on bloodied forepaw.

Half-Tail, Beauty and Zawadi all occupy home ranges within the territory of the same adult male. The role played by a male leopard in ensuring that his cubs survive has always been presumed to be relatively passive – it is a one-parent family, with the female carrying the full responsibility for raising her cubs, feeding them, protecting them, ensuring their safety. But though leopards are basically solitary they are far less anti-social than was once thought. In fact there are occasions when a territorial male leopard meets up with a female and her cubs – his cubs. Far from attacking the young, the male tolerates them and they may even try to play with him. But the territorial male's most important role is defending the females' living space and limiting access to it from interlopers by marking, calling and patrolling. However, a male's territory is often double the size of a female's. Other

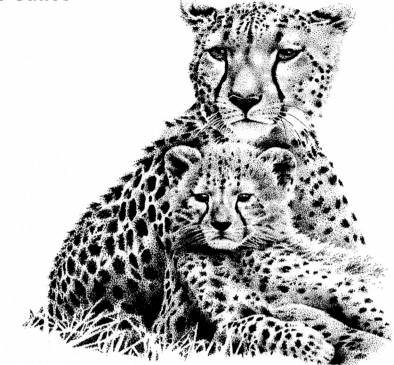

males are bound to slip through at times, and young males wander widely when searching for a place to settle. Adult males will tolerate younger sub-adult relatives as long as they don't try and claim mating rights for themselves, and territory holders living adjacent to one another occasionally meet along their common boundary, walking parallel to one another and calling, drooling saliva with the tension, but not actually fighting: it is a bit like the 'dear enemy' syndrome, whereby you know and tolerate each other as long as you both play by the rules – only fighting when you really have to.

The father of Half-Tail's cubs would certainly have vigorously contested the presence of the male we watched that morning, fighting if necessary to drive him away. But sooner or later every territory holder must face the challenge posed by younger, fitter males. For a young male leopard entering adulthood, killing cubs sired by another male makes perfect biological sense: kill the cubs, and their mother will soon come into oestrus again, providing the opportunity for a new male to sire her next litter – if he can claim the territory.

The film crew were elated: not quite the ending they had hoped for, but what a story! Angie and I felt despondent, exhausted by what we had just witnessed. Watching a leopard with small cubs has been one of the highlights of our years in the African bush. Half-Tail is a special creature

to us. But we could console ourselves with knowing what a survivor she is: Beauty, Mang'aa and Zawadi are proof of that.

When we returned to the Mara a few weeks later, Half-Tail had already been seen mating with a big male at the western edge of her range in a patch of forest just above the spring feeding Musiara Marsh. By the time we came to film the second series of *Big Cat Diary* in September 1998, she had already given birth to her sixth litter of cubs. During the past year she had shifted her home range well to the north of Fig Tree Ridge and Leopard Gorge. The reason for this was probably that Zawadi, who was now two and a half years old, had staked her own claim to the heart of Half-Tail's old range, quite apart from any effect the death of her previous cubs might have had. Now Half-Tail occupied the beautiful tract of bush and woodland between Mara River airstrip and Mara Buffalo Camp north of the main road. Clumps of diospyros trees and tangled acacia bushes mark a series of luggas that snake north towards the Mara River at the foot of the Siria Escarpment. Between these gentle valleys the land rises, rough and rocky beneath the long grass, hard on vehicles but just the kind of place that a leopard with cubs delights in. These saddles of higher ground are covered in places with a dense canopy of acacia bushes the height of a Toyota Landcruiser. It was here that we had so often found the Big Pride during the first series of *Big Cat Diary*. And once the lions were safely tucked away you might find a cheetah and her cubs lying up here.

Tracking Half-Tail down was much more difficult once she moved north. Throughout the long rains, when the grass grows waist high, she was rarely seen. Fewer cars game-drive in this area and with Zawadi so visible in Half-Tail's old haunts very few drivers invested much time looking for the old female, who was now 11 or 12 years old.

Then one day in July 1999 I received the news that I had been dreading: 'Half-Tail is dead.' Apparently she had been taking sheep and goats and the Masai had killed her with a wire snare. If it was true then she had ended her life in the same way many old lions do in the northern Mara, incurring the wrath of people trying to protect their livelihood. Half-Tail had lived the whole of her adult life beyond the protection of the Reserve and I had often thought that she might one day pay the price for her lack of wariness. She had become too trusting of cars and people.

Once, when Mang'aa and Taratibu were young, I saw Half-Tail stash a black sheep in the top of a tree in the patch of forest known as Kampi ya Chui – the place of the leopard. Give any cat the chance of an easy meal and it is going to take it. But no cat on earth is worth more than the life of a domestic animal to the Masai. Where in the world do farmers tolerate predators that kill livestock? In North America and Europe large predators are virtually extinct. Yet here in the northern rangelands lions, leopards and cheetahs continue to be found in good numbers – and will continue to do so as long as they don't start taking livestock. A human who tries to steal cattle will be dealt with just as ruthlessly as a lion, leopard or hyena. Many is the time that I have seen a band of Masai striding across the plains, their blood up at the loss of livestock to cattle rustlers. Spears flashing, bows and arrows slung across their shoulders, there is no doubting their resolve to settle the matter in time-honoured fashion – death to the thieves. The leopard that I knew as Half-Tail was a different creature to the one that sneaked into the boma that fateful night with food on her mind. My leopard was conjured from a longing after wild places and the creatures that inhabit them. Nothing was ever more symbolic to me of the wilderness than the leopard. Half-Tail and Zawadi, like Chui before them, were indeed gifts, the embodiment of a dream. For the Masai Half-Tail was always potentially their enemy – the goat killer.

Though I did not hear about Half-Tail's death until July 1999, she is thought to have disappeared in March or April, by which time her two latest cubs, a male and a female, were about one year old; old enough to hunt but not experienced enough to survive. Half-Tail was a real survivor; a ten-year-old leopard is an old leopard and Half-Tail had lived a year or so beyond that, having given birth to some 15 cubs, three of whom grew to adulthood and are still alive today. Though there have been instances of females living 15 or more years in private game sanctuaries in South Africa, there are few places with more lions and hyenas than the Mara, making Half-Tail's story all the more remarkable.

At about the time that Half-Tail disappeared, Zawadi (who by now was three years old) gave birth to her first litter of cubs in Leopard Gorge. Neither of the cubs survived, killed perhaps by hyenas who, in recent years, have tended to rest up in the gorge in large numbers – perhaps as a retreat from the Masai.

Later in the year Zawadi produced a second litter along Fig Tree Ridge. That was in October and reason enough for us to spend the millennium in the Mara. Accordingly, Angie, David and I set off from Nairobi on 23 December.

The short rains had worked their magic: the Mara was a vivid carpet of fresh green shoots. The luggas and waterholes brimmed, glistening with pools of fresh water. Like dark beads on a necklace, more than 100 elephants trailed across the Marsh, individual families merging at times into one huge herd. Closer to camp the Marsh lions – all 18 of them – buried themselves in the ribcage of a buffalo killed the previous night, grunting and growling for their share of the spoils.

Within the last three months two of the other stars of *Big Cat Diary*, Queen the cheetah (also known as Amber) and her two-and-a-half-year-old daughter had given birth in the Musiara area, although all the cubs had been killed by the Marsh lions. The younger of the females had unwisely chosen the Bila Shaka Lugga as the birthplace for her litter, a fatal mistake that I had witnessed another female cheetah make 20 years earlier. Cheetahs never manage to raise small cubs in the Musiara area – there are just too many lions and hyenas.

Further north a cluster of cars marked the place on Fig Tree Ridge where Zawadi rested in a boscia tree, surrounded by a dense patch of croton bush in which her two ten-week-old cubs slept. This was the same spot that Half-Tail had chosen as a safe hiding place for Zawadi when she was a cub. For the next two weeks we spent every moment we could with the leopard family. Memories of all the other leopards came flooding back, familiar patterns of behaviour repeating themselves with each new generation. But how different each individual has proved to be. Here were two cubs – a male and a female – like chalk and cheese. While the little female was timid her brother was bold; completely the opposite of what I had observed with Half-Tail's last litter of cubs, where it was the female who was outgoing and inquisitive when cars approached, and the male who slunk around in the background.

Zawadi's cubs were a revelation: the jigsaw is never complete. The male cub made his first kill when he was barely 12 weeks old, surprising a half-grown bush hyrax in the crevice it had chosen for its hiding place.

At three months the cubs were quite prepared to stand their ground when a large bull elephant approached the place where Zawadi was suckling them, even when she bolted for safety. A day or so earlier we had photographed Zawadi as she pounced on a hare, then watched her carry it back alive to where her youngsters were waiting, releasing it to the cubs who, after the shortest of chases, trapped and killed it. A brief but violent fight over possession ensued, with the little female conceding the prize to her larger brother before consoling herself with her mother's milk until he had filled his stomach and she could feed.

As the sun rose crimson on millennium morning we hurried to the ridge, arriving just in time to see Zawadi carrying the half-eaten carcass of a young female impala back to where she had left the cubs the previous evening. This is typical behaviour for a mother leopard who doesn't want to risk leading small cubs to where she has made her kill. She will often concentrate her efforts on killing small animals, such as wart hog piglets, young impalas, hares and hyraxes, all of which are relatively easy to transport, reducing the chance of losing them to hyenas or lions on the return journey.

A day or so later Zawadi led the cubs north from the ridge to where she had stashed a young topi kill in the top of an acacia bush. But there were many Masai and their cattle in the area and when we returned the next day she had vanished: back to being a leopard, hidden from view in that secret world that we have been so privileged to observe.

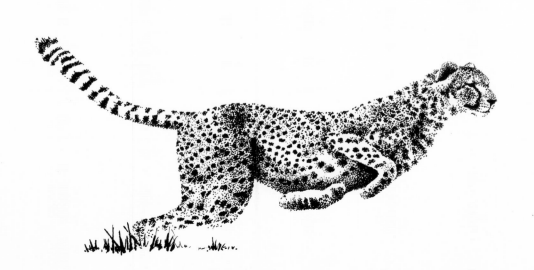

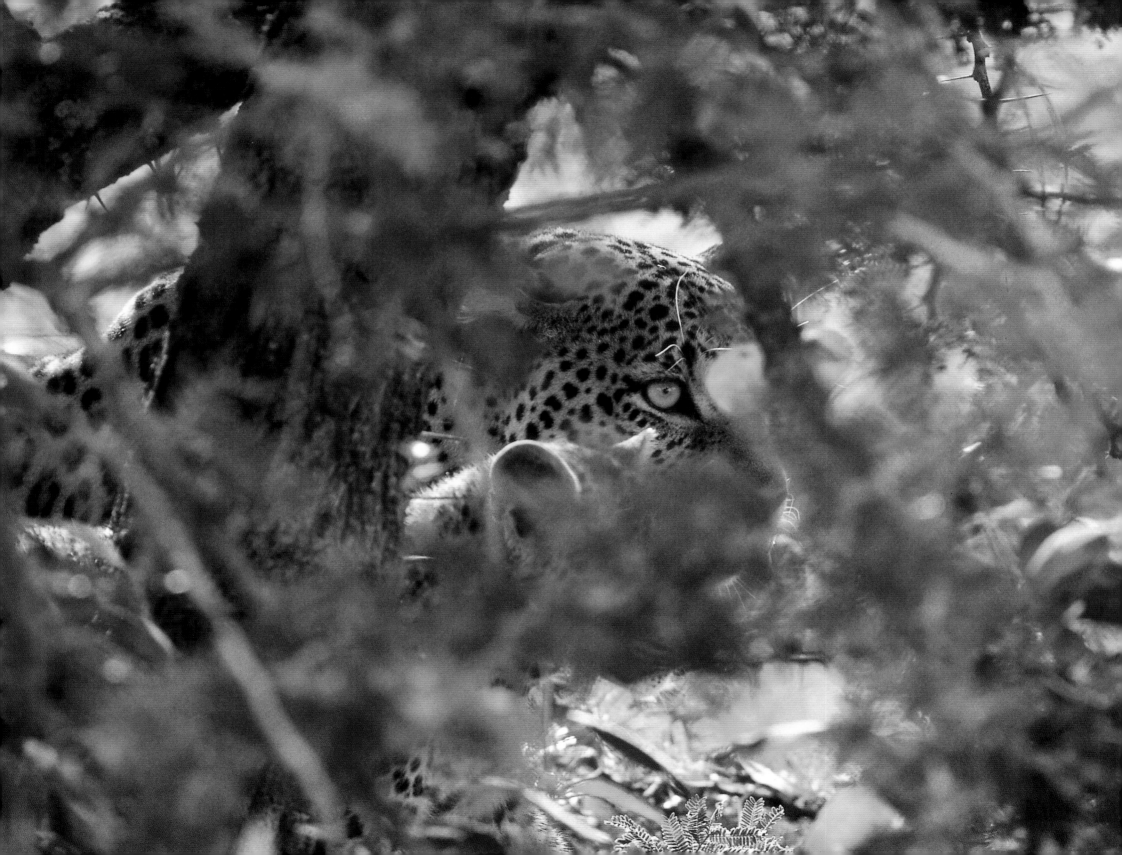

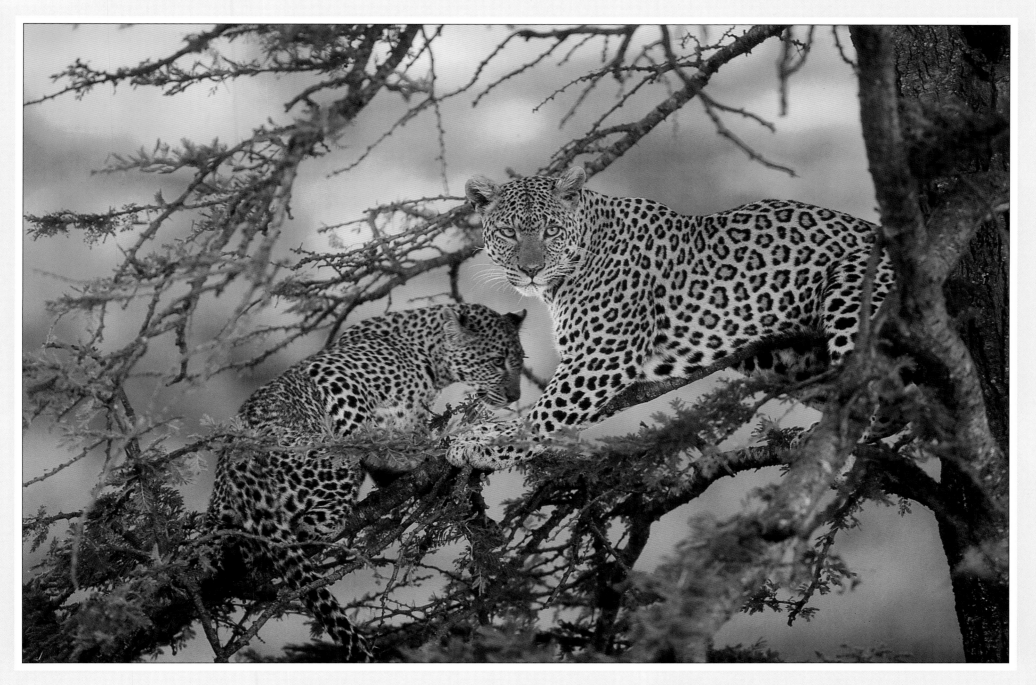

Half-Tail with her female cub Zawadi – known as Shadow in Big Cat Diary. Leopards shun the open places, concealing themselves from larger predators such as lions and hyenas and keeping watch for prey from the trees and thickets. Half-Tail's home range lay beyond the safety of the Mara Reserve, a few kilometres north of the boundary.

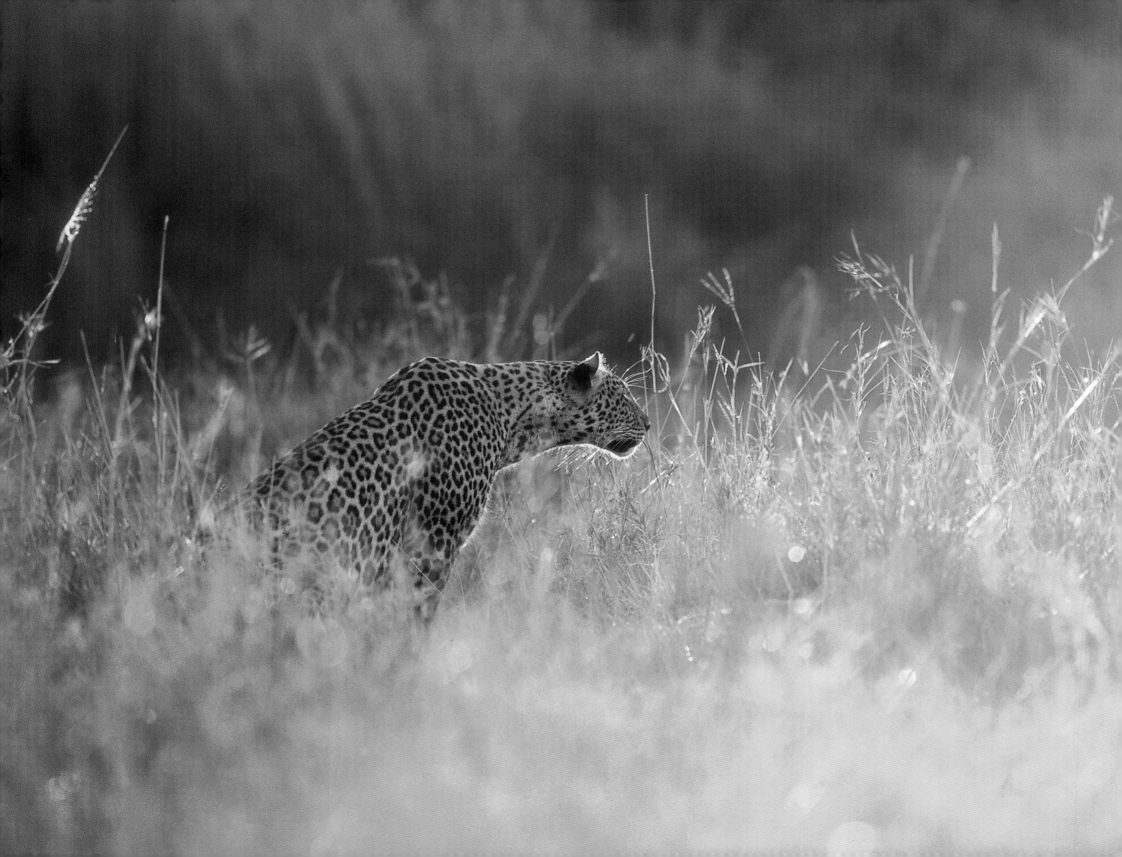

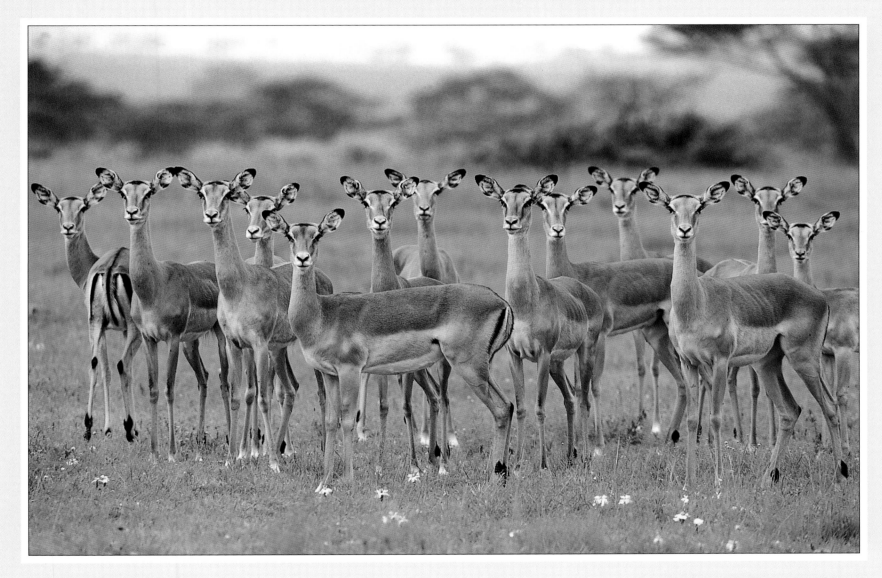

Zawadi on the lookout for prey. Leopards spend much of the daytime resting and their spotted coat markings help them to blend in with their surroundings. The best chance of seeing a leopard is at dawn or dusk when it is cool, or on a night game drive when a leopard is most likely to be active.

Female impalas do not have horns. They form herds of 6-100 individuals moving around a large home range and passing through areas occupied by several territorial males. Each territory holder tries to herd the females and keep them in his territory for as long as possible, mating with any that are in oestrus.

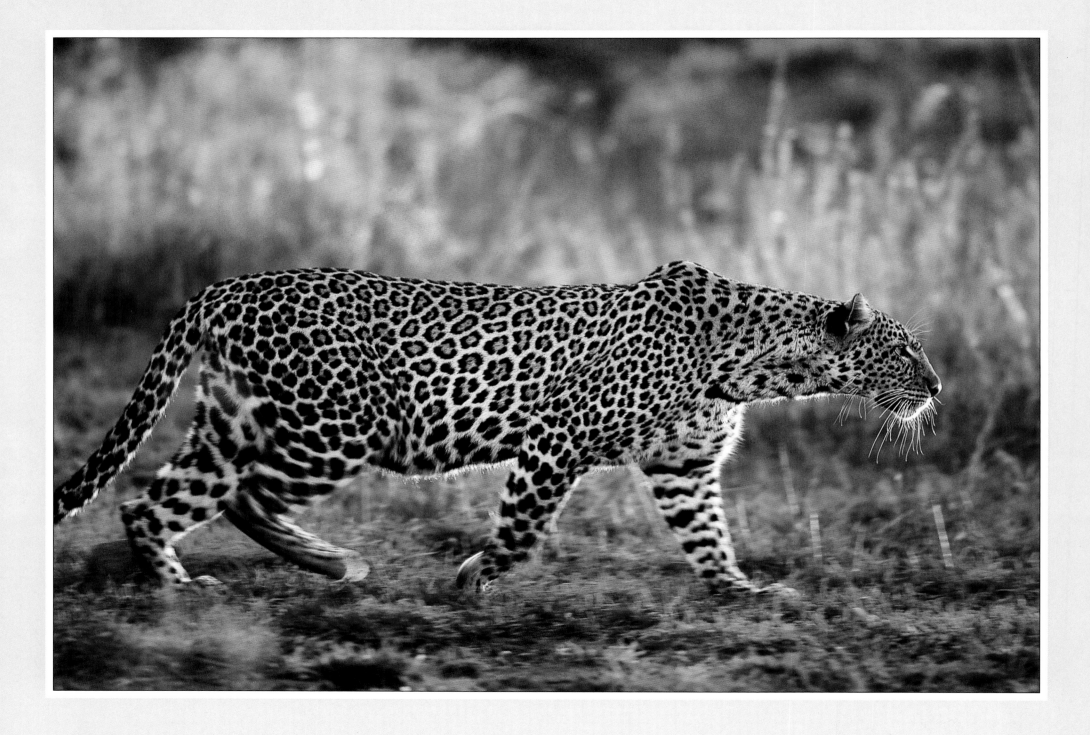

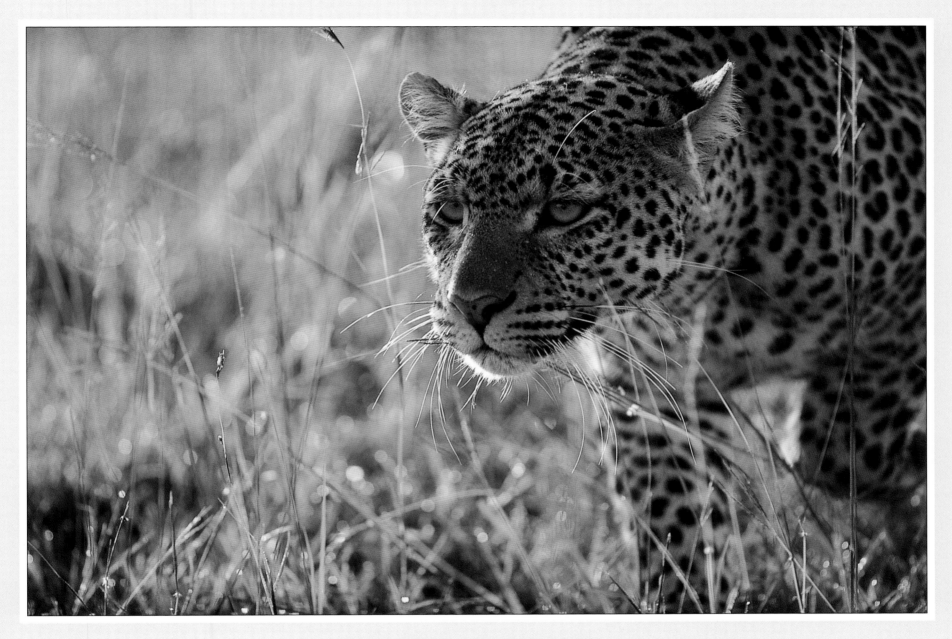

Zawadi stalking. Though leopards are mainly nocturnal, they are very opportunistic and will hunt during the daytime, particularly when they have cubs to feed and need to kill more frequently. They will try to get to within a few metres of their prey before launching into an explosive charge.

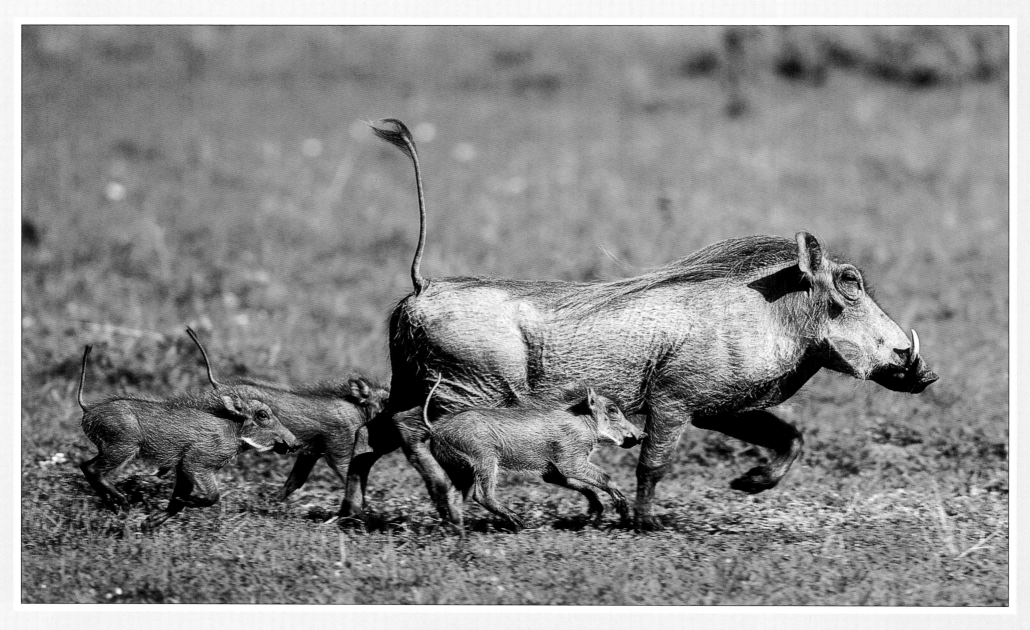

*Leopards kill wart hogs of all sizes, though a
mother wart hog may turn and defend her
young against predators. Leopards and
cheetahs are sometimes forced to release
a piglet rather than risk a gaping wound
from the mother's tusks.*

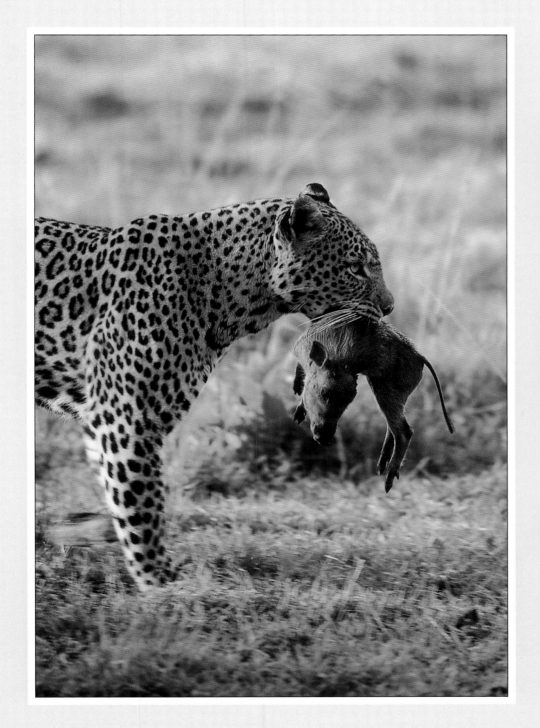

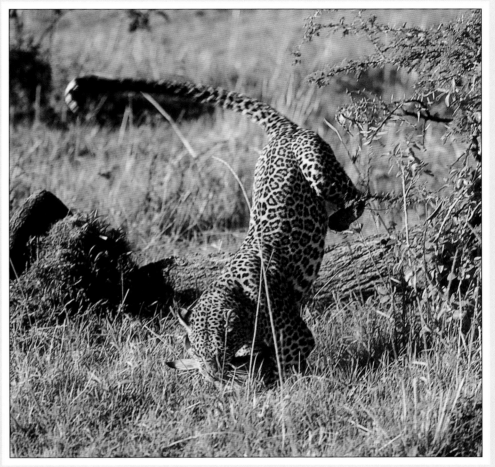

Half-Tail. Wart hog piglets are an ideal size for a leopard mother to carry back to the hiding place where she leaves her cubs, rather than risk leading them out into the open.

Zawadi often hunts hares, which try to avoid detection by remaining motionless in long grass beneath fallen acacia bushes. In this instance she carried the hare back alive and released it for her three-month-old cubs to practise their hunting skills.

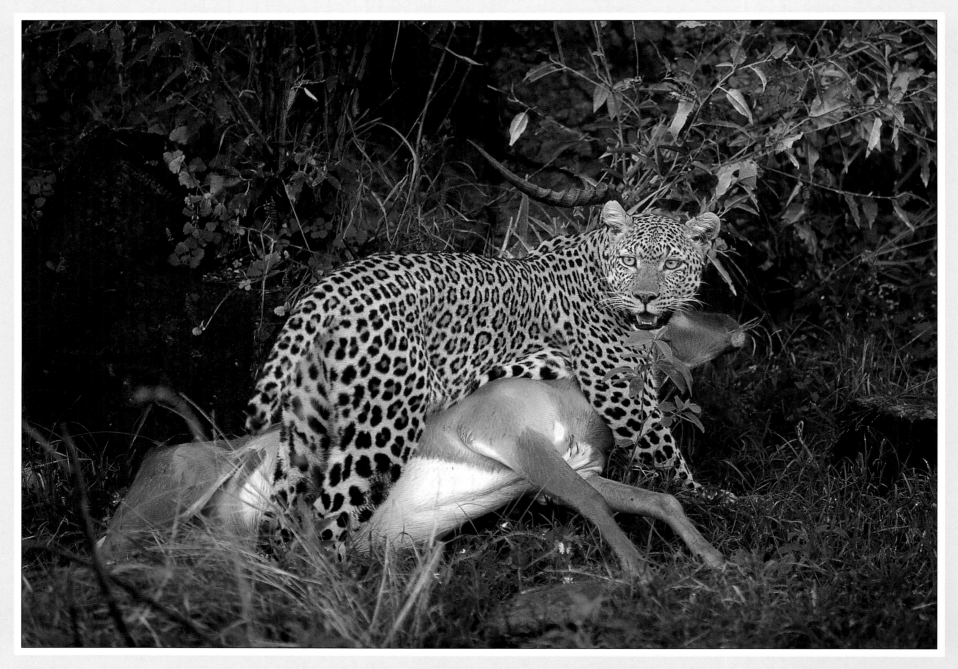

Half-Tail dragging a freshly killed male impala to cover.
Male impalas weigh 50-80 kilograms and are too heavy for
a female leopard to carry into a tree without first
removing the contents of the abdomen.

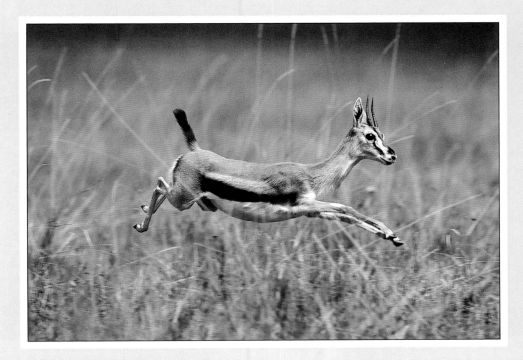

Thompson's gazelles are a favourite prey of leopards, cheetahs and wild dogs in the Mara-Serengeti.

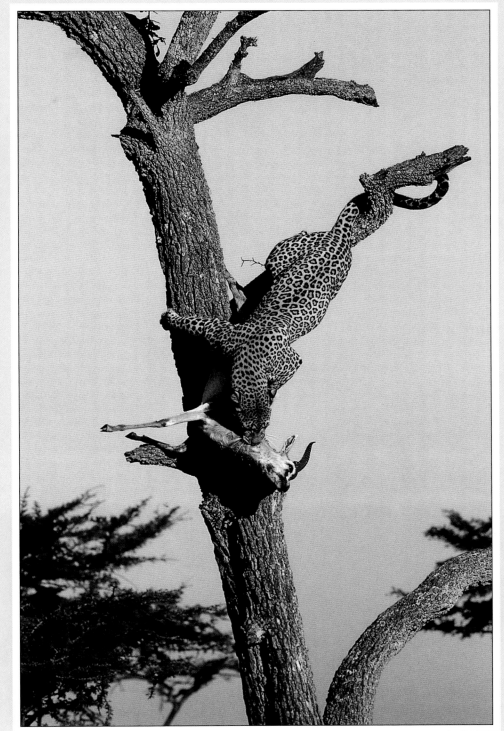

Smaller prey such as this male Thomson's gazelle, weighing 20-30 kilograms, can be stashed in a tree for safety. In this instance, however, Half-Tail (in the days when she still had a magnificent tail) was carrying the gazelle back down to the ground as the tree had very little crown and an eagle had tried to feed on it.

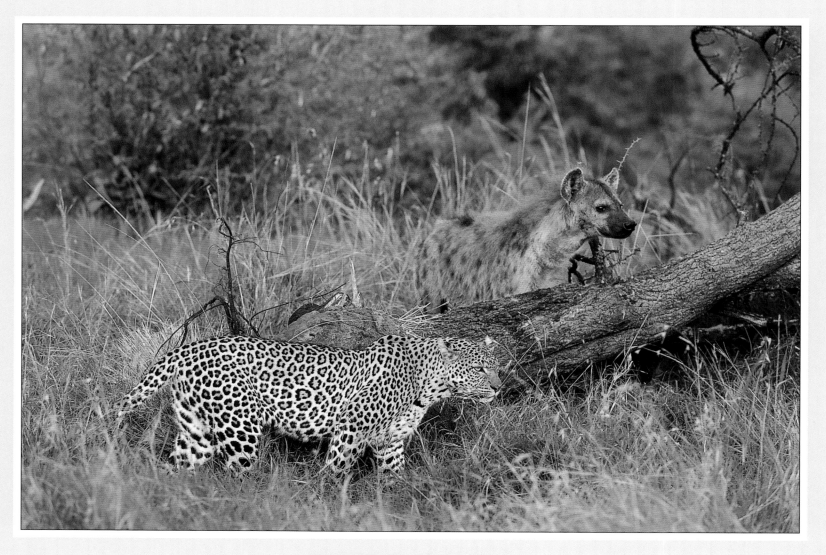

*Half-Tail. Spotted hyenas are the most
numerous of the large predators in the
Mara-Serengeti and at 60-80 kilograms are
larger and heavier than most leopards.
In the Mara leopards often lose their kill
to hyenas before they can haul it into
a tree or hide it in dense cover.*

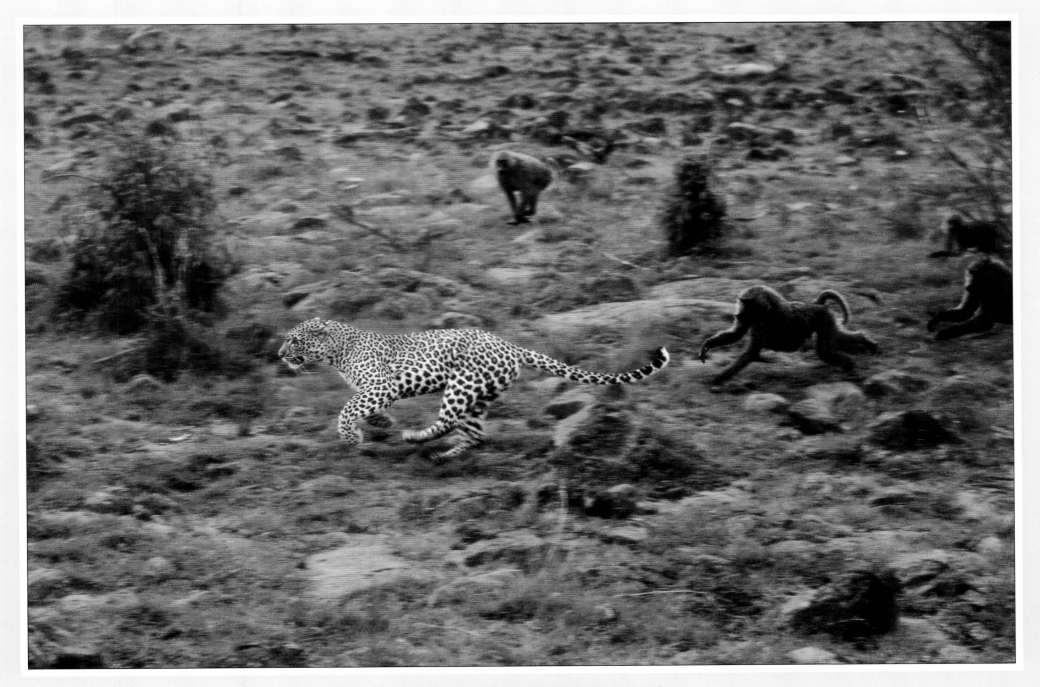

*Baboons have been know to kill leopards, and in the
Mara, where there is an abundance and variety of easier
prey, leopards rarely take baboons; in fact, they do
everything possible to avoid them during the daytime.*

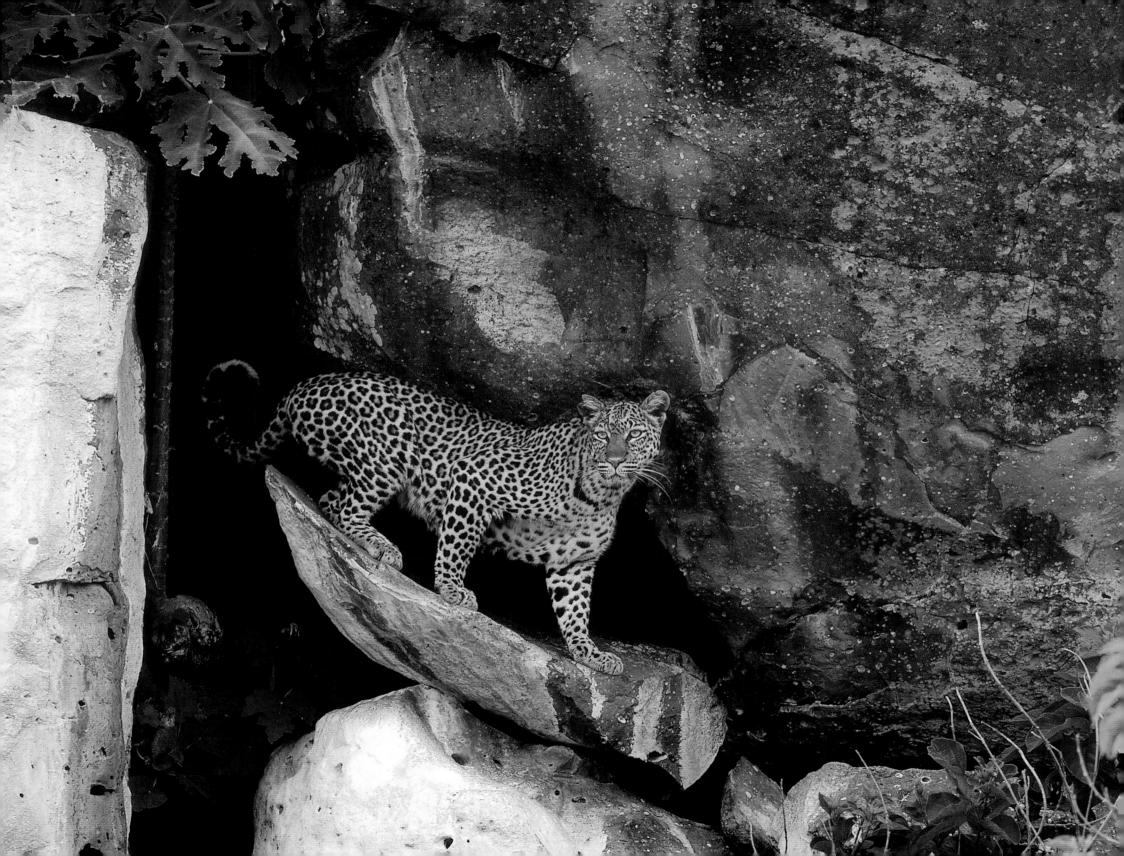

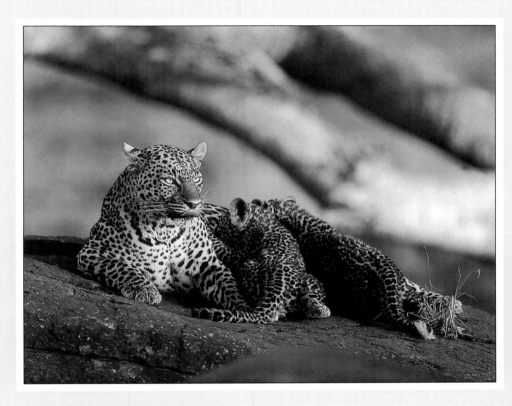

Chui suckling Light and Dark on Fig Tree Ridge. Cubs begin eating meat at the age six weeks, but continue to suckle until they are four months old.

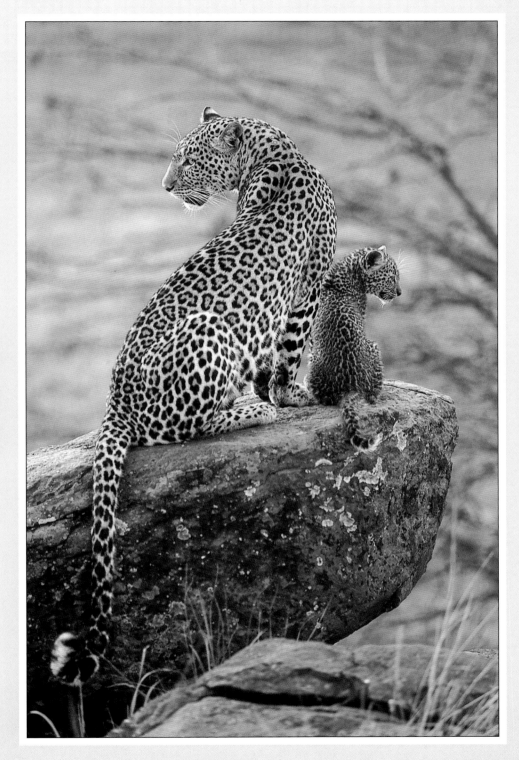

The Mara Buffalo Female, Chui's mother, at Mara Buffalo Rocks. Leopards often choose rocky outcrops as the birthplace of their cubs.

Zawadi alert to danger with her three-month-old female cub. Lions are a major threat to leopards of all ages and will kill them if they can.

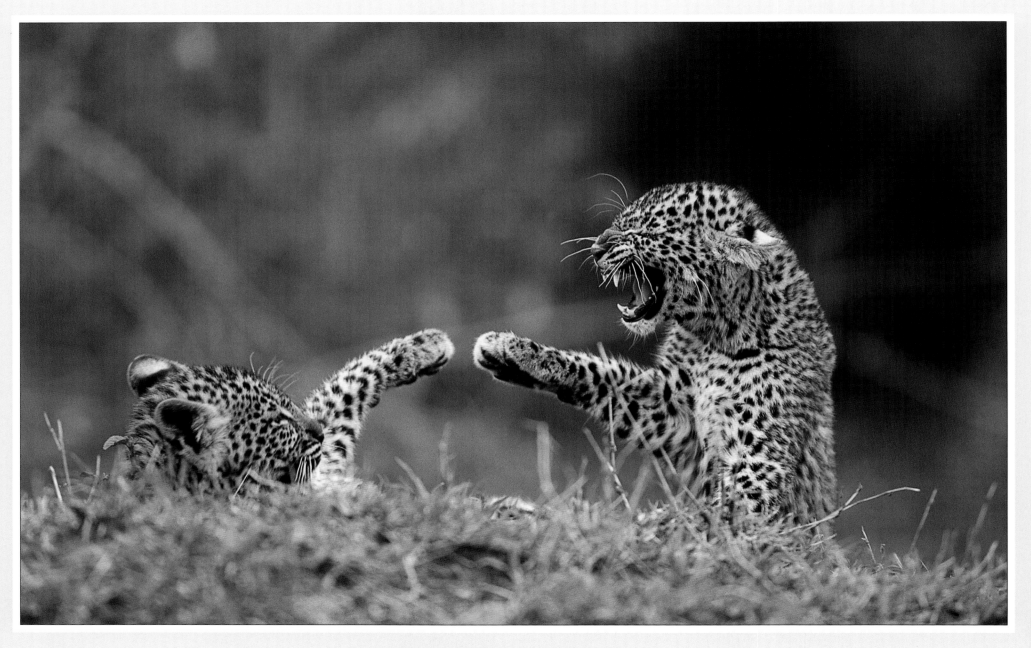

Half-Tail's cubs Mang'aa and Taratibu play-fighting. By the age of three months male leopards are already larger than females, and due to their size and strength usually end up dominating their sisters in fights and disputes over food.

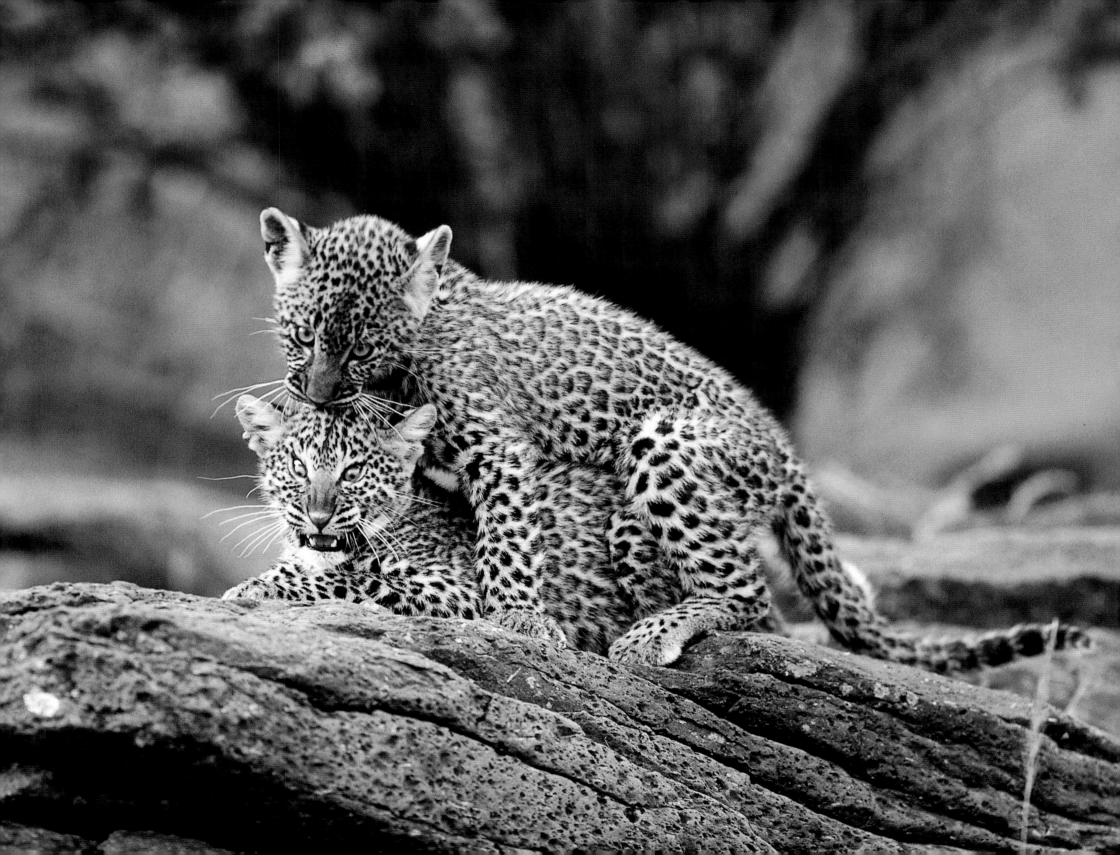

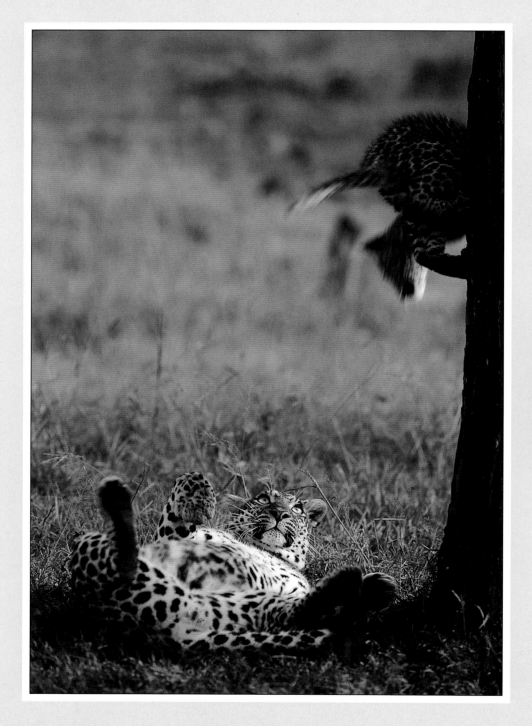

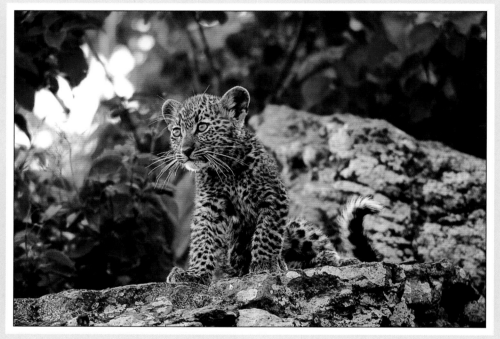

Zawadi's female cub, waiting for her mother to return at dusk. The little female was noticeably shyer and more nervous than her brother, though this is not always the case. The male cub was killed by lions when he was five months old.

Half-Tail playing with Beauty, her oldest surviving offspring. Leopard mothers are very playful with young cubs.

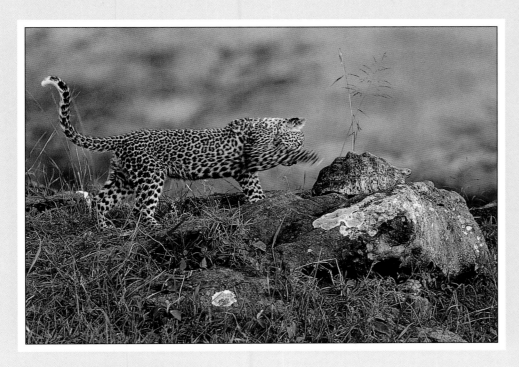

*Chui's cub Dark playing with a
tortoise on Fig Tree Ridge.*

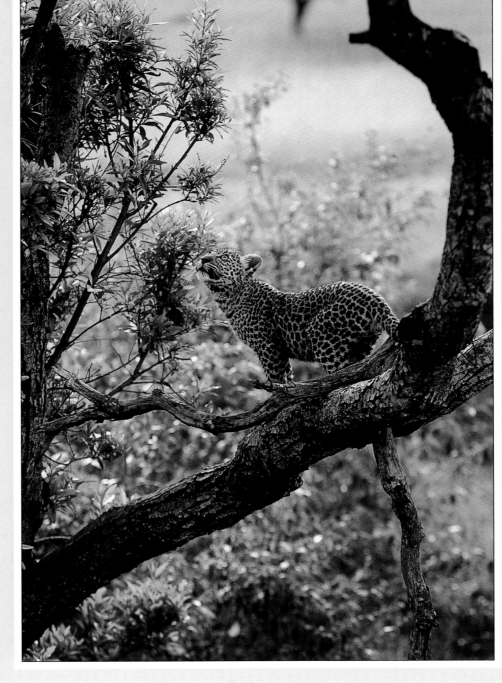

*Leopard cubs are left on their own
for long periods while their mother
is away hunting – sometimes for as
much as two days. During this time
cubs tend to stay hidden in thick
cover, caves or trees, as Half-Tail's
daughter Beauty is doing here.*

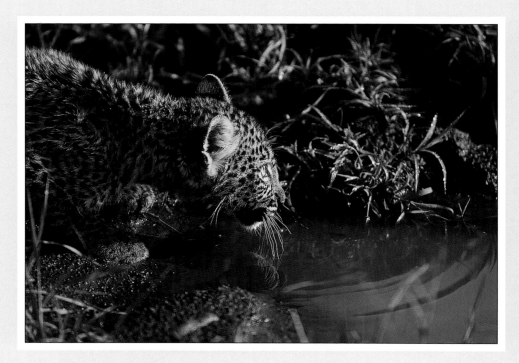

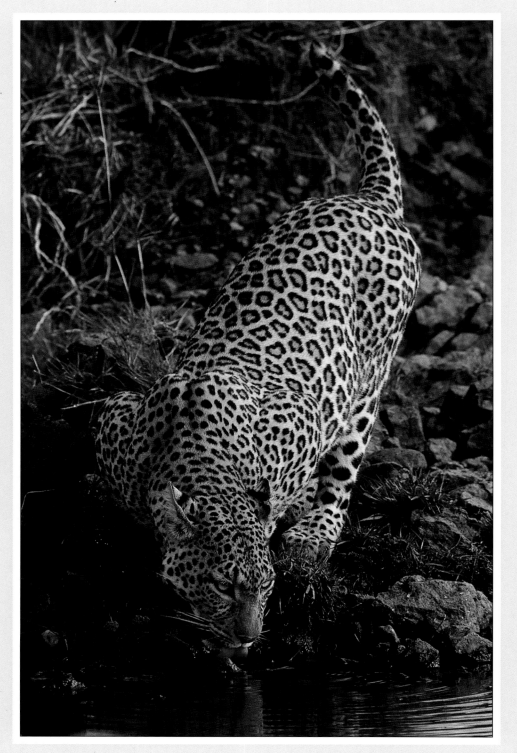

*Taratibu, above, and her mother
Half-Tail drinking after feeding on
an impala kill. Taratibu was killed
by a lioness when she was a year old.
In dry habitats, such as the Kalahari
in Botswana, leopards can go
without drinking for long periods,
relying on the blood and body fluids
of their prey and remaining
nocturnal to avoid heat stress.*

Zawadi suckling her cubs at dusk on Fig Tree Ridge. She held her ground until this bull elephant was within a few metres. Zawadi is as tolerant of vehicles as her mother Half-Tail, which, as her Swahili name implies, makes her a 'gift' to the drivers from the safari camps.

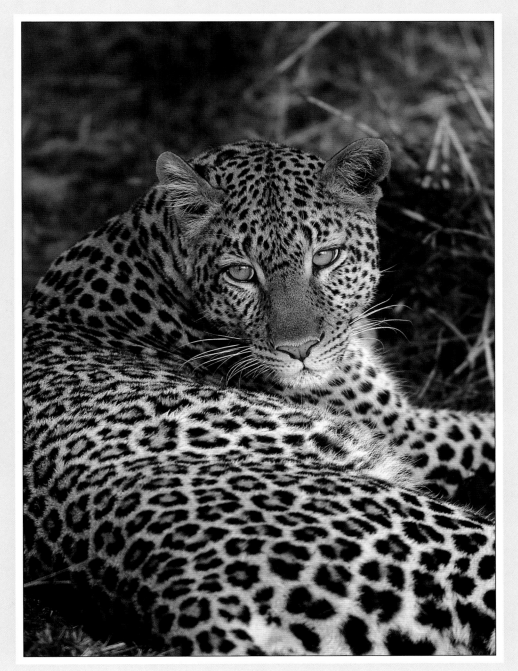

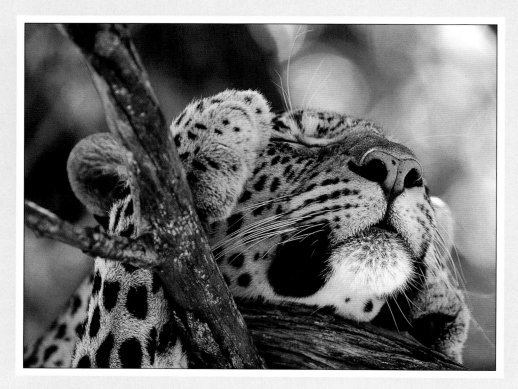

Half-Tail with Zawadi when she was nine months old, the only survivor of three cubs born in her fourth litter.

Half-Tail. Leopards seem to have the ability to sleep comfortably in the smallest and thorniest of trees, though in the Mara they love nothing better than to recline along the broad shady limbs of an ancient fig tree. They spend up to 20 hours of a 24-hour period resting.

This young male killed and probably ate Half-Tail's fifth litter in Leopard Gorge, when the two cubs were ten days old. Territorial males try to prevent any other males from settling in their territory. A new male will kill any cubs sired by the previous territory holder as a way of ensuring that their mother comes into oestrus and breeds with the newcomer.

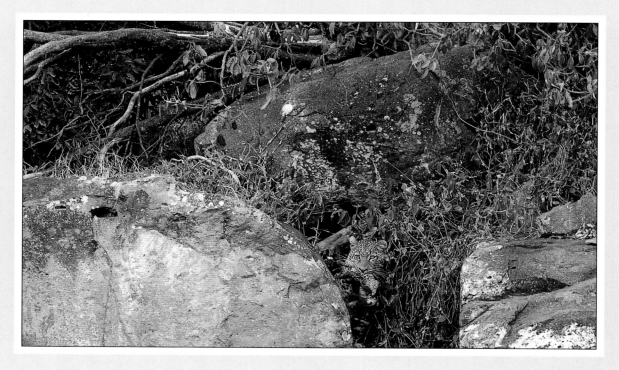

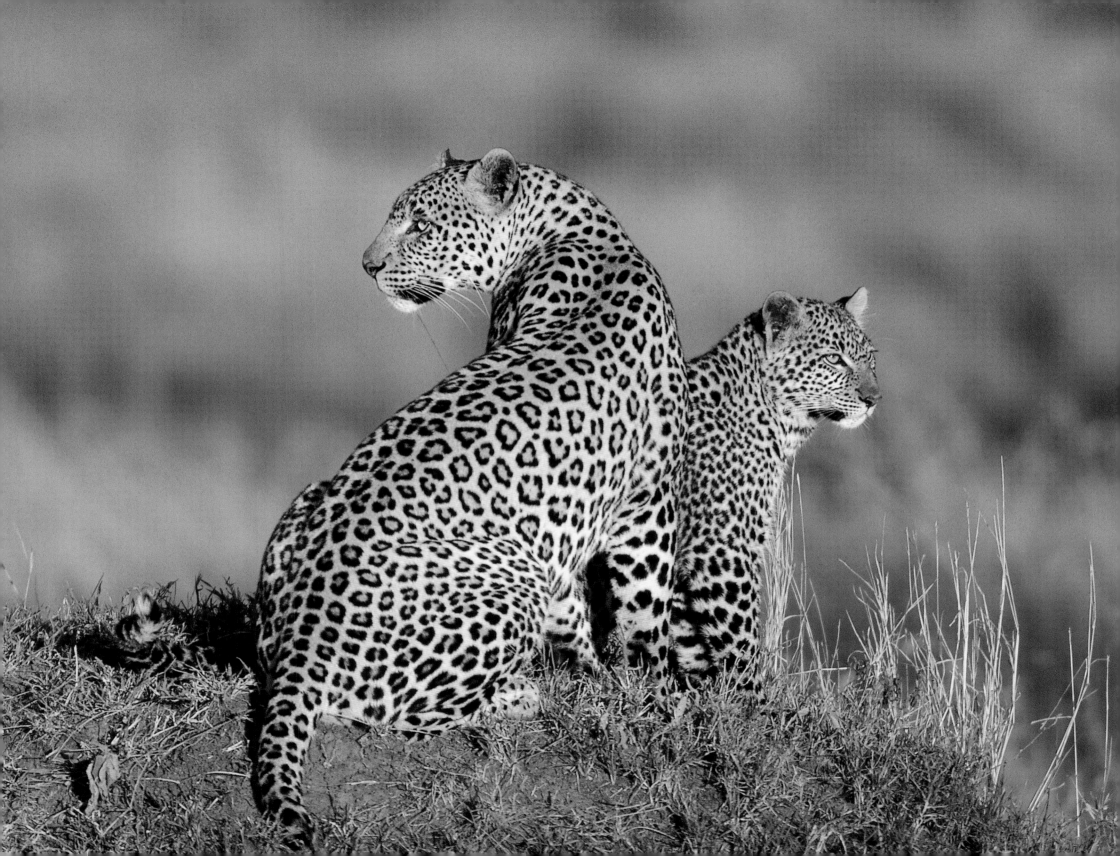

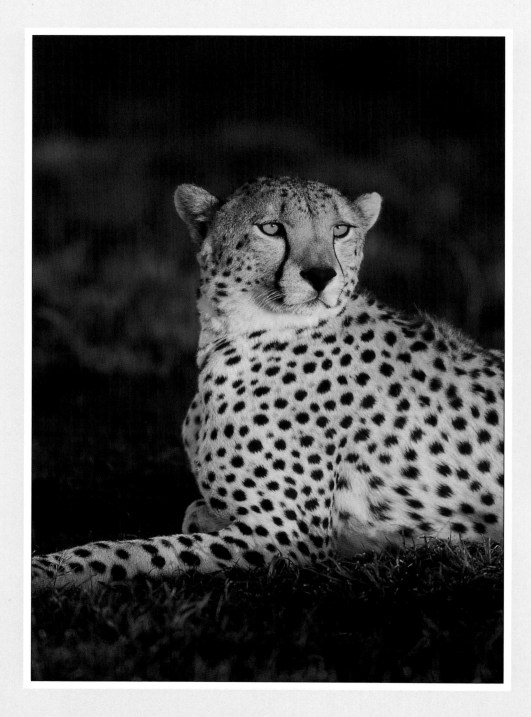

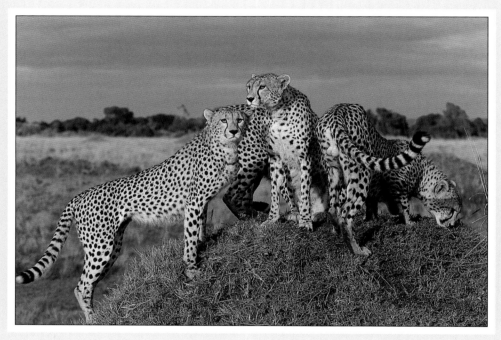

Male cheetahs are larger and heavier than females, with broader heads and a more distinct ruff of hair on their necks. A large male weighs 55-60 kilograms, a female 45 kilograms. Cheetah cubs stay with their mother until they are about 14-18 months old, young females remain with their brothers for a further six months. Brothers stay together for life.

Cheetahs have larger litters than lions or leopards: as many as eight cubs have been recorded. Mortality is high, with lions and hyenas being the biggest threat. In the Serengeti up to 95 per cent of cubs fail to reach maturity.

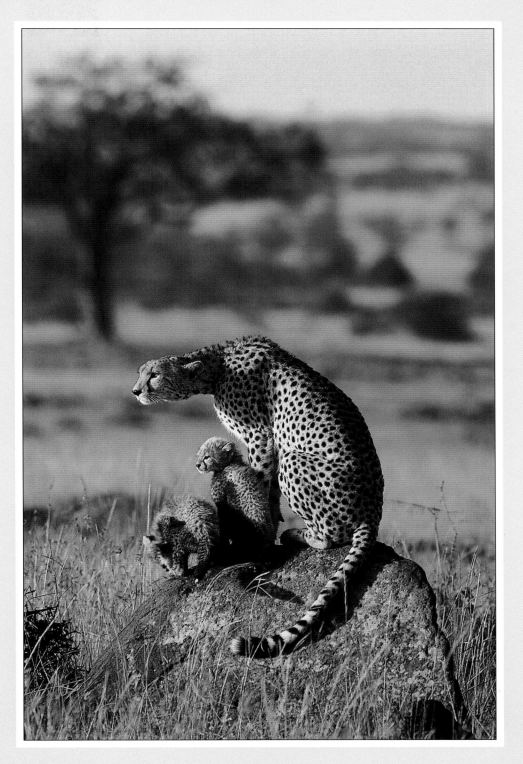

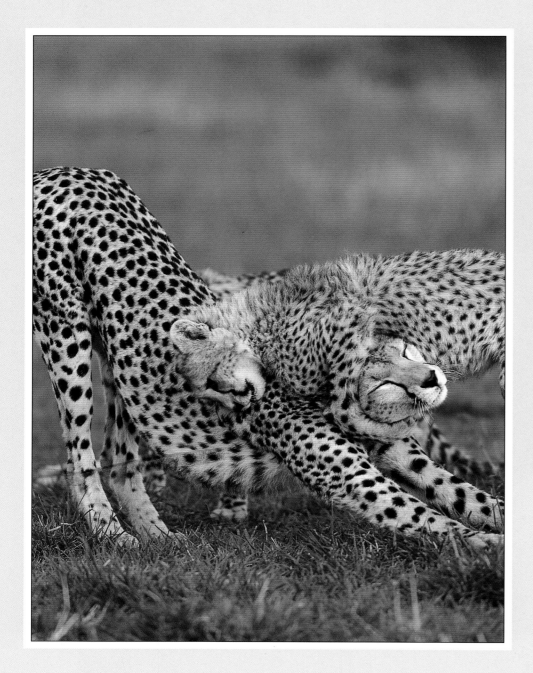

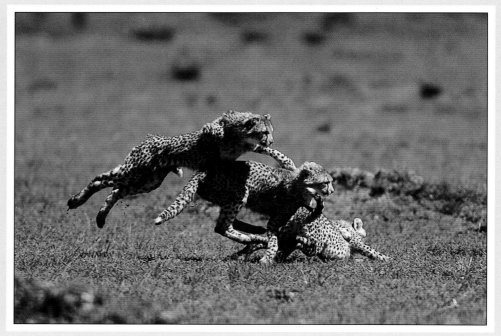

There are approximately 60 cheetahs in and around the Mara, with the world population estimated at 10,000-15,000. Cheetahs are the most specialised of Africa's three big cats, running at speeds of up to 110 kilometres per hour. They hunt during the daytime when there is less likelihood of losing their meal to lions, hyenas or leopards, and rarely if ever scavenge.

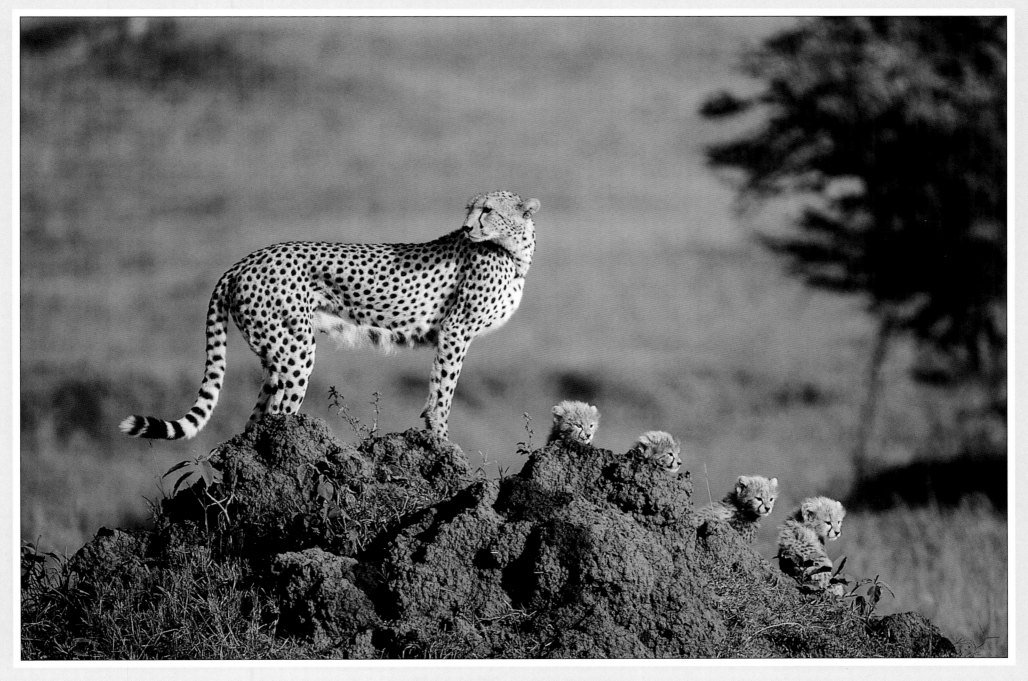

*Cubs start to follow their mother from the
age of six weeks and lose the mantle of
long hair running along their neck and
back when they are three months old.*

107

Land of Endless Space

Men are easily inspired by human ideas, but they forget them again just as quickly. Only nature is eternal, unless we senselessly destroy it. In fifty years' time nobody will be interested in the results of the conferences which fill today's headlines... But when, fifty years from now, a lion walks into the red dawn and roars resoundingly, it will mean something to people and quicken their hearts whether they are bolshevists or democrats, or whether they speak English, German, Russian or Swahili. They will stand in quiet awe as, for the first time in their lives, they watch twenty thousand zebras wander across the endless plains.

Bernhard and Michael Grzimek *Serengeti Shall Not Die*

*I*n his book *The Hunting Animal*, Franklin Russell writes eloquently of the great migration of the North American bison: 'The ritual never changed; the buffalo always came North. It was described as the grandest spectacle in all of nature, the juggernaut advance of millions of great creatures across one quarter of a continental wilderness. There the animal was triumphant over the environment, so successful that a beast became the architect of the grasslands, with weather and soil its servants.' Today, a few thousand animals survive as a reminder of a time when more than 30 million bison roamed the American prairies. Only the wildebeest migration of the Mara–Serengeti, and the 800,000 strong army of white-eared kob in the southern Sudan now serve as a reminder of those days. Europe and America, India and the rest of Asia stand silent by comparison to their past animal wealth.

During my early years in the Mara I was consumed by my desire to spend as much time as possible watching predators. But the Mara is much more than a well-stocked larder for lions, leopards and cheetahs. Time in the Mara is measured by the arrival and departure of the migratory wildebeest: their appearance breathes life into the tall grasslands, their departure leaves the earth exhausted. By June – the beginning of the dry season – tour drivers and safari guides can be heard anxiously enquiring about the whereabouts of the migration, and pilots ferrying tourists to the camps and lodges are besieged with questions from land-based residents as to the movements of the herds.

As you come over a rise just east of the southern Mara Bridge on the road to Keekorok Lodge, there is a clear view of the Serengeti barely a kilometre away to the south. It feels as if you could reach out and touch it. During the years when the border between Tanzania and Kenya was closed (1977–86), this was as near as I could get to the Serengeti. I would

sometimes drive to that spot, look down into the beckoning land and long to be there: to see for myself where the wildebeest were massed. And occasionally, during July or early August, I would be lucky enough to find thousands of wildebeest streaming from the hillsides of the northern Serengeti to join those already crossing a wide stretch of the Mara River. I would watch the army of animals advance towards me; was it possible that there were still so many wild creatures roaming free? The herds would part to let me pass, before galloping off over the next horizon. No hill, no river, not even a pride of lions would stop them for long in their determination to reach their appointed place. I was intrigued by their purposefulness, full of questions. Where were they headed, what was guiding them, were they following a leader? They seemed to know exactly where they were going. Or did they? Here came another mob of animals running in the other direction.

One day, I kept telling myself, I would follow the wildebeest on their journey back to the Serengeti, explore the migration route in the company of the herds, stand atop Naabi Hill and look out across the plains towards the Gol Kopjes, ancient rocky outcrops marooned among a sea of grass where the wildebeest gather in their hundreds of thousands during the rainy season. During the dry season I would visit the Western Corridor, where each year the poachers await the coming of the animals, ambushing them with a tangle of thousands of wire snares among the whistling thorn.

I shall never forget my first view of the Serengeti's short-grass plains when the wildebeest migration was in residence. Standing on Naabi Hill one morning in March, I looked out across a view so immense that it defies description, offering no point of reference, no way of discerning scale or distance. The land was awash in a sea of animals:

hundreds of thousands of wildebeest and zebras spread evenly across the land. And – giving the whole scene an exquisite air of tension – the predators who have always enthralled me: lions and hyenas, cheetahs and jackals and, scarcest of all, the elusive wild dogs.

It was the Masai who gave the Serengeti its name – in their language the word *siringet* means a wide open space, the place where the land runs on forever. Masai herdsmen certainly trekked across these plains long before the first European explorer, Dr Oscar Baumann, set foot in the area in 1892.

The history of the wildebeest migration is an ancient as man. Fossils unearthed at Olduvai Gorge in Tanzania suggest that *Connochaetes taurinus*, the modern wildebeest, seasonally grazed the Serengeti Plains more than a million years ago.

At present the wildebeest move through a region that extends from the Crater Highlands in the east almost to the shores of Lake Victoria in the west, and from the Eyasi Escarpment in the south all the way north to the Mara country in Kenya – an area of approximately 30,000 square kilometres. Each wildebeest travels more than 3000 kilometres on its year-round circuitous trek through this vast region, guided by age-old migration routes modified over the years by constantly changing environmental conditions and influenced by the cumulative experience of individual wildebeest, who may live for over 15 years.

Nearly every facet of the wildebeest's behaviour seems to have been designed to save time – compressed through necessity. How else could they accomplish so much so quickly? They even rut while migrating. And calves gain their feet within minutes of birth so they may survive in the open and keep up with the ever-moving herd. Their annual journey from the southern plains to the dry-season holding areas in the north and west of the ecosystem has certainly been in existence long enough for it to be genetically incorporated into their behaviour.

This would appear to imply a degree of predictability about their movements. Yet I soon discovered that you could spend a lifetime in the Mara–Serengeti waiting for a typical migration. It is a dynamic process which defies predictions: no two years are ever quite the same. Wildebeest are nomadic, responding in a highly opportunistic manner to the vagaries of rainfall and subsequent availability of food, reacting all the time to the ever-changing mosaic of grass and woodlands. The animals' progress is inextricably linked to a myriad assortment of connectives between animal, plant, soil and climate. Some years are wetter than others: it may pour for days on end, from one month to the next throughout the rainy season; in another year, perhaps even the

next, the land may become a dust bowl. And it is this which determines the timing and extent of the herds' movements.

It was not until the late 1950s and the arrival of two more pioneering Germans, Dr Bernhard Grzimek and his son Michael, that the Serengeti became known throughout the world. The Grzimeks were concerned about proposals to change the park boundaries to accommodate demands by the Masai for more grazing land. People had speculated that there were a million large animals roaming the Serengeti, but nobody had ever counted them. Together the Grzimeks learned to fly so that they could track the migratory herds, painstakingly counting the animals from the air and plotting their tortuous journey across the plains and through the woodlands. Their methods were crude by today's standards, their counting inaccurate, but it was a start. Tragically Michael plunged to his death in the Grzimeks' zebra-striped aircraft after a mid-air collision with a griffon vulture. But their work was virtually completed, and in 1959 the publication of their book *Serengeti Shall Not Die* and the release of the film of the same name became a landmark in the fight to save Africa's wild animals. Though boundary changes were implemented, the actual land area encompassed by the park remained virtually the same (at present it is 14,763 square kilometres). The fortuitous addition of a corridor of protected habitat between the Serengeti and the Mara, known as the Northern Extension, has proved to be of vital importance, safeguarding the migration route currently used by the wildebeest and zebras.

More than anything the Grzimeks' efforts helped raise awareness of the plight of African wildlife long before the real poaching took hold, when poisoned arrows were replaced by AK47s and motorised poaching, leaving the Serengeti's elephant and rhino populations in ruins.

I remember reading about the Grzimeks and watching their film at school in England: how I longed to be living that kind of life, to be doing what they were doing. Legendary film-makers Alan and Joan Root filmed many of the wildlife sequences for *Serengeti Shall Not Die*, so it was a strange turn of fate that brought me in early 1977 to Mara River Camp, which had been opened a year earlier by Root and Leakey Safaris, owned by the Roots and Richard Leakey. I still flinch at the thought of the damage I inflicted on their vehicles in those early days. I was so eager to see everything, regardless of how far it might be or how inaccessible. The rockiest hill seemed only a temporary obstacle – anything to glimpse that new litter of lion cubs – and I would willingly have driven right round the Mara if it meant I might see a leopard.

The wildebeest population has grown sixfold since the Grzimeks' efforts to count them. In 1961 there were approximately 250,000; by 1977 there were 1.3 million. Prior to 1961, periodic outbreaks of a viral disease called rinderpest decimated the wild herds, in particular the wildebeest and buffaloes. Inoculation of domestic stock by the veterinary services eventually created a rinderpest-free zone around the Serengeti ecosystem, and by 1963 the disease had been eradicated from wildebeest and buffalo. Once released from the effects of rinderpest and aided by an increase in dry-season rainfall during the 1970s, the Serengeti's population of these animals exploded. Some people felt that there might soon be two or even three million wildebeest roaming the 30,000-square-kilometre ecosystem. But, contrary to expectations, the population has remained at about 1.3 million, held in check by the availability of dry-season forage.

Zebras migrate too, though their population is but a fraction of the wildebeest's, numbering 200,000. There is an underlying sense of orderliness about the movements of the zebra families – whether crossing a river or making their way through the long grass – which is in violent contrast with the air of utter madness about the behaviour of the great herds of wildebeest. You would think they were possessed of demons, or had an urgent appointment with some hidden ruler.

To survive, wildebeest must be capable of detecting suitable feeding sites on a day-to-day basis, and adapting their behaviour accordingly. Rain can be falling 50 kilometres away, yet the wildebeest somehow manage to be there in time to meet the surge of green shoots that showers unleash and that the herds prefer. Do they hurry over the drying plains in response to the sight of lightning flickering across the darkening skies, or is it the sound of thunder that sends them galloping into the distance? Perhaps they can smell the rain with their sensitive noses, detect the dampness on the wind: it is probably a combination of all these senses that ensures they are in the right place on time.

The duration of the wildebeest's stay in an area is determined primarily by the availability of food and water. But they are selective in their feeding habits, preferring, where possible, to graze areas with short green grass having a high leaf-to-stem ratio. Such ideal conditions exist on the short grass plains of the Serengeti and the Ngorongoro Conservation Area, in the south-eastern portion of their range, an area sometimes referred to as the ancestral home of the wildebeest.

The origins of the Serengeti's animal-speckled plains lie within the history of the Ngorongoro Crater Highlands, those far-off mountains that stand watch, dark and menacing, beyond the park's eastern gateway. Imagine the fiery scenes five million years ago as the land shuddered and heaved, then ripped apart. Lava gushed from the earth's wounds, eventually piling up and coalescing to form the Ngorongoro Crater Highlands. During the explosive volcanic activity that followed, Ngorongoro rose to a height of 5000 metres, blasting volcanic debris over an area of thousands of square kilometres to north and west. By the time it had spent its fury, other volcanoes were erupting. Layer upon layer of volcanic ash settled over the undulating plains to the west of the highlands, filling in the hollows and smoothing out the contours to form a relatively flat skin of ash across the earth. Today only the granite kopjes stand as a reminder of the ancient land buried beneath.

In time rainfall leached the salts from the porous upper levels to form a concrete-hard layer below the surface. This hardpan is impenetrable to all but the shallowest roots, inhibiting the growth of trees and allowing for the colonisation of the area by an uninterrupted sward of shallow-rooted grasses that reaches out to every horizon for 10,000 square kilometres. The volcanic soils are rich in calcium, potassium, sodium and phosphorus. A pregnant wildebeest could not wish for more nutritious pastures on which to graze and give birth to her calf.

While living in the Masai Mara I had grown accustomed to a landscape dominated by the russet colours of waist-high red oat grass. But even during the height of the wet season, when the Mara is buried beneath an ocean of long grass, the Serengeti plains do not sprout more than a few centimetres from the earth – they simply never get the chance.

If you abandon your vehicle for a moment and press your face close to the ground you get more than a wildebeest's perspective of the Serengeti plains: you find a carpet of little grass cushions, as neatly arranged as artificial turf. The grasses of the short grass plains are shallow-rooted perennials able to grow unimpeded by the tree-defying hardpan and ideally suited to the alkaline soils. Their roots are covered with minute hairs which absorb every drop of condensation accumulating between the soil particles during the chill nights. Even in

announcing the rule prohibiting off-road driving within 16 kilometres of Seronera Lodge, taller stands of grass line the murram track. The wildebeest and zebras rely on these to sustain them as they migrate to the woodlands at the beginning of the dry season in late May.

By the time you reach Seronera Lodge, in the centre of the park, the Crater Highlands are a hundred kilometres away and barely visible. Here the transition from open grasslands to bush and woodland is abrupt, reflecting the extent of the alkaline ash soils and their inhibiting effect on trees and shrubs. In Serengeti, a unique blend of soil and climate, plant and animal has created some of the most productive pastures on earth. Nowhere else can you see such a wealth of life. And hidden from view is another world of productivity, ensuring the rapid cycling of nutrients between plant and animal. Countless billions of termites harvest the grass at night, rodents feast on the seeds, dung beetles bury the dung. A myriad assortment of nocturnal predators prey on the insects and insect-eaters: aardwolves and aardvarks, civets and genets which hunt like cats but are related to the mongooses, small cats such as servals, caracals and wild cats, creatures that visitors rarely see but are just as important as the lion and the wildebeest in the intricate web of life that is the Serengeti.

During the rainy season from November to May kilometre upon kilometre of plains country is blackened by the wildebeest's presence. Surprisingly, perhaps, the presence of so many wild animals does not damage the plains environment. The wildebeest never stay long enough to do that, retreating to the woodlands during dry spells. As they sweep from one part of the grasslands to another they constantly enrich the thin soils, helping to recycle the nutrients before moving on. Everywhere one looks there are dark piles of dung and urine – vital natural fertilisers. Even as the animals clip the grass, growth hormones pass from roots to shoots, promoting rapid regrowth. And the saliva of the herbivores acts as a stimulant to the grasses. Plants and animals survive in a state of dynamic harmony, allowing both to prosper.

I have so many fond memories of days and nights spent in the company of the great herds. Lying awake in the back of my car, listening to the sound of the wildebeest and zebras at night, grunting and barking, a tide of animals rolling across the plains towards me, engulfing my vehicle, the sounds fading again as they continue their feeding, heads bowed to the ground.

Many people ask where the migration begins. Surely there must be a start and a finish? But there is no real beginning or end to a wildebeest's journey. Its life is an endless pilgrimage, a constant search for food and water. The only beginning is at the moment of birth.

the driest spells, the life of the sward is assured – stored away in the roots, awaiting the next rain. In this way the grasses can survive the withering effects of drought, yet erupt within hours of rain to nourish the wet season deluge of more than a million wildebeest. The dense mat of herbaceous plants helps to shield the powdery alkaline soils from the erosive effects of wind, rain and the grazing pressure of all the animals.

Physically the short grasses look quite different from those found in the long grasslands. They are dwarfed by comparison, bearing small fine leaves and prostrate stems: a protective response to the thousands of hungry mouths that prey on them throughout the wet season. Without the grazing herds, the composition of grass species found on these plains would change, and the taller grasses would crowd out the more prostrate forms in the battle for light. Thus the wildebeest actually help to create the grazing conditions that they prefer. By constantly mowing the grass in a massed feeding front, they prevent less palatable species from flourishing.

As you drive from south-east to north-west across the Serengeti plains the volcanic soils gradually become finer grained, annual rainfall increases and the grasses grow progressively longer. Between the long and the short grasses, there is a belt of intermediate grassland dominated by a species of blue-stem grass, *Andropogon greenwayi*, and certain varieties of drop-seed grass, *Sporobolus*. Close to the sign

possible if females ovulate at the same time each year, and males restrict their sexual activity to a distinct rut in May and June. The timing of mating is critical. In the case of the wildebeest the rut is thought to be triggered in some way by the lunar cycle, working in conjunction with seasonal changes in other environmental factors. But whether the moon's influence stimulates ovulation in females or induces rutting behaviour in males is unknown. Perhaps it helps to cue both, or perhaps the onset of oestrus in females causes the males to rut.

Where before it appeared to be just so many animals – as if every wildebeest were created a clone, functioning as an identical image of the animal standing next to it – a new pattern of organisation now becomes apparent. Fuelled by rising levels of the male hormone testosterone, contenders for territories begin to emerge from the staid bachelor societies to which adult male wildebeest belong for much of the year. The bulls cast off their normally placid mien and start to challenge each other: chasing wildly through the herds, bucking and kicking up their spindly legs, tossing their heads and generally doing everything possible to draw attention to themselves. For the moment the females and calves continue peacefully feeding, ignoring the bizarre activities of the bulls.

By the time the rut begins in earnest the animals are already moving en masse from the plains to the woodlands. They are now at their most concentrated: males and females are in the same place at the same time, and have no need to seek each other out. This helps to synchronise the bulk of sexual activity within the space of a few weeks, ensuring that next year's calves are born at the optimal time. By then the herds will have returned to the plains and, rain permitting, have access to high-quality forage for a month or so before the birth of the calves.

To mate a bull must first acquire a territory. Each year the older bulls – usually at least three or four years old – do battle for temporary possession of a tiny patch of turf. Fighting is ritualised as a harmless jousting display, designed to select the males most fitted to pass on their genes without unnecessarily injuring their rivals.

There is nothing visible to mark the boundary of each territory. Wildebeest bulls *are* the territory. The only symbols of ownership are the bulls themselves and their stamping ground: a patch of grass-torn and earth-scattered turf where they urinate and defecate, scrape and hook, smearing scent from their inter-digital and pre-orbital glands on the bare earth. Almost overnight a mosaic of territories emerges among the wooded grasslands, each little more than the area defined by a tight knot of 20 to 30 females and their calves, guarded by a single territorial bull. The bachelors meanwhile are constantly forced to the edge of the rutting grounds, if they are to avoid harassment by the territorial males. If ousted from his territory a bull can rejoin a bachelor herd and regain condition before the energy-sapping dry season reaches its peak.

During July and August the wildebeest in the Western Corridor concentrate at the rivers' edges where wild figs and podo trees grow alongside borassus palms, together providing a luxuriant touch of shade to temper the harsh land. Even in the driest years, the animals can always find permanent pools of water somewhere among the meanders and ox-bows of the Mbalageti and Grumeti Rivers where huge crocodiles lie waiting for the moment when the herds must drink. Many of the zebras will have already pushed northwards towards the Mara, leaving the Thomson's gazelles to occupy the woodlands at the edge of the plains. Their migration covers less ground than that of the wildebeest and zebras.

A glance through a 1960s guide book to Kenya's animals shows that wildebeest were not even listed as occurring in the Masai Mara 40 years ago. In those days the migration had barely recovered from the debilitating effects of rinderpest and had no need to travel north as far as the Mara. But as the population swelled, the herds began to leave the plains earlier – particularly in drier years – and were forced to venture further north in their quest for food and water. Thank goodness for the addition of the Northern Extension in 1959.

Nowadays, many of the Serengeti's wildebeest do not enter the Western Corridor at all after leaving the plains. Instead they travel directly north as the dry season sets in, tarrying a while in the Loliondo Controlled Area to the north-east of the park after leaving the Serengeti plains. Meanwhile those animals that departed for the Western Corridor at the end of May eventually exhaust the best of the grazing in the valley pastures. Then they must move further north and enter the areas known as the Lamai Wedge and the Mara Triangle (the west part of the Reserve). To do that they must first cross the Mara River.

Watching the wildebeest crossing the Mara River is an epic among wildlife spectacles. Despite the countless times that Angie and I have witnessed this event, it never fails to spark a sense of wonder – it has beauty, power, a life-and-death quality that holds you spellbound.

Some years the river is shallow and the herds rush headlong into the water, with thousands crossing in minutes. At other times they falter, sensing that predators are lying in ambush, which they often are: lions and crocodiles are soon bloated with food. Sometimes the wildebeest try to cross the river at suicidal places, plunging over sheer cliffs and drowning in their hundreds beneath an insurmountable wall of mud;

the river turns black with a confusion of thousands of grunting, bellowing wildebeest.

A few years ago we counted 700 bodies at a particularly treacherous exit point known as the cul-de-sac, yet last year we watched thousands of animals cross here without pause for nearly two hours with only a handful drowned or trampled. What appears to be a difficult crossing place this year may have been far easier in the recent past. The geography of the river-banks is constantly changing. There may be a historical perspective underlying the wildebeest's choice which is not apparent when viewed on a smaller timescale. Older, more experienced animals probably return to places where they have successfully crossed before. Regardless of how many other wildebeest died there in previous years, these individuals survived to try again.

Whatever the factors may be that prompt the wildebeest to cross – and sometimes it is simply a consequence of a build-up of animals wanting to drink – nothing deters them once the urge is established. If visitors or predators disrupt a crossing at a favourite fording place, the wildebeest simply move to the next, or establish a new one, even thundering through thick forest to reach the river if the need takes them.

Many calves become separated from their mothers during the pandemonium of a difficult crossing. As the bulk of the herd heads off into the distance, scores of cows and calves gallop to and fro, grunting and bleating, mingling with those still trying to cross, sometimes even re-entering the river in their efforts to relocate each other.

In a bad year, the Mara claims thousands of victims, and the course of the river is made visible from kilometres away by the constant swirl of vultures overhead. But the river soon washes itself clean again. Crocodiles and hyenas, monitor lizards and catfish all play their part in completing the cycle. Vultures probe and prod, ripping out the softest tissues, and within a few days the bloated carcasses collapse, leaving nothing but mud-spattered skin draped around the bony wrecks.

More than half a million wildebeest and tens of thousands of zebras advance into the Masai Mara at the beginning of the dry season each year. And this year was one to remember. One evening in September Angie and I parked our vehicle on the rocky rise overlooking Musiara Marsh. Whichever direction you looked the Mara's rolling plains were thick with wildebeest and zebras. Through binoculars it seemed as if the animals formed one enormous herd, feeding flank to flank on the flush of short green grass. As the sun dropped towards the blue of the Siria Escarpment shafts of light escaped the grey cloud, spotlighting the animals and creating a primeval vista. We were filming an update for *Big Cat Diary* and all of us gathered on the rise that evening felt humbled by the enormity of this last great animal migration.

During October the animals follow the rains south. If the rains falter the herds wait at the edge of the woodlands; if they continue, the first of the wildebeest reach the short-grass plains by November. The departure of the wildebeest from the Mara poses one of the great mysteries of the migration. What is it that prompts them to head back to the Serengeti as the rains get underway? Why leave at all when the grass is green and growing? The Mara appears to have everything that a wildebeest might need during wet or dry season.

Certainly the vast open plains of the Serengeti are a safer environment for the herds than the woodlands and the long-grass areas. On the plains they can see what is happening around them, and avoid the predators more easily. During the long rains the Mara's heavy clay soils become waterlogged, creating conditions underfoot that the wildebeest tend to avoid. But more than anything it is the mineral-rich character of the Serengeti's volcanic soils, and the grasses that flourish on them, which beckon to the wildebeest, drawing them back each year.

A single wildebeest stands alone in the vastness of the Serengeti plain, a tiny black speck retreating into the distance: can the Serengeti survive, I keep asking myself; is there a collective will strong enough to ensure a place for wild animals in this last great tract of wild Africa? Will the international community join hands to share the cost? The Grzimeks perceived the Serengeti as hallowed ground, a tract of primordial wilderness where the rest of creation was on equal footing with mankind. And they were right. There is nowhere else on earth where you can see such an incredible array of animal life. Here the game still survives, unchanged for thousands of years, despite the periodic devastations wrought by disease and drought, and the ever-present threat of poachers. The Mara–Serengeti can continue to survive. But only if we really want it to.

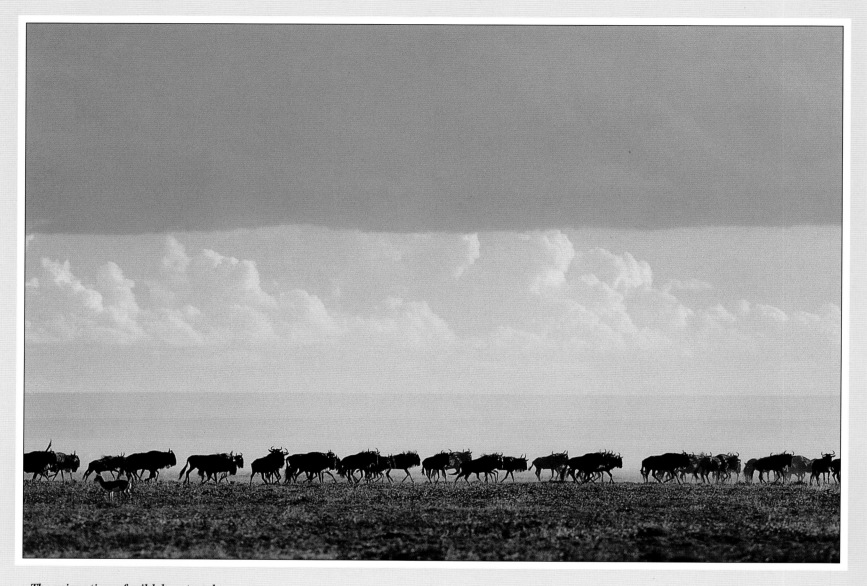

The migration of wildebeest and zebras through the Mara-Serengeti ecosystem involves 1.3 million wildebeest and 200,000 zebras. The great herds spend the rainy season from November to May in the southern part of their range on the short-grass plains of the Serengeti and Ngorongoro Conservation Area, which cover an area of 10,000 square kilometres.

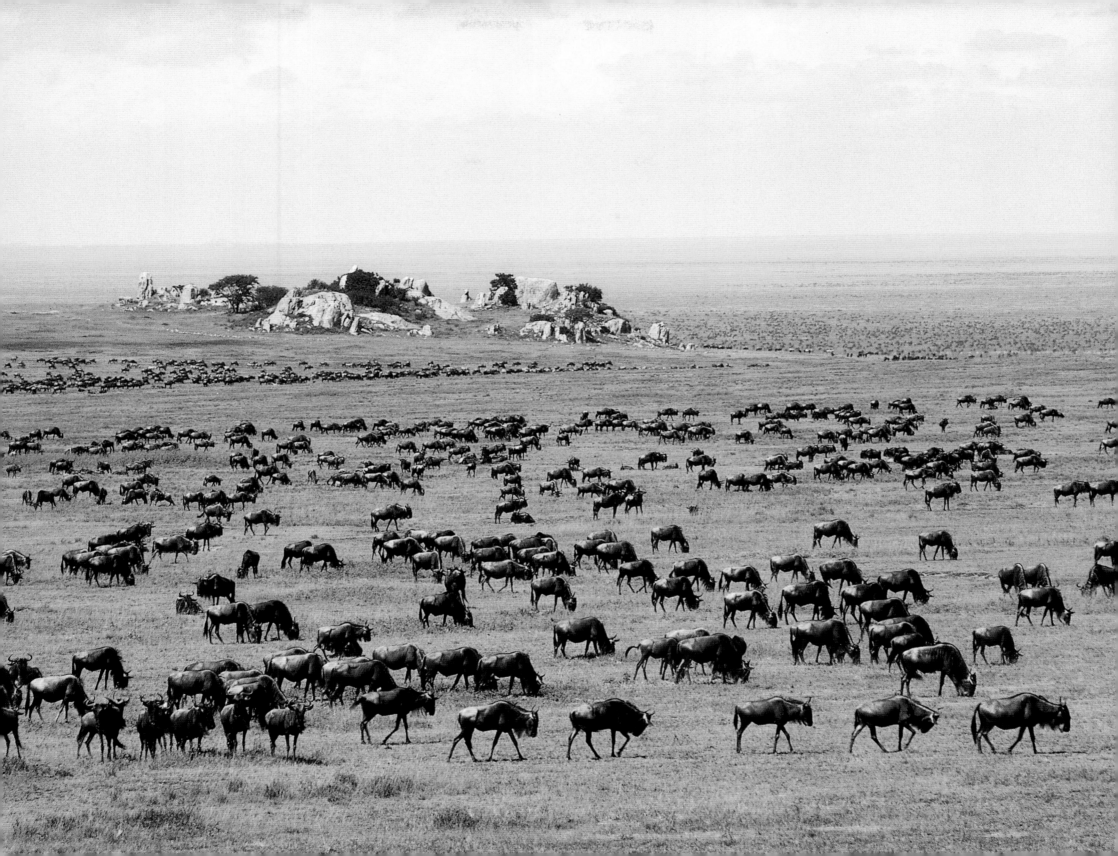

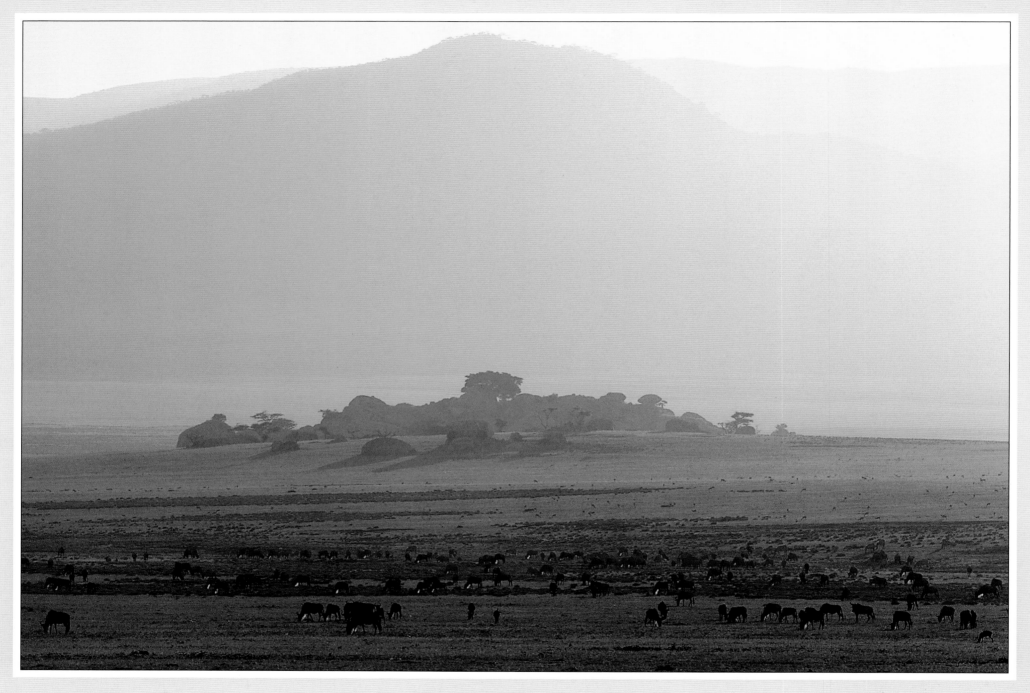

*Wildebeest gathered in the shadow of the Gol Mountains
during the rainy season. The herds prefer the driest part
of the ecosystem during the rains, avoiding waterlogged
areas that can make them susceptible to foot rot.*

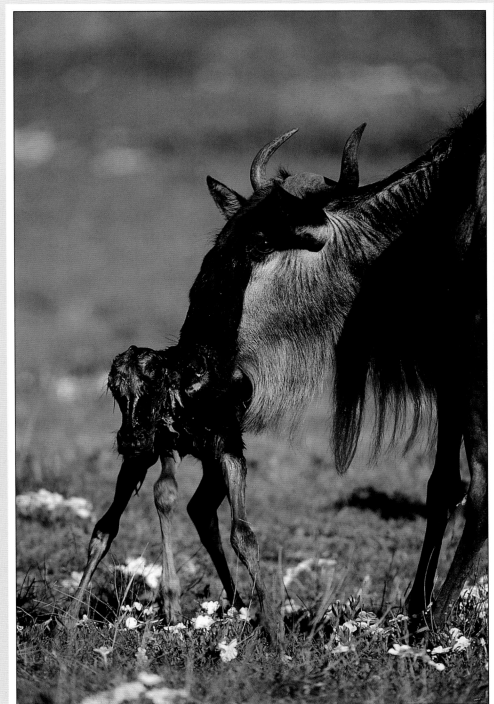

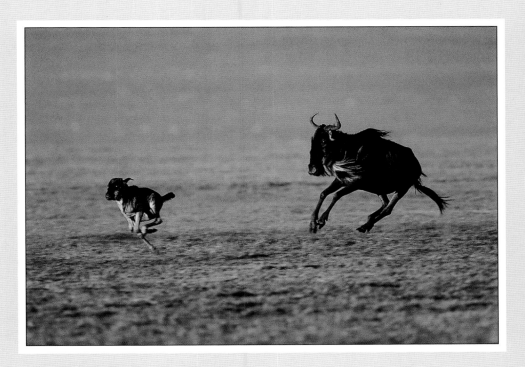

Newborn wildebeest calves gain their feet faster than any other ungulate. Within five minutes they are standing up and being licked clean by their mother. This is all part of the imprinting process that helps mother and calf recognise each other by sound and smell among the 400,000 calves born each year within a few weeks between January and March.

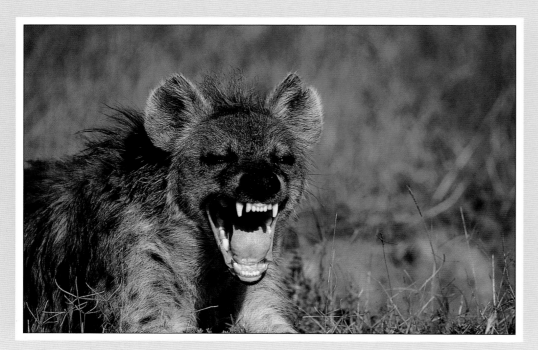

Hyenas have the most powerful jaws of all the large land-based predators. Their bone-crushing molar teeth are capable of chewing through the thigh bone of a buffalo or giraffe to feed on the nutritious marrow, and their droppings are white because of the high calcium content of their diet.

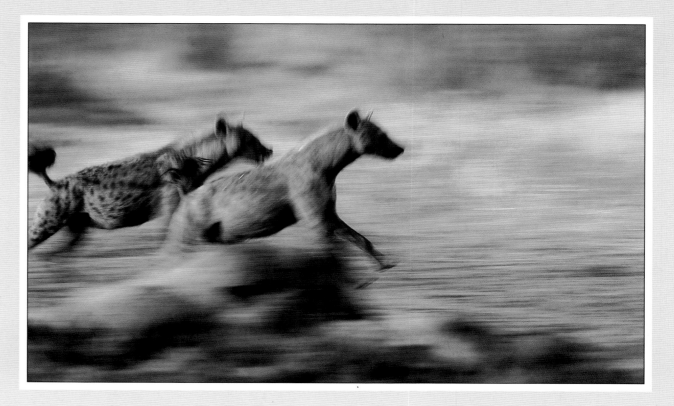

There are 5000 spotted hyenas living on the Serengeti plains and a total of 7500 in the ecosystem as a whole. Hyenas are primarily nocturnal and can hunt alone or in packs. They are formidable predators as well as scavengers, killing their prey by disembowelment rather than the single killing bite used by the solitary cats.

120

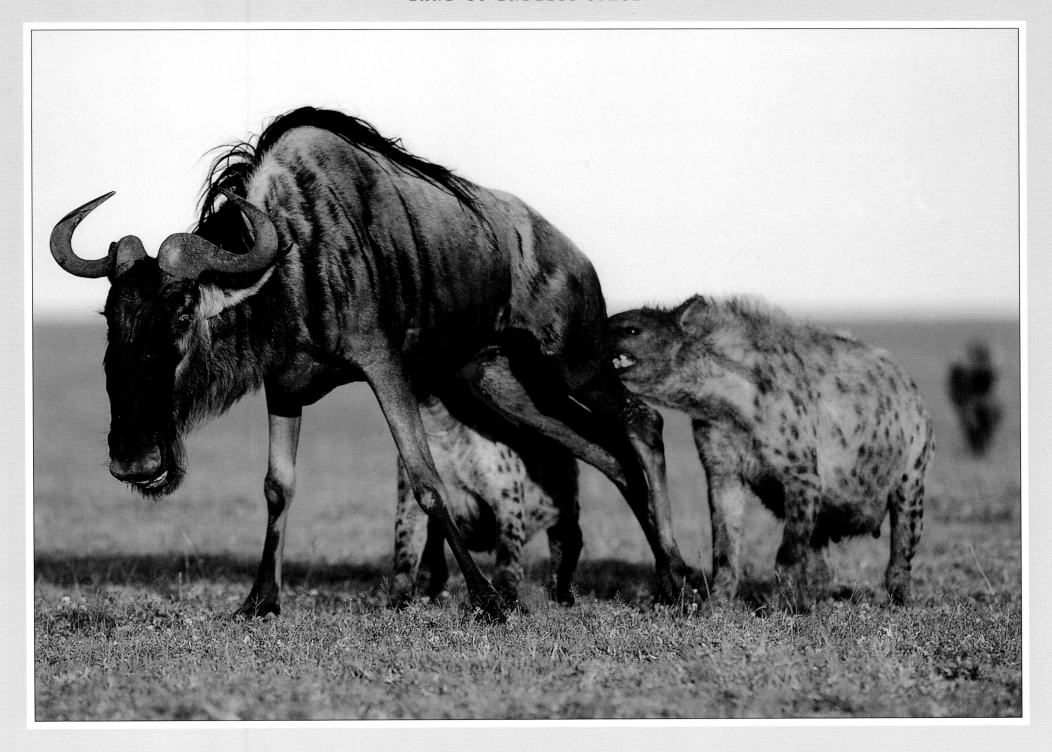

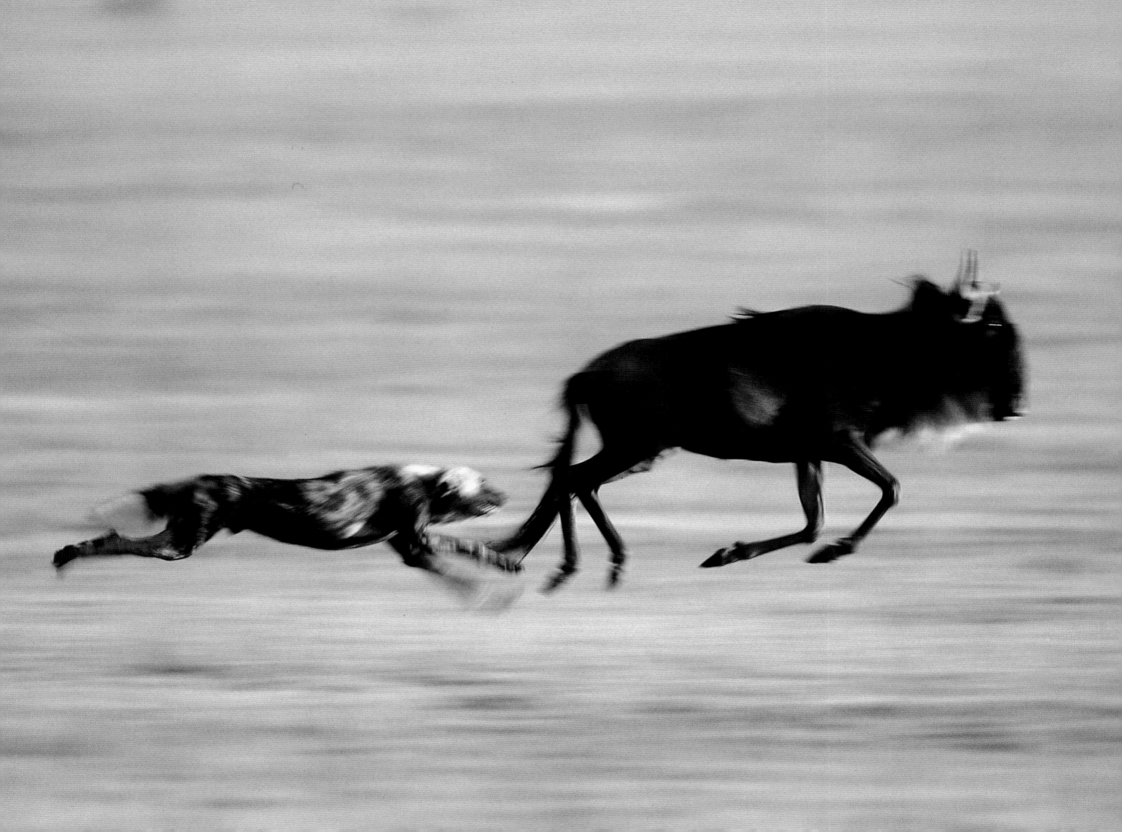

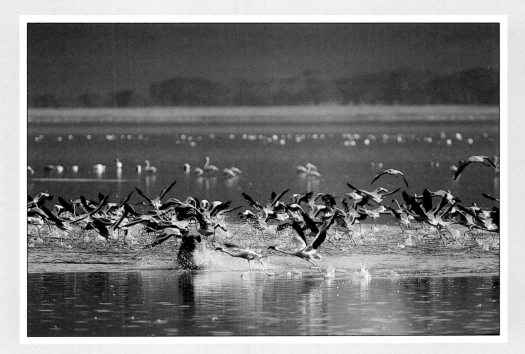

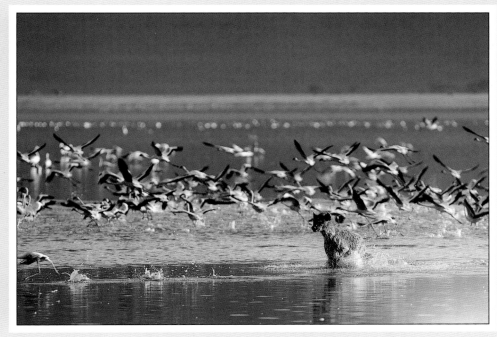

Lake Magadi, Ngorongoro Crater. Hyenas are the most adaptable of the large predators. Their technique when hunting flamingoes is to amble along the shoreline until they are close enough to the birds to run them down before they can take off. At this point the hyenas show a surprising turn of speed.

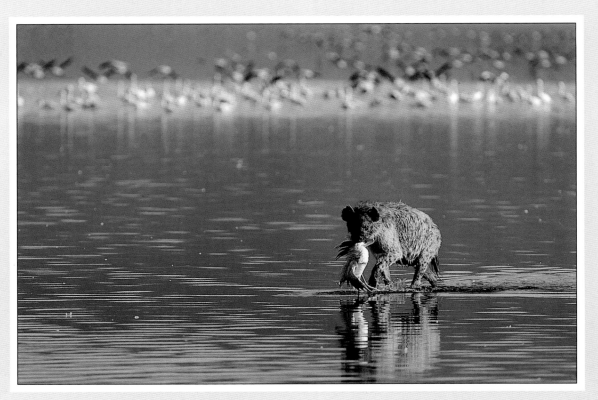

Wild dogs can run at speeds up to 60 kilometres per hour and in the Mara-Serengeti prey primarily on wildebeest and Thomson's gazelles on the plains and impala in the woodlands. High-speed chases across the open plains may last up to 5 kilometres.

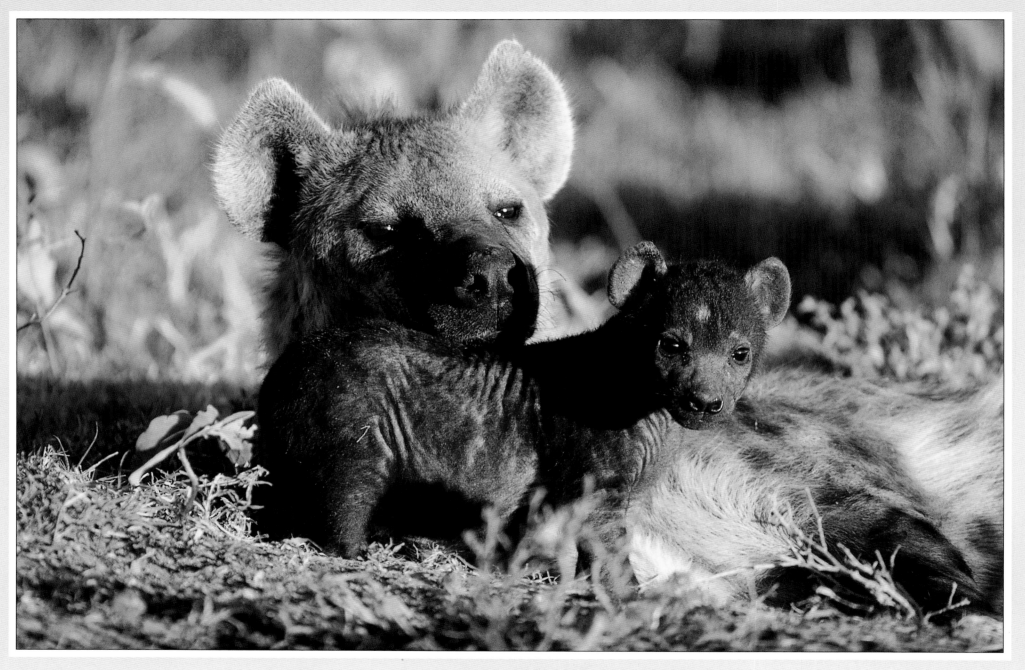

Hyenas usually have two cubs, sometimes three, which are well developed
at birth with their eyes open and their canines and incisors already cut.
Cubs are born black, the spots gradually becoming more obvious as they
grow older. They suckle for 12-14 months, by which time they are
able to accompany their mother on hunts and compete at kills.

*Most lions live in prides and defend
a territory, relying on resident prey
to sustain them year round. Nomadic
lions sometimes follow the migration
as a way of finding sufficient food.*

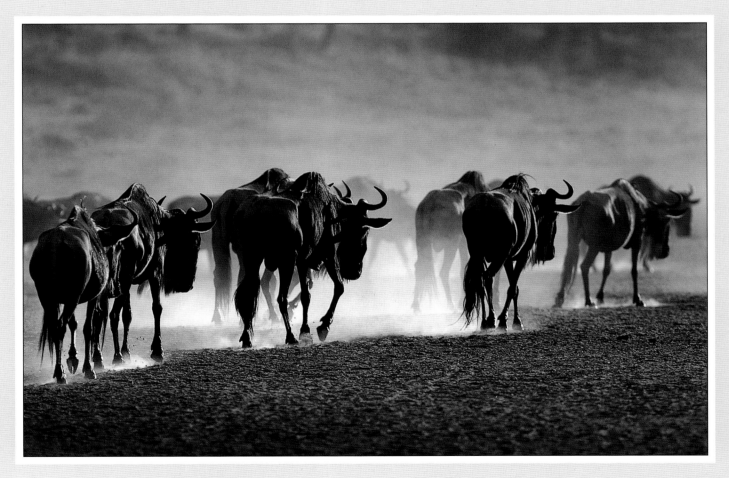

*The wildebeest abandon the Serengeti
plains at the beginning of the dry
season in late May or early June,
bequeathing the vast area to ostriches
and Grant's gazelles – species
adapted to survive without water.*

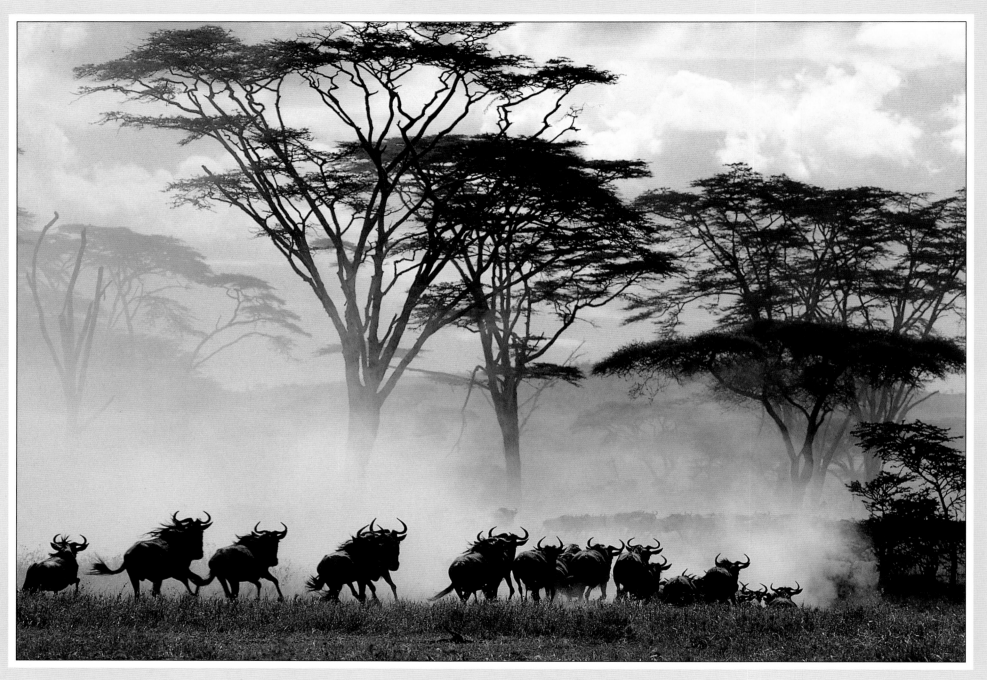

After the herds leave the plains, their movements roughly follow the rainfall gradient, which increases from south-east to north-west. Some of the animals move directly north towards the Masai Mara; others head into the Western Corridor, moving to the Lamai Wedge and Mara only later in the dry season.

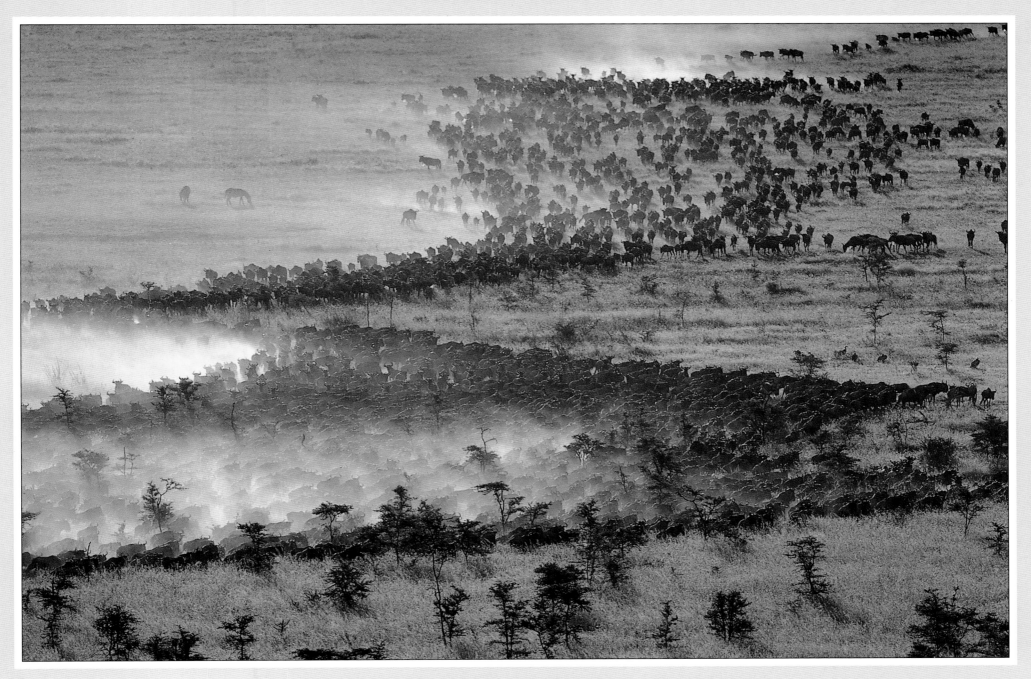

*The rutting of the wildebeest occurs in June, when the herds are moving from the
plains into the woodlands and the animals are at their most concentrated.
The synchronisation of the rut ensures that the majority of the females give birth
within a few weeks of each other on the mineral-rich short-grass plains during
the rainy season when the grass is at its most nutritious.*

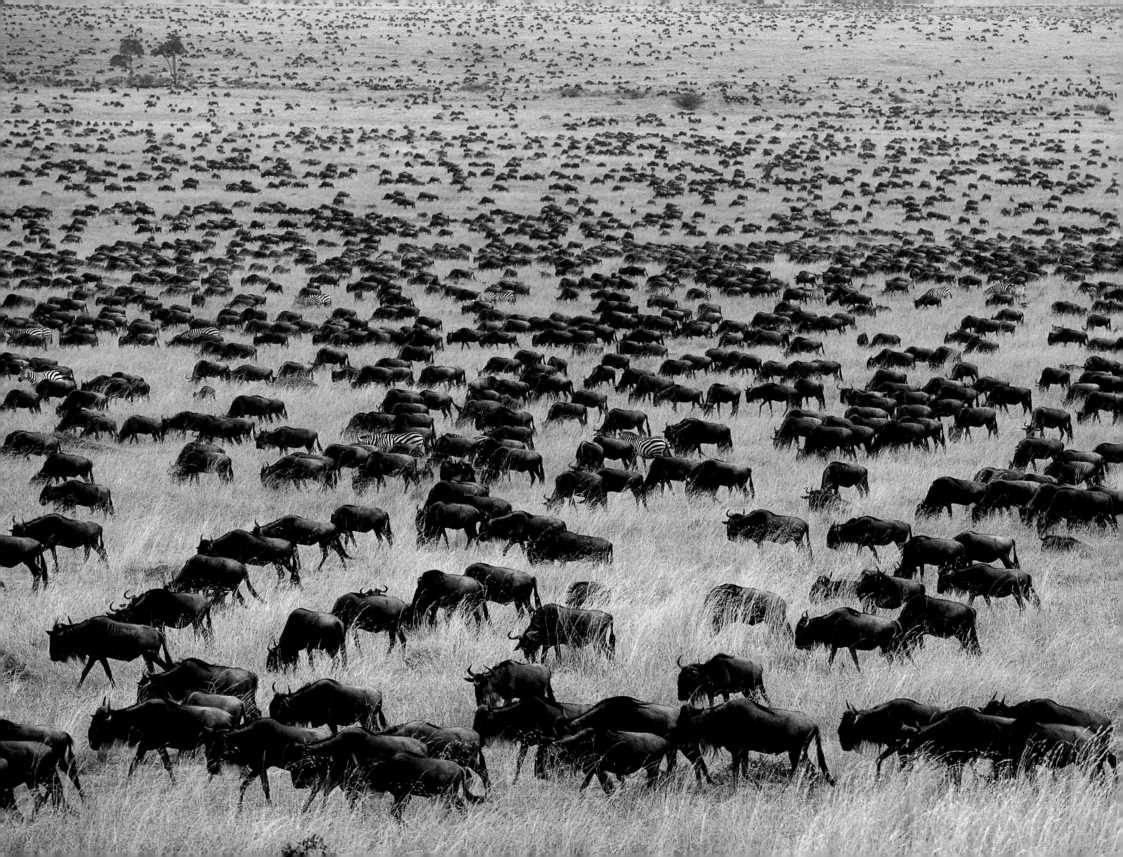

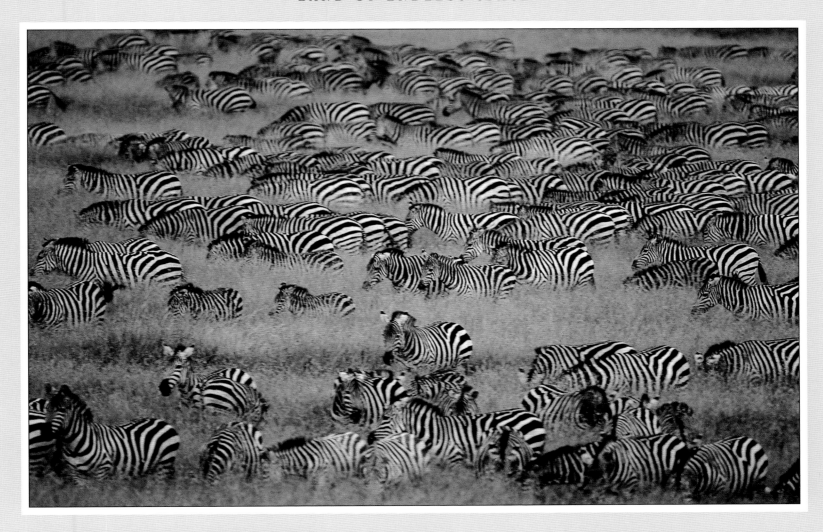

Zebras often arrive first in long-grass areas, they are ruminants that select the stem and seed-head, processing large quantities of grass quickly. The wildebeest move through the Mara's long red oat grass like a massive lawn mower, reducing the plains to stubble within days.

Fires sweep through the Mara-Serengeti during the dry season, reducing thousands of square kilometres of grassland to ashes. The fires may be caused by poachers, by Masai herdsmen in order to green the plains or by the casual toss of a cigarette butt.

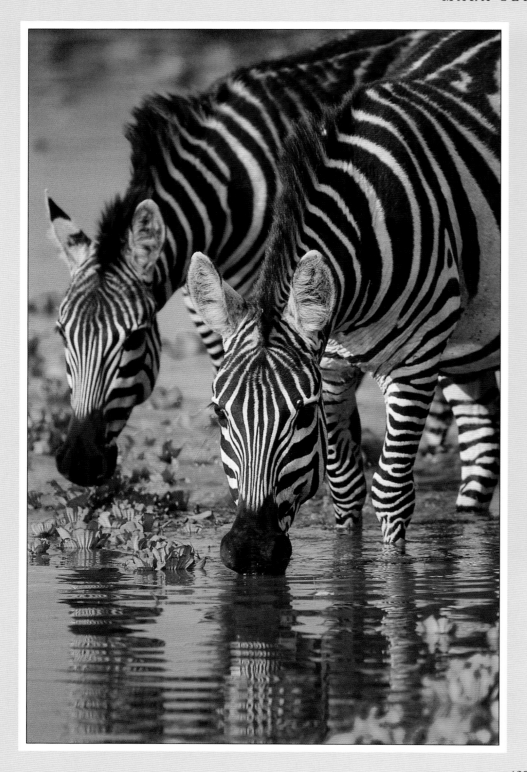

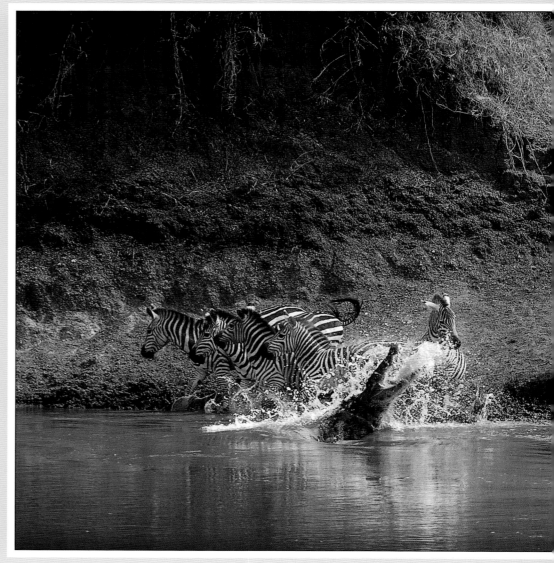

Drinking is a risky business for the prey animals, and predators often stake out waterholes and crossing sites at rivers. Zebras have large ears and eyes placed high on their heads to help them detect predators. The zebras above were fortunate to escape the powerful lunge of this 4-metre crocodile.

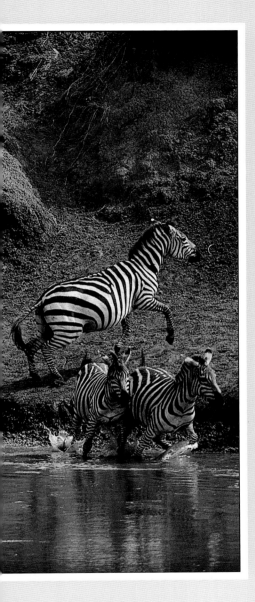

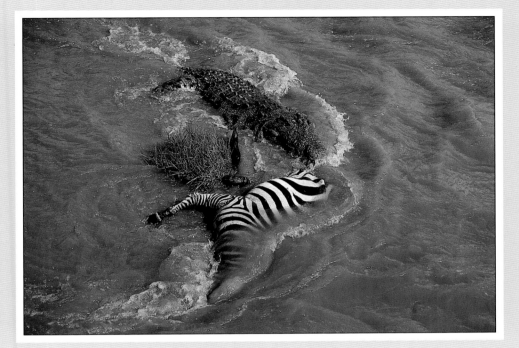

Having drowned its victim a crocodile may stash its kill against the bank or secure it underwater among branches or in a cave. Crocodiles cannot chew their food. They either thrash the carcass against the water to break it up or rip off chunks of flesh by holding fast and spinning – often with a number of crocodiles feeding at the same time.

The largest crocodiles in the Mara River measure up to 5 metres. Some of the crocodiles in the Grumeti River in the Western Corridor of the Serengeti are nearly 6 metres long and weigh more than a tonne, preying on wildebeest in the dry season when they come to drink.

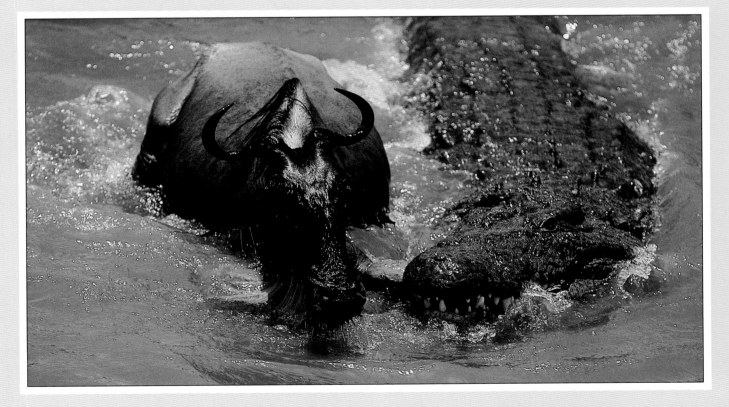

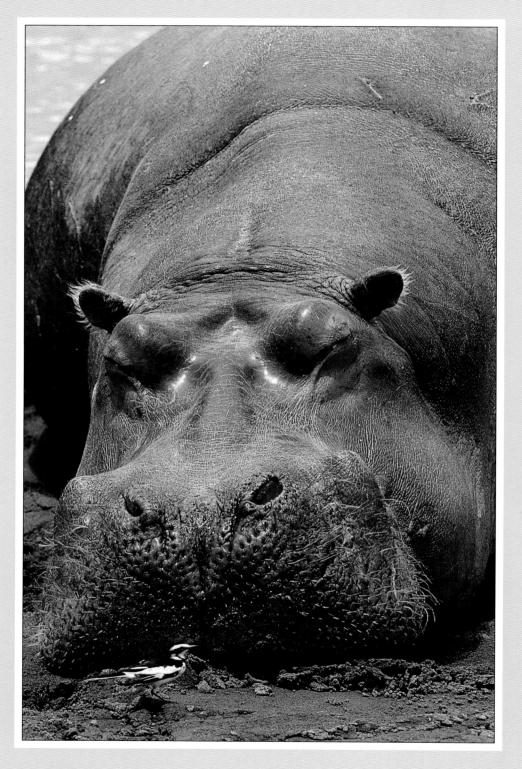

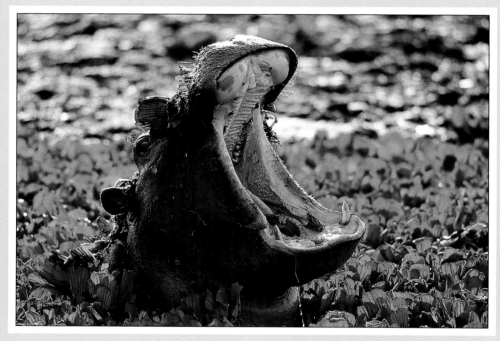

Hippo and pied wagtail. There are more than 2000 hippos in the Mara River. They are distantly related to pigs and have huge canine tusks which the males use in fights over territory and to defend themselves against predators. More people are killed by hippos than by any other large herbivore.

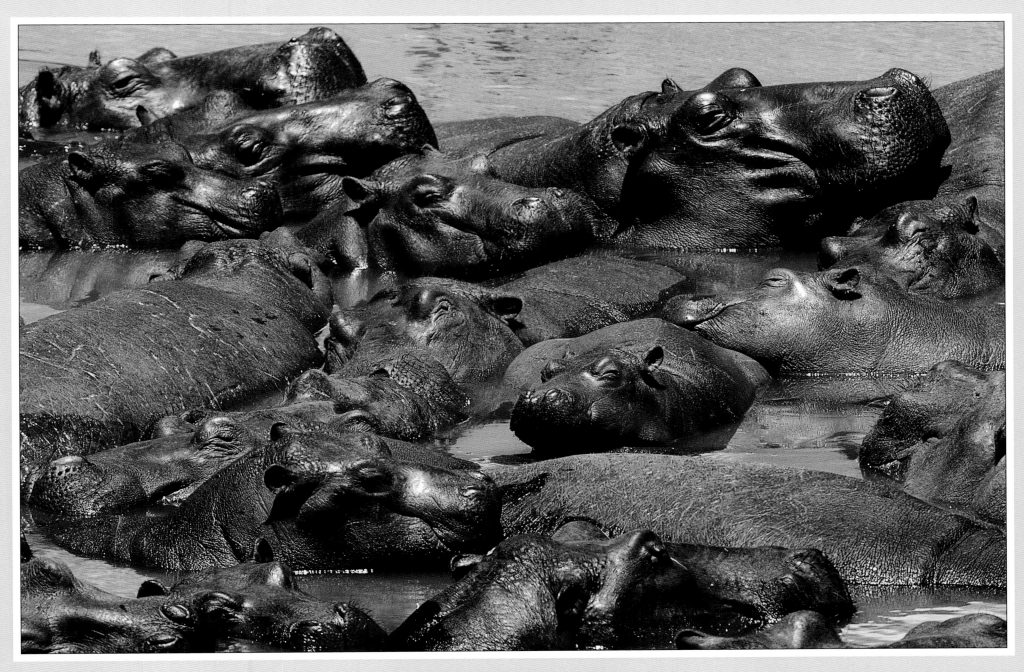

Hippos are gregarious and are usually found in groups of 10-20 females and their young, together with a territorial male who has exclusive breeding rights to the females. They emerge from the river shortly after dusk to feed on grass.

*The wildebeest and zebras leave the
Mara at the end of the dry season in
October or November and head south
again to the Serengeti's short-grass
plains. There the grass is adapted to
heavy grazing pressure and is rich
in calcium, sodium, potassium and
phosphorus – perfect conditions for
the pregnant wildebeest cows.*

*Rainfall is the driving force of the
migration. Wildebeest prefer short
green grass that is rich in protein
and has a high leaf-to-stem ratio.
Scattered thunderstorms during
the dry season in the Mara soon
turn the plains green.*

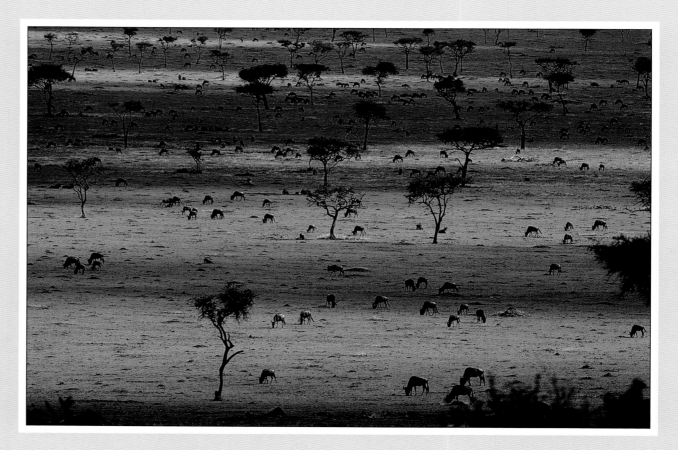

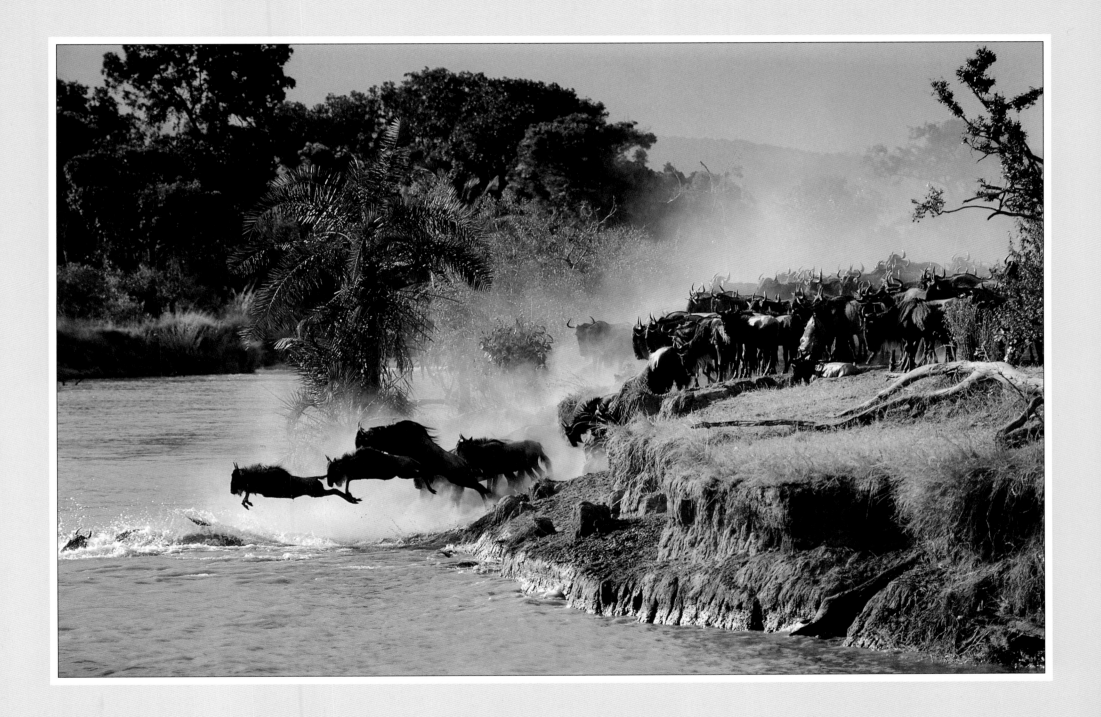

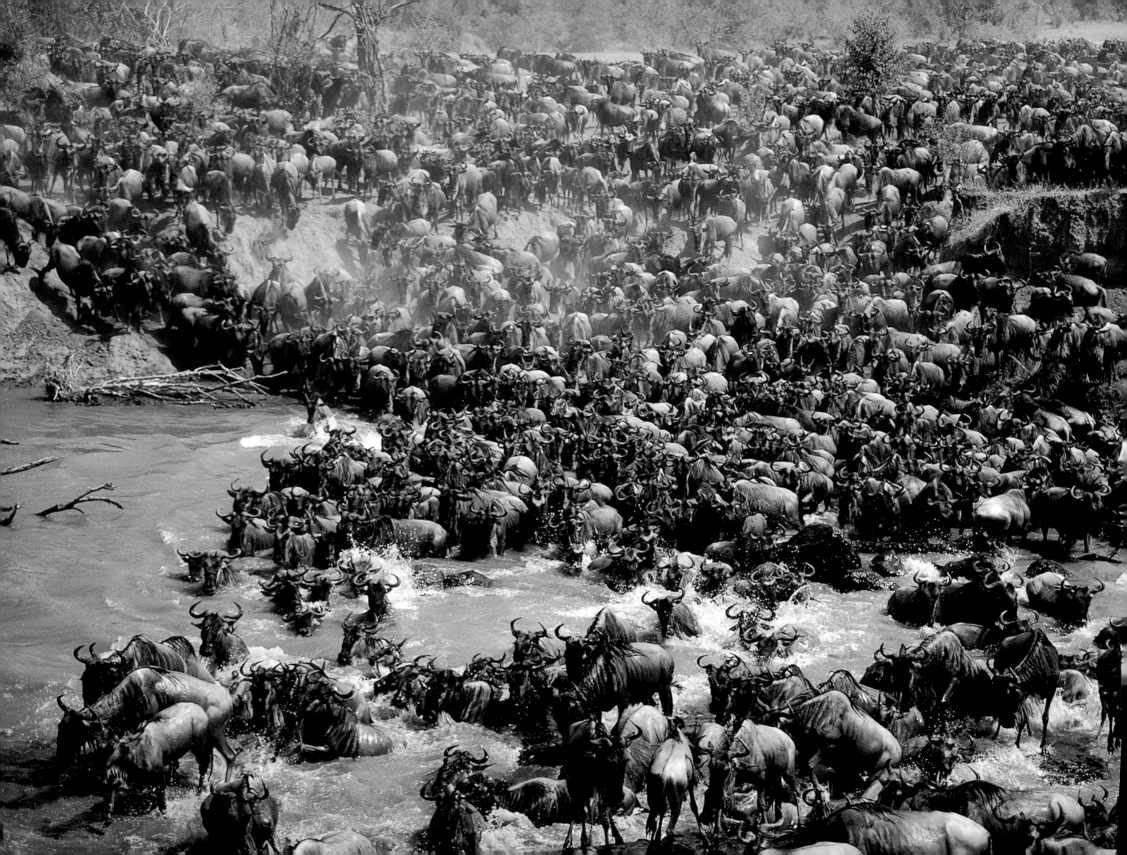

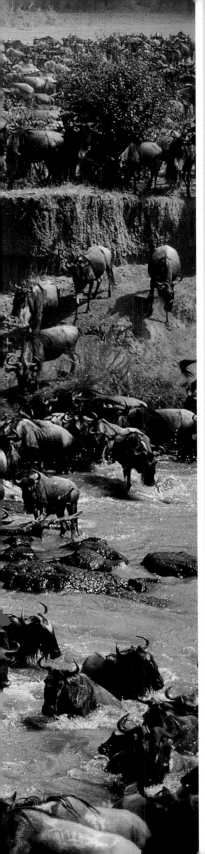

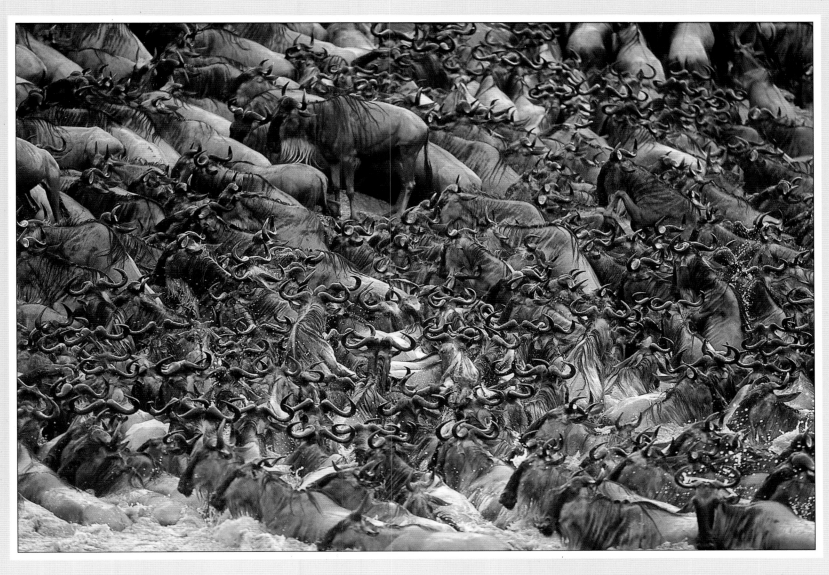

In some years the Mara River is shallow when the time comes for the herds to cross and thousands of animals can walk across without loss of life. But sometimes the river is swollen with rain and the banks on the far side are steep, causing many animals to drown or become trampled in the crush of bodies.

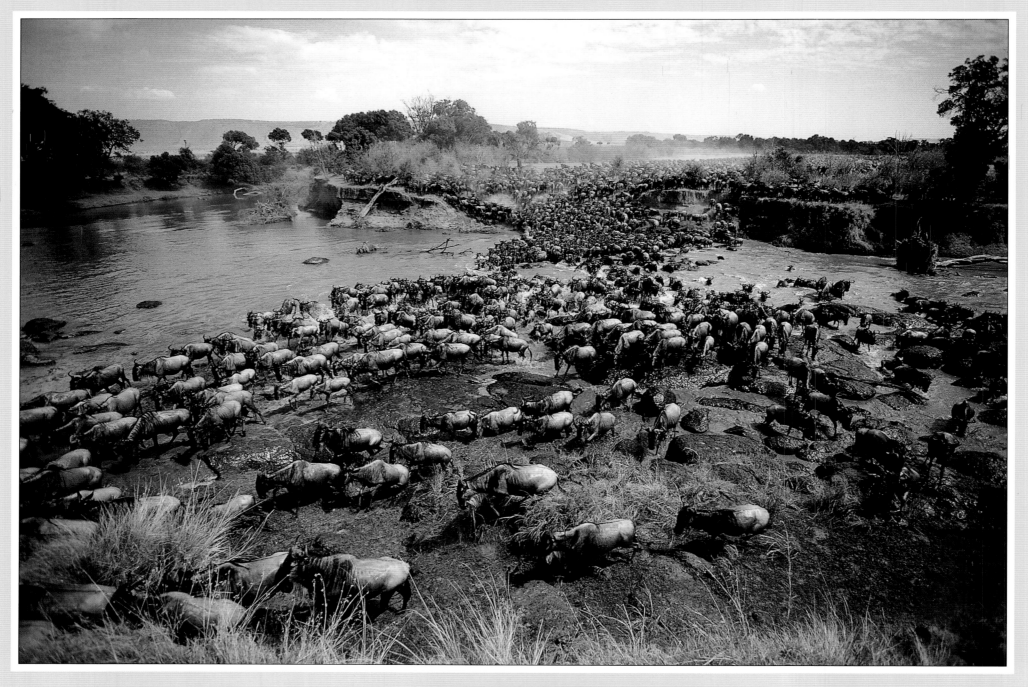

The herds may cross and recross the
river a number of times during the dry
season, depending on where the rain is
falling and the grass is greenest.

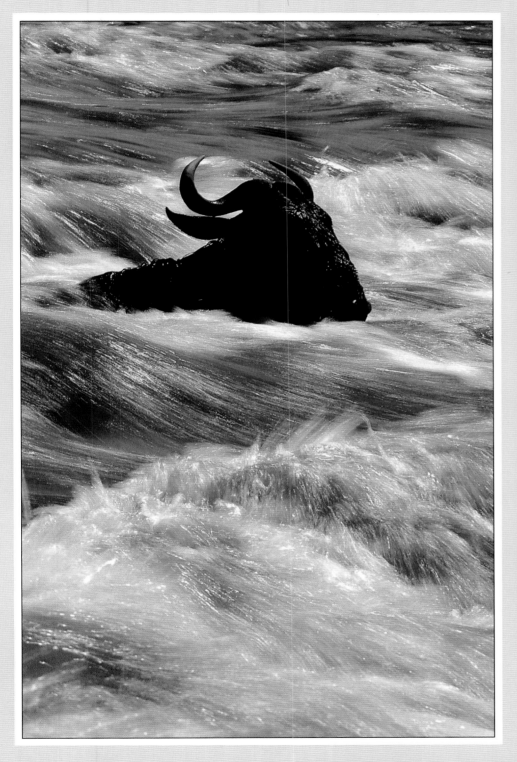

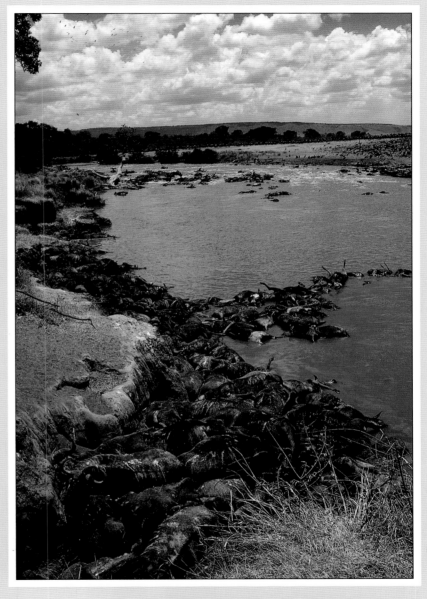

*In a bad year thousands of animals may die
during the river crossings, but it is not events
such as these that ultimately control the size of
the migratory population; it is the availability
of dry-season forage. Even after carnage such
as this, the Mara River soon washes itself clean
again with the help of the vultures, crocodiles,
hyenas, monitor lizards and catfish.*

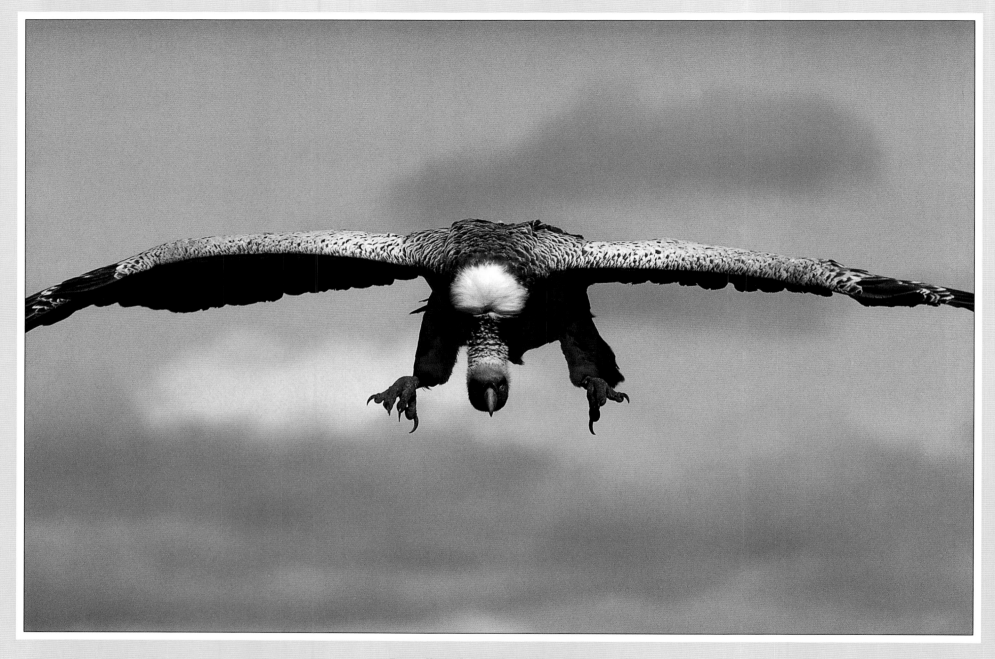

*Ruppell's vulture. The Mara-Serengeti
is home to some 40,000 vultures, many
of which follow the migration in search
of food, consuming an estimated
12 million kilograms of meat annually.*

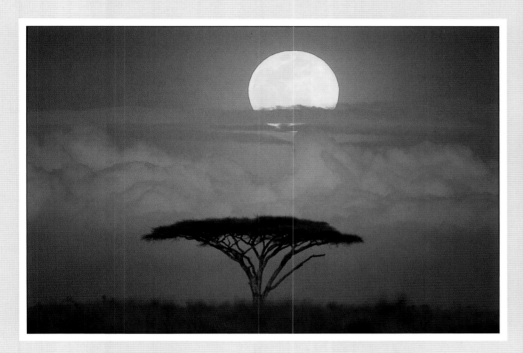

The rutting of the wildebeest is thought to be triggered by the full moon in June each year. Wildebeest are capable of sensing where and when rain is falling, using their long sensitive noses to 'smell' the moisture in the air as well as sight and sound to guide them to where thunderstorms are occurring. This combination of abilities enables them to find the greenest pastures.

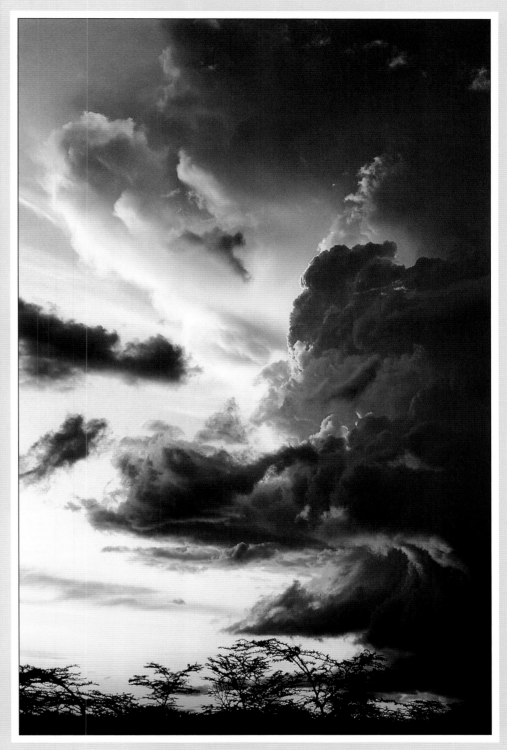

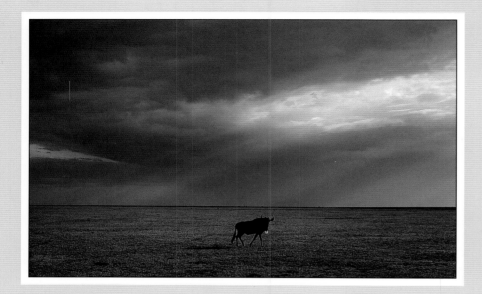

In the space of a hundred years 35 million bison vanished from the American prairies, devastated by man. Today the migration of wildebeest and zebras is the largest land migration on earth, but meat poaching now threatens the future of the herds in Mara-Serengeti.

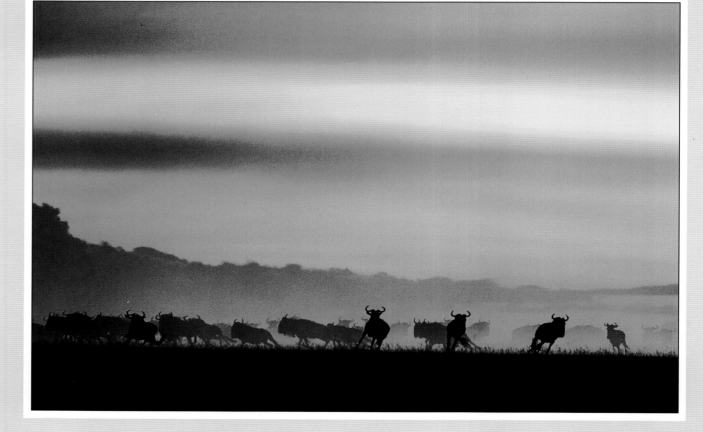

Dusk and dawn are dangerous times for the prey animals, when most of the large predators are active. But the open plains make it more difficult for predators to approach the herds without being seen.

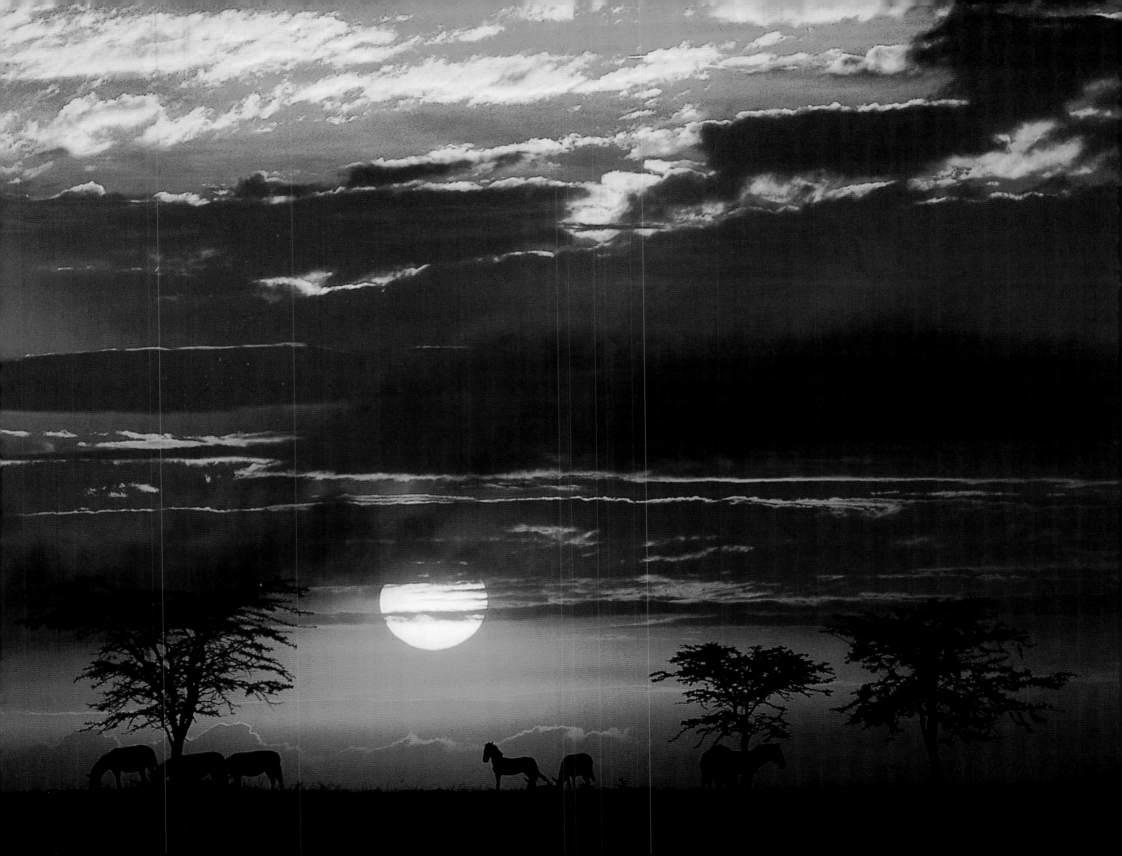

The Wolves of Africa

*Man is a brief event on this continent; no place has ever felt older
to me, less touched or affected by the human race...
the wild animals belong here.*

Martha Gellhorn *Travels with Myself and Another*

*O*ne of my reasons for wanting to follow the story of the wildebeest migration through the Serengeti was that it would give me the chance to spend time with another of Africa's most elusive predators – the wild dog, or hunting dog as it is sometimes known. Whenever people spoke of wild dogs I invariably thought of the Serengeti's treeless plains: kilometre after kilometre of open grasslands brought to life by the appearance of a pack of brindled hunters.

While the leopard had always intrigued me for its secretive nature, the wild dogs fascinated me because of their reputation as the most social of the large carnivores. The contrasts between the two species couldn't have been more extreme, one a cat that walks alone, the other a pack hunting dog, where the life of the individual is moulded to the needs of the group. Neither animal is easy to find. Leopards can hide without even trying, camouflaged by their spotted coat, whilst wild dogs on the Serengeti plains range so widely that they can cover 40 kilometres in a day without stopping to catch their breath. But when the herds of wildebeest sweep back on to the plains during the rainy season and drop their calves they provide the ideal prey for wild dogs. If ever there is a time to catch up with the dogs it is during the migration, when they have just produced puppies; then the normally nomadic adults remain anchored to a den on the southern plains for up to three months.

Wild dogs are remarkable-looking animals with huge bat-ears and a broadly white-tipped tail, weighing 20–30 kilograms and standing slightly less than one metre at the shoulder. They are most similar in habits to the grey wolf and the Asiatic dhole, and were once found in every kind of habitat except for jungle and desert. They are only distantly related to other members of the dog family and are thought to have diverged from the other wolf-like canids two to three million years ago. Their scientific name, *Lycaon pictus*, meaning painted or ornate wolf, celebrates their unique coat markings: a jigsaw of dark brown blotched with patches of burnished yellow and white.

Among Africa's large carnivores, only the Simien wolf (*Canis simiensis*) in Ethiopia is more endangered. Today the wild dog, though still widely distributed south of the Sahara, probably numbers fewer than 5000, of whom 3000 live in protected areas. They are found in only 15 of the 34 countries in which they formerly ranged, and in nine of those countries there are fewer than 100 individuals. The species is listed by the International Union for the Conservation of Nature (IUCN) as threatened by extinction, with strong recommendations that its conservation status be raised from 'vulnerable' to 'endangered'. Only in the Selous Game Reserve in southern Tanzania, the Okavango Delta in northern Botswana and the Kruger National Park in South Africa do they number more than 350. Yet once there may have been 200,000 dogs roaming the continent.

For most of the 20th century wild dogs were indiscriminately destroyed throughout their range, characterised as cruel, vicious killers. Park wardens and conservationists alike were guilty of vilifying wild dogs, encouraging game rangers and trophy hunters to shoot them on sight in the misguided belief that they were helping to conserve the species on which they preyed. In the former country of Rhodesia the government paid farmers and trappers to kill more than 3000 wild dogs, and ranchers in many parts of Africa still shoot or poison them.

What disturbs human sensibilities is the frenzied manner in which a pack of wild dogs tears into its living prey. Unlike members of the cat family, who, with the exception of lions, usually hunt alone, hyenas and wild dogs do not have much need for a single killing bite. Instead they run their prey to the point of exhaustion, and then disembowel it. A small animal such as a Thomson's gazelle is usually dead within seconds. But when the dogs attack an animal the size of a wildebeest, it may be many minutes before it dies – particularly if the pack is small. It is this that has caused people to judge the dogs so harshly. Yet, like all wild creatures, they kill not for pleasure but out of necessity.

Photographer Hugo van Lawick and his former wife Jane Goodall were among the first to create a more realistic portrait of these fascinating predators with their book *Innocent Killers*. In 1967, while working in the Serengeti, they initiated a photographic file, and over the years a comprehensive library of identification cards was built up, detailing pack composition, movements of dogs between packs, degree of relatedness, age of first reproduction and longevity. But when biologist Lory Frame concluded her work in 1978, the Serengeti wild dog project ground to a halt.

It was not until 1985, when John Fanshawe and Clare FitzGibbon began trying to piece together the missing chapters in the history of the wild dog population, that a new photographic file was started. It was thought then that there were as few as 80 dogs in the entire Serengeti. Over the next few years, whenever possible, a radio collar was fitted to at least one member of any new pack discovered in the Park. A similar initiative was soon underway in the Mara.

Like the wildebeest with whom they share the grasslands for part of the year, the dogs of the Serengeti plains are nomadic wanderers, occupying a loosely demarcated home range of 1500–2000 square kilometres. They spend much of the day resting, often huddling together in the shade of an erosion terrace or seeking the coolness of a muddy waterhole. With their lean bodies pressed flat against the ground, or curled head to belly in tight, blotched knots in the wispy grass, it is virtually impossible to detect their presence when they are resting on the plains. Each morning and evening, while the lions and hyenas are still lying up, the dogs rouse themselves to hunt, chasing across the grasslands after Thomson's gazelles or wildebeest at speeds of 55-60 kilometres an hour. Except when they have puppies, they sleep rough, bedding down wherever suits them best. And at times they move and hunt during the night. Today they could be just over the rise; tomorrow they may have vanished.

A typical wild dog pack consists of six to ten adults and a dozen or more puppies. At the heart of the pack is the dominant or alpha pair one or more generations of their offspring, and some male relatives of the dominant male, usually his brothers. Sisters of the dominant female may also be present when a new pack is formed.

Each year the dominant female in a pack gives birth to one litter; the average number of puppies is ten, though up to 19 have been recorded and one pack in Botswana is known to have raised a single litter of 16 pups. All the other pack members act as helpers: feeding the pups, shielding them from predators and guarding kills from scavengers while the younger animals feed. In a small pack this may make all the difference to the puppies' survival. By 'staying on' and helping, yearlings and older relatives gain a genetic advantage – they are all related to the pups.

Sometimes more than one female gives birth at the same time, for instance when a new breeding pack is being forged between a group of sisters and unrelated males (all young females leave their natal pack, usually in their second or third year, thereby preventing inbreeding). When this happens – particularly, it seems, in the Serengeti, where food supply varies greatly from season to season – the dominant sister invariably tries to control or kill her relatives' puppies. Subordinate females must therefore emigrate again to try and find breeding opportunities for themselves.

With packs occupying such huge home ranges, there is considerable overlap and the dogs pee and defecate as a means of making their presence known. Packs seldom meet; when they do the larger pack usually chases the smaller pack away. Occasionally – and particularly when competition to breed is intense – dogs may die as a result of such encounters.

I was fortunate in being able to spend time in the Serengeti between 1986 and 1988, watching one particular group of wild dogs known as the Naabi pack. The dominant female was called Mama Mzee, meaning 'old lady' in Swahili. In January 1987 Mama Mzee produced a litter of 11 puppies at a den near Barafu Kopjes at the eastern edge of the park, and I stayed with them for the next two months. How, I wondered, would they fare amongst the 5000 spotted hyenas that also live on the plains?

It had long been thought that hyenas were one of the major factors depressing the wild dog population in the Serengeti, killing their puppies and stealing their kills. Yet watching the Naabi pack made it quite clear that as a group the dogs were formidable opponents and a den was rarely left unguarded. Whenever a hyena trespassed beyond an

became one of the pack, willing them on to catch their prey, subjugate the bullying hyenas, raise their puppies to adulthood.

One of my favourite moments was when the dogs performed their greeting ceremony. It would start with one of the dogs getting to its feet and stretching, then trotting head low towards one of its companions. The participants would twitter with excitement, licking into each other's mouths, peeing and defecating. Within seconds the whole pack would be on its feet, running in circles, a riot of activity, bonding individual pack members and helping to reinforce each dog's place in the social hierarchy. These greeting ceremonies are often initiated by the hungriest members of the pack – the oldest offspring and subordinate adults – and are usually a prelude to hunting.

On one particularly hot mid-morning I parked the car well away from where the dogs rested and got out on the far side of the vehicle to have a wash. Minutes later I turned round to find three of the dogs within a few metres, bobbing their heads in curiosity, trying to catch my scent. When I stood up they gruff-barked in alarm, recognising me as a human being. Even then they retreated only a short distance, showing the same inquisitive and trusting canine characteristics that led to the domestication of their early dog relatives 6000 years ago. There are no records of wild dogs attacking or killing people.

invisible threshold of approximately 200 metres' radius from the den, the dogs – invariably led by Mama Mzee and Shaba, the alpha male – would advance like a war party, surging towards the hyena at a furious gallop. They would close in effortlessly behind the fleeing hyena, accelerating to within biting distance, nipping at its heels, slowing it down. Like picadors in a bull-ring, they taunted and terrorised their heavier rival with well-aimed ripping bites to neck and bottom. Within minutes the hyena's thick fur oozed red. Its only chance of escape was to reach the relative safety of water or an underground retreat.

The hyenas' influence on the dogs seems to be exerted through competition over food rather than direct predation on puppies. When the dogs killed, hyenas were invariably present at some stage and always managed to scavenge something from the carcass. But by denning during the rainy season, when there is an abundance of Thomson's gazelles and wildebeest calves, the dogs helped to keep competition with hyenas at a minimum.

I had noticed a similar synchronisation in breeding while watching wild dogs in the Mara in the 1970s. There, the dogs always denned around July or August, as the wildebeest moved north with their six-month-old calves, helping to ensure an ample supply of food for puppies and yearlings.

Spending time with the Naabi pack and another group of wild dogs in the Western Corridor known as the Ndoha pack was a unique experience. There were times when I didn't see another soul for more than a week at a time. I became immersed in their world: my sense of time began to mirror theirs. I awoke in the back of my car when they roused themselves; when they rested so did I; and when they hunted I followed. I came to know each pack member intimately, top dog and underdog, runt of the litter and future alpha male. In my heart I

Sometimes on a moonlit night I would see the dogs rise as one, eerie bat-eared figures slipping away from the den to ambush a herd of wildebeest. I would listen to the pounding of hooves and hear the wildebeest coughing on the dust churned up by their own feet. A calf or yearling would be the target, though the pack was quite capable of taking a full-grown wildebeest when the need arose. When a dog became separated I would hear a mournful bell-like call reaching out into the darkness – Hoo…hoo…hoo…hoo…hoo. Repeated again and again, thin and willowy, like the singing of the wind, lacking the boldness of a hyena's whoop or the authority of a lion's roar, yet undoubtedly one of the most beautiful and haunting sounds in Africa.

Being with the dogs allowed me to become part of the wind and the trees, to feel rooted once again to the land. The ethnologist Edward J. Wilson speculates that there are good reasons for such feelings of harmony with nature – it is in our own interests to cherish the earth. In time measured by the geological clock, it is only an instant ago that man walked out on the savanna as a hunter-gatherer, living by the same rhythms and cycles as the other creatures of the plains. As I immersed myself in this other world I was like a snake shedding its old skin, stripping away my city being. I took nothing for granted – water was a precious thing on the plains and cooking my meals became a ritual that made me appreciate food as a gift.

Ironically, just as I had been preparing to visit the Serengeti in 1986 in the hope of seeing wild dogs again, I was told that a pack of nine had been sighted in the northern Mara, near Aitong, where I had first seen wild dogs ten years earlier. Dogs wander very widely, particularly when dispersing to form new packs; they sometimes cover 200 kilometres or more in their search for mates, and I thought it unlikely that I would hear more of the Aitong pack. How wrong I proved to be. Just as they had in the past, these northern rangelands beckoned to the wild dogs, establishing a rhythm to their lives that was almost identical to that followed by the pack I first watched in 1977. Aitong provided ideal denning sites and a lower density of lions and hyenas than other areas replete with prey.

The new Aitong pack prospered, their success measured by three generations of puppies. As the number of dogs in the pack swelled, separate groups of female and male litter-mates emigrated, helping to inject fresh life into the depleted wild dog population of the Mara–Serengeti. This was the kind of pack I had always dreamed of watching, a pack at the height of its fortunes, breeding to the capacity of the land.

In August 1988 the dominant female in the Aitong pack and her sister secluded themselves among the bush-spotted slopes of Aitong Hill. As they had done in both 1986 and 1987 the two females gave birth within a week or so of each other, suckling their puppies side by side, buoyed by the arrival of the migration. But it was not only the migration. The plains and acacia thickets of the northern rangelands support high densities of the wild dogs' staple diet during the wet season when the majority of the wildebeest have departed. Thomson's and Grant's gazelles, impalas and topi all flourish in this area. With an abundance of food and plenty of 'helpers' to provision and defend the puppies, the Aitong pack proliferated with relatively little conflict between the two breeding females, existing in a home range of half the size needed by

packs hunting migratory prey on the Serengeti Plains. It was almost too good to be true.

Then suddenly the adult dogs started to die. A female stood as if in a trance, gently swaying backwards and forwards, oblivious to the raw mid-day heat. One of her brothers came and licked at her mouth, gently greeting her. Would he too be dying by the evening? Half a kilometre north the remains of the Aitong pack huddled beneath a clump of bushes, awaiting the cooler hours of the late afternoon when they would hunt.

Yet again disease was claiming the wild dogs of the Mara-Serengeti, repeating the pattern seen in earlier times. For years 'distemper' was the byword for disease among wild dogs, though we now know that they are susceptible to a variety of other epidemic diseases too: anthrax, rabies, parvovirus and tick-borne diseases are all potential killers of wild dogs. But the increased contact between wild dogs and domestic animals has accelerated their demise. From the point of view of disease a pack of wild dogs is one animal. Their highly social ways virtually ensure that each member of a pack is equally exposed to any outbreak among their number. Was this the end of the road for the Aitong pack? And even more important, what was killing them?

When brain samples were analysed in Nairobi and America they proved to be positive for rabies. Acquired immunity to this most dreaded of diseases is unheard of, unlike distemper or parvovirus. Rabies has been killing animals and humans for thousands of years; it is known from Greek history. However, Kenya had been virtually free of the disease since the late 1950s. Then, towards the end of the 1970s, it reappeared.

The main vectors of the disease in Kenya are medium-sized carnivores such as domestic dogs and jackals – also mongooses. At some point rabies was reintroduced into the Mara.

The death of the Aitong pack wasn't the end of the story. The wild dogs in this vast area form a single breeding population and are capable of traversing the whole extent of the land in search of mates. By 1992 all remaining packs of wild dogs being studied in Mara–Serengeti had died or disappeared and numbers remain low to this day. Rabies was confirmed as the cause of death in five individuals, and a distemper epidemic among the domestic dog population – which eventually jumped into the Mara-Serengeti lion population, killing hundreds of lions – may also have been involved at a later stage in the death of these dogs. Concerns that handling wild dogs to fit radio collars or administer vaccines might have played a role in these deaths by suppressing immunity seem unlikely to be justified. Analysis of data from five different ecosystems where handling of wild dogs has taken place – Mara, Kruger, Hwange (Zimbabwe), Selous and northern Botswana – showed no difference in survival rates between dogs that had been handled and those that hadn't. In fact in Kruger the wild dog population has doubled since handling began.

One positive effect of the hiatus is that it helped to focus attention on the need for careful study of the effects of handling-induced stress and vaccination in endangered species. The vaccine used to inoculate domestic dogs against distemper proved lethal to wild dogs being introduced to Etosha in Namibia in the late 1980s.

Until relatively recently the Serengeti plains were considered ideal habitat for wild dogs. Certainly the open character of the terrain proved perfect for filming them, making it easy to follow the dogs when they hunted. But studies in other parts of Africa such as the Selous, where there are thought to be 850 wild dogs, Kruger with 422 and northern Botswana with 450–500 dogs have shed new light on their lives. These woodland and bush-country habitats are more typical of much of Africa than the open plains and, as far as wild dogs are concerned, provide a more reliable source of resident prey such as impalas and kudus than the feast or famine regime of hunting the migratory species of the Serengeti plains. Here the average home range is 500 square kilometres, compared to 1500–2000 for plains packs in Serengeti. The highest density of wild dogs is found in the northern Selous and in Tanzania's Mikumi National Park with one dog per 25 square kilometres, double that found in other suitable habitats such as Kruger, the Okavango Delta and Hwange.

In 1996 I was able to catch up with Dr Gus Mills, Chief Research Officer in Kruger National Park, who has studied wild dogs for many years. Unlike the Mara-Serengeti, in Kruger the population has remained stable. Here and in other woodland and bush habitats such as northern Botswana and the Selous, lions play a significant role in regulating wild dog populations and are the biggest factor in keeping the numbers low – up to 70 per cent of puppies die in the first year. The most dangerous time for a pack is when puppies begin following the adults when they are three months old. Among the dense thickets, it is easy for lions to surprise a pack and easy too for pups to scatter and become confused, blundering into other members of a pride. On one occasion three lions ambushed a pack and within a matter of seconds killed seven puppies; on another a single lioness killed four adults. Whole litters have been lost to lions, accounting for a third of all known deaths in Kruger. Few dogs in Kruger live for more than five years (many for only two or three), though the alpha female in one pack was nine years old. In Serengeti dogs have been known to live for ten years, 12 even, though this is unusual.

In the Mara I had seen for myself how wild dogs showed considerable respect for lions, though there were occasions when the dogs went on

the offensive in open country, harassing the lions into continuing on their way. But whenever there was food to defend the dogs always ending up reluctantly giving way to lions, even if there was only one of them. Occasionally the dogs vented their frustrations on a lion by nipping at its hindquarters or darting in to bite its tail, and sometimes they misread the situation and ended up in the lion's jaws as it spun round and in one massive bound grabbed a dog. When this happened the rest of the pack were quick to respond, defending their relative by mobbing the lion and forcing it to retreat. Under such circumstances a dog might escape uninjured, though many were not so fortunate. Wisely the dogs listened intently when they heard lions roaring and generally gave them a wide berth.

In recent years I have been fortunate to be able to watch wild dogs in two of their last strongholds, the Selous (in the company of wildlife biologist Dr Scott Criel) and the Okavango Delta (while filming the Mombo pack for the BBC). As in the Kruger lions have a major impact. In fact wherever there are large numbers of lions and hyenas, wild dogs are scarce even when there is plenty of suitable prey. Though two to three times the weight of wild dogs, hyenas are in relatively low densities in the Selous compared to the Serengeti; they locate less than 20 per cent of wild dog kills and rarely manage to take any food. With only one or two hyenas to deal with, the dogs can normally dominate their larger rivals. And in the Kruger, hyenas were seen with wild dogs only 5 per cent of the time. The benefit of numbers was very apparent – smaller packs were more likely to lose kills and generally four dogs were needed to deter each hyena. Watching wild dogs in wooded country made their colourful markings seem much more adaptive. Their mottled earth colours match perfectly with the orange, yellow and browns of the bush, helping them to avoid detection.

Regardless of where they live, wild dogs are one of the most efficient hunters, with a success rate of 30–50 per cent. They employ a different strategy when hunting in thicker bush, with some members of the pack trotting along roads or game trails while others head into the bush to flush prey. A chase is usually over within 600 metres and rarely lasts more than a kilometre. Often multiple chases take place which, combined with the reduced visibility, make it much more difficult for hyenas to locate kills or for vultures to pinpoint them and give their whereabouts away to lions and hyenas. Dogs hunting on the Serengeti plains often chase gazelles and wildebeest for a number of kilometres, and in this open country it is far easier for vultures – and hence hyenas and lions – to locate kills.

Scientists are still debating the benefits of living in a pack: does each dog have a greater chance of a square meal or does communal living simply

decrease the probability of being eaten? Though the dogs do sometimes hunt large prey which can feed the whole pack, surprisingly a single dog can survive on its own for many months, hunting for itself and maintaining good health. But a single pair of dogs has little chance of rearing puppies, not because they can't provide enough food but because of the danger posed by lions and to a lesser extent hyenas. Being part of a large pack certainly helps the dogs to protect their food from these larger rivals, and reduces the risk of being attacked because other pack members keep watch for predators at a kill.

It is easy to raise support for the more popular symbols of our wild places, such as elephants and lions. But even now age-old prejudices linger on in and outside protected areas. In southern Africa collision with vehicles and conflict with farmers – not disease or the impact of other large predators – are the biggest threats to the dogs; and in many parts of the continent wire snares set by meat poachers are an increasing danger. The wild dogs could vanish in the next 20 years. Their only hope of survival is in large areas of relatively undisturbed wilderness such as national parks and game reserves, preferably with corridors linking them. Reintroducing wild dogs to sizeable areas where they used to occur is another possibility. If we can help Africa's painted wolves in their struggle to survive it will be a potent symbol of our good intentions.

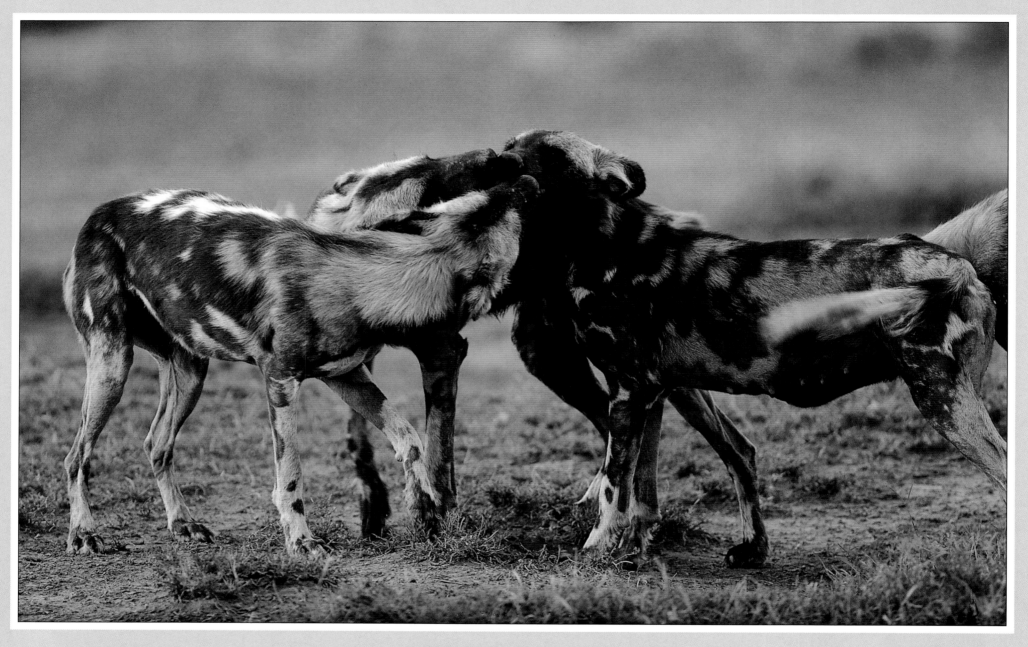

Members of the Naabi pack greeting Mama Mzee, the dominant female.
Wild dogs are the most social of all the large predators. Pack members greet
one another before setting off to hunt, helping to reaffirm social ties and
rally the whole pack for the chase. A pack consists of a dominant pair who
are unrelated, their adult relatives and the dominant pair's offspring.

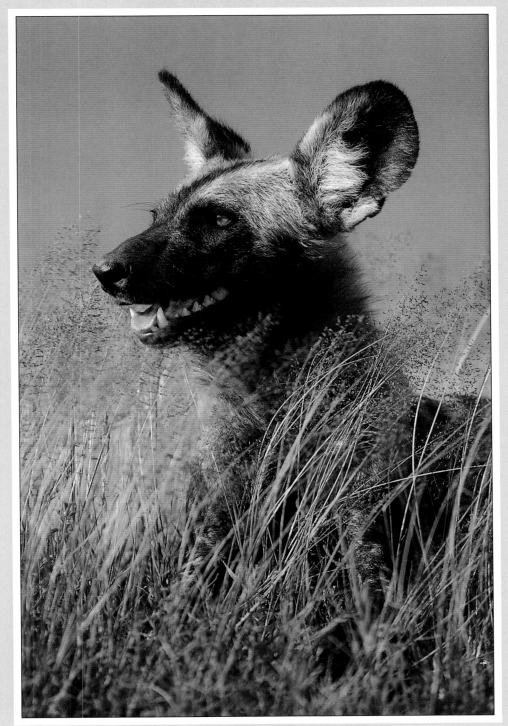

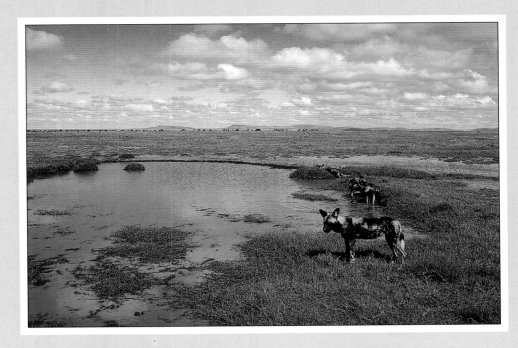

The Naabi pack. Wild dogs on the Serengeti plains often lie up close to water so that they can drink and wallow.

Individual pack members may be recognised by the unique pattern of their blotchy coat, which helps to conceal them in optimum habitat in bush and woodland areas. Their large bat-like ears help them to keep cool.

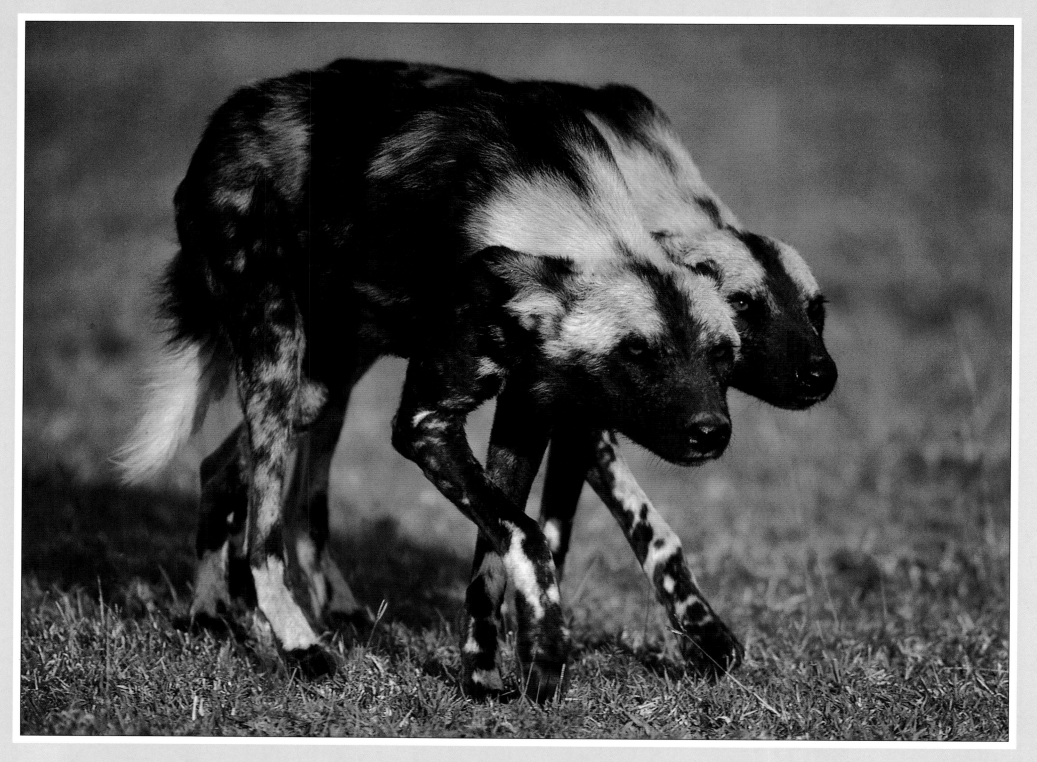

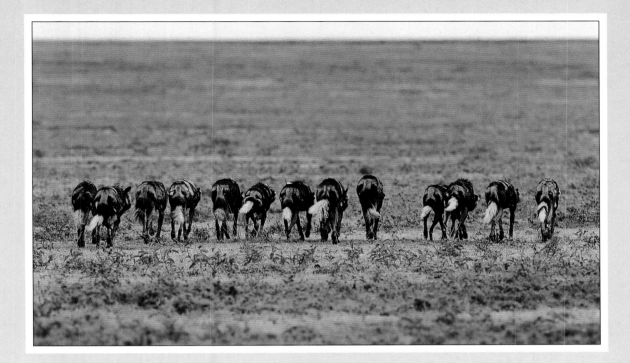

Wild dogs are coursers, hunting down their prey by speed and stamina rather than stealth. But in open habitats such as the Serengeti plains they get as close to their prey as possible before beginning to chase, bunching together and adopting a head-low posture to conceal their intentions.

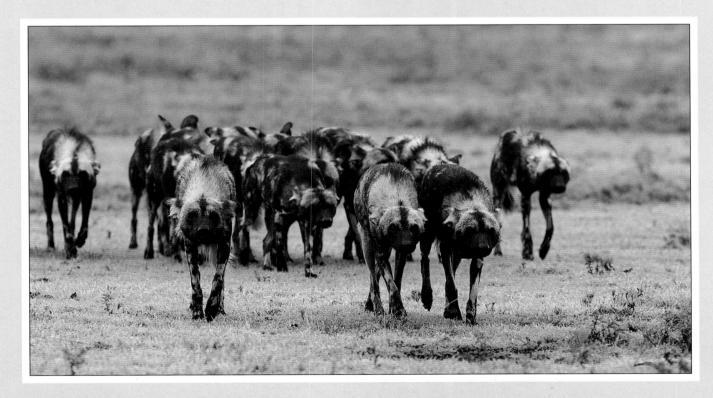

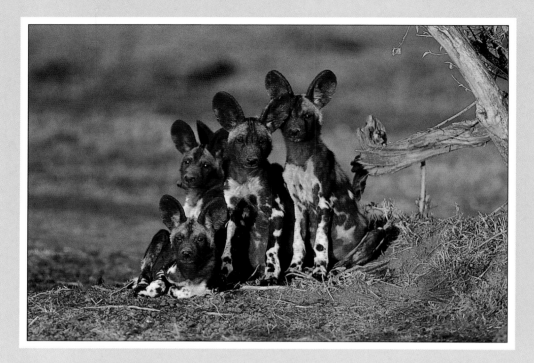

The Aitong pack's three-month-old pups. Pups are born in a disused aardvark or wart hog burrow and remain at the den for up to three months. The dominant pair usually monopolises breeding, producing a single litter each year. The average litter contains 5-12 pups, though up to 19 have been recorded.

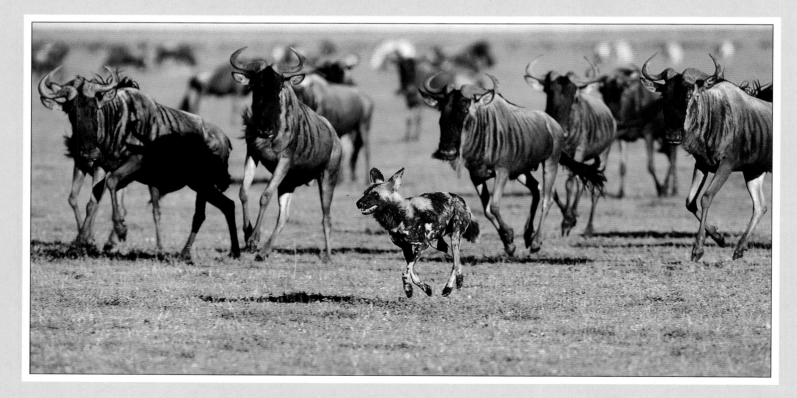

Wildebeest bulls weigh 200 kilograms, ten times the weight of a wild dog, and will defend themselves en masse by confronting a dog and driving it away. This sometimes allows mothers with calves time to escape. Though a pack is capable of taking down a full-grown wildebeest, calves and yearlings make less dangerous prey.

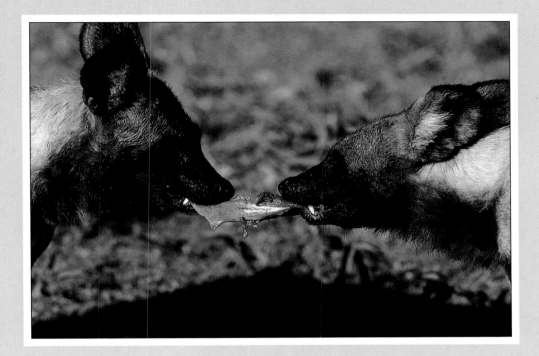

Dogs feed relatively amicably at a kill, competing with one another by bolting their food rather than by fighting. Pups are given priority when feeding.

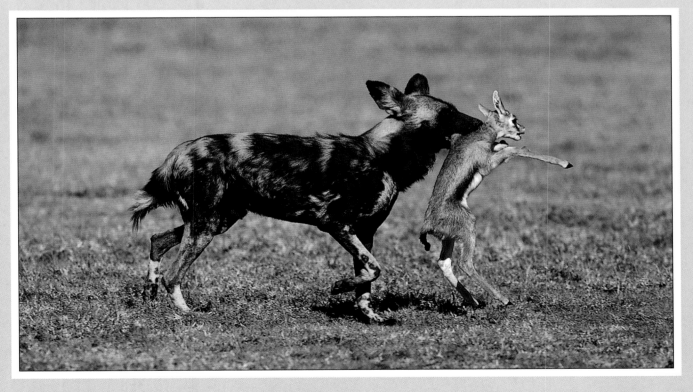

Pack members occasionally bring a small kill, such as this Thomson's gazelle fawn, back to the den for the pups to feed on.

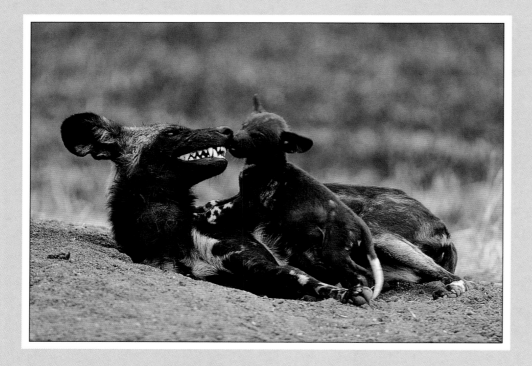

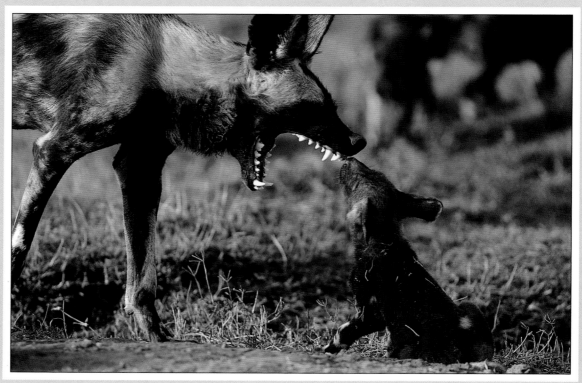

*The Naabi pack. Yearlings love to
play with young pups, and all pack
members regurgitate food for their
younger relatives. But as the pups
become older and more demanding
the adults and yearlings become less
tolerant, baring their teeth and
sometimes even nipping them
to stop them begging for food.*

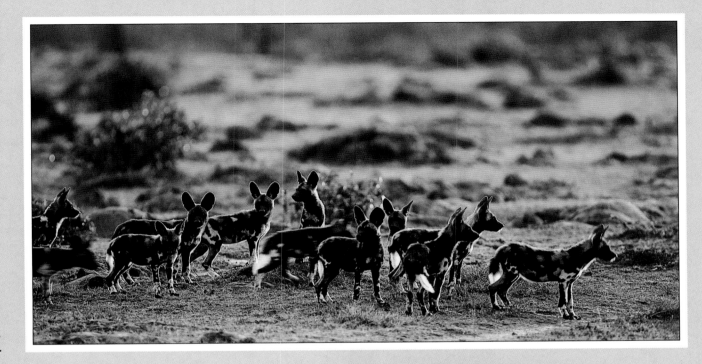

The Aitong pack's pups.
A pack establishes a den at the time
when prey is most abundant –
during the rainy season for packs
living on the Serengeti plains, and in
the dry season for packs in the Mara.

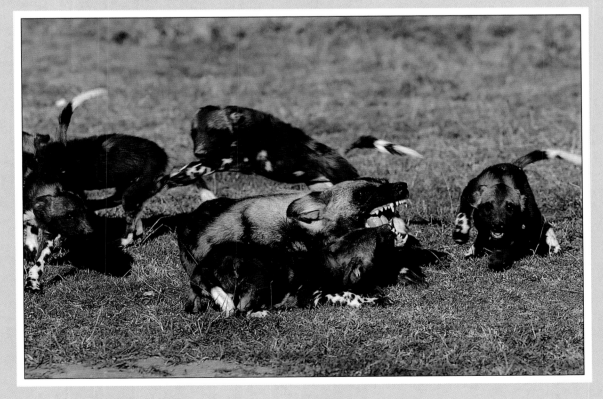

By the time pups are three months
old they are ready to abandon their
den and accompany the adults
wherever they wander, which
sometimes involves journeys of
20 kilometres or more at a stretch.
When they first start to move with
the pack, the pups are inexperienced
and vulnerable to attack by lions.

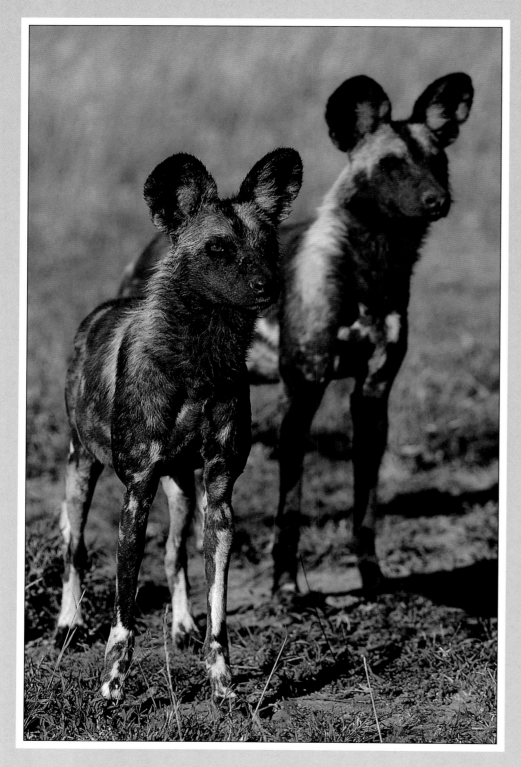

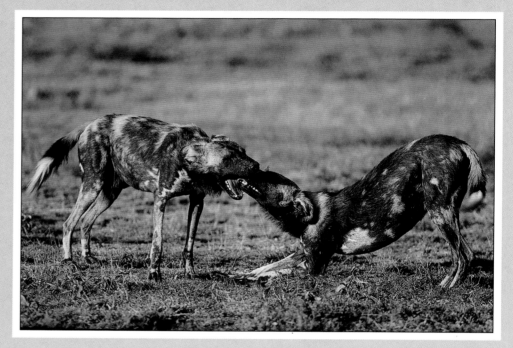

Because they lick into each other's mouths as part of their greeting ceremony, it is easy for pack members to spread contagious diseases such as distemper and rabies. From the perspective of disease, the pack is the same as a single dog.

The Naabi pack. Wild dogs have acute hearing, allowing them to pinpoint the calls of individuals separated from the pack. Groups of males or females emigrating to establish new packs roam widely in search of mates, calling repeatedly with a distinctive bell-like hoo sound.

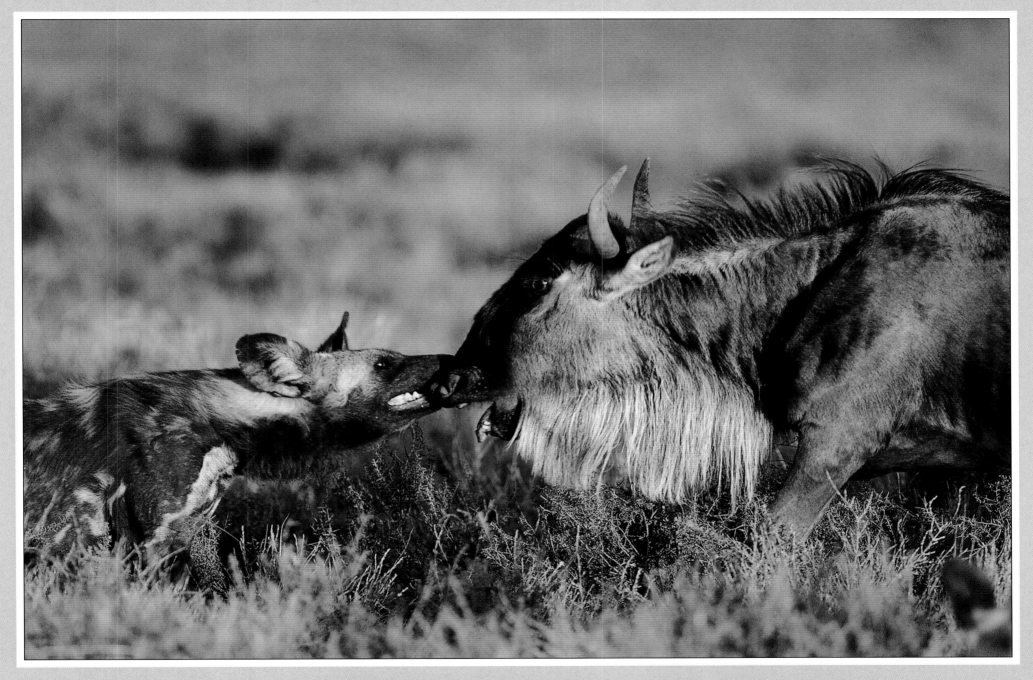

Wild dogs often use a nose-lip hold to immobilise large prey such as wildebeest and zebras, making it easier for other members of the pack to disembowel their victim. It is usually one of the older, more experienced male dogs that does this.

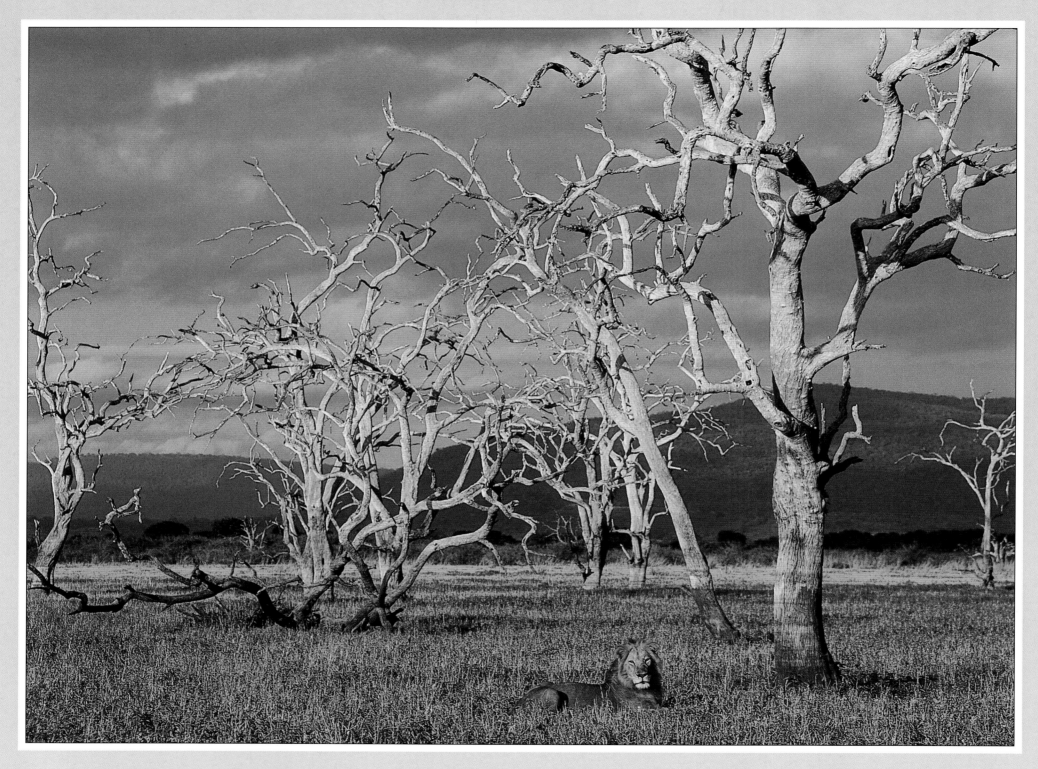

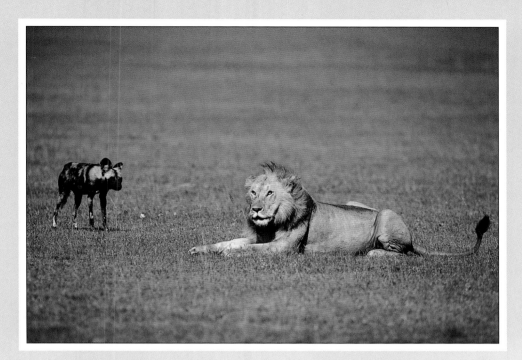

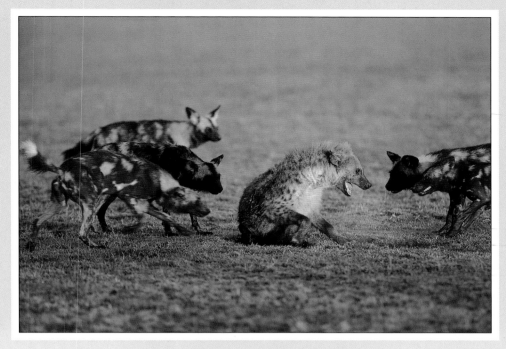

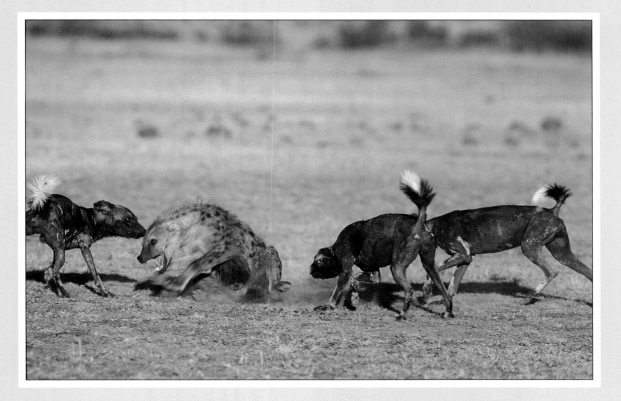

Lions are a major factor in keeping wild dog numbers low where their ranges overlap; they kill both adults and pups. The Selous Game Reserve in southern Tanzania is home to 850 wild dogs, the largest population in Africa. Wild dogs defend their den fiercely against hyenas, chasing and mobbing them, though rarely killing them.

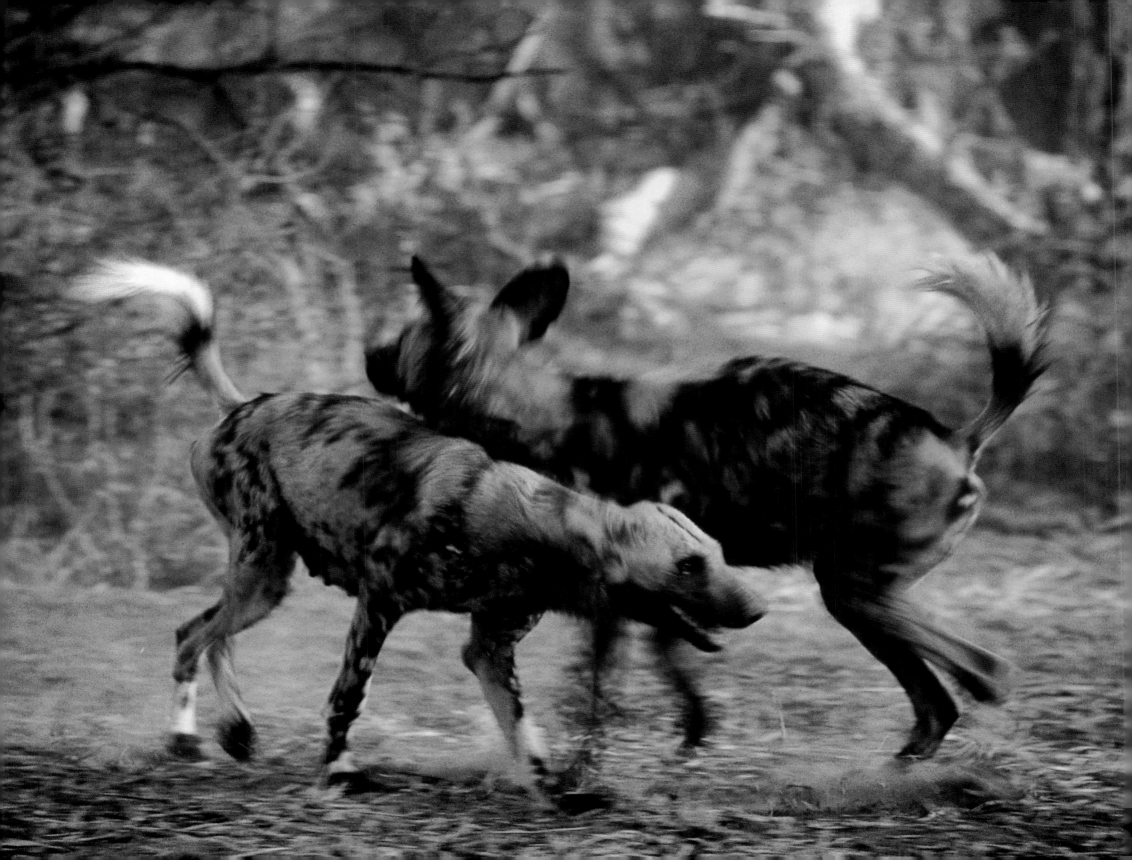

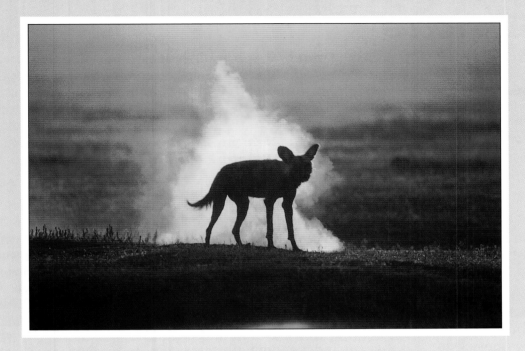

*Wild dogs are active mainly at dawn
and dusk when it is cool.
They generally hunt twice each day.
Hyenas are always a threat,
competing for similar prey and
stealing the dogs' kills.*

*The dominant pair in a wild dog
pack regularly performs the pee
ceremony, with the male
overmarking the spot where the
female has urinated. This allows the
male to monitor the female's sexual
state, as well as creating a strong
bond between the pair.*

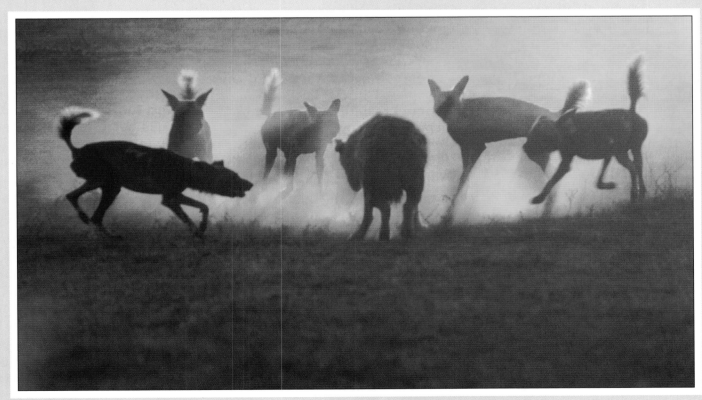

163

With the advent of the colonial era the Masai were confined within boundaries drawn on a map, restricted by treaties that robbed them of much of their power and half of their land. Yet it was always cattle, not land, that the Masai desired most. Cattle were the fabric around which their lives were woven. Land was seen as something more transitory, more ephemeral, a provider of grass and water for their herds rather than something to be coveted as private property. The Masai's existence in country that has always been as changeable as the wind – a place that could be lush and green one year and a dust-brown desert the next – was nothing if not precarious. The pastoralists were forever destined to wander far and wide to ensure that their rangy cattle survived from one season to the next. Most attempts at adopting new ranching methods and upgrading the quality of their livestock have failed and the benefits of modern medical and veterinary practice have been slow to take hold. The dilemma facing the Masai is how to improve the quality of their life without sacrificing their cultural identity.

Traditionally the Masai have occupied areas unrivalled in beauty and rich in soil, adopting a form of land tenure similar to that of the wild herds with whom they unselfishly shared the pastures. Like the migratory wildebeest and zebras, the Masai rotated around the grasslands, moving back and forth between wet-season dispersal areas, where the grass was short and nutritious, and dry-season holding areas, where they could find perennial streams to water their herds and sufficient grazing to sustain them until the advent of the rains. By not staying too long in any one part of their range they were able to avoid overgrazing the land. Only during the severest droughts did they kill wild animals for food – eland or buffaloes, God's cattle. And only when a predator threatened their livestock did they take up arms and hunt it down, except of course for the age-old custom of battling a male lion for the honour of wearing his mane as a war bonnet.

This benign attitude to the wild creatures, in such contrast to man's depredations elsewhere, could be construed as a form of active wildlife conservation on the part of the Masai. It is certainly one of the reasons why Masailand still harbours the greatest array of wild animals to be found anywhere in Africa. Some of the world's most famous animal sanctuaries – Amboseli, Lake Manyara, Ngorongoro, Nakuru, Serengeti, Masai Mara – bear Masai names and are part of Masailand. Because their culture dictated the central role of cattle as food and sustenance, wild animals could in most cases be ignored, either as a source of meat or as direct competitors for grazing. The reason the Masai did not kill animals was that they had no use for them. They neither ate them nor used them to clothe themselves: cattle, sheep and goats provided for

battle with change, will be decided by the Masai's ability to adapt to a new reality.

Nobody is sure where the Masai evolved. The origins of the Maa-speaking tribes – the Masai and their Samburu brothers in northern Kenya – are shrouded in mystery. There are no written records to help unravel the past, though the Masai pride themselves on a rich tradition of oral literature passed down from one generation to the next and enshrined in time-honoured ceremonies. Clues may be found in Egypt, Sudan and Ethiopia where place names of Masai origin are still evident. And there is talk, fanciful though it might be, of them being the lost tribe of Israel or descendants of a long-forgotten Roman legion. What is certain is that the Masai migrated into East Africa from the north sometime during the 15th century, earning for themselves a reputation as fearless warriors in their pursuit of land and cattle.

But the skill and bravery of their warriors was unable to protect the Masai from the assault of a different kind of enemy. In the closing decades of the 19th century they were devastated as a nation, their drought-weakened livestock crippled first by an outbreak of pleuropneumonia and then a few years later by rinderpest. Soon the cattle wealth of the Masai had dwindled to a few scrawny animals: by 1892 they had lost 95 per cent of their herds. Drought and famine dogged their footsteps and the Masai succumbed to a smallpox epidemic. A once great warrior tribe was brought to its knees.

lions killed a donkey the Masai laced the carcass with poison, killing the pride of lions that visitors so eagerly sought on their game drives. Even though the wildlife dispersal area surrounding the Mara is now being subdivided into individual plots, there are many Masai who favour preserving a semblance of the old ways of life with no fences, where livestock and wildlife can continue to live side by side. But only if they can earn a decent living from doing so.

Angie reminded me of something I had written years earlier about the Masai in my book *The Leopard's Tale*: 'I remember one afternoon a Masai appeared. He walked casually towards my car, resplendent in his blood-red shuka. After exchanging greetings the man asked me where my 'manyatta' was and if he could have some water. Before saying goodbye he invited me to visit him at his manyatta on the Talek River, just outside the eastern boundary of the Reserve, insisting that I must share meat with him at his own home. Then he continued on his journey, crossing the lugga barely 40 metres north of where Chui had stored her kill. I had warned him of the leopard and her cubs, but he just nodded, acknowledging something that he already knew. He shrugged his shoulders and walked away.

I sat and watched him as he strode out into the plain. The game drifted apart to let him pass, then closed in behind him until he was just another tiny speck amongst many others.

I thought of the two of us. Me with my notebook and my cameras, taking it all so seriously, cocooned in my noisy tin box. He striding off, much more a part of the natural world that he shared with Chui than I would ever be.'

their every need. Sharing the wide open spaces with herds of wildebeest and zebras was not so much a choice as a necessity.

Having lost so much of their land during colonial times, the Masai are understandably suspicious of any attempts to wrest still more concessions from them for the sake of preserving wild animals. The irony as far as they are concerned is that they were the ones living in harmony with the wild animals in the first place, long before governments and conservationists realised there were profits to be made from tourism and decided that the Masai must move out of places like the Mara, Amboseli and the Ngorongoro Crater to 'protect' the wild animals, so that wealthy visitors from countries which have long ago destroyed their own wildlife can enjoy a luxury safari.

If, as has happened in the past, the Masai find that their interests are being subverted in favour of wild animals, then they will resist such efforts with all the powers at their disposal. This has already happened on a number of occasions and is well illustrated by the situation in Amboseli National Park, which until the 1970s was traditionally used by the Masai as a dry-season refuge and watering place for their livestock. When the Masai agreed to sell their land and vacate the park, one of the guarantees made to them was that they would be provided with a reliable source of water for their cattle. But the government failed to honour their pledge and the warriors took their revenge by spearing the black rhinos that helped to make Amboseli world famous. And when

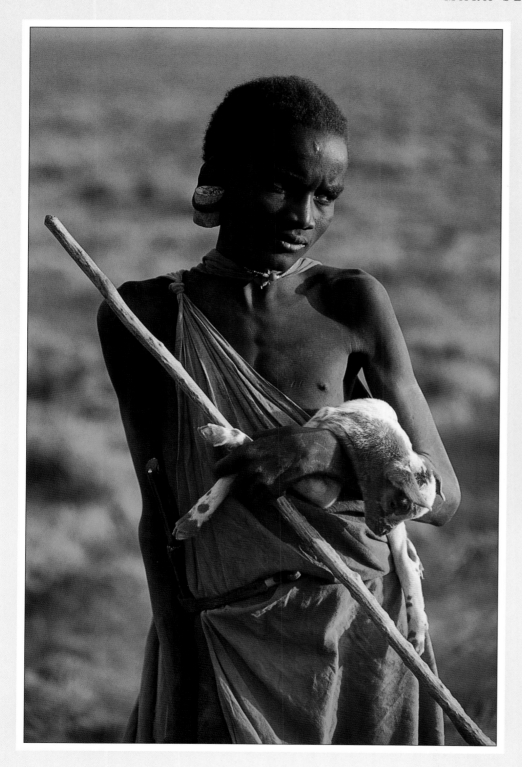

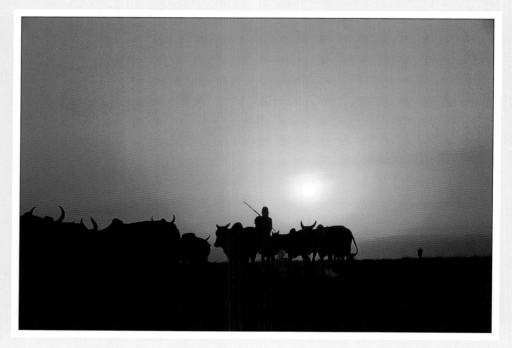

The Masai of Kenya and Tanzania are a Nilotic people who moved south along the Nile into East Africa in the 15th century. Many Masai still adopt a traditional lifestyle, herding their cattle, sheep and goats. They have lived in the Mara-Serengeti region for the last 300 years.

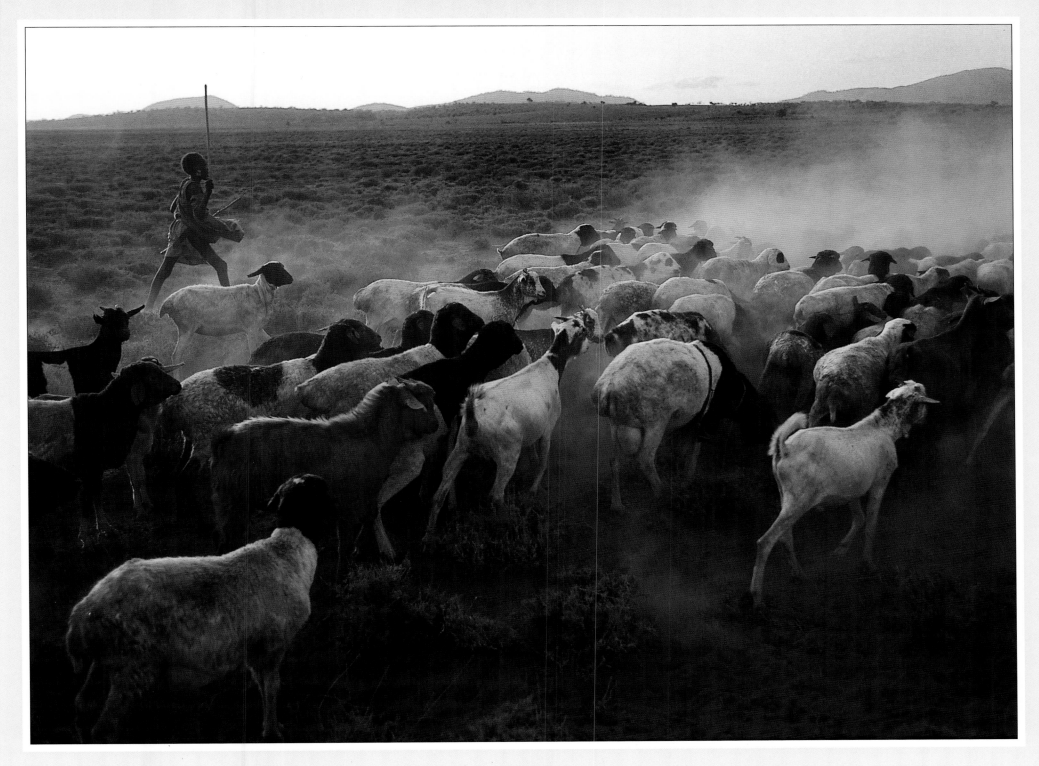

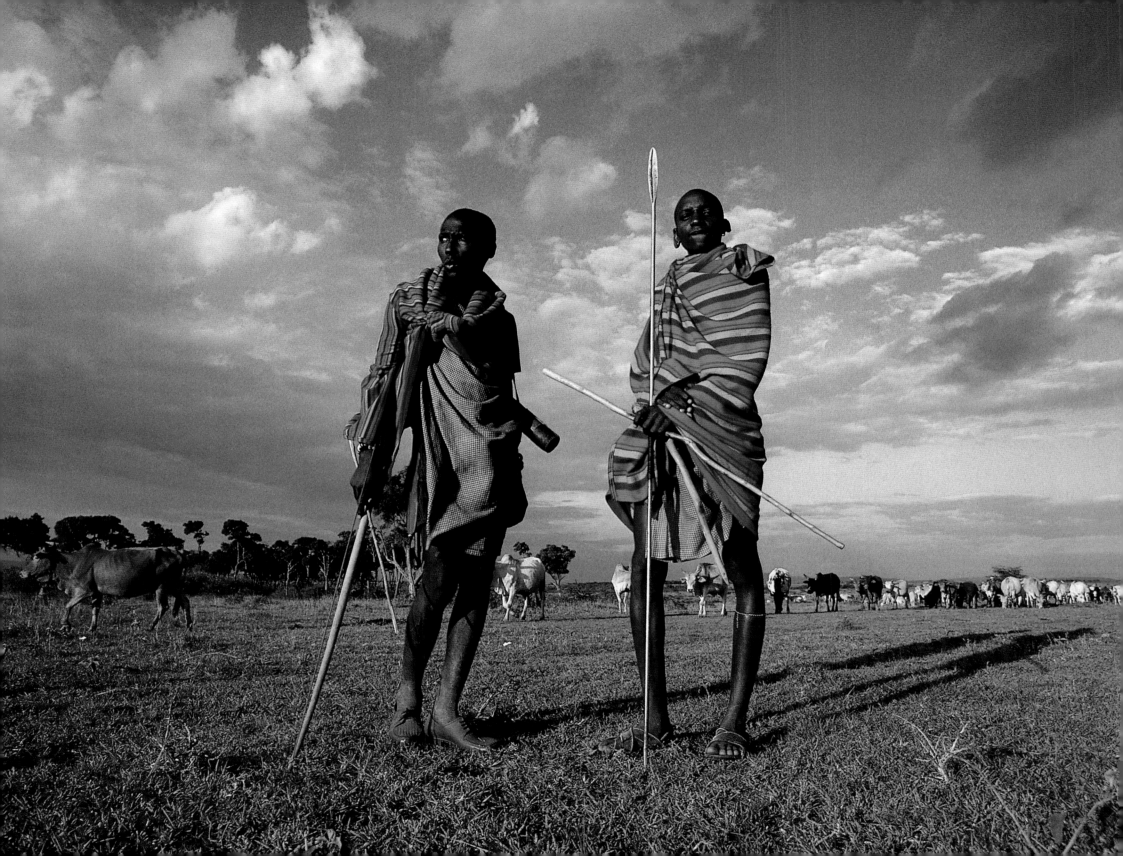

Life for the Masai revolves around cattle and other livestock. Blood is sometimes taken from a cow and either drunk alone or mixed with milk and allowed to coagulate. Men still dominate Masai culture. Wealth is measured by the size of a man's herds and the number of wives and children he has.

Women build and maintain the traditional mud and wattle houses within the thornbush boma, coating them with cow dung. The women are also responsible for milking the livestock and collecting the water.

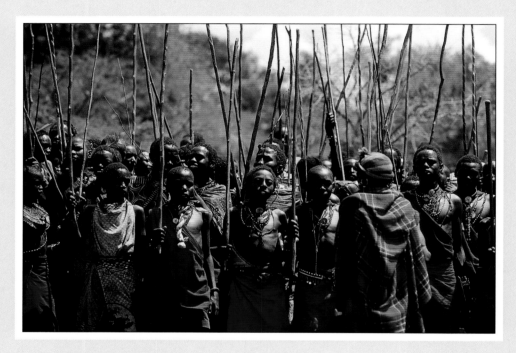

Masai culture is based on age
groups, with each generation in turn
handing over to its juniors, and is
defined by a number of important
and colourful ceremonies.
Young boys are circumcised
when they are teenagers.

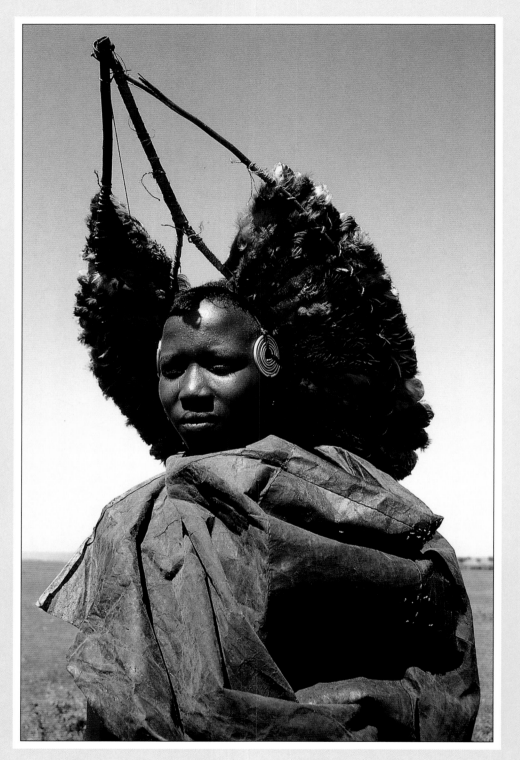

After being circumcised the youths
rest at their mother's house for three
months, collecting bird skins which
they wear in a head-dress.

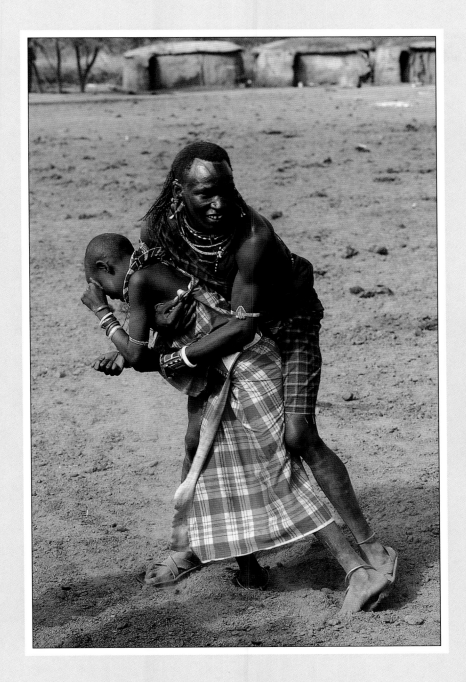

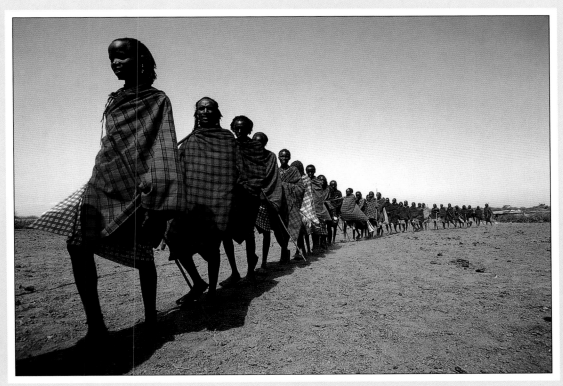

After a number of years as warriors – the army of their tribe – the time comes for them to settle down, become junior elders and marry.

After circumcision boys become warriors, grow their hair long and beautify themselves with red ochre. They cannot marry or own cattle, but they love to flirt and are allowed girlfriends.

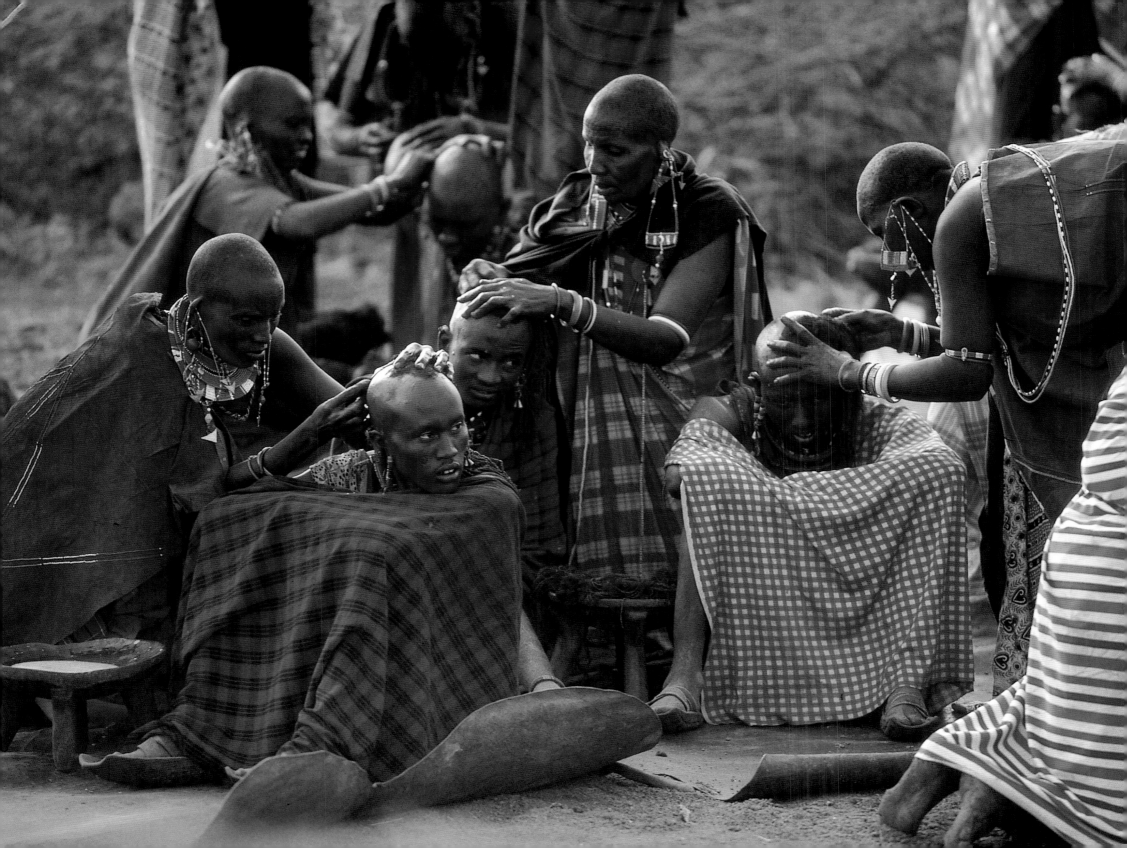

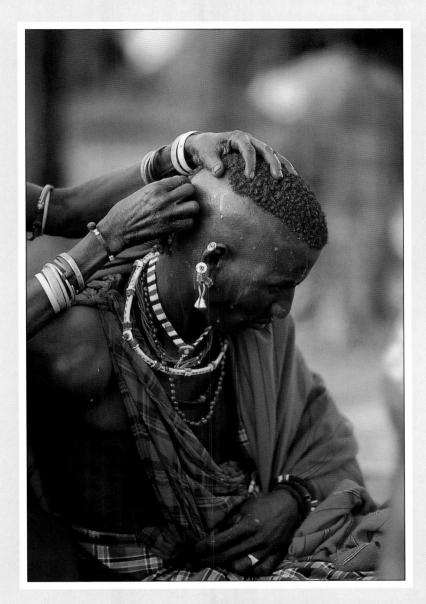

*Before becoming junior elders the
warriors must have their heads shaved.
Each warrior sits on the cowskin on which
he was circumcised and his mother
shaves off his beautiful long locks.
It is an emotional experience; many of
the warriors need to be comforted
by their mothers and age-mates.*

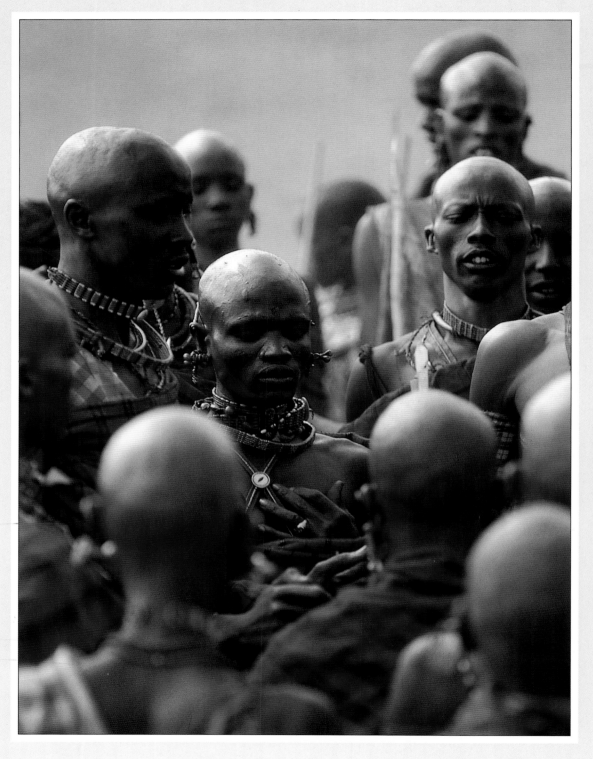

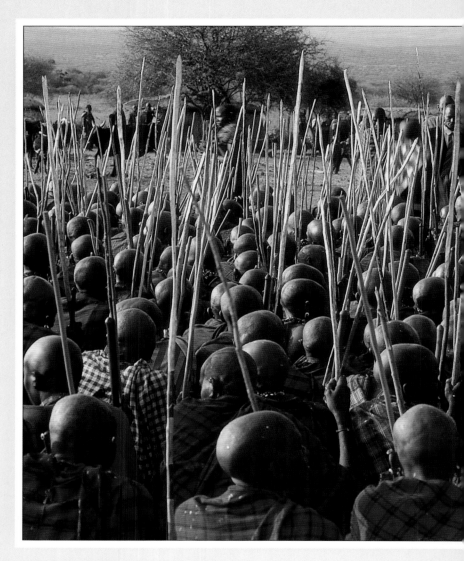

After having their heads shaved the warriors are blessed by the elders and sing and dance in celebration of their past feats of bravery.

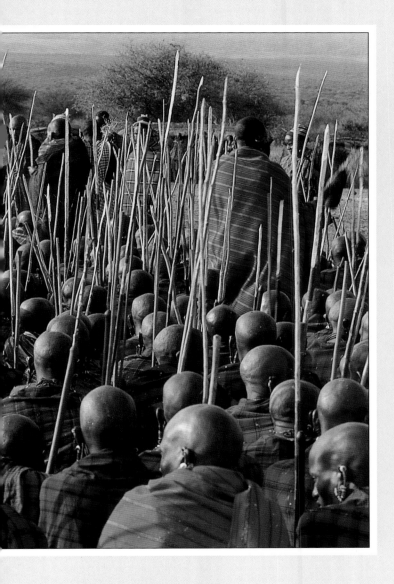

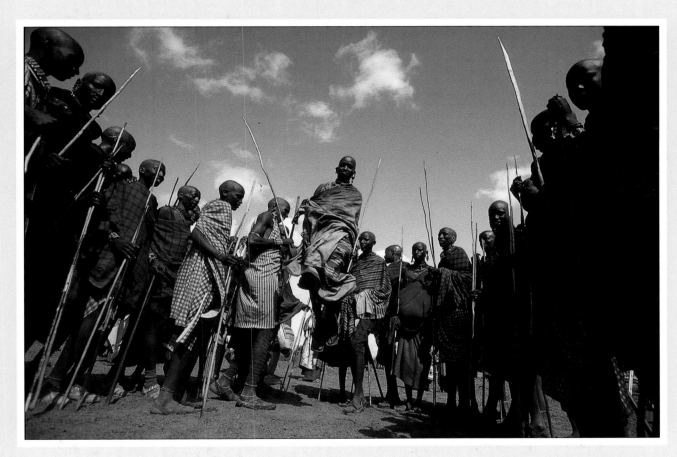

Masai men dance by taking it in turns to leap high into the air, something that boys begin practising from the earliest age. The ability to jump high and gracefully is much admired by both men and women.

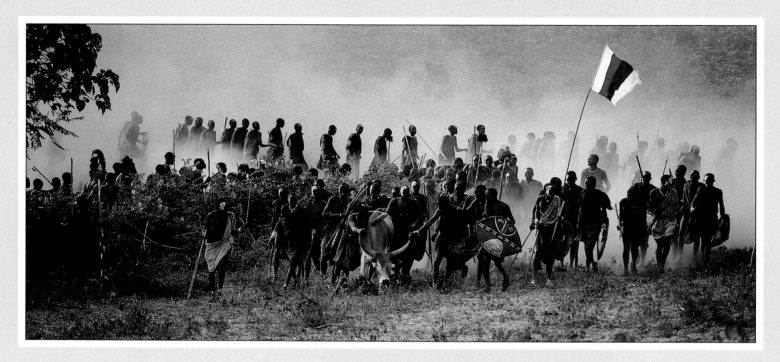

The Masai of Kenya and Tanzania number 350,000 people and are divided into independent units known as *il-oshon*.
Though each *il-oshon* celebrates the same ceremonies, the timing and details vary. The sacrifice of a bull and feasting on meat are an important part of most ceremonies. To mark the passage from warrior to junior elder, initiates wear rings of cow hide. The Kisongo, the majority of whom live in Tanzania, are the largest *il-oshon*.

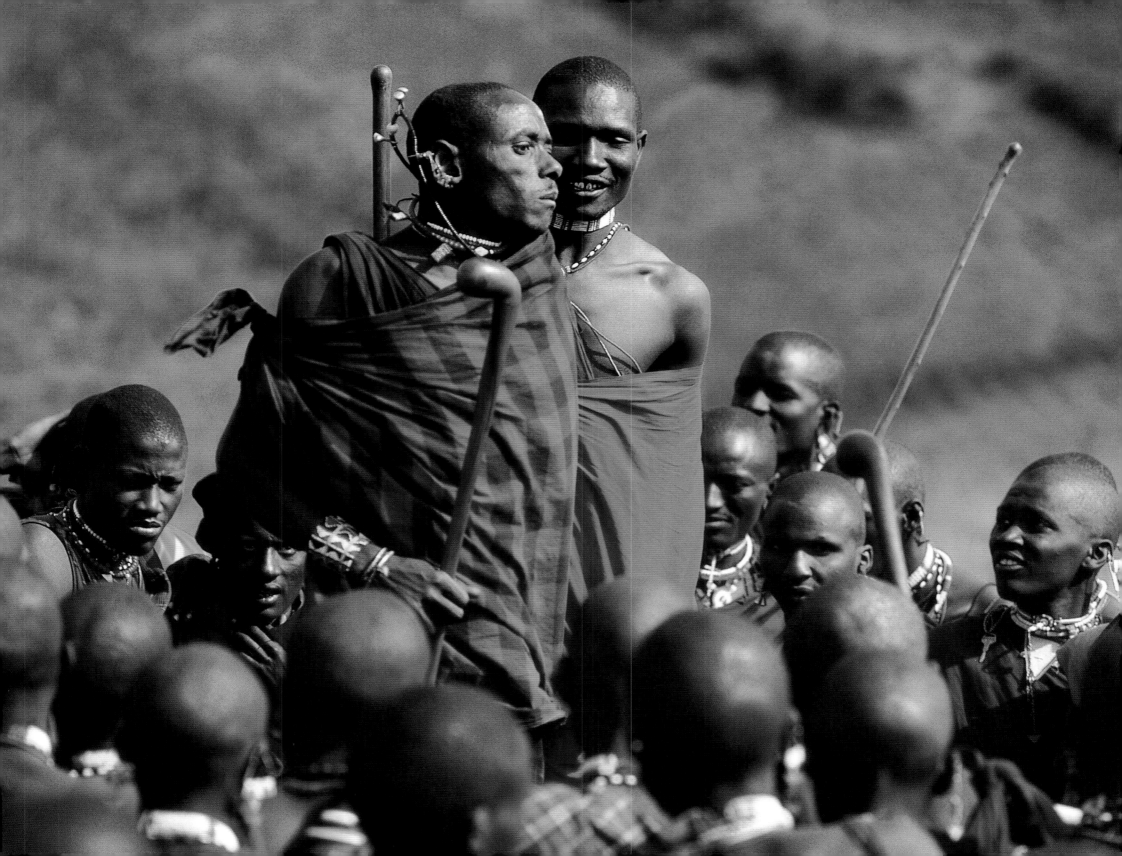

The Last Such Place on Earth

We abuse land because we regard it as a commodity belonging to us.
When we see land as a community to which we belong, we may begin
to use it with love and respect.

Aldo Leopold, *Sandy County Almanac*

*I*n 1995, scientists A. R. E. Sinclair and Peter Arcese wrote in a report entitled 'Serengeti in the Context of Worldwide Conservation Efforts': 'The Serengeti–Mara ecosystem is one of the great natural wonders of the world. Yet since the early 1900s, [it] has lost over 50 per cent of its area as a natural ecosystem... A once vast natural area bordered by undeveloped lands, the Serengeti–Mara ecosystem is fast becoming an insular assemblage of native species in a sea of humanity. As a result, the area is now severely threatened by the detrimental effects of human encroachment, the over exploitation and loss of its wildlife species, and the progressive loss of the natural system within its boundaries.'

Were the worst fears of those pioneer naturalists Bernhard and Michael Grzimek finally coming true? Had *Serengeti Shall Not Die,* which had so inspired me 40 years ago, been in vain? In those days meat poachers were more akin to traditional subsistence hunters than today's highly organised commercial gangs. True, there are many more wildebeest, zebras and gazelles in Serengeti than when the Grzimeks counted them. But much else has changed.

Shortly after I came to live in the Mara in January 1977, Tanzania closed its border with Kenya. The repercussions were enormous, and the number of visitors to the Serengeti plunged from 250,000 a year to just 10,000. The loss of revenue precipitated a 60 per cent decline in anti-poaching patrols and by 1986 only a single patrol vehicle was available in the whole of Serengeti. By the end of 1977 50 per cent of the park's 550 rhinos were dead, and within three years they were virtually extinct. But it wasn't just the rhinos. Armed motorised gangs had turned their attentions to the Serengeti's 2400 elephants, which for some while had been illegally targeted by trophy hunters both in and outside the park. By 1986 1500 elephants had perished, with the remnants of the herds granted a reprieve by the worldwide ban on the sale of ivory in 1989. During the same period meat poachers using wire snares and pitfalls decimated the buffalo population in the woodlands to the north and killed 50 per cent of those in the west, with gangs of men driving the herds to their deaths in lines of 100 snares or more.

Today, meat poaching is the most serious threat to wildlife in the Serengeti. It is estimated that nearly 20,000 poachers are killing 150,000 animals a year, mainly with wire snares, providing game meat to a potential market of a million people living within 45 kilometres of the western boundary of the Serengeti. Wildebeest make up more than half the dead animals, while other thicket-dwelling species such as giraffes, waterbucks, topis, impalas and warthogs are also commonly taken. Predators have suffered too. Meat poachers have no love for lions, hyenas or leopards and kill them with snares or poison. Surprisingly both wildebeest and zebra numbers have remained relatively stable over the last 20 years, prompting some people to question the poaching figures and downgrade the number by half. But this is little consolation. With the ever-increasing human population pressing up against the boundary of the Park, the demand for cheap meat can only intensify. If the wildebeest population were to crash the effect would reverberate throughout the ecosystem: Serengeti as we know it would indeed die. The migration *is* the Serengeti; the impact of the great herds of animals patterns the lives of everything else.

While meat poaching threatens the existence of the Serengeti in the west, in the east it is the loss of land to agriculture that is cause for concern. If implemented, plans to fence off part of the Loliondo area for wheat or barley would spell disaster for the migration, which has in recent years have used this route when moving to the Mara.

Ironically, before the border closure, the Masai Mara was little more than an overnight stop for many visitors to the Serengeti, one last destination on their homeward journey via Nairobi. Then suddenly it was forced into the limelight as Kenya's premier tourist attraction. Today it is the most visited wildlife sanctuary in East Africa with 300,000 visitors a year. But its newfound prominence has been a mixed blessing. Unplanned tourist development has meant the proliferation of tented camps and lodges; there are currently more than 30 in the area, with a number of other sites earmarked for development, and in 1997 Friends of Conservation estimated that there were 120 campsites

operational on the Group Ranches, as the communally owned land is called. A moratorium on any further development was recently adopted by the Kenya Association of Tour Operators pending the outcome of the current Land Use survey. But the golden goose continues to be plucked.

Large-scale wheat fields have replaced much of the forests and grasslands to the north of the Reserve and are spreading southward. Loss of habitat and competition for grazing with livestock is increasingly constricting the area available for wild animals, threatening traditional migration routes and leading to a marked decline in wildlife populations outside the Reserve. Hundreds of wire snares are set by meat poachers along the Siria Escarpment and in the acacia thickets bordering the Mara River, with tons of meat ferried out to the local population. Though the Masai are generally not actively involved in meat poaching, fewer wild animals mean fewer mouths competing for precious grazing in the dry season, and the impact of livestock is increasingly being felt within the Reserve. Compounding the situation are the high levels of immigration – 7 per cent per annum. The agricultural tribes gaze hungrily at the great tracts of land that the pastoralists still wander with their cattle. Their covetousness is fuelled by Kenya's 2.6 per cent annual population growth: elsewhere the best of the land has been subdivided, then divided once again, in keeping with the time-honoured culture of inheritance whereby each son receives a plot of land from his father. Now there is no land left to subdivide. Masailand is being carved up and apportioned to the people, some of whom have no rightful claim to it. Flying over the area to the north and west of the Mara reveals gaping holes in the ancient forests that cloak the hillsides. A patchwork of cultivation is seeping across the country.

It is no coincidence that many of East Africa's most famous wildlife sanctuaries lie within Masailand. For centuries the Masai and their livestock have lived side by side with the wild animals. Each year during the dry season between 200,000 and 600,000 wildebeest move into the Mara from the Serengeti. Many of these animals spill over into the ranchlands, eating up the precious grass. Because of this, many Masai feel it only fair that they should be able to graze and water their herds within the Reserve when times are tough and drought threatens. But one long-term resident of Masailand feels that this is courting disaster: 'If, for the sake of argument, the Masai are allowed to take their cattle to Mara without any control or check from the administration, the vegetation will go, as it has in many other parts of Masai country. First the game will go and then the bush, trees, grass and finally the streams and soil itself, to become brown, bare, pock-marked with gullies like the sliced, dust-devilled sun-sodden Loita Plains.'

Today most Masai see wildlife – and wildebeest in particular – as a source of disease for their cattle, competition for grazing and a threat to crops. Though many wildlife sanctuaries are unsuitable for farming – which was one reason why they were set aside for wildlife – large portions of the Group Ranches around the Masai Mara have high agricultural potential. Now that the old system of communal ownership is being abandoned and land adjudication completed, individual title is being granted to landowners. Clusters of rocks splashed with white paint designate the boundaries of newly subdivided land on the periphery of the Mara and can now be seen along Fig Tree Ridge and Leopard Gorge.

The fear is that more and more Masai will be persuaded to sell off parts of their land to agriculturalists who will then fence it off, sealing the fate of wild animals living beyond the Reserve boundary and effecting those within. Though many of the landowners have banded together to form Land Associations to protect the old Group Ranch areas, some individuals are unhappy about the unequitable sharing of profits: relatively few people make a decent financial return from their land; many at grass roots level do not. Tourism, even when combined with livestock revenue, has not yet proved capable of generating sufficient income to offset the costs of not developing the land for agriculture.

But there is no doubting that there is still money to be made from wildlife. Tourism is one of Kenya's largest sources of foreign exchange. The Mara is owned by the government of Kenya and managed by the Narok County Council for the benefit of the Masai people, generating 8 per cent of national tourist revenues, 10 per cent of all tourist bednights, and some $20 million a year in foreign exchange. Part of this sum is in the form of fees levied on lodges and camps and the daily entrance tickets issued to each tourist who visits the Reserve, some of which is passed on to the Masai living adjacent to its boundary and helps provide for development projects including schools, medical dispensaries and veterinary services. The Group Ranches themselves also generate $10 million of foreign exchange, though the bulk of the profits from tourism is made by commercial operators. So long as the money accruing from wildlife is utilised for the benefit of the people and is seen to do so, then wildlife conservation may continue to be viewed as a valid form of land use in the area. But tourism is a fickle industry, and in recent years Kenya has seen a marked drop in visitors and revenue. There is a salutary lesson to be learned from Tanzania's experience in 1977.

So how much is the developed world prepared to pay to safeguard places like the Mara-Serengeti? Anti-poaching patrols could be far more effective if only there were more vehicles and better surveillance equipment. There would be less demand for game meat if beef were available at an affordable price. More money needs to be spent on expanding education initiatives for communities living in the area. And the Masai would be less inclined to plough up their land for agriculture if they were all paid a fair price to continue to share the area with wild animals. But all this requires massive investment.

Despite the woes, the northern rangelands still harbour sizeable populations of wildlife and some species are thriving both in and outside the Reserve. Ironically the killing of elephants in the northern Serengeti forced 400-500 elephants to seek refuge in the Masai Mara, where poaching was virtually non-existent by the mid 1980s. The large number of tourist vehicles criss-crossing the Reserve made it difficult for poachers to act unhindered, and the ban on both trophy hunting and the sale of wildlife products also played their part. The Mara's rhino population has rebounded from an all-time low of 11 in 1982 to 25 today.

Change is an integral part of ecosystems, and man's impact is just one of the factors causing it. The 1500 elephants moving back and forth between the Mara and the dispersal area to the north and east play a significant role in maintaining the area as grasslands – particularly inside the Reserve. As they move across the plains they unerringly home in on the patchwork of tiny acacia seedlings, wrapping their prehensile trunks around the tasty morsels and deftly uprooting them with a nudge from one of their massive forefeet. Fires, too, play a major role in this gradual transformation from woodland to grasslands, inhibiting the regeneration of seedlings and sometimes killing mature trees. The loss of wooded habitat is almost certainly the reason for a decline in the numbers of giraffes and eland in the Reserve and for the rhino population being held in check. In places outside the Reserve there is a noticeable increase in the wooded areas. The combined effect of livestock and resident wild animals, swelled each year by the arrival of the migration, keeps the grass short, limiting the amount of fuel for fires and thereby helping the thickets to flourish.

In recent years we have heard much of the notion that wildlife must pay its way if it is to survive. Its value to the world for purely aesthetic reasons has lost ground. Bernhard Grzimek saw tourism as a way of creating awareness about wild animals and the environment and of raising revenue to finance the parks – an alternative to hunting. But he also saw the affinity and awe that we feel for living things as part of our being, helping to bind body and spirit. Nature has a magnetic hold on the human psyche: in destroying our natural world we are also courting spiritual disaster.

Perhaps the reason we are drawn to the savanna with its flat-topped acacia trees, winding rivers and open grasslands, is that this was the

home of our ancestors for millennia: two million years ago a deep understanding of nature and a reverence for it had very obvious survival value. You had to understand the rhythms of life, to be a keen observer, to be a naturalist if you were to find sufficient food. But many people exist today in a world far removed from nature, where the only other living things are human beings. Our destruction of the planet is immense. Yet we don't even know how many species exist on Earth: it could be 10 million or 100 million. We do know that the tropical rainforests harbour at least half of the world's species, yet the land is disappearing at a rate of 17 million square kilometres a year with the loss of nearly 30,000 species. A pinch of soil is thought to contain more than 4000 species of bacteria, creatures of whom we aren't even aware.

Nothing is forever in nature. But man's impact on the Mara-Serengeti is carved deep into the flesh of the land.

In March Angie and I travelled down to the Mara for one last visit before completing this book. Nairobi had been experiencing a heat wave and the Rift Valley was as dry as we had seen it in years. The grass had gone and dust devils tore at the parched earth, sucking the dry soil upwards into towering spirals, chasing across the plains. Where before there had been open landscapes – mile upon mile of untamed Africa – now a patchwork of homesteads patterned the ground, each fenced off to denote ownership.

Leaving the Rift Valley behind us we crossed the dry Loita plains, sparse country stippled in places by whistling thorn. Groups of gazelles shimmered in the heat, staring back at us before bouncing away with that familiar stiff-legged trot.

We chatted about the future: could the Mara survive; in years to come would we find fences and crops pressed against the boundary, the animals gone? But as we drew closer our mood changed. The Mara soothes the spirit, stifles the tension. We were excited at the prospect of seeing Zawadi and her cubs, and finding out how much they had grown in the two months since we were last there. Those would be the first questions we asked on arrival at Governor's Camp: how is she, where is she, what's been happening? But the answers were not what we had been hoping for. The drivers told us that just a few days earlier one of Zawadi's cubs – the male – had been killed along Leopard Lugga just to the north of Leopard Gorge. A hyena was seen dragging away the body, but in all probability the cub had been killed by lions: the following day Zawadi and the little female spent most of the afternoon hiding in the top of a tree to escape a pride of lions. Over the years we have come to

Photographic Notes

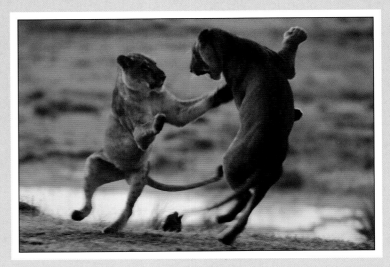

Try to be different. Don't chose the obvious
– think about creating abstract images.
80-200mm f2.8 zoom lens, 1/125th sec at f2.8.

Early morning and late evening light
creates warm, highly saturated colours.
Front light – with the sun coming over
your shoulder – is fine in these
circumstances, but always try to offset
your position by a few degrees to create
some shadows to model your subject.
300mm f2.8 lens, 1/250th sec at f2.8

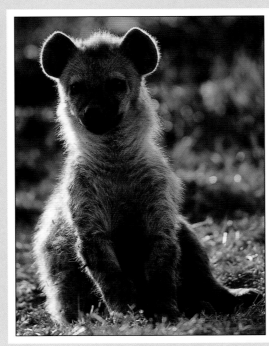

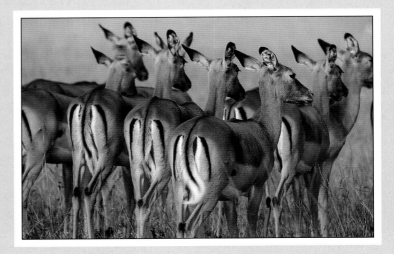

The rule of thumb when using sidelight or
backlight is to open up by one stop if your
subject is sidelit and by two stops if it is
backlit. But the best way is to bracket –
taking a number of shots, each varying by
a third to half a stop of light – to ensure
that you end up with an image that
pleases you.
500mm f4.5 lens, 1/250th sec at f5.6

Photography is all about light, about learning to see
with the eye of your camera and using different lenses
to create different images.
500mm f4.5 lens, 1/125th sec at f4.5.

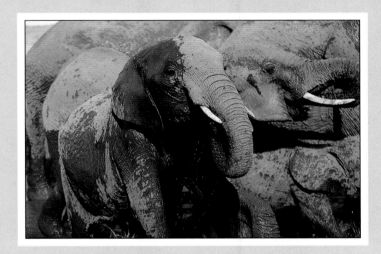

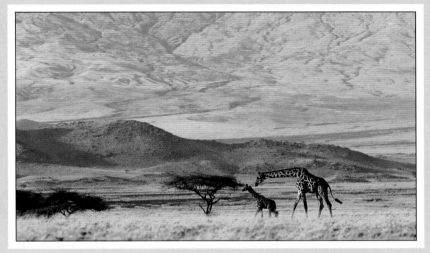

Using a zoom lens allows you to react quickly to changing circumstances and vary your composition without having to change lenses. With wildlife things often happen quickly and fractions of a second can mean the difference between getting the shot or losing it.
35-350mm, f4.5-5.6 zoom lens, 1/125th sec at f8

The rule of thirds is designed to avoid pictures with the horizon running through the middle of the frame. If you are taking a landscape, decide which is more important – the sky or the foreground, then give the more important element two-thirds of the frame. Don't put your subject slap in the middle of the frame; offset it to left or right, giving a sense of space for your subject to look or move into.
500mm f4.5 lens, 1/250th sec at f4.5.

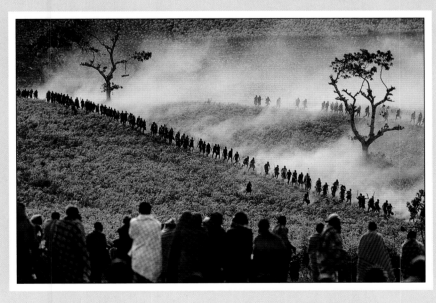

Diagonals help add a powerful visual element to a picture. Normally one tries to avoid having anything in the foreground out of focus, but in this instance the old men watching in the foreground help to frame the picture.
300mm f2.8 lens, 1/250th sec at f4.

Vary your shot; try making your animal subject an integral part of its environment. In this instance backlight created bold shapes and a sense of mood.
500mm f4.5 lens, 1/250th sec at f5.6.

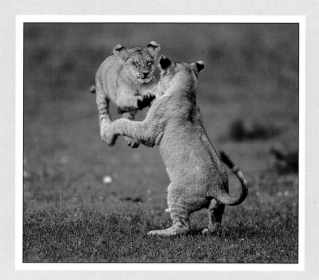

*Auto-focus can help you to
capture the action.*
1/ 250th sec at f4.

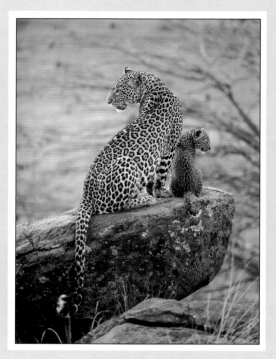

*Many of our favourite images are taken with
backlight or sidelight. This helps to create
mood and atmosphere. But the camera's
meter may be fooled, causing underexposed
images. To prevent this you may need to open
up – add light – to give some detail in the
subject's shadow areas.*
70-200mm f2.8 lens, 1/125th sec at f2.8.

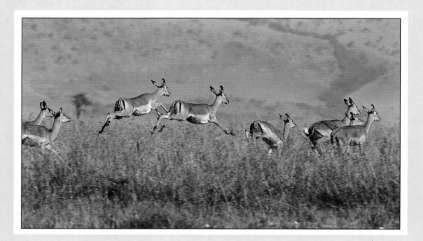

*Use your camera's speed setting in a creative way.
Speeds of 1/1000th sec freeze the action of a moving
subject. But using slow speeds and panning with your
subject as it moves often create a far more visual
sense of speed and movement.*
200mm f2.8 lens, 1/60th sec at f2.8.

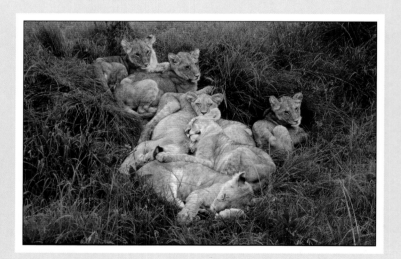

*Wide-angle lenses provide
plenty of depth of focus and
work best when you are able
to get close to your subject.
Having something big in the
foreground – a herd of
wildebeest, a tree, a person –
helps; if your subject is small –
a flower, for instance, you need
to get close to make it look
large in the frame.*
20-35mm f2.8 lens, 1/500th sec at f5.6.

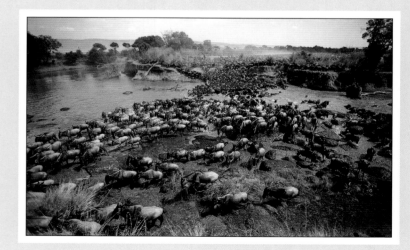

*Looking down on your subject makes
it easier to get all your subjects in
the same plane of focus.*
70-200mm f2.8 zoom lens, 1/30th sec at f11.

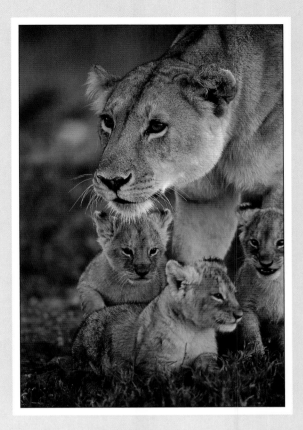

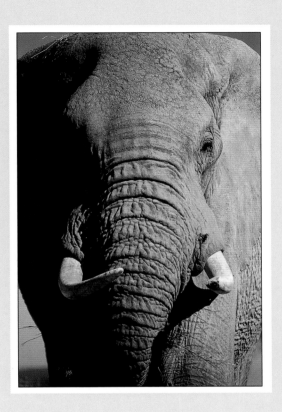

Long telephoto lenses have a shallow depth of focus, helping to isolate the subject from its background, and can be used to create a more intimate picture.

500mm f4 lens, 1/60th sec at f4.

Even something as large as a crocodile or an elephant has far less impact visually when viewed from a high position. Getting low allows you to get eyeball to eyeball with your subject, making it look more imposing.

500mm f4.5 lens, 1/60th sec at f4.5

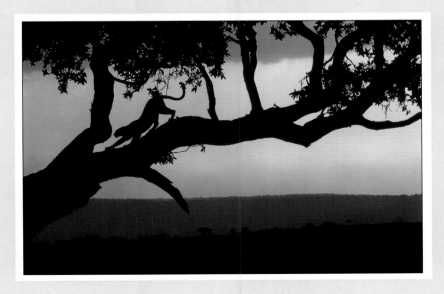

When photographing sunrises and sunsets, take a meter reading of the sky without the sun in the frame or use a spot meter. Point your camera to one side of the sun and lock in the exposure reading before recomposing your image to include the sun. If you meter with the sun in the picture without compensating, the final image may be too dark.

Left: 500 mm f4.5 lens, 1/125th sec at f8.

Right: 20-35mm f2.8 lens, 1/250th sec at f2.8

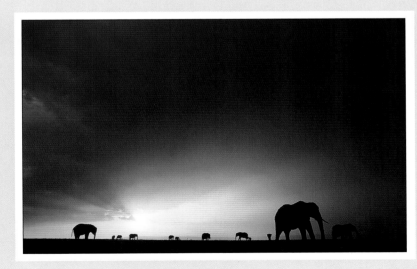

Bibliography

I have been fortunate to be able to draw on a wealth of material published on the Mara-Serengeti over the years. Though I have not cited individual references in the text, the work of the scientists and authors listed below proved indispensable in telling this story. My thanks also to Dr Markus Borner of the Frankfurt Zoological Society for providing me with an update on various aspects of the Serengeti. The most comprehensive account of the ecosystem is to be found in *Serengeti: dynamics of an ecosystem* and *Serengeti II: dynamics, management and conservation of an ecosystem*. I hope that the various authors will forgive me for any inaccuracies or simplifications that I have made in interpreting their work.

The Koiyaki-Lemek Wildlife Trust and Maasai Mara Management Committee (see below) is currently engaged in a pilot planning project for communities neighbouring the Masai Mara, aimed at optimising benefits from their land and natural resources, while maintaining the ecosystem's ecological functions and wildlife conservation values. This is a vital step forward.

Finally, my reason for calling this book Mara-Serengeti was simply that the bulk of the material is based on time Angie and I have spent in the Mara; that is where we have lived and how we think of the area.

Ames, E. *A glimpse of Eden,* Collins: London 1968.

Bailey, T. N. *The African Leopard: ecology and behaviour of a solitary felid,* Columbia University Press: New York 1993.

Bertram, B. C. R. *Pride of Lions,* J. M. Dent: London 1978.

Burrows, R., Hofer, H., & East, M. L. *Demography, extinction and intervention in a small population: the case of the Serengeti wild dogs.* Proc. R. Soc. Lond. B 256:281-92 1994.

Caro, T. M. *Cheetahs of the Serengeti Plains: group living in an asocial species,* University of Chicago Press: Chicago & London 1994.

Criel, S. *Sizing up the competition,* Natural History, Vol. 107, No.7, p.34 1998.

Fanshawe, J. H., Frame, L. H., & Ginsberg, J. R. *The wild dog - Africa's vanishing carnivore,* Oryx, Vol. 25, No. 3 1991.

Gellhorn, M. *Travels with myself and another,* Eland Books, London & Hippocrene Books, Inc: New York 1983.

Ginsberg, J. & Cole, M. *Wild at heart,* New Scientist, p.34 1994 (19 Nov).

Grzimek, B. & Grzimek, M. *Serengeti shall not die,* Hamish Hamilton: London 1960.

Hanby, J.P. & Bygott, J. D. *Lions share: the story of a Serengeti pride,* Collins: London 1983.

Hayes, H. T. P. *The last place on earth,* Stein & Day: New York 1977.

Three levels of time, E. P. Dutton: New York 1981.

Jackman, B. J., & Scott, J. P. *The marsh lions,* Elm Tree Books: London 1982.

The big cat diary, BBC Books: London 1996.

Lawick, H. van *Innocent killers,* Collins: London 1970.

Leopold, A. *A sand country almanac: and sketches here and there,* Oxford University Press: Oxford 1987.

Lopez, B. H. *Of wolves and men,* Charles Scribner's Sons: New York 1978.

The Koiyaki-Lemek Wildlife Trust & Maasai Mara Management Committee. *Mara ecosystem natural resources management planning: summary report of 1st workshop.* The Conservation Development Company Ltd: Nairobi 2000 (Jan).

McNutt, J. & Boggs, L. *Running wild: dispelling the myths of the African wild dog.* Southern Book Publishers: South Africa 1996.

Mills, G. *Kruger's wild dogs,* Air Tales, Vol.2, No.5 1995 (Oct/Nov).

Mol, F. *The Masai and wildlife,* Swara, Vol.4, No.2, p.24 1981.

Ogutu, J. O. *Test of a call-in technique for estimating lion (Panthera leo, Linnaeus 1758) population size in the Masai Mara National Reserve, Kenya,* Moi University, M.Phil.thesis: Nairobi 1994.

Packer, C. *Into Africa,* University of Chicago Press: Chicago & London 1994.

Polking, F. *Leoparden,* Tecklenborg Verlag: Germany 1995.

Russell, F. *The hunting animal,* Hutchinson & Co. (Pub.) Ltd.: London 1984.

Schaller, G. B. *The Serengeti lion: a study of predator-prey relations,* University of Chicago Press: Chicago 1972.

Serengeti: a kingdom of predators, Collins: London 1973.

Scott, J.P. *The leopard's tale,* Elm Tree Books: London 1985.

The great migration, Elm Tree Books: London 1988.

Painted wolves: wild dogs of the Serengeti-Mara, Hamish Hamilton: London 1989.

The leopard family book, Picture Book Studio: London 1991.

Kingdom of lions, Kyle Cathie Ltd: London 1992.

Jonathan Scott's guide to East African animals (Revised & updated by Angela Scott), Kensta: Nairobi 1997.

Jonathan Scott's Guide to East African birds (Revised & updated by Angela Scott), Kensta: Nairobi 1997.

Seidensticker, J., & Lumpkin, S. *Great cats,* Merehurst Ltd: London 1991.

Sinclair, A. R. E., & Norton-Griffiths, M., (eds.). *Serengeti: dynamics of an ecosystem,* University of Chicago Press: Chicago 1979.

Sinclair, A. R. E., & Arcese, P. *Serengeti II: dynamics, management,and conservation of an ecosystem,* University of Chicago Press: Chicago 1995.

Turner, M.; Jackman, B. J., (ed.). *My Serengeti years,* Elm Tree Books: London 1987.

Wilson, E. O. *Living with nature,* US News & World Report Inc: Washington, DC 1992 (Nov).

Wood, M. W., & Coulson, D. *Different drums,* Century Hutchinson: London 1987.

Acknowledgments

We have received such generous support from so many individuals and companies that it is possible to mention only a few of them here.

We would like to thank the governments of Kenya and Tanzania for allowing us to live and work in the Mara-Serengeti, and to acknowledge the assistance of Tanzania National Parks, and the Narok County Council, who administer the Masai Mara National Game Reserve. Over the years Senior Wardens John Naiguran, Simon Makallah, James Sindiyo, Michael Koikai and Stephen Minis in the Mara, and David Babu and Bernard Maregesi in the Serengeti have all been helpful and supportive of our projects.

Gillian Lythgoe, Christopher Angeloglou, Fran Norgren and all the staff at Planet Earth Pictures have been helpful and hospitable in equal measure during our visits to London. Special mention must be made of Jennifer Jeffrey, the library manager, for whom no task is too much trouble and no request for help refused: regardless of our demands everything is accomplished with good grace, humour and a smile.

Both Angie and I have family living in England who have been an unfailing source of inspiration and encouragement to us. My sister Caroline and her husband Andy have been wonderfully hospitable to us at their home in Inkpen, delivering us to the airport, storing our equipment and providing a la carte food at a moment's notice. We miss not seeing more of my brother Clive and his wife Judith, but greatly appreciate their love and support. There is always a warm welcome and a vehicle for us to use at Joy and Alan Seabrook's home in Hindhead, and a big thank you must go to Angie's brother David and his wife Mishi for their inimitable style of hospitality in England and India.

Many other people have provided us with a second home during our visits to England, particularly Pippa and Ian Stewart-Hunter, Pam Savage and Michael Skinner, Ken and Lois Kuhle, Cissy and David Walker, Dr Michael and Sue Budden, Brian and Annabelle Jackman, Martin and Avril Freeth, Charles and Lindsay Dewhurst – all wonderful hosts and friends. And in Kenya our neighbours Frank and Dolcie Howitt kept watch over us and our house like the best of 'parents' – something they seem to manage for half of Nairobi. Sadly, my mother, Margaret Scott, died while we were filming in India last year, just a few days short of her 89th birthday. She meant more to me than words can express and this book is dedicated to her.

For many years our American friend David Goodnow helped us with purchasing film stock, cameras and lenses, and Neil and Joyce Silverman have been the best of friends, providing hospitality at their beautiful home in Florida and purchasing supplies for us on many occasions. Carole Wyman is one of those rare people whose help has touched many, but who never asks for thanks. Her love and generosity has been felt by all our family.

Jock Anderson of East African Wildlife Safaris gave me the chance to begin living in the Masai Mara in 1977 by allowing me to stay at Mara River Camp. Over the years Jock has been of tremendous support to both Angie and myself in the bush and in Nairobi. Stephen Masika, Jock's office manager, still keeps track of correspondence and renews licences for us with unfailing efficiency.

Geoff and Jorie Kent of Abercrombie & Kent, and Anne Taylor-Kent provided us with accommodation for many years at Kichwa Tembo Camp, and we would like to say a special thank you to Kazumi Oguro for his hospitality at Mpata Lodge. Aris and Justin Grammaticas have been generous in allowing us to base ourselves at Governor's Camp in the heart of Marsh Lion territory in recent times. Pat and Patrick Beresford and their staff at Governor's Workshop have done a fantastic job in keeping us on the road, regardless of how seriously we damage our Toyota Landcruiser.

Many drivers and guides generously provided us with updates on the animals and helped us to locate them. First among these was Joseph Rotich, my old friend from Mara River Camp, a gentle man of great warmth and humour who died in 1990. More recently Enoch Isanya of East African Ornithological Safaris and Stephen Mutua at Governor's Camp have been particularly helpful.

John Buckley and Anna Nzomo at Air Kenya have always been generous and efficient in flying both us and our supplies to and from the Mara.

Mehmood and Shaun Quraishy at Spectrum Colour Lab in Nairobi processed our film with speed and efficiency, and Pankaj Patel of Fuji Kenya has provided a wonderful service in keeping us supplied with Fuji Velvia, Sensia and Provia – our favourite films.

Mike Shaw, my literary agent at Curtis Brown, and his assistant Jonathan Pegg were generous with their time and support. Caroline Taggart has edited all but one of my books and kindly agreed at very short notice to apply her considerable talents to this project – what would I do without her? And a big thank you to Harry Ricketts of Fountain Press for making this project possible, and to Grant Bradford for all his efforts in designing a book to match the subject.

Finally, a very special vote of thanks to our daughter Alia, who has worked tirelessly on our behalf at home in Nairobi, organising our slide collection, writing proposals, keeping track of correspondence and accomplishing a hundred and one other tasks with enthusiasm and attention to detail while we have been away on safari.

Vehicle
Kevin Gilks of Lonrho Motors East Africa, Jan Thoenes, Malcolm Bater and Alan Walmsley of Toyota Kenya and Shigeru Ito of Toyota East Africa were all instrumental in providing us with the loan of a Toyota Landcruiser during the past eight years. The space, reliability and comfort of the vehicle has made all the difference to our life in the bush.

Camera equipment
We have always used Canon cameras and lenses and would particularly like to thank Chris Elworthy for years of unfailing support, and Geoff Thorn. Service managers Malcolm Tester and Steve Johnson, and Lynne Scott, Sue McGarvey and Kishor Dahyatker in the Service Department kept our equipment healthy regardless of dust, fungus and falls from great heights. When I recently dropped my 300mm EF lens off the roof of my car on to my winch with a sickening thump it continued to function perfectly – without a service. We use EOS 3, EOS 1n, and EOS RS camera bodies, and our favourite lenses are the 20-30mm and 70-200mm f2.8 zooms, the 300mm f2.8, 500mm f4 (image stabilised), and 600mm f4 telephotos.

Index

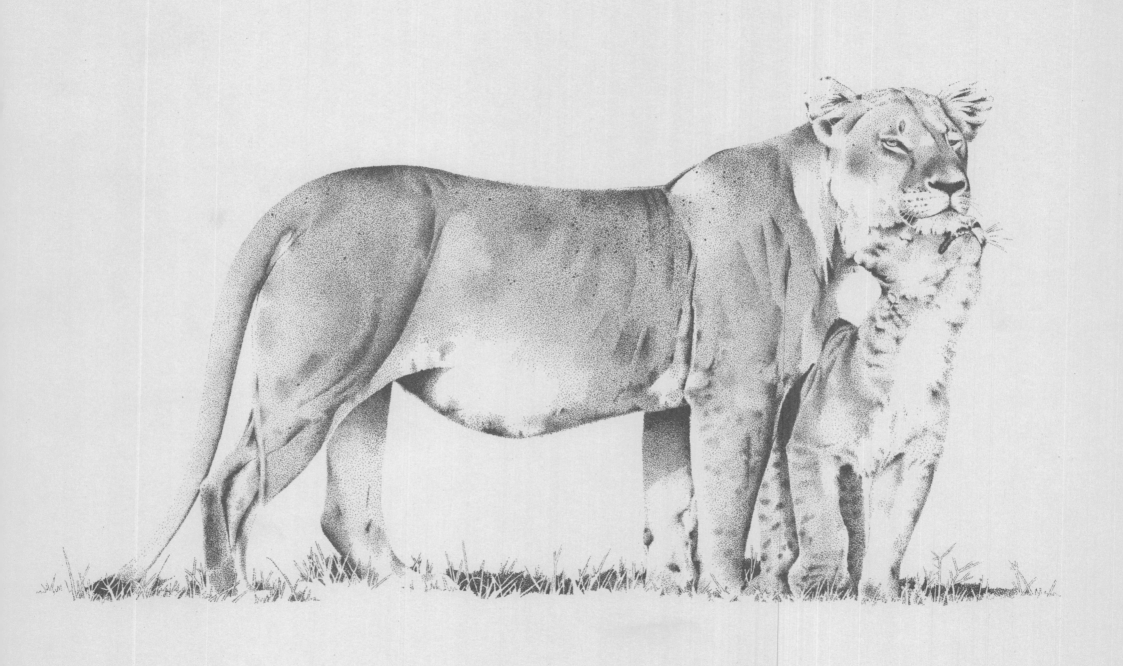